MARY

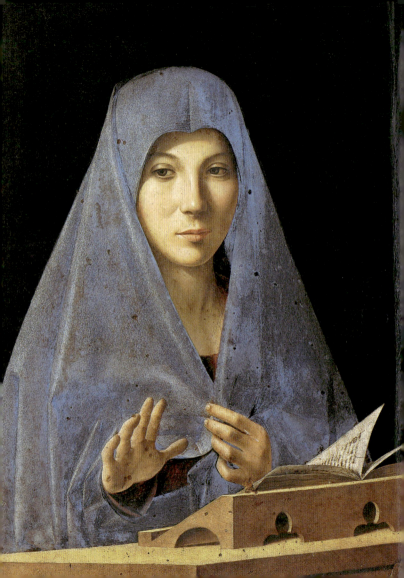

MARY

BY MARTINA DEGL'INNOCENTI
& STELLA MARINONE

Abrams, New York

Cover illustration: Cesare da Sesto,
Madonna and Child with the Lamb of God, (detail)
c. 1515, Museo Poldi Pezzoli, Milan

Page 2:
Antonello da Messina,
The Virgin Annunciate (detail), c. 1476
Museo Nazionale, Palermo

Opposite:
Albrecht Dürer
Adoration of the Magi (detail), 1504
Galleria degli Uffizi, Florence

Editorial direction: Virginia Ponciroli
Editor: Studio Zuffi
Graphic direction: Dario Tagliabue
Layout: Elena Brandolini
Picture research direction: Elisa Dal Canto
Picture research: Simona Pirovano
Technical direction: Lara Panigas
Quality control: Giancarlo Berti
English translation: Rosanna M. Giammanco Frongia,
 Ph.D.
English-language typesetting: William Schultz

Library of Congress Control Number: 200929010
ISBN 978-0-8109-8285-7

Copyright © 2008 Mondadori Electa S.p.A.
English translation © 2009 Mondadori Electa S.p.A.
Biblical passages are taken from *The New American
Bible,* Greenlawn Press, South Bend, Indiana, 1991.

Originally published in 2008 by Mondadori Electa
S.p.A., Milan

Published in 2009 by Abrams, an imprint of ABRAMS.

Printed and bound in Spain
10 9 8 7 6 5 4 3 2 1

Abrams books are available at special discounts when
purchased in quantity for premiums and promotions as
well as fundraising or educational use. Special editions
can also be created to specification. For details, contact
specialmarkets@abramsbooks.com or the address below.

THE ART OF BOOKS SINCE 1949

115 West 18th Street
New York, NY 10011
www.abramsbooks.com

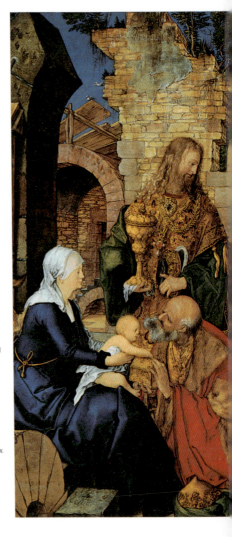

Table of Contents

Introduction

The figure of Mary, the Mother of Christ, has from the beginning of Christianity fascinated millions of people, believers and nonbelievers alike, attracted by the miracle of her inviolate maternity. Mary is, of course, a real person who lived in a specific historical time. For the Christian world, the trajectory of her life and the inexorable role that God assigned her in human history has made of the Madonna a model of virtue, the emblem of the Church, the guardian and advocate of the faithful, and even a symbol of hope in eternal life. Because of the complexity of the subject matter, we have designed this book around multiple points of view. We have also chosen to include images that complement the text.

The book begins with a section on Marian prophecies and prefigurations, examining the Old Testament predictions—which mark the passage from the Old Covenant to the New—about the coming of a Messiah, who would be born of a Virgin. Mary is also prefigured in the many bold figures of Old Testament women who share her virtues and traits. The transposition of behaviors and moral qualities from these ancestor women to Mary actually mirrors popular devotion, which compares Mary's virtues to those of the Old Testament heroines, thus giving a sense of continuity to the story of salvation.

The second section, on iconography and symbolism, identifies and illustrates those unique traits that help define the image of the Madonna, from her principal attributes to the complex body of visual symbols, which are subdivided, somewhat arbitrarily, into abstract and general categories, including places, flowers, fruits, and objects, that all symbolize Marian virtues. The salient events of Mary's life, from her infant years through her

pregnancy and her participation in the redeeming mission of Jesus Christ, are the heart of this book and are explored in the sections about Mary's family and childhood, Mary's relationship with her son Jesus, and the Passion of Christ. Mary's life, summarized through what Catholics consider its most important moments, has been researched using sources such as the official Gospels and the Apocrypha. Sometimes, we have included episodes that, while not actual historical events, are the object of special cults and devotion. Over time, these imaginary episodes gave rise to iconographies that have made them famous and recognizable, so that they too have become part of history.

In the section examining Mary and the saints, we focused on the influence that the Virgin has exerted on those most devoted to her, even during her earthly life, through apparitions and visions. Other chapters touch on the special cult of the icons dedicated to her in the Eastern Church, as well as the principal works of Marian art by influential artists who contributed over time, and in a decisive fashion, to change the tastes and visual lexicon of society at large. Through these works, we follow the changing image of the Madonna.

The last chapter is about the Marian feasts that today remain the object of strong devotion worldwide. In some cases, because of historical, cultural, and artistic importance, we assigned several pages to the same episode. The appendices contain useful alphabetical indexes of episodes and artists, and a list of the principal Marian apparitions. The images that complement all of these texts draw a comprehensive view of the figure of Mary.

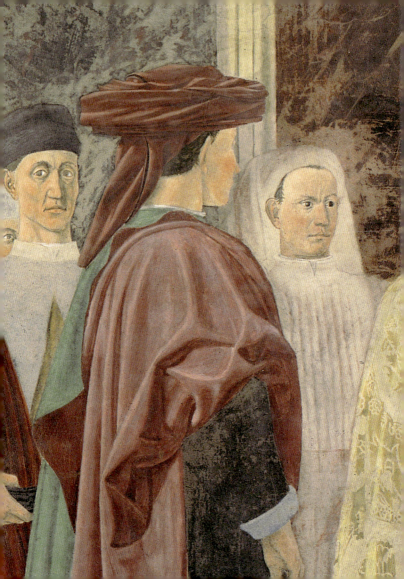

Marian Prophecies
and Prefigurations

Eve

Eve, *Hawwah* in Hebrew, is "she who gives life," the first woman, the progenitor of humankind created by God from Adam's rib. Seduced by the serpent, she ate the fruit of the Tree of Knowledge of Good and Evil, thereby disobeying God's will and committing the Original Sin. But since a woman, Eve, brought sin into the world, God arranged that another woman, Mary, would free the world of it, by participating in the redemption of humankind. For it was through Mary that Jesus, Son of God, became a man and defeated the Evil One. And just as Eve is the mother of living sinners, so Mary is the mother of a human race that has been lifted from sin. In Dante's *Paradiso*, Saint Bernard points out Eve's soul to the Poet, remarking: "The wound that Mary closed up and anointed, / She at her feet who is so beautiful, / She is the one who opened it and pierced it." Mary heals the beautiful woman in supplication, Eve, who originally caused the wound to humankind.

(Dante Alighieri, *Paradiso*, Canto XXXII, 4–6, translated by Henry Wadsworth Longfellow)

Hieronymus Bosch
Triptych of Haywain (detail)
1500–1502
Museo del Prado, Madrid

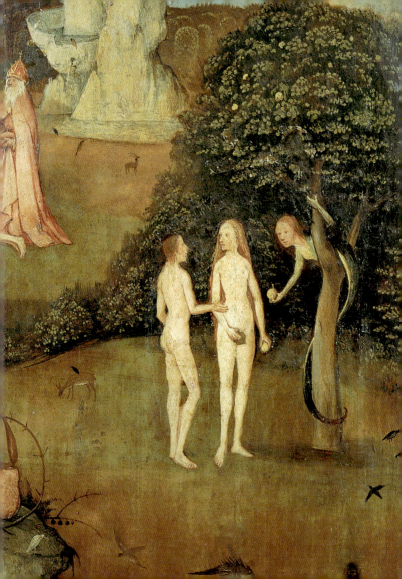

Eve

Mary is called the "New Eve" because, unlike Eve, who was weak and disobedient, the Virgin answered God's call with humility and faith. Mary represents means by which the breach caused by the serpent was healed. Mary undid the sinful knot that Eve had tied, imprisoning man by overstepping the boundaries God had set, choosing instead the pleasures proffered by the serpent. Mary, on the contrary, accepts God's will with strength and determination, thereby achieving the redemption of humankind. For this reason, the episode of Adam and Eve's banishment from Eden appears often in the figurative arts along with that of the Archangel Gabriel announcing the Immaculate Conception.
(Genesis 3:6–13)

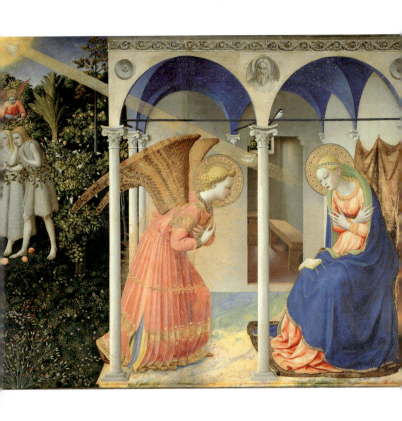

The Madonna on the Globe

Because of Original Sin, God cursed the serpent and sentenced it to be crushed under the woman's feet. Thus began the enmity between the snake, symbolic of all sinners, and Mary's progeny, the human race after the Savior's descent to Earth. In this scene, the globe represents at once the world and each individual soul, beguiled by the snake, the tempting devil over which Mary will triumph. The Virgin conquers sin by crushing the snake's head under her feet, assisted by her son, who places his foot on top of hers. Mary sits on the globe in her God-given role of co-redeemer, mediator, and advocate of humankind; she helps to fight sin and defeat it.
(Genesis 3:15–20)

Carlo Maratta
*The Virgin in Glory between Saint Francis
of Sales and Saint Thomas of Villanova*
1671
Sant'Agostino, Siena

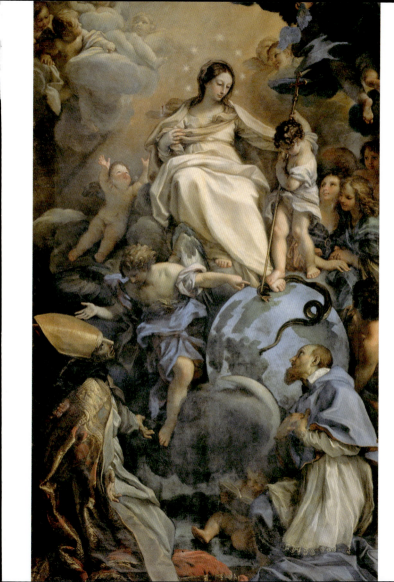

Hagar

When Sarah, Abraham's wife, learned that she was sterile, to conceal her condition, which was dishonorable in the eyes of the Hebrew community, she allowed her servant Hagar to lie with her husband. In this way, the child born from their union, Ishmael (which means "God will hear") would be considered hers by the community. But when Abraham discovered that through God's action Sarah was no longer sterile (the same would happen to Anne, the Virgin's mother), he gave Hagar a goatskin full of water and some bread and banished her. Hagar and the child wandered for years in the desert near Beersheba in search of the way to her home in Egypt. Like the Madonna, Sarah symbolizes the Church, while Hagar is the Synagogue. The slave is also the prefiguration of the Virgin whom Herod would force to flee into Egypt to protect the infant Jesus.

(Genesis 16:1–16; 20:8–21)

Giovanni Francesco Barbieri,
known as Guercino
Abraham Casting Out Hagar and Ishmael
1657
Pinacoteca di Brera, Milan

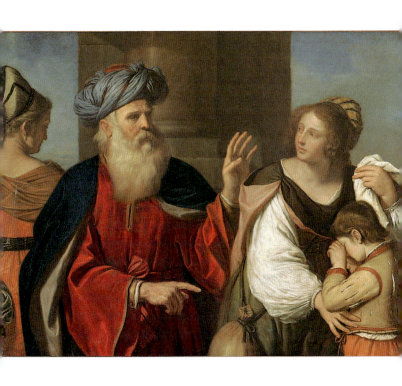

Sarah

When Abraham's wife turned 89, God changed her name
from Sarai to Sarah, which means "princess, high holy one,"
and assured her that she would miraculously conceive a son
whom she would name Isaac, which means "God's laughter."
When Isaac was a boy, God subjected Abraham to an immense
ordeal, asking him to sacrifice his only begotten son. With
death in his heart, Abraham obeyed, but just as he was tying
the boy up to slit his throat, an angel appeared and caught his
arm, for God had appreciated Abraham's obedience. Therefore
Sarah, the mother who gave birth to a son destined to be
sacrificed, is the prefiguration of the mother of Jesus, the sacri-
ficial lamb par excellence.
(Genesis 17:15–22; 18:1–15; 19:1–7; 22:1–19)

Jan Provost
Abraham, Sarah, and the Angel
c. 1520
Musée du Louvre, Paris

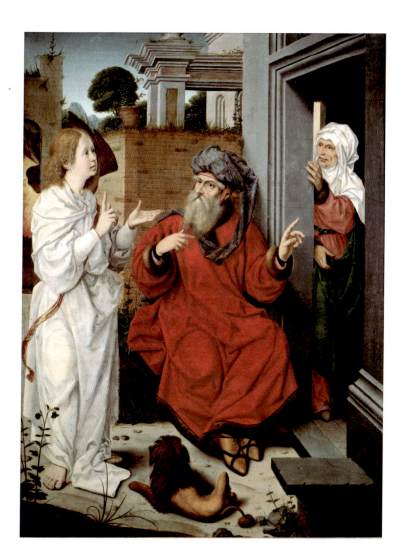

Rebekah

One evening in the town of Paddam-aram, Rebekah, daughter
of Bethuele and Abraham's great-niece, went to the well to
fetch some water and there met a stranger: Seeing that he was
thirsty, she offered him and his camels water. The man was
Eliezer, Abraham's servant dispatched by his master to his nati-
ve land to find a wife for his son Isaac; the master had counsel-
ed him to choose a woman from his own clan. Eliezer asked
God to send him a sign so that he could recognize the woman
he should choose, and at that point Rebekah walked toward
him. The servant revealed the reason for his journey and
returned to his master's house in the land of Canaan with
Rebekah, who married Isaac. Her openness and generosity,
and her obedience to the will of God, make her a prefigura-
tion of Mary, such that in Jacopo da Varagine's *Legenda Aurea*
(Golden Legend) the Virgin is called "Rebekah, whose jar is
full of water," meaning, full of grace.
(Genesis 25; Jacopo da Varagine, *Legenda Aurea*)

Francesco Hayez
Rebekah at the Well
1848
Pinacoteca di Brera, Milan

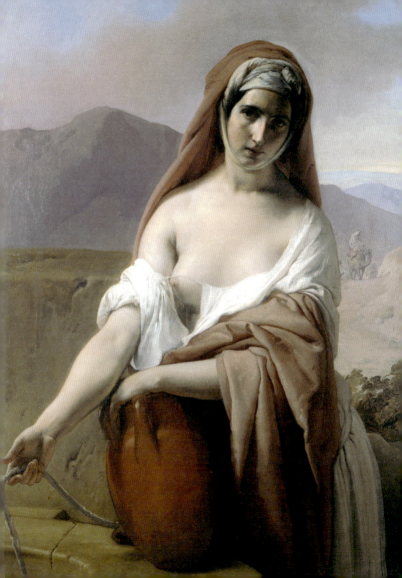

Rachel

Leah and Rachel were the daughters of Laban, Rebekah's brother. After a long wandering, Jacob, the second-born son of Isaac and Rebekah, reached the town of Haran, where he met his beautiful cousin Rachel as she was leading the flock to water. He fell in love with her and agreed to work in his uncle's employ as a shepherd for seven years before marrying Rachel. But at the end of his servitude, the cunning father-in-law stealthily married him to skinny, haggard Leah, Rachel's ugly sister. Jacob fathered six sons and a daughter with her. After seven more years of shepherd's work, Jacob was finally allowed to marry his beloved Rachel, with whom he fathered Joseph and Benjamin. Rachel died while giving birth to Benjamin. Through the centuries, Leah and Rachel have been seen as the prototypes, respectively, of the Synagogue and the Church—that is, the Hebrew and Christian communities. In this sense, Rachel prefigures the role of Mary as mother and emblem of the Church, understood as the community of all the faithful who gather in the presence of God.
(Genesis 29)

Dante Gabriel Rossetti
Dante's Vision of Rachel and Leah
1855
Tate Gallery, London

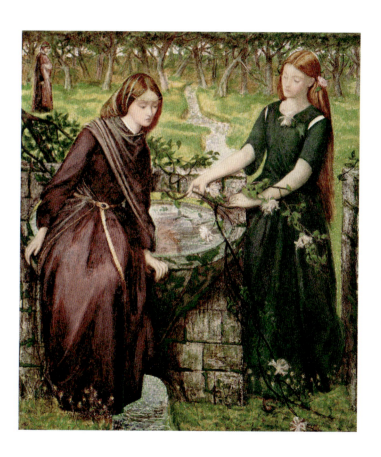

The Burning Bush

The prophet Moses, leader of the Hebrew people, was grazing his father-in-law Jethro's flock on the slopes of Mount Sinai, when he saw a thornbush that was on fire, but not consumed by the flames. Troubled by the unusual apparition, he began to approach when he heard the voice of God order him to remove his sandals, because he was walking on hallowed ground. Then God entrusted Moses with the task of leading his people, who were oppressed by the Pharaoh, out of Egypt and into the land of Canaan. The burning bush has been interpreted as an emblem of Mary's virginity, she who gave birth to Jesus with her womb untouched. For this reason, in some representations of this episode artists add a figure of the Virgin holding the Child in the center of the bush, with the Child holding a mirror in which the two figures are reflected. This detail alludes to the Immaculate Conception, and to Mary as the *speculum sine maculae*: the "spotless mirror," the only human being free of Original Sin, so that she alone could mirror without distortion the image of the Christ. (Exodus 3:1–6)

Nicolas Froment
The Burning Bush
1476
Saint-Saveur, Aix-en-Provence

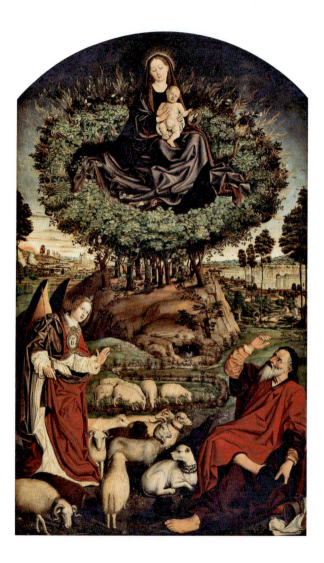

The Burning Bush

The biblical episode of Moses and the burning bush inspired an unusual icon that became popular in Russia starting in the fourteenth century. At the center stands the Madonna with the Child in her arms inside a green diamond, the color of which refers to the plant part of the bush. At each diamond point are the angels of the Apocalypse with their scourges (stars, clouds, thunderbolts, torches, and swords). Behind the green diamond is a red one that forms an eight-pointed star with the green diamond: This represents the divine flame that burns but does not consume the bush; at the four corners are the symbols of the four Evangelists. Around the star are the angelic powers subjected to the Virgin, and in each corner of the icon are the visions that prophesied the Incarnation: Moses's burning bush, the seraph purifying the mouth of Isaiah with a burning coal, Ezekiel's closed door, and Jacob's ladder. With this blended symbolism, the icon may be seen as a bridge between the Old Testament prophecies, which foretell the salvation of man through Mary, and the New Testament.
(Exodus 3:1–6)

Russian School
The Virgin of the Burning Bush
19th century
Musée du Louvre, Paris

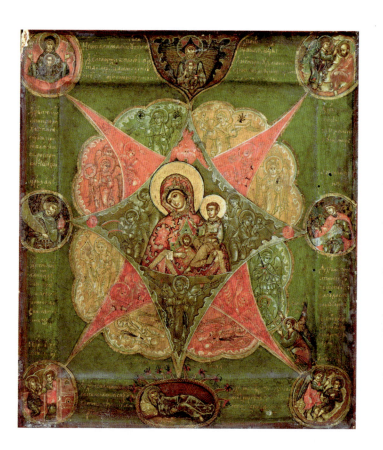

Miriam, the Sister of Moses and Aaron

As Moses's sister, the prophetess Miriam is, along with her brother, a fundamental figure in the wondrous deeds of the Exodus from Egypt. After the waters parted, the people crossed the dry seabed, and Pharaoh's horsemen and chariots were swallowed up by the sea. Miriam picked up a tambourine and sang a victory laud in honor of the Lord, calling the girls and women to join her in singing and dancing. "Sing to the Lord, for he is gloriously triumphant; horse and chariot he has cast into the sea." She continued to exhort and support her people during the 40 years of wandering in the desert. A central figure in Hebrew history, Miriam spoke in the name of the Lord and waited for His word to be fulfilled; she trusted Him, as did Mary, who took her name from her ancestor, for Miriam is the Hebrew spelling of Mary and means "most high, august, lofty." (Exodus 15:21)

Luca Giordano
The Song of Miriam
c. 1660–70
Private collection

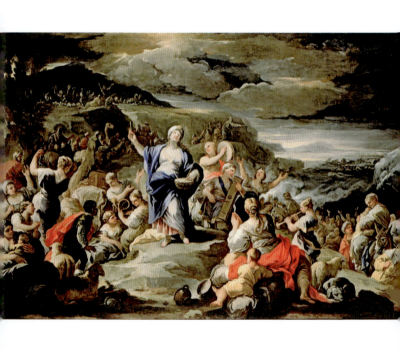

Deborah

It is written in the Old Testament that Deborah was "a prophetess, the wife of Lapidoth, she judged Israel at that time." The only woman in the Bible to be called a "judge," in Judges she is described sitting under the palm tree, which took its name from her, where "the children of Israel came up to her for judgment." Following the advice of the Lord, Deborah summoned the valiant leader Barak and ordered him to wage war against Sisera, who was oppressing the Israelites. Barak accepted, on the condition that Deborah go with him. She agreed, but predicted that the glory of capturing the enemy commander would not belong to him but to a woman, Jael. All through this episode, Deborah acts as a strong, resolved, bold woman full of initiative, just as Mary would be. The prophetess is also a symbol of justice, another virtue that the Mother of the Righteous One embodied.
(Judges 4:1–16)

Salomon de Bray
Jael, Deborah, and Barak
1635
Museum Catharijneconvent,
Utrecht

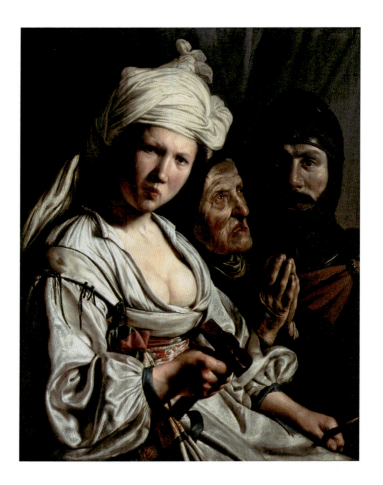

Jael

When she was a judge of Israel, Deborah decided to launch the Hebrew tribes in harsh battle against the Canaanite natives led by General Sisera. Jael, a member of the Bedouin Kenite tribe, a historical enemy of the Israelites, broke rank and chose to fight for the Hebrews. When Sisera, thinking that the two tribes were at peace, accepted Jael's invitation to join him in her tent, she welcomed him and offerd him milk, inviting him to rest. As soon as he fell into a deep sleep, she killed him using a peg and hammer, probably made of wood, similar to those the Bedouins used to secure their tents to the ground. Jael's transformation from a peaceful, welcoming hostess to a resolute, strong, courageous woman makes her the perfect prefiguration of Mary the Deliverer, she who would proudly and firmly crush the serpent's head.

(Judges 4:17–22)

Jael Killing Sisera
from the *Speculum humanae salvationis*
Miniature
c. 1360
Hessisches Landesbibliothek,
Darmstadt

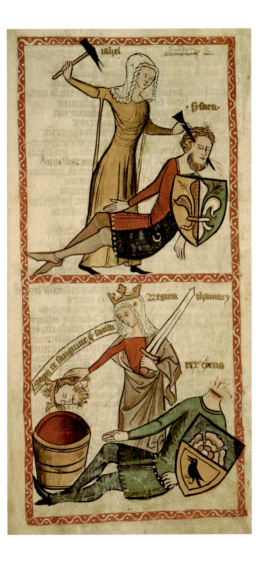

Jael

The story of this biblical heroine illustrates how God can ridicule evil and destroy it. In fact, Jael's is not a premeditated act but one born out of a sudden, instinctive hatred of evil. This is corroborated by the few humble words that Jael addressed to Barak, the commander of the Israelite troops, after her deed: "Come, I will show you the man you seek." When the battle was over, Deborah sang a praise to the Lord mentioning how the people of Meroz, out of fear, had not taken Israel's side, and how Jael the Bedouin had saved the day. For this reason, Deborah calls Jael "blessed among all women"—the same salutation with which Elisabeth addressed Mary at the Visitation—because she dared to root out the evil that threatened God's people.
(Judges 4:17–22).

Artemisia Gentileschi
Jael Killing Sisera
1620
Szépmûvészeti Múzeum, Budapest

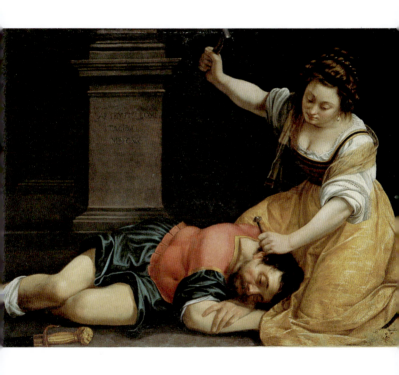

Gideon and the Fleece

Before the state of Israel was founded around 1200 BCE, the Israelites' survival and independence were threatened by many nomadic tribes, in particular the Midianites. Seeing this, the Lord sent a messenger to Gideon, a member of the poorest family of Manasseh, to appoint him to be the judge, leader, and chief of the nation at that difficult time. Gideon asked God for a sign of His will: "If indeed you are going to save Israel through me, as you promised, I am putting this woolen fleece on the threshing floor. If dew comes on the fleece alone, while all the ground is dry, I shall know that you will save Israel through me, as you promised." At night the dew fell on the fleece only. Thus, Gideon gathered an army of only 300 men, yet, with the Lord's aid, defeated the enemy. For this important task, God chose someone who was humble and poor, just as He would do with Mary; He chose someone who was considered weak, and made him strong with his faith. The night dew in a land as dry as Palestine is a symbol of God's blessing; the Virgin's womb may be thought of as a fleece into which God's gift would descend.
(Judges 6:36–37)

French School
Maciejovski Bible
Miniature
c. 1250
The Morgan Library & Museum, New York

Hannah, the Mother of Samuel

Hannah was the wife of Elkhanah of the tribe of Ephraim. She longed to bear her husband a son but was sterile, and therefore despised and shunned by the rest of the tribe, because in Old Testament society, a woman occupied a lower social rank than a man, even more so when she was sterile. Desperate, she went on a pilgrimage to the shrine of Siloam, where she silently prayed to God. Her supplication attracted Eli's attention; he was a temple priest, and the custom was that prayers be recited out loud. But when Hannah confessed her plea to Eli, he gave her his blessing. The Lord answered the woman's prayer, and she begat Samuel. Hannah sang the *Exultavit cor meum*, a hymn of joy and gratitude, to God. This laud has been often compared to the *Magnificat*, which Mary sang when she met her cousin Elizabeth. Both express faith in the Lord of the weak and the poor who are raised up. To keep her vow, Hannah entrusted her son Samuel to Eli for his education; he grew up to become a prophet and the last judge of Israel.

(I Samuel 1:20)

Gerbrand van den Eeckhout
Hannah Presents Samuel to the High Priest Eli
17th century
Musée du Louvre, Paris

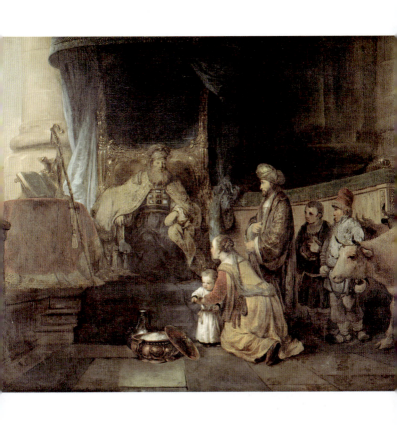

Ruth

During a famine in Palestine, Elimelech and his wife Naomi
left Israel for the land of Moab. Their sons married Orpah
and Ruth, two Moabite maidens, but soon the sons and their
father died, leaving the widows and Naomi alone. When Naomi
decided to return to Bethlehem, Ruth followed. They lived
together in the land of Judaea, and Ruth married Boaz, a rela-
tive of her dead husband. They begat Obed, future father of
Jesse, father of David. Ruth was a foreigner, which caused
a scandal in puritanical Hebrew society, but precisely for this
reason she became the instrument of the Holy Spirit in the
history of salvation, for David would be born from her, just
as the Messiah would be born from Mary. Thus both women
participate in the divine design of humankind's salvation.
(Ruth 1–4)

Nicolas Poussin
Summer (Ruth and Boaz)
1660–64
Musée du Louvre, Paris

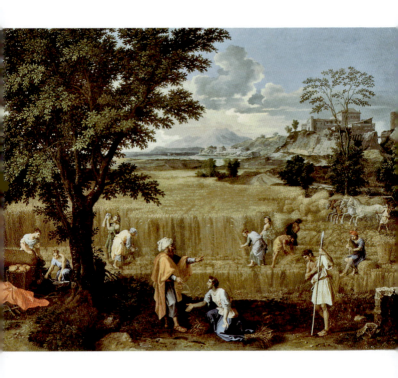

Mary, Ark of the New Covenant

Jerusalem, the capital of the present-day state of Israel, was founded in the eleventh century BCE by David, son of Jesse of the tribe of Judah. Anointed king by Samuel, he became the son-in-law of King Saul after defeating Goliath. David succeeded his father-in-law and united the Israelite tribes, adding the Philistines, who were then the Israelites' subjects, to the kingdom and founding a new capital. To give the city a sacred dignity, he made it the new home of the Ark of the Covenant—a vessel made of acacia wood on top of which two cherubim held a gold plate. This vessel was worshiped as God's Ark or "God's footstool"; it was believed to be the throne of his earthly presence. For the people of Israel, the Ark was of incommensurate value: While it stayed with them, they were guaranteed God's protection and support, but should it be seized by enemies in a battle, it would mean that the Lord had forsaken His people. In the New Testament, Mary becomes the Ark of the New Covenant because she is the Seat of Christ. Just as the biblical Ark denotes the presence of God among His people, so Mary is the vessel that holds Jesus, and thus the most accomplished divine presence among men.
(II Samuel 6:1–26)

Augusto Passaglia
The Madonna as the Ark of the Covenant
1887
Santa Maria del Fiore, Florence

42

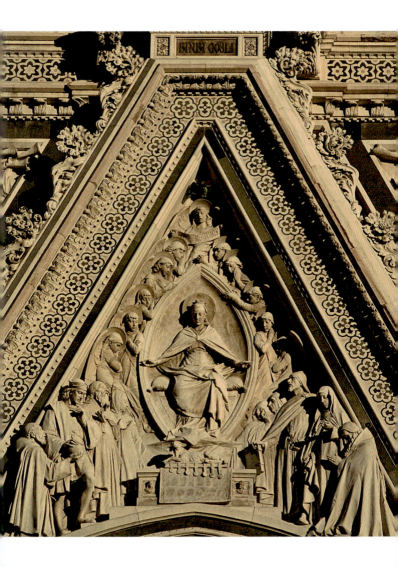

Mary, Daughter of Zion

Mary's title, "Lofty Daughter of Zion," was confirmed by Vatican Council II in 1962. Zion is the hill of Jerusalem, the capital founded by David; it is the city's oldest district, its stronghold, a safe, protected place. With time, the hill's name came to refer to the entire city, which God had chosen as His seat. Here the Lord made a pact with His people. Zion welcomes and protects the faithful just as Mary holds and protects the Son she carries in her womb. This appellation is translated visually in the hill that is visible on Mary's chest.

Stroganov School
Mountain Uncut by Human Hands
early 17th century
Sol'vycegodsk Museum,
Sol'vycegodsk

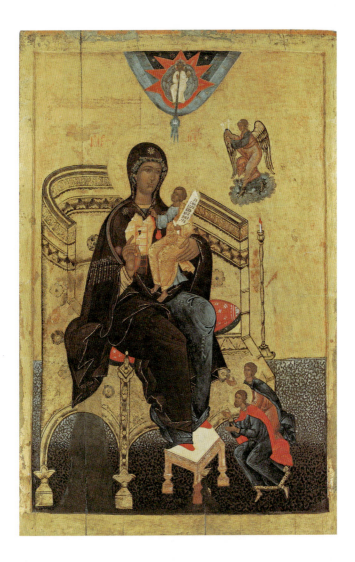

Abigail

This biblical heroine foreshadows the Madonna's prudence. Abigail was Nabal's first wife; her husband's name means "fool." When he first met Abigail, David, the future king of Israel, was the leader of the rebels who had fled King Saul's army. Nabal had haughtily refused David's request for assistance, failing to understand that his refusal could have meant his death. Abigail decided to negotiate with David unbeknownst to her husband. Unlike her rude husband—a symbolic representation of the sinner—the graceful, pleading woman (typical qualities of Mary) brought David "two hundred loaves, two skins of wine, five dressed sheep, five measures of roasted grain, a hundred cakes of pressed raisins, and two hundred cakes of pressed figs," and asked him to be merciful to her husband: "Let not my lord pay attention to that worthless man Nabal, for he is just like his name. Fool is his name, and he acts the fool."
(I Samuel 25:2–42)

Guido Reni
David and Abigail
1615
Szépművészeti Múzeum, Budapest

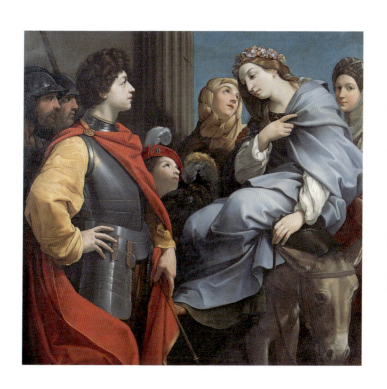

Bathsheba

From the terrace of the royal palace, David, king of Israel,
glimpsed Bathsheba taking a bath and fell in love with her.
Although he knew that she was Uriah's wife, David laid
with her and made her pregnant. To conceal the adultery, he
recalled her husband from the war hoping he would lie with
her, but Uriah refused to sleep in his home. Then David
sent him back into battle, hoping he would die, thus freeing
Bathsheba to marry him. But God punished David by causing
the death of the child. Later, Bathsheba would give birth to
another child by David, Solomon. When he ascended the
throne, Solomon decided to have a second throne placed next
to his, to seat "his mother, and she sat on his right hand," just
as Christ would crown Mary the Queen of Angels. Thus
Bathsheba interceded with her son, becoming a prefiguration
of the Madonna's pleading with Jesus on behalf of sinners.
(I Samuel 11:2–25; I Kings 2:13–25)

Lucas Cranach the Younger
David and Bathsheba
c. 1537
Gemäldegalerie Alte Meister,
Dresden

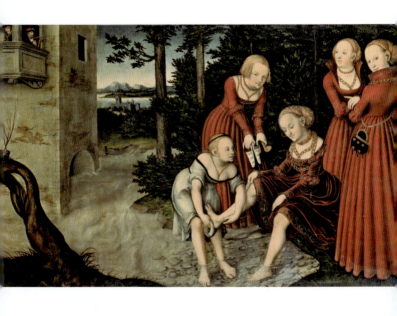

Abishag

Of all the women mentioned in the Old Testament whose lives exalt the Virgin's holiness and greatness, surely Abishag is one of the most neglected. When King David was in his advanced age, his councillors suggested to him, "Let a young virgin be sought to attend you, lord king, and to nurse you. If she sleeps with your royal majesty, you will be kept warm." A search was made throughout the land of Israel until Abishag from Shunam was found and brought to him. She was very beautiful, and dutifully served David, who made her his wife but did not consummate the marriage. Therefore, Abishag serves as an excellent prefiguration of Mary, who is at once *Uxor et Virgo*—Bride and Virgin.
(I Kings 1:1–4)

David and Abishag
from the *Bible de Manerius*
Miniature
12th century
Bibliothèque Sainte-Geneviève, Paris

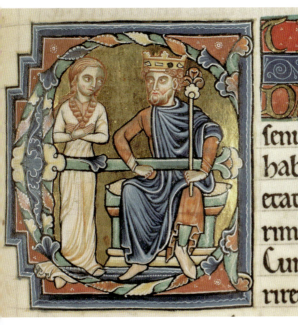

REX
DAVID

senuerat!
habebátq;
etatis plu
rimos dies.
Cumq; ope
riretur ues

The Queen of Sheba

"The Queen of Sheba, having heard of Solomon's fame, came to test him with subtle questions." The two began to challenge each other with cunning and wisdom; in the end, the queen recognized Solomon's great wisdom, and he invited her to the palace. According to Jacopo da Varagine's *Legenda Aurea*, while crossing the wooden foot-bridge, the queen was struck by the intuition that "this would would one day be used to build Jesus' Cross and the kingdom of the Hebrews would be destroyed." Hearing this prediction, Solomon decided to have the timber buried, but during the days of Jesus' trial it resurfaced and was indeed used to make the Cross. The Queen of Sheba, with her wisdom and intelligence, pre-figures Mary as *Sedes Sapientia* (the Seat of Wisdom), she who knows God's will.

(I Kings 10:1–13; Jacopo da Varagine, *Legenda Aurea*)

Piero della Francesca
Meeting of Solomon and the Queen of Sheba
(detail)
c. 1452
San Francesco, Arezzo

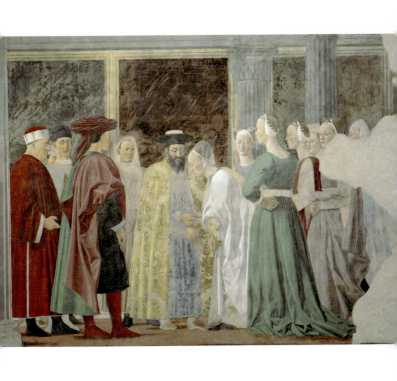

Judith

General Holofernes, leader of the armies of the Assyrian King
Nebuchadnezzar, had set siege to the city of Bethulia in a key
area between Samaria and Judea. The desperate townfolk were
ready to surrender when Judith, a well-regarded, God-fearing
woman who had been widowed three years before, decided
to act. With her maidservant, she left the city, and while her
people were deep in prayer, she slayed the general. Before
embarking on her mission, Judith put on lovely garments
and jewels and prayed. Once she was before the enemy, she
charmed Holofernes into believing that she would deliver the
city to him. On the fourth day, the commander invited Judith
into his tent. Once alone with the drunken general, she took
a sword lying at the foot of the bed and beheaded him. She
then wrapped the bleeding head in a sheet and handed it to
her servant. The two women escaped thanks to a permit that
Holofernes had given them, prayed outside the camp, and
made their way back to the city. At dawn, the Hebrews showed
Holofernes's head to the Assyrian army, who were routed.
(Judith 1–16)

Michelangelo Merisi da Caravaggio
Judith and Holofernes
1598–99
Galleria Nazionale d'Arte Antica,
Palazzo Barberini, Rome

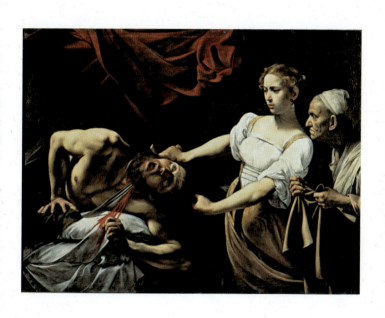

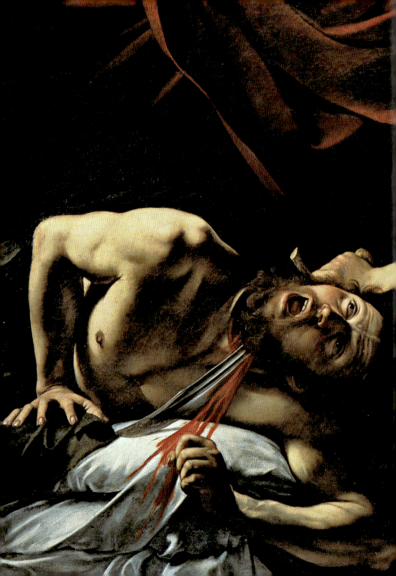

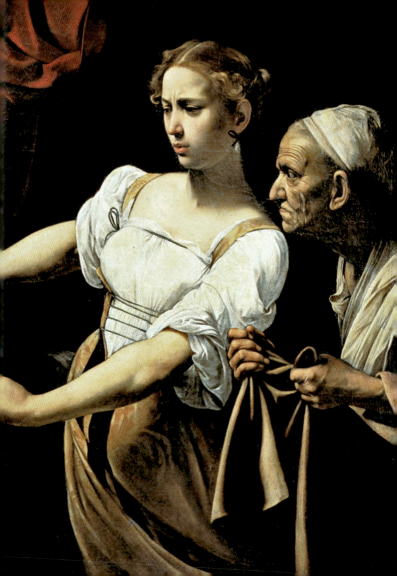

Judith

Upon returning to Bethulia, Judith was welcomed enthusiastically by the Hebrews. Uzziah, a city elder, lauded her in a way that recalls some Marian prayers: "You are the glory of Jerusalem, the surpassing joy of Israel; you are the splendid boast of our people. With your own hand you have done all this; you have done good to Israel, and God is pleased with what you have wrought. May you be blessed by the Lord Almighty for ever and ever." The strength that Judith demonstrated recalls one of the incarnate virtues of the Virgin Mary, who humbly defended the Christian people as her immaculate foot crushed the head of the infernal serpent. Mary is a new Judith, defeating violence and evil in the name of her Lord. A beloved heroine, Judith is one of the Old Testament figures most represented in the history of art, undoubtedly for her dramatic, spectacular courage.

(Judith 1–16)

Cristofano Allori
Judith with the Head of Holofernes
1613
Galleria Palatina, Palazzo Pitti,
Florence

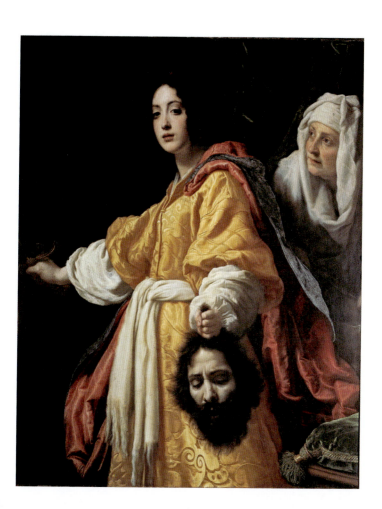

Esther

Esther, the wife of the Persian king Xerxes I (Ahasuerus), learned that Haman, the king's favorite, planned to kill her beloved uncle Mordecai and exterminate the Jews. Esther wanted to intercede with her husband the king, but the law forbade anyone to appear unbidden before him, under penalty of death. Whoever dared to transgress the law could be saved only if the king turned his golden scepter toward him. Still, Esther invoked the Lord and plunged ahead: Trembling, she appeared before the king, who calmed her, telling her that "this law is made for everyone else," not for her, and granted her wish. The privilege of Mary's Immaculate Conception lies in the fact that God excluded Mary alone from Original Sin. Esther's intercession with her husband is analogous to the Virgin's power of intercession with her son.
(Esther 1–21)

Rembrandt van Rijn
*Esther, Ahasuerus, and Haman
at Table*
1660
Pushkin Museum, Moscow

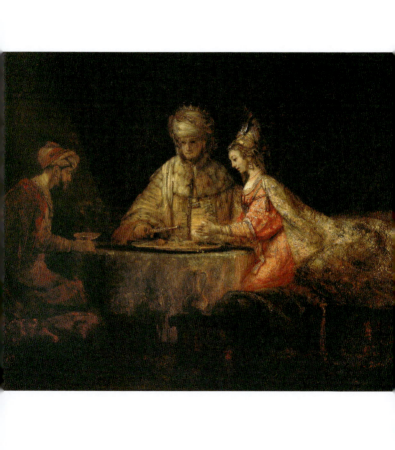

Isaiah

A prophet who lived between the eighth and the seventh centuries BCE, Isaiah was an important official in the service of the kings of Judah. He had his first experience of God in a temple, where he heard the voice of the Lord calling him. After a seraph purified him by rubbing his lips with a burning coal, Isaiah engaged in an intimate dialogue with God. The prophet was known for his predictions about the coming of a Messiah. In particular, under the rule of Ahaz, the kingdom of Judah was severely threatened by an Assyrian invasion. Isaiah urged the king to resist the enemy, promising God's support. To reassure the king, he warned him: "Behold, a virgin shall conceive, and bear a son, and shall call his name Immanuel," which means "God is with us." The child to be born of the virgin is the sign of God's trust in His Covenant with David: Through him, the Lord dwells among His people. Saint Matthew the Evangelist repeated the prophet's words, translating them into Greek from the original Hebrew, but while the word that Isaiah had used for the mother means "maiden," Matthew used a Greek word that also encompasses the meaning "virgin," thus initiating the use of "Virgin" as Mary's primary title. (Isaiah 7:14; Matthew 1:23).

Melozzo da Forlì
Isaiah
(detail)
1480
Santuario della Santa Casa, Loreto

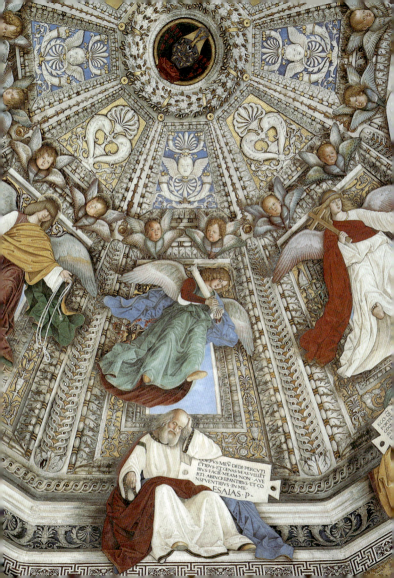

CORPVS MEV DEDI PERCVTI
ETIBVS ET GENAS MEAS VELLET
IBVS FACIE MEAM NON AVE
RTI AB INCREPANTIBVS ET CO
NSPVENTIBVS IN ME
ESAIAS · P ·

Daniel

When the Persians ruled Asia Minor in the sixth century BCE, King Darius appointed 120 satraps to govern the provinces of his empire, and three ministers to oversee them. One of the ministers was Daniel, the Hebrew prophet. He immediately stood out for his skillful governance and became the king's favorite. This aroused the jealousy of the other ministers and satraps, who looked for a pretext to accuse him. Finding no weakness in his conduct, they decided to undermine the prophet's faith and his obedience to his God. They went to Darius and persuaded him to approve a decree that "no one is to address any petition to god or man for thirty days, except to you, O king; otherwise he shall be cast into a den of lions." But Daniel continued to pray to his Lord, and so he was sentenced and thrown into the lion's den, which was sealed with a heavy stone. Darius was present and wished him help from the God to whom he was so devoted. The following day, the king went to the den and found Daniel still alive. This episode has been seen as a metaphor of the Resurrection of Christ; the image of the sealed, untouched den refers to Mary's womb, which remained intact even after she gave birth.

(Daniel 6:8)

Michelangelo Buonarroti
The Prophet Daniel
(detail)
1508–12
Sistine Chapel, Vatican Palace, Vatican City

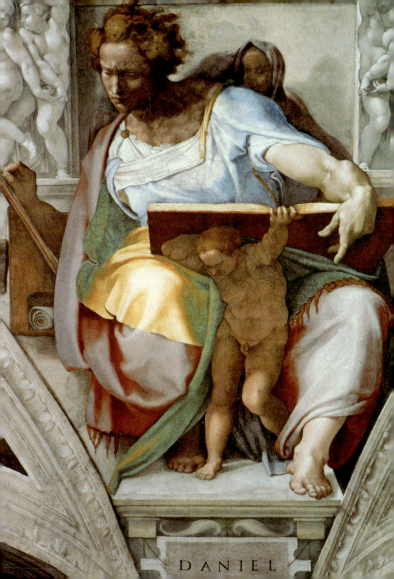

DANIEL

Augustus and the Sybil

The Roman historian Suetonius, in his *De vita Caesarum* (On the Life of the Caesars), speaks of a Marian prophecy from the Roman Empire. When Octavian Augustus was emperor (27–14 BCE) he turned to Albunea, the Tiburtine Sybil, for advice on whether he should accept the Roman Senate's proposal to deify him, so that the people could worship him as a god. The Sibyl showed him a heavenly vision with the image of Mary holding Jesus in her arms, revealing to him the only God to whom he should offer sacrifices. At this sight, the emperor knelt and renounced his deification. He also donated an altar, the *Ara Coeli* (Heavenly Altar), which was later placed in a Roman church.

(Gaius Suetonius Tranquillus, *De vita Caesarum*)

Antoine Caron
Augustus and the Sybil
1575–80
Musée du Louvre, Paris

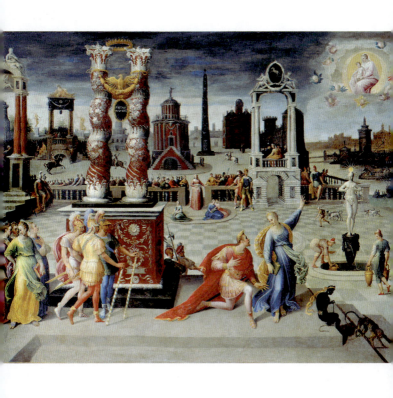

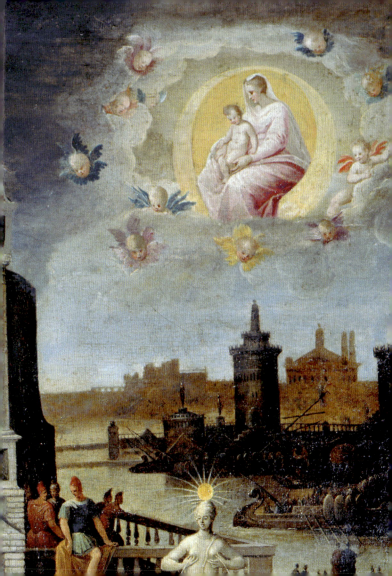

The Woman of the Apocalypse

The Woman of the Apocalypse is the best-known figure in the only prophetic book of the New Testament: "A woman clothed with the sun, with the moon under her feet, and on her head a crown of twelve stars. She was with child and wailed aloud in pain as she labored to give birth." This woman represents the Immaculate Conception. The sun that dresses her is God. The stars symbolize her virtues, as well as the Apostles of the Church of Christ. The moon under her feet indicates that Mary and the Church rule over all changeable things. The prophecy goes on to speak of a red dragon that is about to devour the Woman's newborn son, when the Child is taken up to Heaven and the Woman is given shelter in the desert. The dragon would be defeated by the Archangel Michael. (Revelation 12:1–18)

Mary Clothed with the Sun
from the *Commentary to John's Apocalypse and to the Book of the Prophet Daniel*
Miniature
1549
Biblioteca Nazionale, Turin

neq; locus eor̄ invent̄ ē. Et implatū celo.
Et expulsus ē draco magnus anguis an-
nosus qui dicit̄ diabol' et sathanas seducens
totū orbē. Expulsus ē in terrā et anġli
ei̅ cū eo expulsi su̅t. & audivi vocem
magnā in celo dicentē. Modo facta
ē salus & virtus. & regnū di n̄ri. & potes-
tas ē accusator frm̄ n̄ror̄ qui accusa-
bat eos in conspectu dī die ac nocte. & ip-
i vicer̄ eū in sanguine agni. & ppt̄ ver-
bū testimonii eor̄. &c̄ō dixerū aīal
viū usq; ad mortē. ut ad hoc re aīal
Ve ubi tu & mare. quia descendet diabol'
ad vos habens irā magnā. sciens qm̄ breve
tempus habet.

Pr̄ q̄ vidisset draco q̄ pr̄iectus esset in ter-
ra p̄secutus ē mulierē quae pepererat mas-
culū. & datae su̅t mulieri duae alae aquilae dī
magnae. ut volare in herema ubi lo-
ci̅ suū. & ut nutriret̄ illac tempus & tp̄a ab illac
ubi nutrit̄ illac tempus & tp̄a facie serpentis. Et misit
serpens de ore suo post mulierē aquam
tāquā flum̄ ut eā de flumine auferret. & ad-
iuvavit tr̄a mulierē. & aperuit os suā
& absorbuit flum̄ qd̄ misit draco de ore
suo. & iratus ē draco in mulierē. & abiit
facere pugnā cū reliquis seminis eius. Et servant
mandata dei & habent testimoniū īhu
xp̄i. Et stetit sup̄ arenā maris. Ōmis

EXPLICIT ISTORIA MULIERIS SUPRA

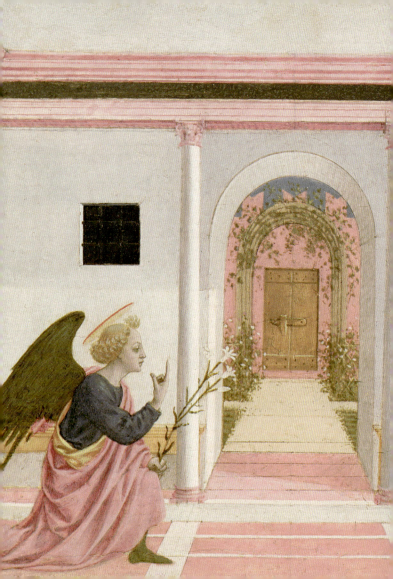

Mother

"Blessed is the womb that carried you, and the breasts at which you nursed." Motherhood is Mary's first, inescapable role, sanctioned at the Council of Ephesus (431 CE) when she was given the title of Mother of God. Mary's motherhood is part of the mystery of the Incarnation and illustrates her full acceptance of her destiny and her son's mission. Before everything else, the Madonna is seen as the ideal mother who takes care of her child: She raises him, cares for him and supports him throughout his life. The immense grief she feels at her son's death, and her acceptance of the task of salvation that God entrusted to Jesus, transcends comprehension; it is the agony of a mother who loses her child too soon. Artists have often portrayed Mary and Jesus simply as a mother and child. (Luke 9:27)

Giovanni Pietro Rizzoli,
known as Giampietrino
Virgin and Child
c. 1530
Pinacoteca di Brera, Milan

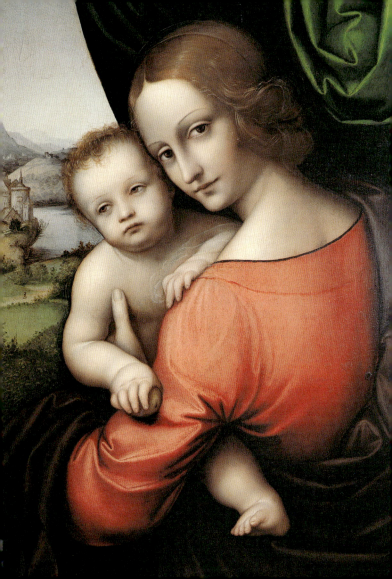

Virgin

The greatest mystery surrounding the figure of Mary is her virginity, which remained intact before, during, and after the birth of Jesus. The birth itself was natural, accomplished by Christ himself, who opened the maternal womb, then returned it to its original state. The concept of virginity implies purity of the heart, integrity of the body, and abstinence from sexual passion, and it is closely linked to Mary's immunity to sin and her own Immaculate Conception. The title *Maria semper Virgo* (Mary Always Virgin) was first established at the Council of Constantinople (553 CE) and later at the Lateran Council (649 CE). Mary's arcane privilege gave rise through the centuries to innumerable symbols and images, all seeking to portray her unique condition.

Gaetano Previati
Annunciation
1912
Civica Galleria d'Arte Moderna, Milan

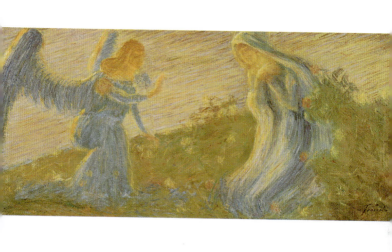

Queen

"Queen" is the title that Christians often use to invoke Mary. After being raised to Heaven, Mary was crowned by God the Father, by Christ, and by the angels as the queen of all the Lord's faithful. The appellation has taken on many connotations: Queen of Heaven, of angels, of patriarchs, of prophets, of virgins, of saints, of peace. Even the last mystery of the Rosary presents Mary's coronation as Queen of Heaven and Earth. The importance of this title in Marian liturgy has grown over time, especially because of the prayer *Salve Regina* (Hail, Holy Queen), penned in the eleventh century by the monk Hermann Contractus.

Bartolomeo di Paolo del Fattorino,
known as Fra Bartolomeo
Madonna Enthroned with Saints
1509
Cattedrale di San Martino, Lucca

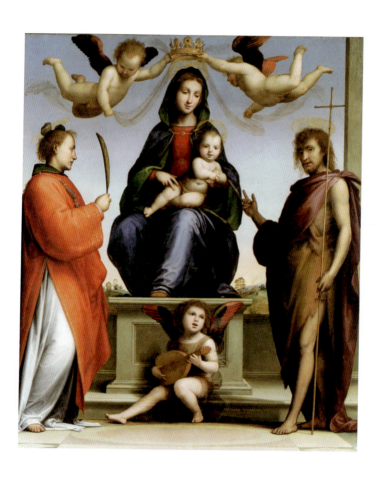

Regina Coeli (Queen of Heaven)

"But mark the circles to the most remote, / Until thou shalt behold enthroned the Queen / To whom this realm is subject and devoted." With these words Saint Bernard, Dante's guide in *Paradiso*, invites the poet to raise his eyes toward the highest and farthest heavenly circle in order to admire Mary. She is the Queen of Paradise and of the sky, motionless in her ecstasy; by the grace of the Holy Spirit she sits in a whirl of golden splendor. The appellation *Regina coeli* comes from a twelfth-century hymn by an unknown author, dedicated to Mary and sung especially at Easter time. The tradition assigns the authorship to Pope Gregory the Great, who is said to have heard angels sing the hymn in Rome on an Easter morning during the sixth century. This joyful laud invites the Virgin Queen of Heaven to rejoice for the Resurrection of her son Jesus.

(Dante Alighieri, *Paradiso*, XXXI, 115–17, translated by Henry Wadsworth Longfellow).

Giovan Gerolamo Savoldo
Pesaro Altarpiece
1525–26
Pinacoteca di Brera, Milan

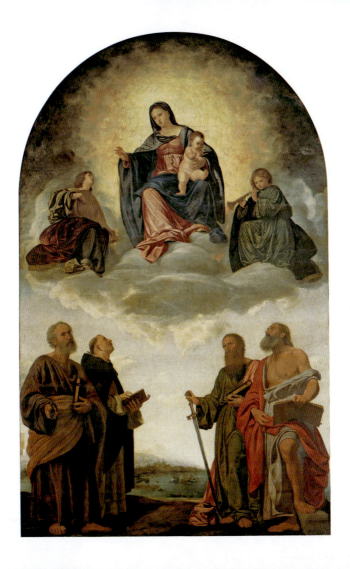

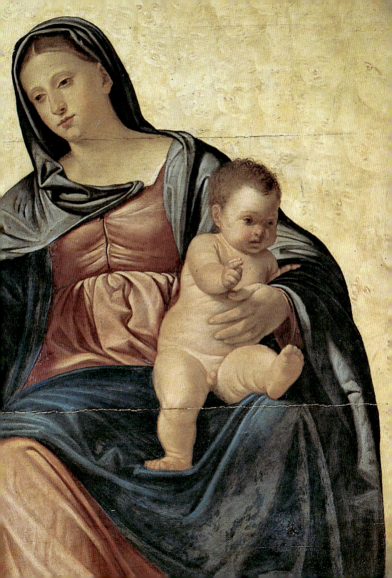

Regina Angelorum
(Queen of Angels)

Mary, as the Queen of Heaven, rules over the souls that dwell in Paradise, starting with the angelic choirs. For this reason, she is often called Queen of the Angels, those creatures created by God to be intelligences driving the heavens. Angels are infinite in number and are divided into nine choirs. First are the Seraphim, the closest to God, equipped with six wings; with two they cover their faces, with two their feet, and with the remaining two they fly. Below them are the Cherubim, who have four wings and four faces: those of a man, a bull, a lion, and an eagle. The third choir are the Thrones, sometimes described as intersecting wheels that move about Paradise carrying God's throne. Next are the Dominions (or Dominations), whom God has appointed to maintain the order of the universe. Below them stand the Virtues; like lightning flashes, they dispense grace. Next are the Powers, many-colored clouds that oversee the distribution of power to humanity and guard history. The Principalities (or Princedoms) follow; they protect religion and worship. The last choirs are the Archangels, who are the councillors of men, and the Angels, who are the closest to humankind.

Jean Fouquet
Virgin and Child Surrounded by Angels
(detail)
c. 1450
Koninklijk Museum, Antwerp

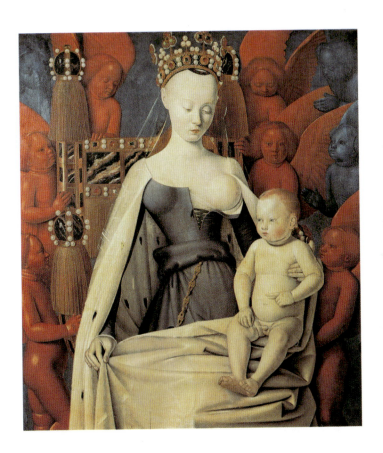

Sponsa Christi (Bride of Christ)

The covenant between God and His people has frequently been described in the Scriptures as a marriage. The prophet Isaiah speaks of the bond between the Lord and Jerusalem, His beloved capital: "As a young man marries a virgin, your Builder shall marry you; And as a bridegroom rejoices in his bride, so shall your God rejoice in you." The fulfillment of this alliance will only occur through Mary, the Daughter of Zion, mother of the Savior. Her maternity becomes an unbreakable communion with God, through her full acceptance of her role and her fate. From the simple physiological level we ascend the spiritual dimension: The mother accepts and deeply participates in her son's mission of salvation; after her death, she is raised to Heaven, where she reunites with Christ and is crowned Queen, Bride of Christ, wife of the King of Kings. (Isaiah 62:5)

Pietro Cavallini
Christ Enthroned with Mary and the Saints
(detail)
1291
Santa Maria in Trastevere, Rome

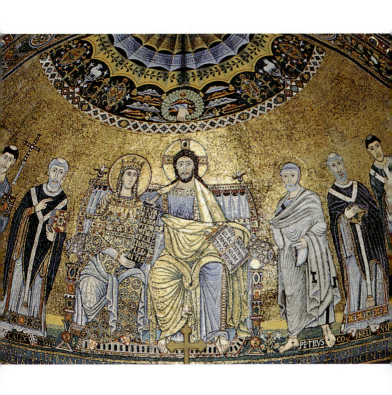

Domina Ecclesia (Lady of the Church)

Mary, the Bride of Christ, is the most authentic expression of faith. Her full knowledge of and deep participation in the fate of her son make her the archetypal believer, the symbol of Christ's faithful, who gathered over time to form the community of the Church. Mary is the Lady of the Church, *Domina Ecclesia*, and because of this she is often represented inside the holy edifice. It was Jesus who entrusted her with this role, when he was on the Cross, by delivering to her John, who was Jesus' beloved disciple. Her role was subsequently extended, making her the motherly protector of all children who rely on Christ's saving mission. Furthermore, just as the Church guides and serves as the mediator between Christ and the faithful, so is Mary the intermediary of salvation.

Jan Gossaert, known as Mabuse
Madonna and Child
c. 1515
Galleria Doria Pamphilj, Rome

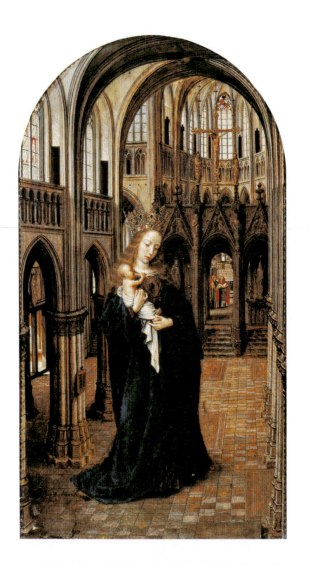

Womb

The Church is first and foremost a physical place of worship where the faithful gather. The Church welcomes, protects and shelters the believer, much as a mother welcomes the future life in her womb. In this sense, we can make a symbolic transposition from Mary, the emblem of the Church, to her womb, repository of the Saving Christ—but also of his Passion and death. Hence, Mary's womb becomes the symbolic seat of the body and blood of Jesus, whose divine nature was joined to his humanity. Toward the end of the Middle Ages, unusual icons representing this quality of Mary became popular: Wooden statues depicted Mary with Jesus on the outside, but opened to reveal Christ on the Cross.

Unknown French artist
Madonna with Child, Mercy Seat
1450
Musée Cluny, Paris

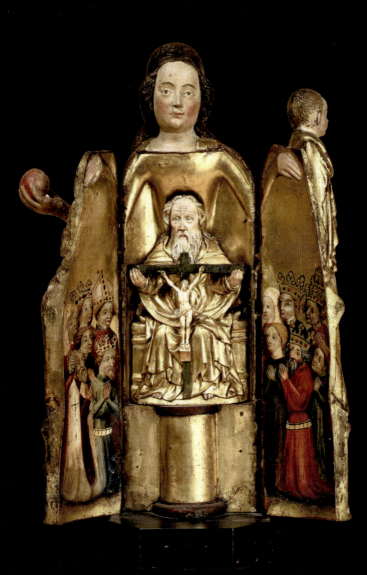

Ancilla Dei (Handmaid of God)

When the Archangel Gabriel announced her future pregnancy, Mary answered that she was the "handmaid of the Lord." The Latin term used in the Gospel of Luke, from the Hebrew, is *ancilla*, handmaid, which also had the connotation of servant or slave. With these words, Mary placed her full faith and obedience in God's will. She made no changes, brought no novelties, did not interfere in the divine plan, but simply became the obedient handmaid who made it possible. The title "servant of God" is also used in the Old Testament to refer to all those individuals whom God called to partake in the salvation of humanity. In art, Mary's meek attitude is rendered with resigned, humble poses.
(Luke 1:38)

Jacopo Palma,
known as Palma Giovane
Virgin Annunciate
1592–1600
Scuola Grande di San Teodoro, Venice
on display at the Gallerie
dell'Accademia, Venice

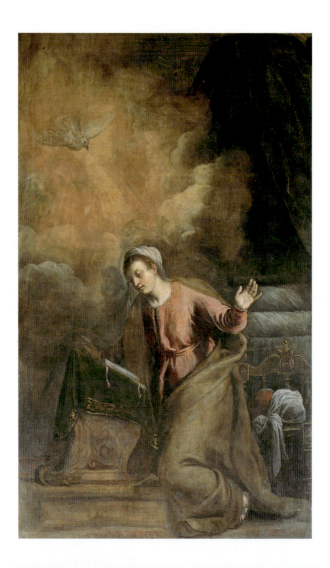

Sedes Sapientiae (Seat of Wisdom)

Mary is the seat of divine Wisdom because she knows God's will. The idea of linking Mary to God's wisdom has its ancient roots in the thought of the Eastern Patristics, especially Romanus the Melode (fifth to sixth century) and Saint John Damascene (670–749). In this role, the Virgin Mary appears holding the Child in her arms or on her lap—expressing the human form of divine Wisdom, and an ideal type of purity, a favorite metaphor from the earliest times to express the human form of divine Wisdom. For as we read in Proverbs, "From of old I was poured forth, at the first, before the earth. When there were no depths, I was brought forth, when there were no fountains or springs of water; before the mountains were settled into place, before the hills I was brought forth." Thus, Mary is represented with the Child in this pose, as if she were a seat supporting the Incarnation of divine Wisdom. (Proverbs 8:23–25)

*Maddona Enthroned and the Child
with the Archangels
Michael and Gabriel and Apostles*
12th century
San Giusto, Trieste

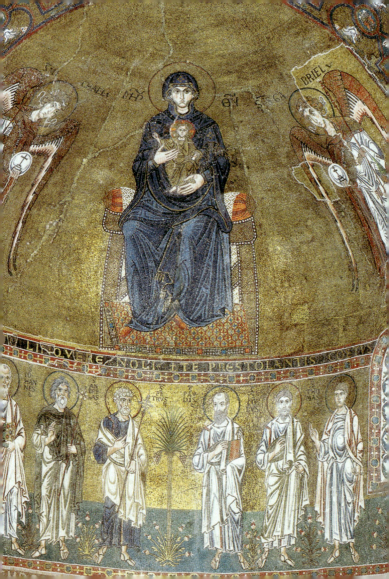

Mater Misericordiae (Mother of Mercy)

In her role of mediator for and advocate of the faithful, Mary also has a protective function. As the emblem of the Church, throughout the centuries Mary undoubtedly has been the figure most invoked in times of need and distress, such as war or pestilence. Thus a unique iconography developed, with Mary, open–armed, welcoming under her sheltering mantle the faithful who kneel in prayer. This representation found much favor in the Western Church through the monastic orders. The Mother of Mercy has become an autonomous guardian figure, sheltering under her mantle all those who turn to her for help, protection, and intercession.

Piero della Francesca
Polyptych of the Misericordia
(detail)
1460–62
Pinacoteca Comunale, Sansepolcro

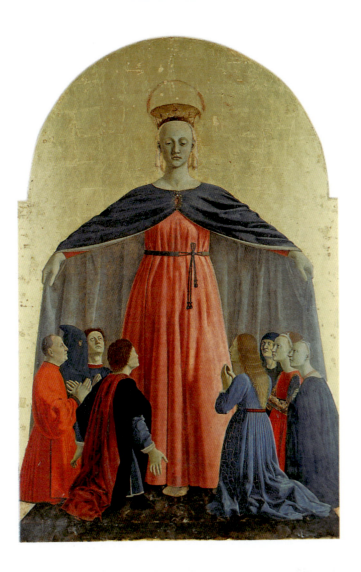

Mater Misericordiae (Mother of Mercy)

The image of the Mother of Mercy was especially popular during the Renaissance. In addition to works of art painted for the churches, which show the patron who commissioned the work kneeling with the rest of the anonymous worshipers, a large number of Mothers of Mercy were also produced for hanging in private homes. These were the work of artists of all calibers, commissioned by members of the aristocracy or the upper bourgeoisie, to be used in family chapels. The patron is shown standing at the feet of the Virgin in a praying pose, covered by the Virgin's mantle. Sometimes the size of the kneeling figure is out of proportion with the majestic figure of the Madonna, justifying the required humble attitude of someone who asked to be included in a work of art destined for a church (we also find this device in public paintings, to signify the respect owed to the Mother of God).

Hans Holbein the Younger
Madonna of the Basel Mayor
Jakob Meyer zum Hasen
1528
Städelsches Kunstinstitut, Frankfurt

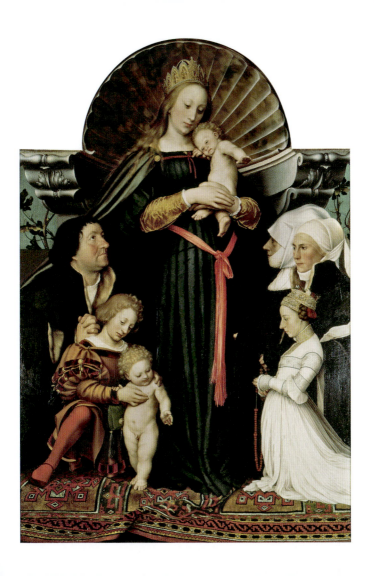

Mater Humilitatis
(Mother of Humility)

The Madonna knows that she received the gift of grace from God, and for this she is grateful. It is precisely on account of this humility that she was chosen to be the Mother of Christ. In the figurative arts, her humbleness is represented by highlighting her modesty. For this reason, instead of being depicted on a throne to indicate her regal status, she sits on a pillow inside a garden. This symbolism is also etymological, for the word humility has its root in *humus*, which means soil, or earth. Therefore, Mary is portrayed sitting on the ground, sometimes intent on nursing her son, who is God on earth.

Stefano da Zevio
Madonna in the Rosary
c. 1410
Museo di Castelvecchio, Verona

Double Intercession

In giving birth to Jesus, Mary becomes his natural intercessor. From the instant that God chose her to conceive His son through the Holy Spirit, two bonds (Mary-Jesus, Jesus-God) were formed so that, by praying to the Virgin, the faithful can reach God. To represent this complex theological concept, the artists have generally turned to a simplified imagery based on the three-way dialogue of the characters.

Filippino Lippi
Intercession of Christ and the Madonna
1496
Alte Pinakothek, Munich

Hortus Conclusus (Enclosed Garden)

"You are an enclosed garden, my sister, my bride, an enclosed garden, a fountain sealed," sings the bridegroom in the Song of Songs. These verses are a clear allusion to Mary's virginity, for she remained intact before, during, and after childbirth. Thus the Madonna is not only the mother of Jesus, she is also his spiritual bride. This concept is expressed symbolically through the image of an enclosed garden perfumed with every virtue. This iconography is also drawn from other Biblical images such as the Garden of Eden, certain oases described in the Gospels, and the new Heavens and Earths of John's Revelation.

(Song of Songs 4:12)

Upper Rhenish Master
Little Garden of Paradise
c. 1410–20
Städelsches Kunstinstitut, Frankfurt

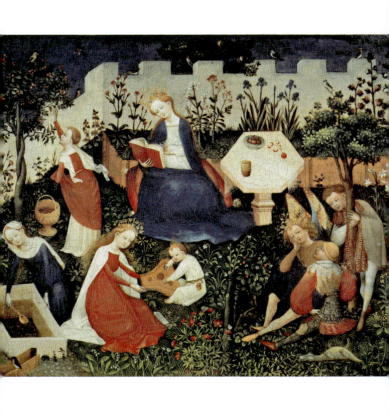

Hortus Conclusus (Enclosed Garden)

Often the *Hortus Conclusus* is depicted as a secret, fantastic garden inside a sheltering cloister that shuts out all evil things. In the garden are fruits and flowers dense with symbolism: The rose represents the Virgin, but also the blood of the Passion of Christ; the lily is a symbol of purity and poverty; violets are the image of modesty and humility; the fig is a metaphor for fertility; the olive a symbol of mercy and peace; the clover alludes to the Trinity. The enclosed garden is thus a representation of the Garden of Gardens, or the earthly Paradise.

Stephan Lochner
Madonna of the Rose Bush
c. 1440
Wallraf-Richartz Museum, Cologne

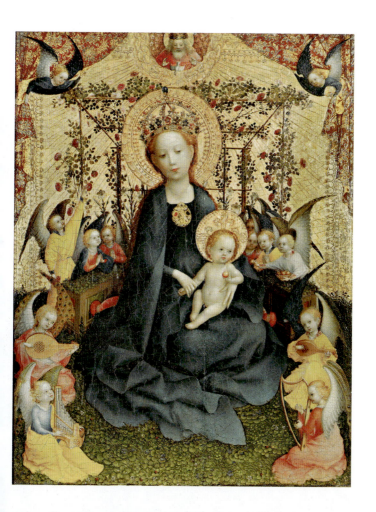

Closed Door

"This gate is to remain closed; it is not to be opened for anyone to enter by it; since the Lord, the God of Israel, has entered by it, it shall remain closed." The door symbolizes not only the entryway, the passage to another place or dimension, but also a secret, inaccessible space just beyond, where one cannot venture. The image of the closed door has been used to signify Mary's virginity, for her womb remained incorrupt even after childbirth. This symbol appears especially in Annunciation scenes, positioned between the Archangel Gabriel and Mary. (Ezekiel 44:2)

Domenico di Bartolomeo,
known as Domenico Veneziano
Annunciation
(detail)
c. 1445
Fitzwilliam Museum, Cambridge

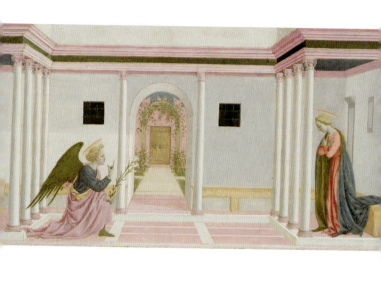

Castle

In comparing the figure of the Madonna to a fortified castle, we may quote Saint Luke, who prefaces his story about the healing of ten lepers thus: "As [Jesus] was going into a village." The word "village" was translated from the Latin *castellum*, which does refer to an inhabited center, but also its most secure and protected place, the fortress. At one time all cities had a fortified citadel with a castle, to be defended to the last. Mary is the fortress that Jesus has entered, assailed in vain by the Devil. And as the fortress shelters and defends the people of the village, so does the Virgin watch over and protect her son and all the faithful.

(Luke 17:12)

Frankfurt Master
The Holy Family
c. 1460
Museo Thyssen-Bornemisza,
Madrid

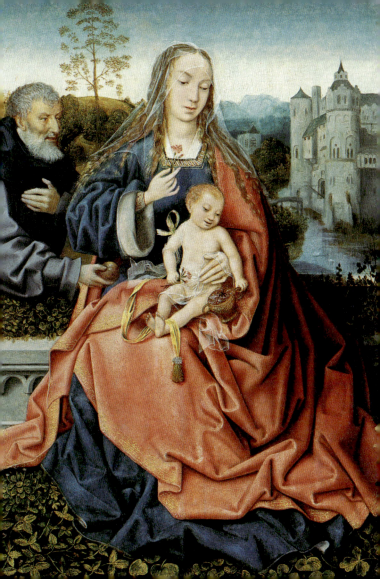

Tower

The tower symbolism celebrated in the Song of Songs is linked above all to the idea of the Madonna's physical beauty. The tower represents Mary's steady, secure, inaccessible womanhood. The association with the Tower of Babel is immediate, from the Akkadian *babel*, "God's gate," which suggests that tower's original function must have been one of communication between man and the divine—exactly Mary's role. In time, the symbol would take on the Christian connotation of vigilance and ascent, of spiritual elevation. Among Mary's main appellations is *Turris Davidica*, a reference to David's Tower, which rises in the Jerusalem sky, and *Turris Eburnea*—Ivory Tower—which signifies the inaccessibility of the divine mystery.

(Song of Songs 4:4)

Giorgio Barbarelli da Castelfranco,
known as Giorgione
The Reading Madonna
1508
Ashmolean Museum, Oxford

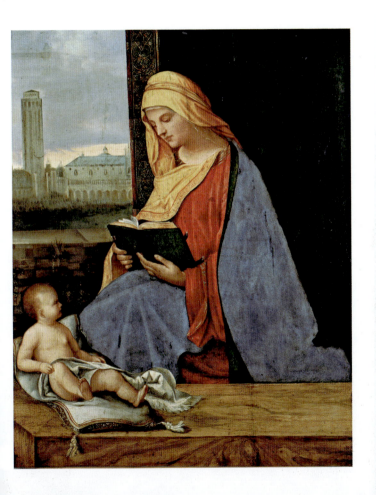

Grove

The woodland is a place of silence, an enclosed space where nature is full of wonders. A symbol of unexplored femininity, it alludes to Mary's virginal status: Her womb, untouched like the heart of a grove, suggests the sacred enclosure where man meets the divine. Compared to the wild, chaotic forest in which humans feel threatened and disquieted, the smaller grove is a safe shelter and a quiet haven; in art and literature, groves have frequently offered shelter to those in flight. Transposing this function to Marian symbolism, it is clear how the grove became an ideal shelter where the divine miracle could take place.

Giovanni di Niccolò de Luteri,
known as Dosso Dossi
The Virgin and Child (Gypsy Madonna)
c. 1511
Galleria Nazionale, Parma

Grapes

Grapes, vines, and vineyards are metaphors that run through the Sacred Scriptures. John the Evangelist defines the relationship between Jesus and His disciples as the branch and the vine: "Just as a branch cannot bear fruit on its own unless it remains on the vine, so neither can you unless you remain in me. I am the vine; you are the branches." This bond, symbolized by the vineyard, takes on a Eucharistic connotation in the image of the grapes—wine—which represent the blood of Christ. A symbol of the Passion and death of Jesus, grapes are also associated with the Virgin, who is a conscious participant in her son's destiny. White and red grapes together allude to the blood and the water that flowed from the side of Christ on the Cross. In many works of art, the Virgin has a sad, resigned mien; she holds the Child and a bunch of grapes lies at her side.

(John 15:4–5)

Cosmé Tura
Madonna and Child
1460–1463
Gallerie dell'Accademia, Venice

Pear

Another fruit symbol of Jesus' Passion and redemption is the pear, which the sacred characters hold in their hands, or which appears on the side, a reminder of the Son's sacrifice and the Mother's role of co-redeemer. Because of its shape—wider at the bottom, evoking the female figure—the pear has been frequently associated with the Virgin. The white flowers of the pear tree symbolize sorrow and sacrifice, but also beauty and purity. In fact, white, as a mixture of the colors of the solar spectrum, is the symbol of unsullied innocence par excellence. It could also have negative connotations, however; white is also the color of death.

Albrecht Dürer
Madonna and Child
1526
Galleria degli Uffizi, Florence

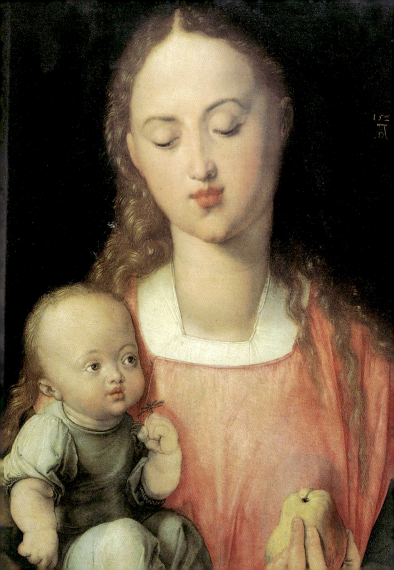

Pomegranate

An emblem of fruitfulness, abundance, fertility, and resur-
rection, the pomegranate has highly positive connotations.
In the Child's hands it symbolizes rebirth and liberation; in the
Madonna's, it alludes to her virginal motherhood. The orderly
array of the seeds in the pomegranate has, over the centuries,
produced metaphors of amity and harmony. In the Christian
era, the notion that the seeds are all hidden under a single
shell has come to represent the faithful united in the commu-
nity of the Church. Hence the fruit represents the Church's
capacity to bring together people of diverse cultures, as well as
being a symbol for Mary, the guardian Mother of all believers.

Raffaellino del Garbo
Madonna with Child and Saint John
1504–5
Museo Nazionale di Capodimonte,
Naples

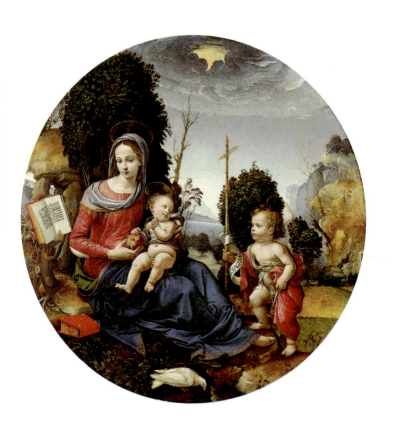

Tree

The Virgin Mary is compared to the tree of salvation, from whose fruit the Redeemer is born. The 15 golden A's that hang like fruits from the dried-out branches symbolize the *Ave Maria* (Hail Mary) prayers of the Rosary. The thorns evoke the crown of Christ's Passion. The parched branches of the tree also recall the tree of the Original Sin, for we read in the *Legenda Aurea* that a branch had been given to Seth, son of Adam, with the promise that his father would be healed only after the tree bore fruit. And Jesus is the fruit born of Mary. The Immaculate Conception is Mary's privilege and also connotes Mary's complete lack of sin, as well as signifying the reparations delivered through Christ's sacrifice. For this reason, the Virgin is represented as a dry tree that bears fruit. (Jacopo da Varagine, *Legenda Aurea*)

Petrus Christus
Our Lady of the Dry Tree
c. 1450
Museo Thyssen-Bornemisza, Madrid

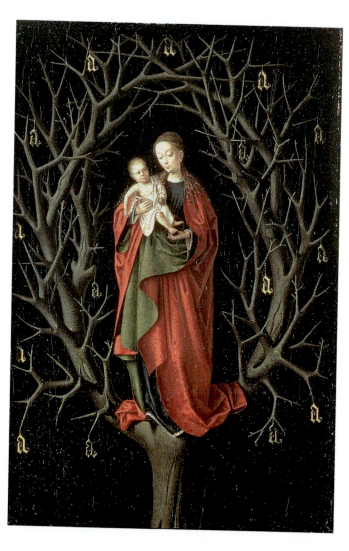

Wreath

In Christian symbolism, the wreath expresses victory over darkness and sin. The Virgin, born without sin, is often depicted under a wreath of fruits and flowers; the circular shape means everlasting life. Wreaths are worn on the head as decoration; they are also used as gifts or decorations on feast days. God's people use them to celebrate their happiness for having been redeemed through Mary, the incorrupted one. Still today on religious feast days, the faithful decorate their churches with wreaths and flowers, symbolizing joy and eternal life.

Giorgio Schiavone
Madonna and Child
1460
Galleria Sabauda, Turin

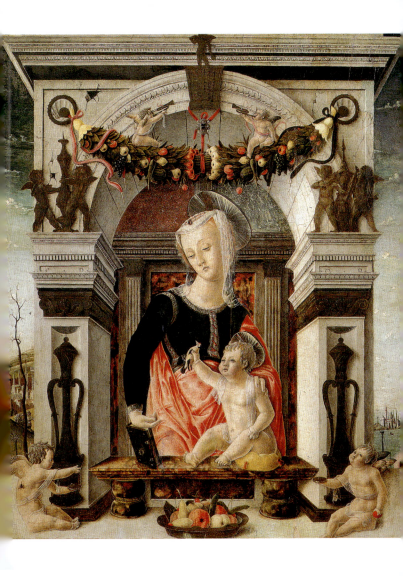

Arbor

The image of the enclosed garden, symbol of the Madonna's virginity, can also be contained in the arbor image that sometimes is glimpsed behind Mary as she stands inside the garden. Treated as a separate element, the arbor takes on the same connotation of a sacred, enclosed space where the Virgin, born without sin, dwells. Here there is space for Jesus, the fruit of Mary's incorrupt womb. If Christ is the vine, Mary is the arbor: support, aid, and shelter.

Giovanni Battista
Cima da Conegliano
Madonna of the Arbor
1489
Museo Civico, Vicenza

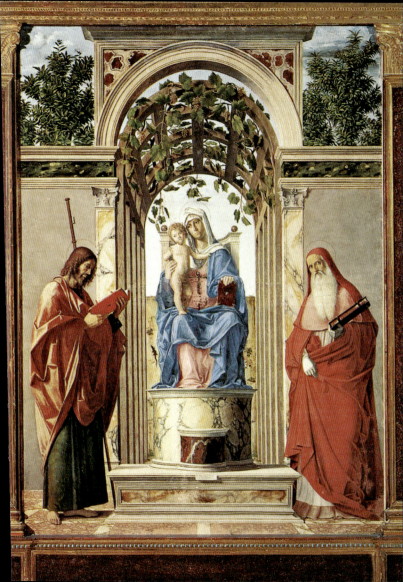

Lily of the Valley

The lily of the valley is one of the first flowers to bloom, a harbinger of spring. For this reason, it is emblematic of the Savior's coming and of his Incarnation, because it shoots up from the ground at about the time of the Archangel Gabriel's Annunciation to Mary (March 25). Generally speaking, the flower is a symbol of resurrection and vital energy, for it announces the rebirth of nature, the end of winter, and victory over death. This plant, with elongated leaves and clusters of small, bell-shaped, fragrant white flowers, is also associated with Mary's virginal candor.

Edward Reginald Frampton
The Annunciation
c. 1890
Private collection

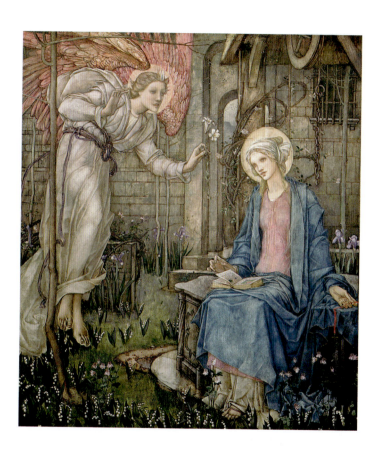

Lily

In Christian culture, the lily represents pure love, which finds its fulfillment in the figure of Mary. Like the lily of the valley, its white petals suggest the purity and innocence of she who was born without fault. The lily's straight stem and its white, funnel-shaped flower, which opens on top, evoke Mary's full, open acceptance of God's will and her participation in the fulfillment of the heavenly plan.

Gaetano Previati
Madonna of the Lilies
1893–94
Civica Galleria d'Arte Moderna, Milan

Rose

"Mary was a rose: white for her virginity, vermilion for her mercy." The rose is the queen of flowers, the loveliest ornament of the garden, and for this reason is associated with Mary, the Heavenly Queen. Saint Bernard of Clairvaux called Mary the "mystic rose": The flower suggests an unattainable beauty; Mary is mystical because she is fated to transcend earthly values and realities. While the red rose is a symbol of the blood that poured from Jesus on the Cross, the white rose denotes the Virgin's absolute, pure perfection. Mary, the preeminent flower, is also called the "rose without thorns," referring to a legend that traces the existence of thorns on Earth to Original Sin: Before the Fall, the rose had no thorns, just as Mary has no fault.

(Bernard of Clairvaux, *Sermons on the Madonna's Feast Days*)

Raffaello Sanzio, known as Raphael
Madonna della Rosa
1518–20
Museo del Prado, Madrid

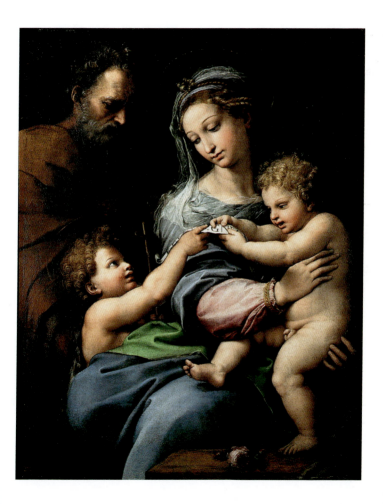

Rose Garden

The Virgin is often portrayed in a rose garden. A place of contemplation and meditation, it recalls the enclosed garden that represents the purity of Mary's immaculate womb. An element of the earthly Paradise, the rose trellis where birds sing and make their nests marks the boundaries of a pure, complete space. In some works of art, the flowers twisted around the trellis become blood-red stains, a backdrop to the sad, rapt figure of the Madonna holding the Child in her arms. Going one step further, we can distinguish between the rosebuds—the memory of Jesus' and Mary's childhoods; the budding roses—symbol of their suffering; and the roses in full bloom—signifying triumph over death. Finally, the rosebush can also signify the grace and love of God, associated directly with that instrument of prayer, the Rosary.

Bernardino Luini
Madonna in the Rose Garden
1505–10
Pinacoteca di Brera, Milan

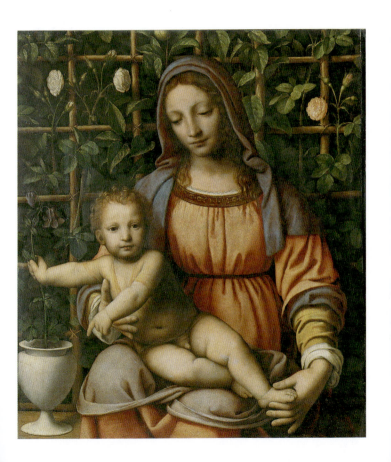

Rosary

"Rosary" refers to many small roses on a rosebush or in a rose garden. Following a medieval tradition, flower garlands were placed on the statue of the Virgin, and each rose corresponded with a beautiful, sweet-smelling prayer dedicated to her. From this custom originated the string of prayer beads that guides the faithful through the four Mysteries (Joyful, Luminous, Sorrowful, and Glorious), retracing the message of the Gospels, from the Annunciation to the Resurrection of Jesus and Mary's Assumption to Heaven. The Rosary then is a garland of mystic roses offered to the Madonna, the preeminent flower, and becomes a message of the salvation that Christ brings through his Mother's mediation.

Lorenzo Lotto
Madonna of the Rosary
1539
Pinacoteca Civica, Cingoli

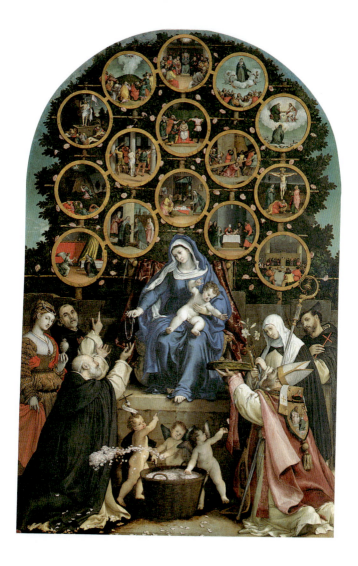

Sparrow

The human soul freed from the body is often visualized as a humble sparrow. This small bird with brown back, black throat, and gray sides symbolizes the Christian soul that flies away from the body at death. In this sense, it prefigures the Passion, in particular Christ's Resurrection. An expression of freedom, it alludes to the saving action of the Christ through Mary. In some works of art, the sparrow pauses on Mary's hand, ready to take wing, while she looks on with full consciousness and sympathy for the drama that is about to unfold.

Giovanni Francesco Barbieri,
known as Guercino
Madonna of the Sparrow
1618–20
The Denis Mahon Collection, London

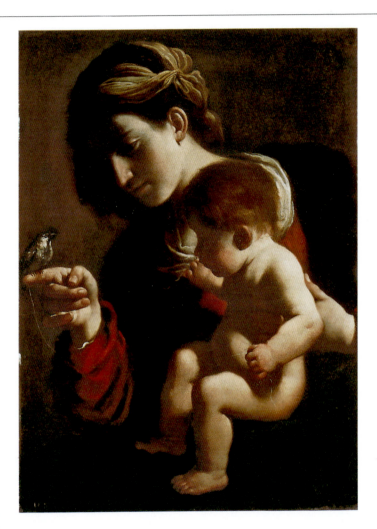

Goldfinch

The goldfinch likes to peck at the seeds of the cardoon, an edible plant with thorny scales. This bird evokes Jesus crowned with thorns, and so has become an emblem of the Passion. According to a legend, a goldfinch, fluttering above Christ's head as he was climbing to Calvary, plucked a thorn from his forehead. In doing so, he was stained with red, a drop of the Savior's blood. The bird's red face evokes the image of blood, and thus sacrifice, or of fire, the only incorruptible element (just as Mary was never stained with sin nor subjected to carnal temptation). These two antithetical meanings—innocence and purity, sorrow and sacrifice—justify the presence of this tiny bird next to the image of Mother and Child.

Raffaello Sanzio, known as Raphael
1507
Madonna of the Goldfinch
Galleria degli Uffizi, Florence

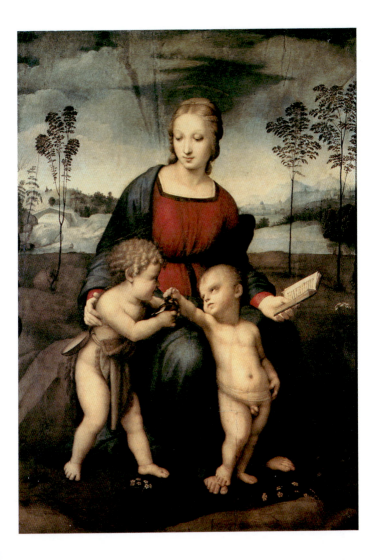

Pillar

A recurring motif in the Bible, the pillar is rich with symbolic meanings. This architectural element has been associated with the figure of the Virgin Mary to signify strength and integrity. In some representations—the emblematic one being Parmigianino's painting, aptly called *Madonna with the Long Neck*—Mary's neck suggests a pillar, and is related to the concept of the Immaculate Conception. The perfection of the pillar, its clear, accomplished lines, recall the white throat of she who was born without sin.
(Job 9:6; Proverbs 9:1)

Girolamo Francesco Maria Mazzola,
known as Parmigianino
Madonna with the Long Neck
1534–40
Galleria degli Uffizi, Florence

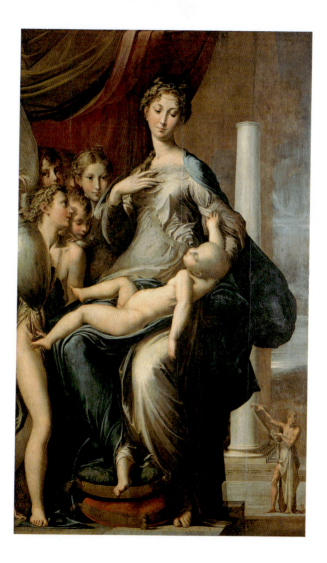

Candle

The candle is an almost primitive object, so humble and plain and yet so important that it has acquired mystical and religious connotations: Its flame is a sign of hope in everlasting life; its light a symbol of life, progress, beauty. An unlit candle symbolizes the word of God conceived in purity. The candle, therefore, is linked to the idea of Mary's purification, giving rise to Candlemas Day, which falls on February 2 and marks the ritual end of winter. On this day, candles are lit and blessed because from the Virgin was born Jesus, "a light for revelation to the Gentiles, and glory for your people Israel." (Luke 2:32)

Carlo Crivelli
Madonna of the Taper
1490–92
Pinacoteca di Brera, Milan

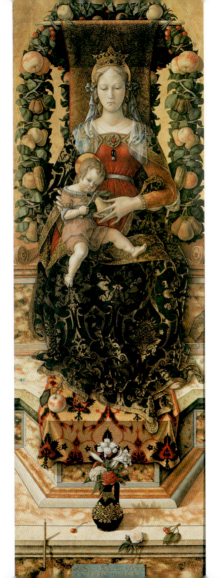

Lamp

Mary is always lit by the splendor of God who, like a lamp, illuminates those who live in the world's darkness. She is a source of brightness that guides the faithful toward all things holy. Like the moral in Jesus' parable about the wise and the foolish virgins, the lamp is also a symbol of prudence. In the story, only the five provident virgins who had brought extra lamp oil with them were welcomed by their bridegroom. Mary is the preeminent *Virgo prudens* (Prudent Virgin), and she is a beacon because she was the pure vessel that housed the light of Jesus. The Madonna lights the way for all those who trust in her. This complex symbology explains the presence of a lamp hanging from the ceiling in many Holy Conversations. (Matthew 25:1–13)

Galeazzo Campi
Presentation to the Temple
c. 1525
Museo Bagatti Valsecchi, Milan

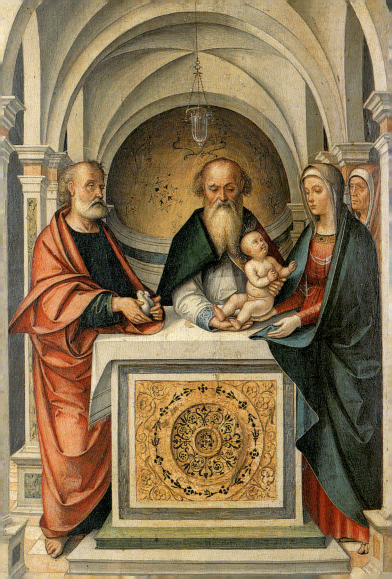

Book

Mary is the book that brought to men the knowledge of the Word become flesh. She is the mystical book written by the Holy Spirit that erased the old Covenant and wrote a new one. The book is also a symbol of wisdom, and Mary is, of course, the Seat of Divine Wisdom. The book par excellence is the sacred Scripture, the symbol of prayer and faith, of the Virgin Mary's devotion to God, and of the life of contemplation she led before the Annunciation of the Archangel Gabriel.

Vincenzo Foppa
The Virgin and Child
1490–95
Museo Poldi Pezzoli, Milan

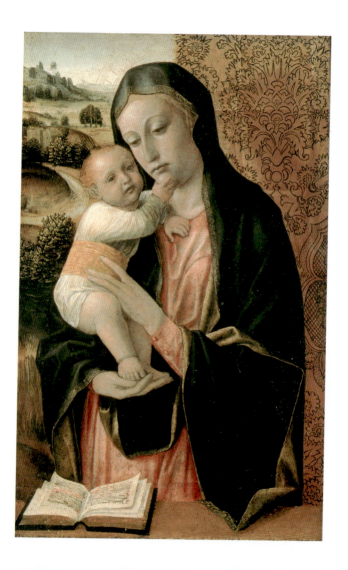

Moon

The moon is an ancient pagan attribute of Isis and chaste Diana that was later adapted to the iconography of the Virgin. Mary's moon has no blemish, symbolizing purity. In Christian cosmology, the Moon-Virgin stands by the side of the Sun-Christ, ruling the universe. The light of the Sun-Christ is too strong if we look at it directly, but seen through its reflection on the moon (the Virgin as the mediating source of grace), we can withstand the brightness. Representations of the moon under the feet of the Madonna indicate her preeminence— thus also the preeminence of the Church, of which she is a symbol—over changing destinies and situations.

Baudo Luca
Madonna and Child between Saints Apollonia and Lucy
c. 1500–10
Pinacoteca Malaspina, Pavia

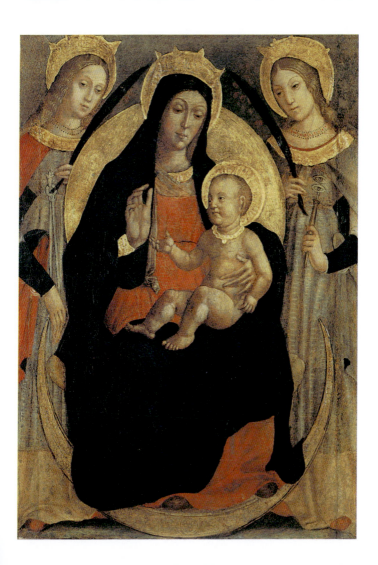

Fountain

Mary is like a spring gushing forth from a flowering meadow or even from parched land, a source of divine abundance and grace. But Mary is also a sealed well, insofar as she is pure and untouchable. The Virgin Mary is the fount from which the divine fountainhead, Jesus, originates, and she is the stretch of water in which God's image is reflected. The fountain is a symbol of nature's continuous renewal, purified by the running water. It possesses extraordinary healing powers that return vitality to the body, just as Mary returns health to the sick.

Jan van Eyck
The Virgin of the Fountain
c. 1430
Koninklijk Museum, Antwerp

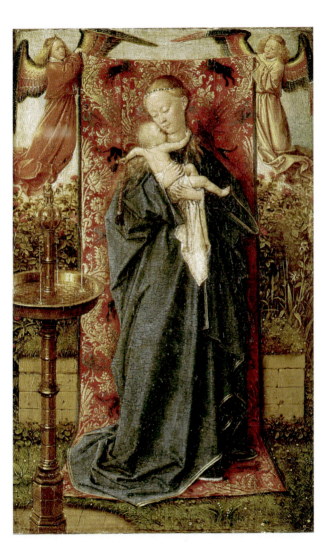

Ladder

Jacob, son of Isaac and Rebekah, was sent by his father to
Haran to find a wife. Having reached a nearby town, he stop-
ped to spend the night. After falling asleep, Jacob "had a
dream: a stairway rested on the ground, with its top reaching
to the heavens; and God's messengers were going up and
down on it." In his dream, the patriarch sees Heaven and
Earth joined by a stairway, or ladder, which has been inter-
preted as a prefiguration of the Virgin Mary, the living ladder
on which Christ descended to Earth, allowing man to be reu-
nited with God. Mary mediated the distance between belie-
vers and the Lord, a chasm that, as decreed by God after the
Original Sin, only Mary could bridge.
(Genesis 28:12)

Michelangelo Buonarroti
Madonna of the Stairs
c. 1490–92
Casa Buonarroti, Florence

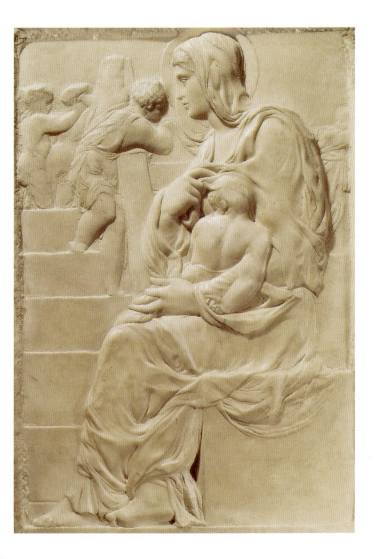

Curtain

The symbolism of the curtain underscores Mary's roles of protector, shelterer and comforter of humankind. Represented as hanging drapes with folds that blend with Mary's garments, the curtain has the function of a stage curtain, under which the divine couple finds brief shelter from the outside world, which appears behind the opening to remind the viewer of the impending, sorrowful mission. Understood as the Ark of the Covenant, the curtain becomes a concrete place where God dwells among His people.

Giovanni Pietro Rizzoli,
known as Giampietrino
Madonna with Child
c. 1520
Museo Bagatti Valsecchi, Milan

The Tree of Jesse

The Gospel of Saint Matthew begins with the genealogical tree of the Holy Family. But unlike the Hebrew custom of only listing the father's lineage, ending with Joseph, the Evangelist ends the tree with Mary, a descendant of Jesse and his son David. The early Christian communities and the Fathers of the Church thus conferred on Matthew's text, read during the Christmas liturgy, a strong Marian emphasis. Saint Luke also lists the genealogy of Jesus Christ, but while Matthew writes for the Hebrews and stops at Abraham, Luke, also writing for a Gentile readership, goes all the way back to Adam. (Matthew 1:1–17; Luke 3:23–28)

Miniaturist after Pietro Cavallini
The Tree of Jesse
Miniature
14th century
Biblioteca Civica, Catania

The Tree of Jesse

The expression "tree of Jesse" appears in one of Isaiah's prophecies: "But a shoot shall sprout from the stump of Jesse, and from his roots a bud shall blossom." The announcement is confirmed by Jeremiah: "Behold, the days are coming, says the Lord, when I will raise a righteous shoot to David; as king he shall reign and govern wisely, he shall do what is just and right in the land." Usually this prophecy is illustrated by a trunk rising next to a sleeping Jesse; on its branches are the ancestors of Jesus. The top of the tree sometimes supports the Virgin with the Child in her arms.
(Isaiah 9:1; Jeremiah 23:5)

Family Tree of Mary
1542
Basilica di San Marco, Venice

Anne

After twenty years of marriage, Anne, who would give birth to
Mary, was still unable to give a heir to her husband Joachim.
She recalls the sterile women of the Old Testament: Abraham's
wife Sarah, Samuel's mother Hannah, Zachariah's wife
Elizabeth. As was the custom, the Jewish community looked
upon sterile women with scorn and marginalized them. For
these women, however, the suffering was purifying, for it
became faith in a God who rewards even the childless wife—
the weak. The cult of Saint Anne began in the East in the first
Christian centuries and only later spread to the Western
Church. A feast day for Anne, with Joachim, was added to the
liturgical calendar only in 1584.
(Infancy Gospel of James 2)

Cesare da Sesto
Madonna and Child with Saint Anne
(detail)
1500–10
Gallerie dell'Accademia, Venice

Joachim

Mary's father was Joachim, a rich and devout Israelite. Having reached an advanced age and finding himself still without an heir, he went to temple carrying offerings for the Lord, but was refused because he still had not fathered a child. The Israelite tribes considered sterility a sign of a lack of God's blessing. In despair, without telling Anne, Joachim left for the desert where his flock was grazing, determined to fast for 40 days and 40 nights and to beseech the Lord to give him a son. The Apocryphal Gospels and the figurative arts portray Mary's father as an elderly man, his white beard confirming his age, wearing a long tunic and mantle. Sometimes he holds a staff or a book in his hands, to indicate the coming of the Lord. (Infancy Gospel of James 1:1–4)

Saint Joachim
(detail)
c. 1151
Santa Maria dell'Ammiraglio,
Palermo

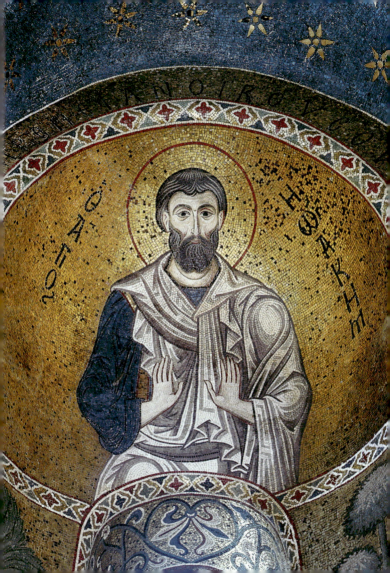

The Announcement to Anne

Anne wept, distressed about her husband's flight into the desert and her own sterility. She donned her wedding gown and went into the garden to pray to the Lord. Raising her eyes to Heaven, she saw among the laurel branches an angel who announced: "Anne, Anne, the Lord has heard thy prayer: thou shalt conceive and bear, and all the earth shall speak of thy progeny." Anxious, the woman returned home, where she spent day and night in prayer. She made a vow to offer the fruit of her womb to God, after which two more angels appeared and invited her to go and meet her husband, Joachim, who was on his way home near the city gate. (Infancy Gospel of James 4:1]

Bernardino Luini
Annunciation to Saint Anne
1516
Pinacoteca di Brera, Milan

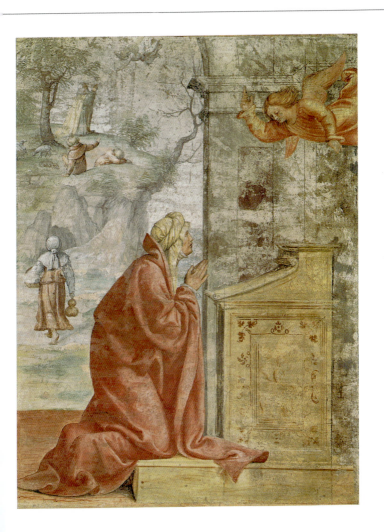

The Announcement to Joachim

The same angel who had appeared to Anne to bring her the good news awoke Joachim in the desert, telling him that his wife would give birth to a little girl, who would be named Mary. "She shall belong to the temple of the Lord, the Holy Spirit shall dwell in her and she shall be blessed above all other holy women, such that there shall not be in the future another woman her equal on Earth." Beaming with happiness, Joachim sacrificed a lamb to the Lord, then asked the other herders to bring him calves to offer to the priests, and 100 kids for the people. With these gifts, he set off for home. (Infancy Gospel of James 4:2)

Quentin Metsys
The Holy Kinship,
or the Altarpiece of Saint Anne
(detail)
1590
Musées Royaux des Beaux-Arts,
Brussels

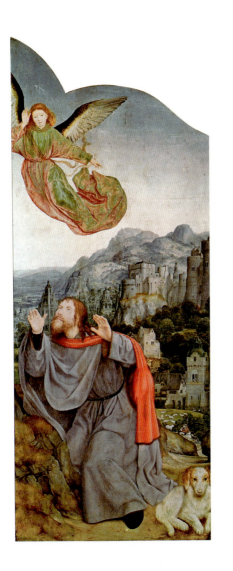

The Meeting at the Golden Gate

As the angel had announced, Joachim found Anne waiting for him at the city gate. As soon as she saw her husband, she exclaimed: "Now I know that the Lord God has greatly blessed me: for behold the widow is a widow no more, and she that was childless has conceived." Reassured by God's promise, the couple embraced and kissed chastely. Every source pinpoints that exact moment as the moment Anne conceived (the kiss is an emblem of Mary's conception, even though she would not be born of a virginal birth; the only Virgin-Mother in the Scriptures is Mary). Of all the episodes about Mary's birth and childhood, the meeting at the Golden Gate of Jerusalem is the one most often represented.

(Infancy Gospel of James 4:4)

Gilde Siloe
Saint Joachim and Saint Anne
(detail)
1486–88
Cathedral, Burgos

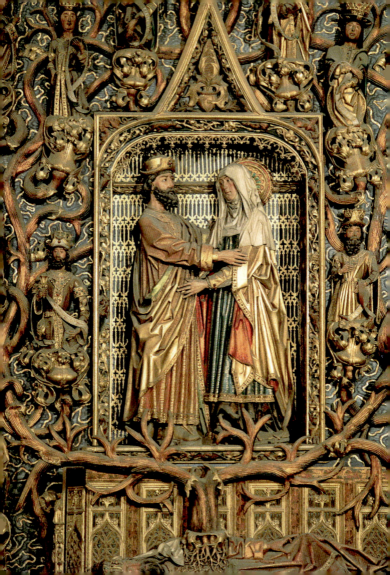

The Immaculate Conception

"I will put enmity between you and the woman, and between your offspring and hers; he will strike at your head, while you strike at his heel," God says to the tempting serpent, revealing the future coming of Jesus. The woman he refers to is Mary, the only woman on Earth to be conceived without Original Sin, so that she could welcome the Messiah into her unblemished womb. The expression "Immaculate Conception" has sometimes been interpreted incorrectly to refer to the conception of Jesus, not of Mary. This misunderstanding has even led some to think that "without sin" means "without carnal relationships." Clearly, though, the Original Sin is a guilt transmitted from Adam and Eve to all human beings, except for Mary, the only one exempted from it thanks to divine intervention.
(Genesis 3:15)

Francisco de Zurbarán
Immaculate Conception
1630–35
Diocesan Museum, Sigüenza

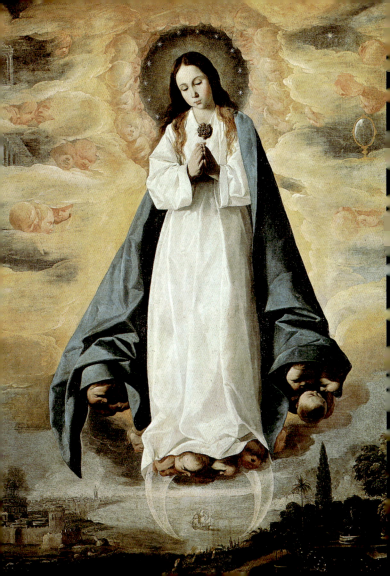

The Immaculate Conception

God's prophecy to the serpent in Genesis is reiterated by John in Revelation when he describes the "woman clothed with the sun." This image, later associated with the concept of the Immaculate Conception, shows a woman suspended in Heaven, her feet resting on a crescent moon. A serpent, sometimes with an apple in its fangs, lies waiting, as a memento of Eve's sin, the stain from which Mary, who is dressed in white, is miraculously exempt. In his *Sermons on the Madonna's Feast Days*, Saint Bernard of Clairvaux explains that the Immaculate Conception of Mary occurred because "our Creator, to become man, and wanting to be born of a human being, had to choose among all women, actually had to create a mother who would be worthy of Him and to Him pleasing. Thus He chose an immaculate virgin from whom He, who purifies all stains, would be born immaculate. He also wanted her to be humble, as a necessary and efficacious example to all of these virtues." (Genesis 1:15; Revelation 12:1–18; Saint Bernard of Clairvaux, *Sermons on the Madonna's Feast Days*)

Giambattista Tiepolo
The Immaculate Conception
1767–69
Museo del Prado, Madrid

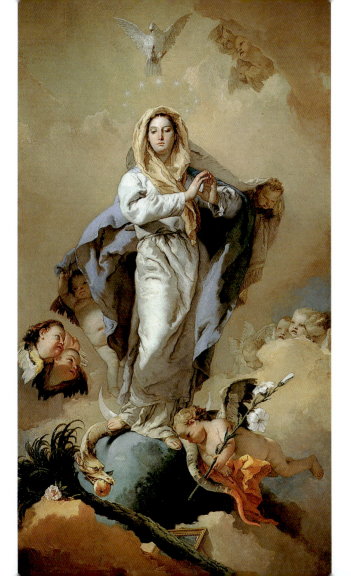

The Nativity of Mary

"The months of pregnancy having passed, at the end of the ninth month Anne gave birth. She then asked the midwife: 'What have I given birth to?' to which the midwife replied, 'A girl.' 'Today,' exclaimed Anne, 'my soul is magnified!' And she laid down the baby. After the prescribed days, Anne purified herself, offered her breast to the child and called her Mary." This is how James narrates the birth of the Mother of God, a natural event, for the divine, supernatural intervention had taken place earlier, by allowing a sterile woman to conceive a child, and especially by infusing in her a pure, blemish-free soul. The episode stresses Anne's maternal feelings and refers to the Jewish religious practice that considers the mother of a newborn girl impure for two months; she must undergo purification for 66 days, double the time set for the birth of a boy.

(Infancy Gospel of James 5:2; Jacopo da Varagine, *Legenda Aurea*)

Master of the Turin Book of Hours
Nativity of Mary
Miniature
1410–20
Biblioteca Reale, Turin

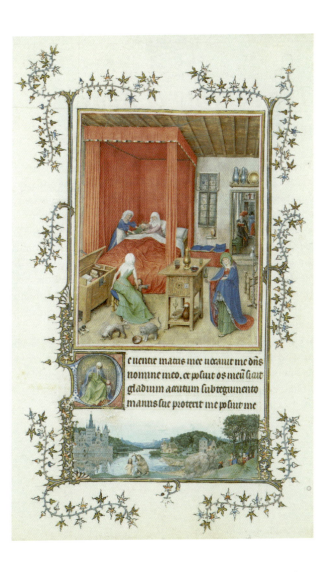

e uentre matris mee uccauit me dns
nomine meo. et posuit os meu sicut
gladium acutum subtegumento
manus sue protexit me posuit me

The Nativity of Mary in the Temple

There is no text, no source to even remotely suggest that Mary was born in a temple. Such representation is entirely metaphorical. On the one hand, it insists on the important relationship of the Virgin to the temple where she was to spend most of her childhood. On the other, it reiterates Mary's identification with the Church. The nativity of the Virgin is the only scene in the New Testament in which men are not represented at all. The participants usually include Anne's sister Ismeria and niece Elizabeth, Mary's older cousin and the future mother of John the Baptist. With them are the maids who assist at the delivery by preparing a basin and towels. Sometimes at the foot of the bed on which Anne lies is a pair of sandals, a memento of the sandals that Moses took off before the burning bush, another symbol of Mary's virginity.
(Infancy Gospel of James 5:2; Jacopo da Varagine, *Legenda Aurea*)

Albrecht Altdorfer
The Birth of the Virgin
1525
Alte Pinakothek, Munich

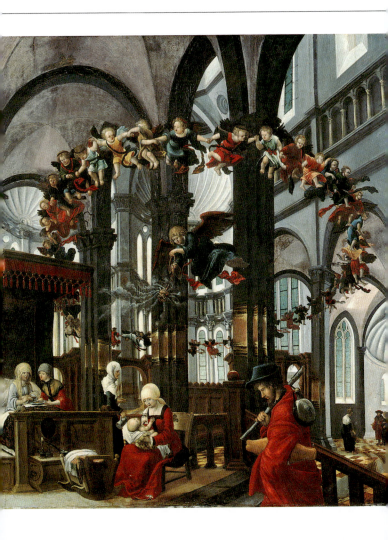

The Education of Mary at Home

"Day after day, the child grew strong; and when she was six months old her mother stood her on the ground to see if she could stand: The child walked seven steps and returned to her mother's bosom. And Anne picked her up, saying: 'As the Lord my God lives, you shall walk no more upon this ground, until I bring you into the temple of the Lord.' And she made a sanctuary in her bed chamber and suffered nothing common or unclean to pass through it." Mary spent the first three years of her life with her parents; her mother taught her early on to read and sew. In these years, important for Mary's growth, she and her mother Anne became very intimate.

(Infancy Gospel of James 6:1)

Giambattista Tiepolo
Education of the Virgin
1732
Santa Maria della Fava, Venice

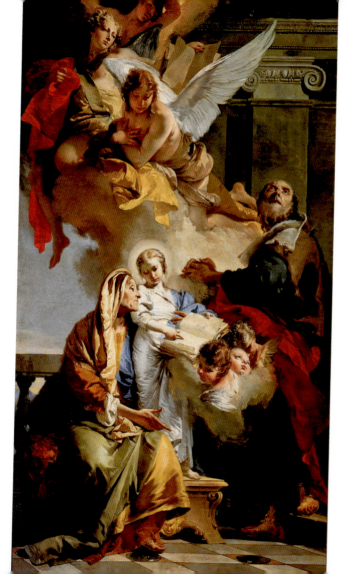

The Presentation of Mary to the Temple

"When she stood before the temple of the Lord, she ran up the fifteen steps without looking back or calling her parents, as children are wont to do." Mary was only three years old when Anne and Joachim brought her to the temple, but as we read in the Gospel of Pseudo-Matthew, her mature, determined walk made her look "like an adult." Perhaps for this reason she is portrayed in art as older. The fact that the Virgin does not turn around to look at her family refers to the Genesis episode of the wife of Lot, a figure antithetical to the Virgin Mary, who did not resist the temptation to look back and was turned into a pillar of salt for disobeying God's command. Thus, Mary's grandeur also resides in her total faith and obedience in God since her youngest years.
(Genesis 19:26; Gospel of Pseudo-Matthew 4:1; 6:1)

Vittore Carpaccio
Mary at the Temple
1505
Pinacoteca di Brera, Milan

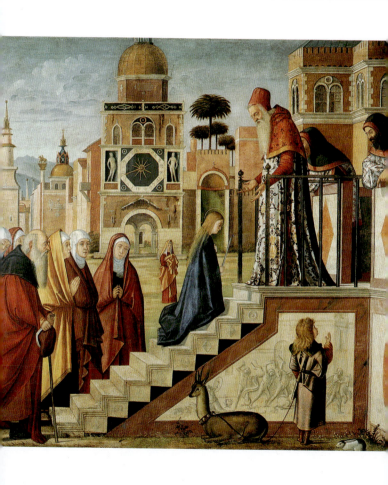

The Presentation of Mary to the Temple

The temple has 15 steps, just as the Old Testament Psalms called Graduals, which pilgrims recite as they climb the steps. At the top of the stairs the high priest welcomed Mary, surprised and proud of the little girl's confidence. Actually, there is no mention in the Bible of a tradition whereby the first-born daughters were consecrated to God. Nor is there mention of children, either boys or girls, being entrusted to priests to be educated inside the temple. Probably, therefore, the idea that Mary was delivered to the temple, where she spent much of her childhood, developed over time, to justify her perpetual virginity and holiness.

(Infancy Gospel of James 7:2–3; Pseudo-Matthew 4:1; 6:1)

Gaudenzio Ferrari
Presentation of Mary at the Temple
1539
Pinacoteca di Brera, Milan

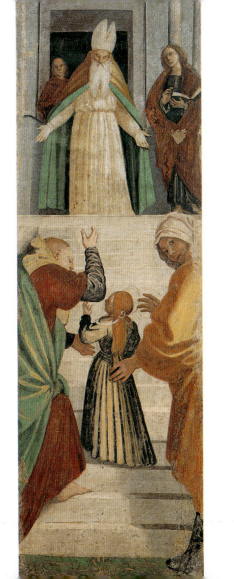

Mary the Seamstress

"And this was the order that she had set for herself: from the morning to the third hour she remained in prayer; from the third to the ninth she was occupied with her weaving; and from the ninth she again applied herself to prayer. She did not retire from praying until there appeared to her the angel of the Lord, from whose hand she used to receive food." Mary's main chores at the temple were spinning and weaving. The Virgin organized her activity alternating it with prayer, thus providing a model for the future monastic communities, especially those of the order of Saint Bernard, whose rule was written around the principle of *Ora et Labora* (Pray and Work). Every day Mary ate whatever food the angels brought, so that she could distribute to the poor the meals that the high priests provided for her. Thus Mary exercised the virtue of charity from a very early age.

(Pseudo-Matthew 6:2)

Master of the Church of Saint Primus
The Virgin at the Loom
1508
Saint Primus, Kamnik

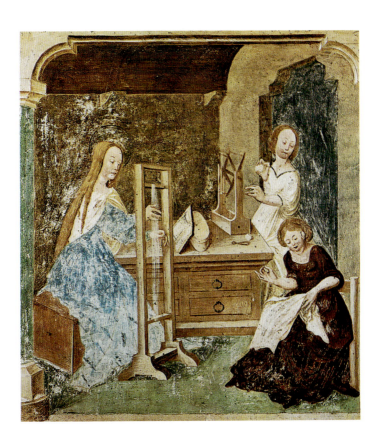

Zachariah Prays Before the Rods

When Mary turned twelve and began menstruating, the temple priests feared that she would "pollute the sanctuary," since it was considered a serious impurity. Thus they decided to find her a husband, but the Virgin objected, saying: "It cannot be that I should know a man." Then the high priest began to pray that he might understand how to resolve the situation. An angel appeared and told him: "Zachariah, Zachariah, go forth and assemble them that are widowers of the people, and let them bring every man a rod, and to whomsoever the Lord shall show a sign, his wife shall she be." Already in the Old Testament God had used this device of the rod to reveal His choices. To Moses he had said: "Speak unto the children of Israel, and take of every one of them a rod according to the house of their fathers, of all their princes according to the house of their fathers twelve rods: write thou every man's name upon his rod . . . And it shall come to pass, that the man's rod, whom I shall choose, shall blossom." (Numbers 17:16–20; Infancy Gospel of James 8:2–3; Pseudo-Matthew 7:1)

Stephan Lochner
The Flowering of Saint Joseph's Rod
c. 1440
Private collection

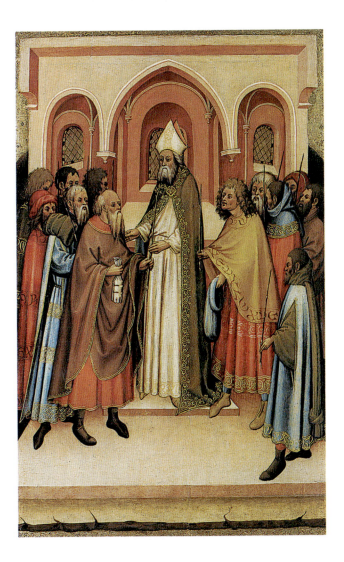

Mary's Suitors

After praying to the Lord, the High Priest Zachariah left the temple and returned the rods to the suitors: Joseph's rod was last. As soon as Joseph touched it, it bloomed and a dove flew out above his head. Having recognized God's sign, the priest entrusted Mary to Joseph, an old widower with children who was reluctant to marry such a young girl because he feared he would become the town's laughingstock. Apparently, Joseph had even hidden his rod at first, ashamed of competing for the hand of such a young girl.

(Infancy Gospel of James 9:1–2)

Jean Fouquet
Wedding of the Virgin
from *The Book of Hours of Étienne Chevalier*
Miniature
c. 1445
Musée Condé, Chantilly

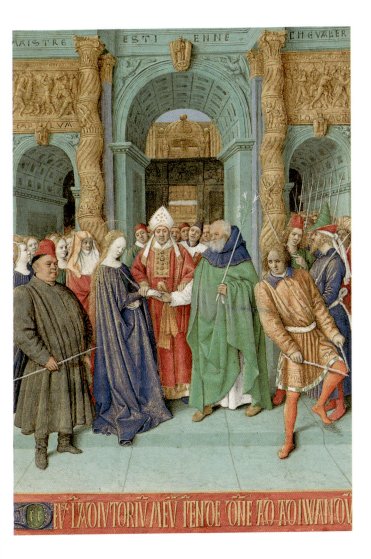

The inscriptions visible in the illustration read:

Top: MAISTRE ESTI ENNE CH GVALER

Columns/frieze: TEMPVLVM ... ALO AON

Bottom banner: IV LAOINTORIV MEV IENOE ONE AO AOIWANOV

The Presentation of Joseph to Mary

Faced with Zachariah's firm decision to entrust Mary to him, Joseph relented and declared that he did not want to marry her, but offered to keep her with him until he learned what God's plan would be: "I shall be her guardian until I can ascertain concerning the will of God, as to which of my sons can have her as his wife. Let some virgins of her companions, with whom she may meanwhile spend her time, be given for a consolation to her." Thus the maiden was led to Joseph's house with seven other virgins, and Joseph went back to his work, saying to her: "The Lord shall watch over you." (Infancy Gospel of James 9:2–3)

Vittore Carpaccio
Wedding of the Virgin
1504–8
Pinacoteca di Brera, Milan

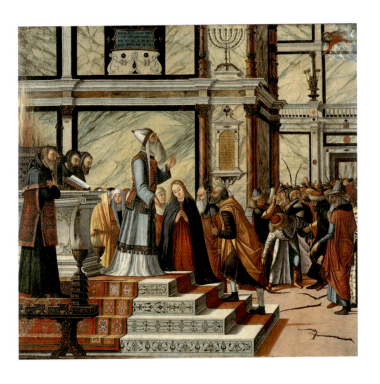

The Priest Entrusts Mary with the Skein

After Mary was entrusted to Joseph, "there was a council of the priests, and they said: Let us make a veil for the temple of the Lord." Befitting Mary's exceptional status, the High Priest gave her the largest loom so she could weave the temple's precious curtain—the same curtain that would be rent in the instant of Christ's death. According to tradition, while the other seven virgins worked with silk, linen, gold, and brightly-colored yarn, Mary was given the true purple and scarlet yarns, which are the colors of blood, of the Passion of Jesus. Pseudo-Matthew narrates that the other maidens were offended because "although she is the last, and humbler, and younger than all, yet she was given the purple," which is more precious. Then an angel appeared to reveal that their angry words were "a prophecy that will most surely come true." (Infancy Gospel of James 10:1; Pseudo-Matthew 8:5)

The Priest Entrusts Mary with the Skein for Weaving the Temple Curtain
(detail)
14th century
Kariye Camii, Istanbul

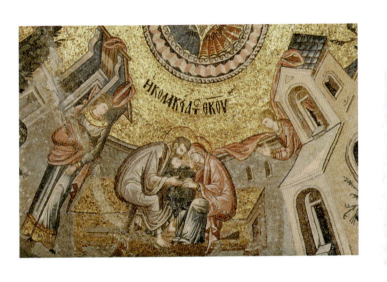

The Wedding of the Virgin Mary

The episode of Mary's wedding to Joseph has been a frequent subject in art, though just as with the other episodes in her life before the birth of Jesus, there is no mention of it in the Scriptures. Nor do the Apocrypha or medieval traditions such as the *Legenda Aurea* mention it. The idea that an actual marriage took place was formed over time, although the sources clearly speak of betrothal or guardianship. In fact, Joseph simply took Mary under his tutelage; for this reason he was deeply upset when he found out that she was pregnant.

Giovannino de' Grassi
Wedding of the Virgin
from the *Offiziolo Visconti*
Miniature
1388–98
Biblioteca Nazionale, Florence

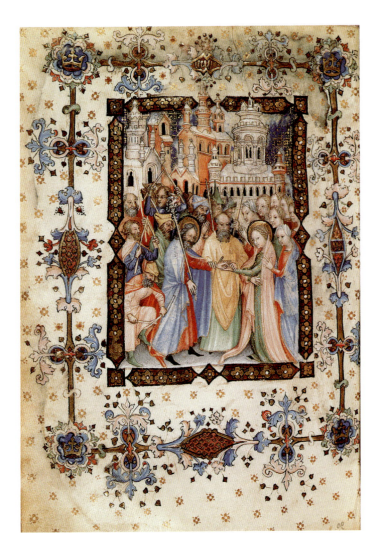

The Wedding of the Virgin Mary

The figurative arts have frequently represented the wedding, an event that leaves much space to the artist's imagination precisely because no source mentions it. Usually the ceremony is set inside or before the temple where Mary was educated, and is celebrated by a Jewish High Priest—perhaps Zachariah. Next to the Madonna are the seven virgins who were her close companions in the temple; near Joseph stand the rejected suitors. The gestures of the bride and groom vary from one painting to another: Sometimes they embrace; other times they shake hands—symbolizing an alliance. Other artists have, as Raphael does in this painting, visualized it as a literal marriage and represented the bride and groom in the emblematic act of exchanging rings.

Raffaello Sanzio, known as Raphael
The Engagement of the Virgin Mary
1504
Pinacoteca di Brera, Milan

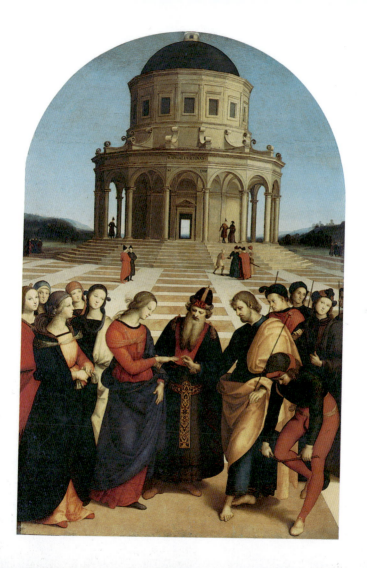

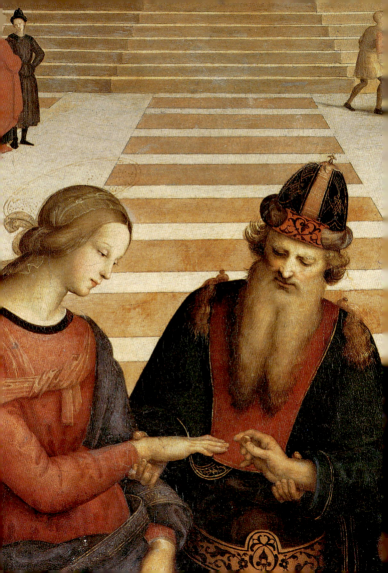

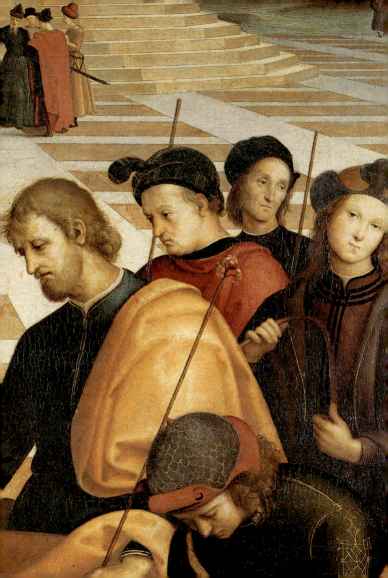

The Angel's Mission

Gabriel is a high-ranking angel of the heavenly cohort whom God sends to Earth to carry His divine messages to man. In the Old Testament, he appears twice to Daniel: the first time to explain the vision of the end of the world in which he saw the billy-goat and the ram; the second, to announce the prophecy of the "70 weeks," the time allotted to the Jews for putting an end to their ungodliness. In the New Testament, Gabriel relays to Zachariah the good news that he and his wife Elizabeth, now elderly, would be blessed with a child, John the Baptist. Still, the most important message that God entrusts to Gabriel is for Mary. For this reason, in their representations of the Annunciation some artists have also included a scene portraying God summoning the archangel for the all-important mission.

(Daniel 8:1, 15–26; 9:1, 20–27; Luke 1:11–20; 26–38)

Andrea di Nerio
Annunciation
1350
Museo Diocesano, Arezzo

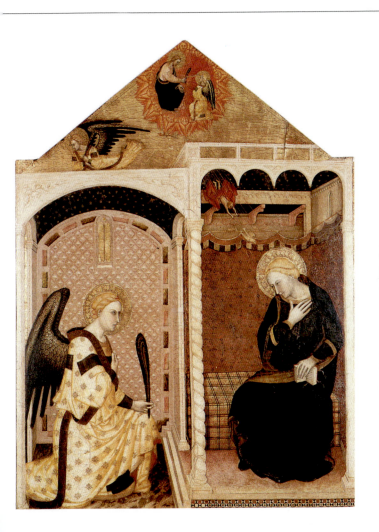

Mary at the Well

In recounting the episode of the Annunciation, the Byzantine tradition refers not to the four canonical Gospels but instead to the Infancy Gospel of James. Saint James narrates that "she took the pitcher and went forth to fill it with water: and heard a voice saying: 'Hail Mary, full of grace, the Lord is with you, blessed are you among women.' And she looked about her upon the right hand and upon the left, to see whence this voice should be: and being filled with trembling she went back to her house and set down the pitcher, and took the purple and sat down upon her seat and drew out the thread." This episode precedes Gabriel's Annunciation as reported in the official Gospels; it underscores the symbolic value of water, for the pitcher that Mary carries as she walks to the well becomes a metaphor for her womb being readied to be Jesus' receiving "vessel."

(John 4:13–14; Infancy Gospel of James 9:1; Pseudo-Matthew 9:1)

Stories of the Virgin
(detail)
12th century
Basilica di San Marco, Venice

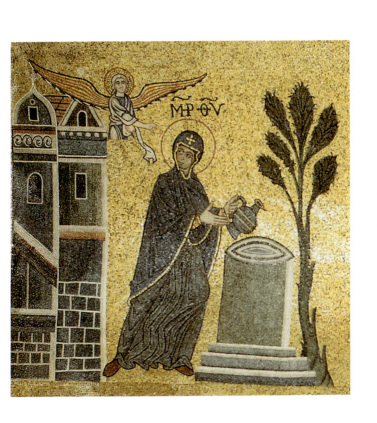

The Annunciation

Standing before Mary, the Archangel Gabriel exclaimed,
"Hail Mary, full of grace, the Lord is with you!" The
Annunciation is undoubtedly one of the episodes in Mary's
life that has enthralled most Christians from the earliest times.
In fact, it is one of the earliest episodes to have been repre-
sented in art. The interpretation of this event by early Christian
artists is only symbolic, however, for they wanted to express
a transcendental sense of the divine, to render in a finite
medium—painting—an infinite reality. Thus the narrative is
restrained and consists of just two figures: a man and a
woman, Gabriel and Mary.
(Luke 1:28)

Annunciation
2nd century
Catacombe di Santa Priscilla,
Rome

The Annunciation with the Holy Spirit

Through the Holy Spirit, God realizes His divine will. Therefore, the Holy Spirit is considered the tool through which the Lord caused Mary to conceive. It is expressed as a dove, because after the Deluge (a symbol of baptism), Noah released a dove, which returned bearing an olive branch in its beak, signifying that the land was again fit for habitation. And when Christ, having just received baptism, came out of the water, "Heaven was opened, and he saw the Spirit of God descending like a dove and lighting on him." The word "spirit" translates as the Hebrew *ruah*, which means "breath, air, or wind." In the Scriptures, it is also called the *Paraclete*, which in Greek means "helper or comforter."
(Genesis 8:10–11; Matthew 1:20; 3:13–17; Mark 1:9–11; Luke 1:34–35; 3:21–22; John 14:16–26)

Lodovico Carracci
Annunciation
1585
Pinacoteca Nazionale, Bologna

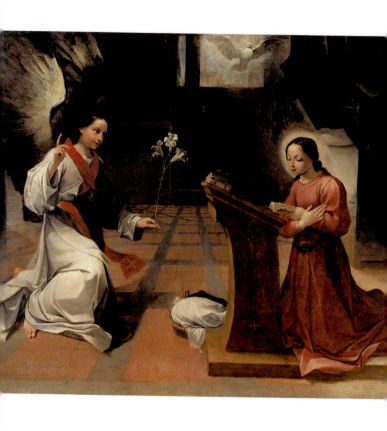

The Annunciation with the Lily

The lily stands for Mary's purity. After the Annunciation, Mary, protective of the virginity which she had consecrated to God, asks the angel for an explanation of the mysterious motherhood that has just been revealed to her: "How can this be, since I have no relations with a man?" It is here that God's greatness becomes manifest: She will be a mother through the work of the Holy Spirit, and shall give birth to the Son of God, but will preserve her virginity and her vow of chastity. Thus the lily also becomes a symbol of God's love that communicates His divine essence to the human world. The lily stem that the angel offers to Mary has three blooming flowers, alluding to Mary's virginal state before, during, and after the holy conception.

(Luke 1:34)

Orazio Gentileschi
Annunciation
c. 1623
Galleria Sabauda, Turin

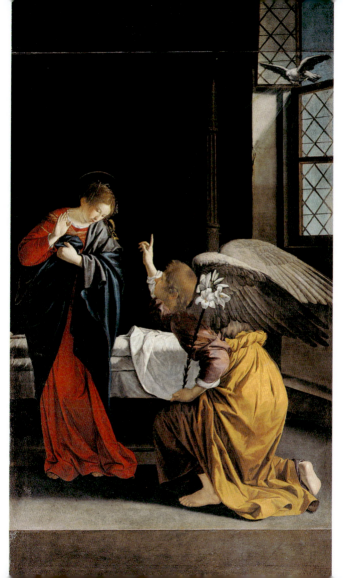

The Annunciation with the Olive Branch

Some renderings of the Annunciation show the Archangel Gabriel carrying an olive branch. This symbol of peace already appears in the Old Testament when the dove, after the Deluge, flies back to Noah carrying an olive branch in its beak. In that case, the olive branch was God's sign that His wrath—the Deluge—was spent and a new world, in which divinity was reconciled to man, had begun. Here the olive branch has the same meaning: Gabriel carries it because he is announcing the Lord's descent to Earth to defeat evil and wipe out once and for all the progenitors' fault.

(Jacopo da Varagine, *Legenda Aurea*)

Simone Martini and Lippo Memmi
The Annunciation and Two Saints
1333
Galleria degli Uffizi, Florence

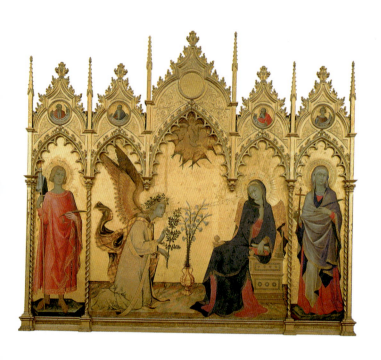

The Annunciation with the Conception

After the angel relays the message, Mary replies: "Behold, I am the handmaid of the Lord. May it be done to me according to your word." This answer is the premier demonstration of the humble nature of the Virgin, in whose pure womb the conception of a human creature united with the Father's divine nature takes place. In the womb of the Daughter of Zion, God will be present among His people. The Virgin became aware of God's presence at the instant of conception and, crossing her hands on her womb, manifested the eternal embrace between God and humankind.

(Luke 1:38)

Filippino Lippi
Annunciation
1485
Hermitage Museum, Saint Petersburg

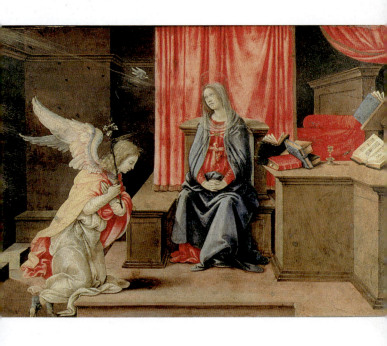

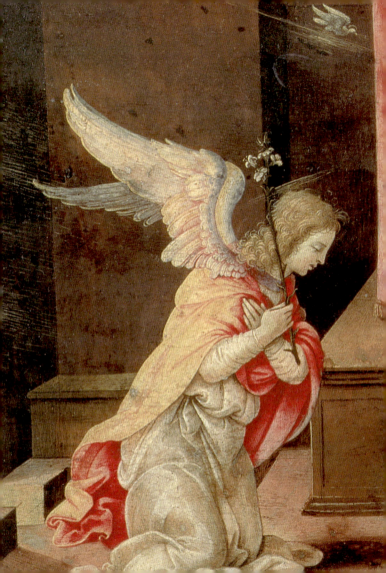

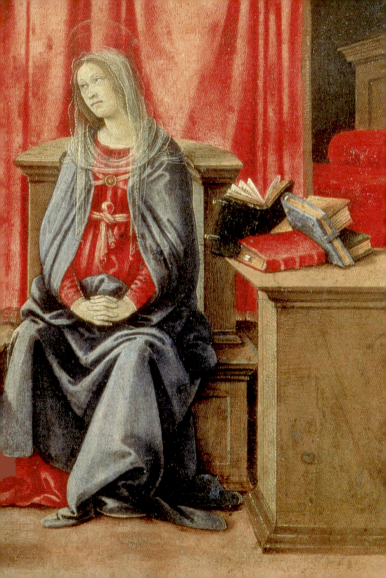

The Annunciation with Mary Perturbed

Gabriel's Annunciation to Mary has a Christological intent, for it aims to present the figure of the Messiah glorified. Luke's narrative of the episode follows a structure typical of vocational stories: the apparition, the disturbance, the message, the objection, and the sign. As Jacopo da Varagine narrates anecdotally, at the angel's announcement the Virgin is overcome with modesty and leaps back in shock. Still, she is not afraid of Gabriel because she is used to heavenly visions. Mary is troubled by the angel's words; for this reason he comforts her, saying, "Do not be afraid, Mary, for you have found favor with God."

(Luke 1:29–30; Jacopo da Varagine, *Legenda Aurea*)

Lorenzo Lotto
Annunciation
c. 1527
Pinacoteca Comunale, Recanati

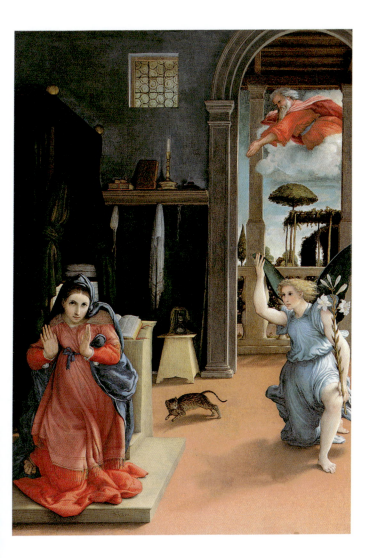

The Virgin Annunciate

The Annunciation rendered with just Mary but without the angel is rather unusual. Here the artist wanted to capture the moment immediately after the canonical face-to-face meeting between the angel and the Virgin. Mary is now alone and reflects on the news she has just received. As if a shiver of consciousness were running through her, she smiles ever so slightly. Her face is lit by the grace of God, but especially by the Christ-Light, which at this very moment is coming into world through her.

Antonello da Messina
Virgin Annunciate
c. 1476
Museo Nazionale, Palermo

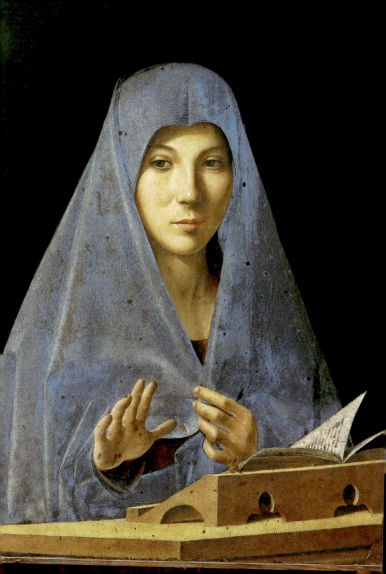

The Mystical Hunt

In the Scriptures there is often talk of a *re'em*, a fantastic animal. In the Septuagint (the oldest Greek version of the Old Testament), it was called *monokeros* or "unicorn," a white horse with a long, straight horn rising from the center of the forehead. The earliest text linking this fantastic creature to the legend that only a virgin could tame it is the *Corpus Hermeticum*, a collection of ancient writings which probably originated in the first century CE. In the thirteenth century, the fable was the subject of allegorical depictions of a "mystical hunt of the unicorn" that began to take on the character of an Annunciation. Mary sits in an enclosed garden with the gate shut and bolted, the fountain sealed, and the Davidic tower in a corner: all emblems of virginity. The Archangel Gabriel appears dressed as a spear-carrying hunter: He plays the *Ave Maria* on his horn and sets four dogs (representing the four virtues of mercy, justice, peace, and truth) on the unicorn, but the animal runs to the Madonna, who gently welcomes and tames it.

Martin Schongauer School
The Mystical Hunt
(detail)
1475
Musée d'Unterlinden, Colmar

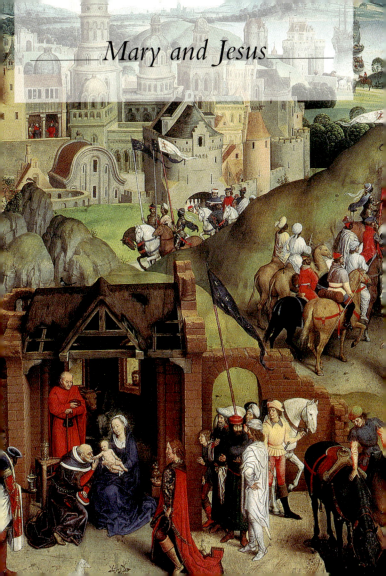

The Virgin's Seven Joys

This title refers to the seven joyful moments in the life of the Virgin Mary. The first joy is the news brought by the Archangel Gabriel that she has been chosen by God to be the Mother of Christ. The second joy is the Virgin's visit to her cousin Elizabeth, who recognizes her as the Mother of the Lord and blesses her. These events are followed by the Nativity, when Mary gives birth to Jesus without the pains of childbirth and maintains her virginity intact. The next moment is the visit of the Magi who come to adore the infant Jesus in Bethlehem. During her son's teenage years, Mary thinks she has lost him and is enormously happy to find him deep in discussion with the doctors in the temple. The sixth and seventh joys are the apparition of the resurrected Christ and Mary's Assumption and crowning as Queen of Heaven and Earth. The paintings depicting this theme join the various events into a single, unified composition.

Hans Memling
Advent and Triumph of Christ
1480
Alte Pinakothek, Munich

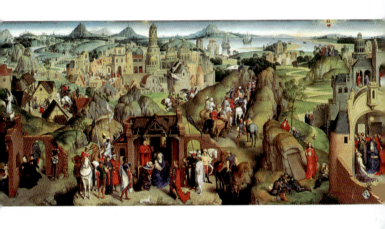

The Incarnation

"God sent His Son, born of a woman, born under the law."
Jesus became man by being born of a woman and under the
law. Only by becoming flesh could he achieve the work of
redemption willed by the Father. By subjecting himself to the
uncertainty, sorrows, and captivity that is the human condition,
he brought salvation to humanity, allowing humans to become
reconciled with God. And Mary is a crucial figure in this divi-
ne plan. Here the theme of the Incarnation is rendered by the
Holy Spirit shining its light upon the Madonna, who is the
focus of the composition; to her side, the angels celebrate the
event with music.
(Galatians 4:4)

Matthias Grünewald
Concert of Angels and Nativity
from the *Isenheim Altarpiece*
(detail)
1509–12
Musée d'Unterlinden, Colmar

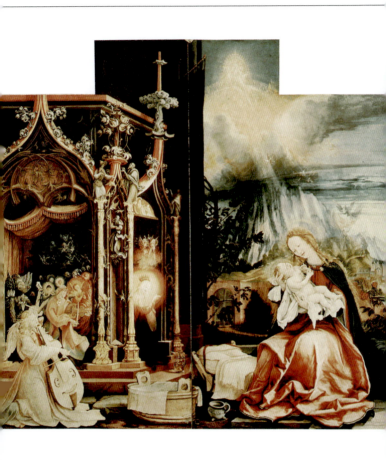

The Madonna of Childbirth

This Madonna of Childbirth (*Madonna del Parto*) does not describe any specific episode; there is no mention of it in either the canonical or the apocryphal sources. Again, it is a freely conceived image whose iconography became codified over the centuries. Mary is portrayed with a large belly, either standing, sometimes in the classic position of pregnant women with a hand over her belly and the other akimbo to support her kidneys, or sitting. She is often flanked by two angels who hold open the drapes, suggesting the curtain that covered the Ark of the Covenant, thus making an analogy between the two divine containers on Earth. The ceremonial, solemn pose of the angels heightens the sacred nature of the representation, perhaps a moment of reflection on the part of the Mother who meditates on her future and that of the Son she carries in her womb.

Piero della Francesca
Madonna del Parto
(Madonna of Childbirth)
c. 1476–83
Chapel of the Cemetery, Monterchi

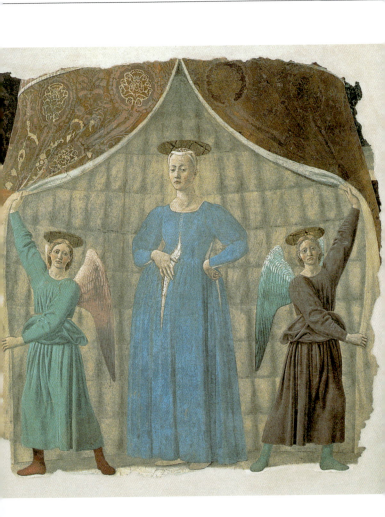

Mary's Dream

Some unofficial traditions, not part of the canonical Gospels, speak of a dream that Mary had before giving birth. In the dream she saw her son nailed to the Cross as he was emerging from her womb. This is the moment Mary started to become aware of the future Passion of the Christ. Mary's prescience signals her knowledge of the path of sorrows that her son was to face, an ordeal in which she was both messenger and participant.

Simone dei Crocifissi
Dream of the Virgin
c. 1355–60
Pinacoteca Nazionale, Ferrara

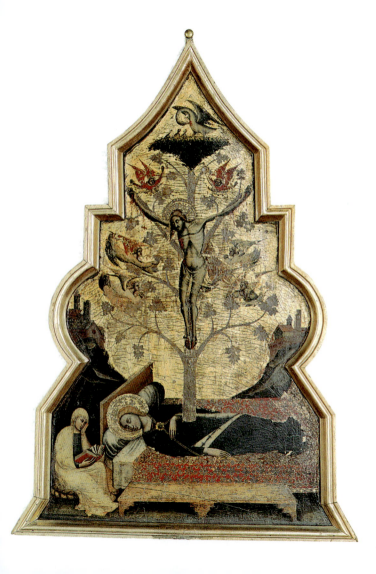

The Visitation

The Archangel Gabriel announces to Mary that her cousin, Elizabeth, is also pregnant. Full of joy, the Madonna decides to pay a visit to her relative. As soon as Elizabeth sees Mary, she feels her son jump in the womb and exclaims: "Most blessed are you among women, and blessed is the fruit of your womb." The Infancy Gospel of James reports that Mary, having forgotten the angel's words, replied to the greeting with these words: "Who am I, Lord, that all the generations of the earth do bless me?" Elizabeth's greeting has become part of the most famous Catholic prayer dedicated to Mary, the Hail Mary. (Luke 1:42; Infancy Gospel of James 12:2)

Jacopo Robusti,
known as Tintoretto
The Visitation
1550
Pinacoteca Nazionale, Bologna

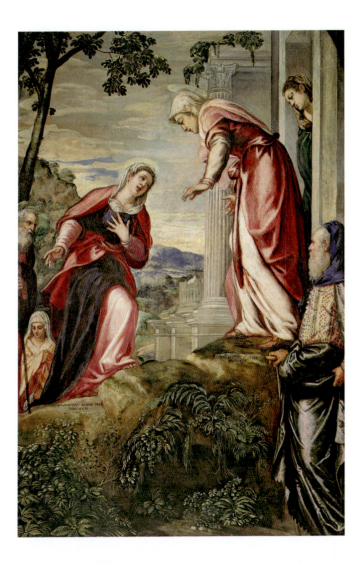

The Visitation

"Blessed are you who believed that what was spoken to you
by the Lord would be fulfilled." Elizabeth's blessing refers to
the Virgin's blessed state, since her motherhood is the fruit
and the reward of her faith in God. With these same words,
Elizabeth shares with Mary the full awareness of the coming
of the Savior. Although it has the appearance of a simple visit
between relatives, the two cousins share the miracles of their
pregnancies: Mary is expecting Christ and Elizabeth has beco-
me pregnant in her old age. This episode is a popular subject
in art, and perhaps the most suggestive interpretation
is this *Visitation* by Pontormo. The artist has captured the
embrace of the two women in profile, then, as if in a double,
has rendered them again in a frontal background view, in a
sort of playful dialogue with the viewer.
(Luke 1:45)

Jacopo Pontormo
Visitation
1528–29
San Michele, Carmignano

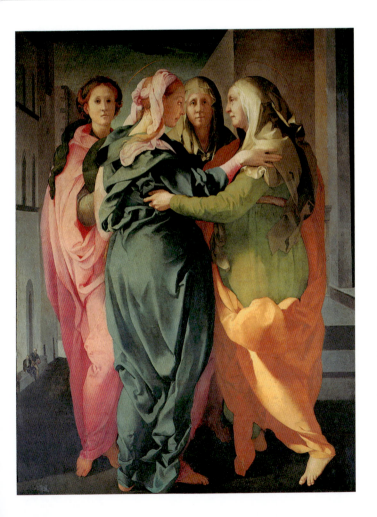

The Magnificat

Magnificat is the initial word, and the name in Latin, of the laud with which Mary replies to her cousin Elizabeth's greeting. "My soul does magnify the Lord, my spirit rejoices in God my Savior. For He has looked upon His handmaid's lowliness." The Virgin is inspired by the Old Testament tradition, especially the Greek term *tapéinosis* (which means "poverty or humbleness") used by Hannah of Samuel, to celebrate the wonders that God has worked in her. But in addition to glorifying humility, with this laud Mary confirms the hope that the injustice of human history will be overturned by God in Heaven, where the humble will be powerful and the hungry sated. The hymn is now part of the liturgy of the Hours and is sung at vespers. The beauty of the lyrics has inspired sacred music composers such as Bach, Monteverdi, Vivaldi, and Mozart.

(I Samuel 2:1–10; Luke 1:46–55)

Alessandro di Mariano Filipepi,
known as Sandro Botticelli
Madonna of the Magnificat
1480–81
Galleria degli Uffizi, Florence

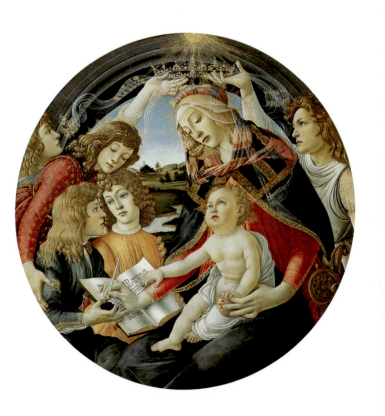

The Birth of the Baptist

Saint John the Baptist is the last of the prophets before Jesus, and the first of his disciples. In addition to Mary, he is the only saint who is remembered in the Christian liturgy on the day of his birth (June 24) as well as the day of his death (August 29). When John was born, his father Zachariah, who had lost his voice for not believing the announcement of the Archangel Gabriel, regained his speech. John was born in Ain Karim, about seven kilometers west of Jerusalem, where Mary had visited her cousin Elizabeth. The *Legenda Aurea* narrates that the Mother of God was the first to take the Baptist in her arms when he was born, but according to the Gospel of Saint Luke, Mary returned home before John's birth.
(Luke 1:56; Jacopo da Varagine, *Legenda Aurea*)

Rogier van der Weyden
Saint John Altarpiece
(left panel)
c. 1455
Gemäldegalerie, Berlin

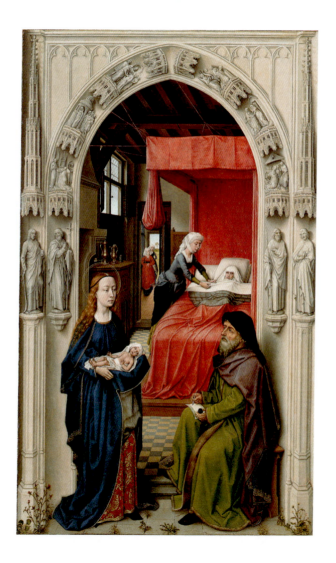

Joseph's Dream

Mary stayed for three months at Elizabeth's house, then returned to Nazareth. When she was already in her sixth month of pregnancy, Joseph came home, realized that she was with child, and beat his breast in despair, thinking that he had betrayed the promise he had made to God by neglecting her, to the point of allowing someone to ravish her. He continued to be torn with guilt, unsure of whether to inform the authorities of Mary's condition, when an angel appeared to him in a dream, and said, "Fear not this child, for that which is in her is of the Holy Ghost, and she shall bear a son and thou shalt call his name Jesus, for he shall save his people from their sins." Joseph awoke, thanked the Lord, and continued to care for Mary. (Infancy Gospel of James 14:2)

Stefano Maria Legnani,
known as Legnanino
Joseph's Dream
1708
Museo Civico, Novara

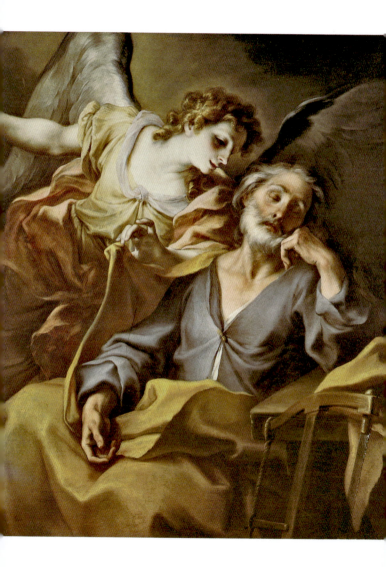

The Bethlehem Census

While Mary was pregnant, the Roman Emperor Augustus issued an edict decreeing a general census of the Roman world. Each inhabitant had to go to his own town to sign in the imperial registers. Thus Joseph traveled with Mary from Nazareth to the town of Bethlehem in Judea, the town of David, for he belonged to the house and the line of David. According to the Infancy Gospel of James, Joseph was worried, unsure of how he should register Mary: "As my wife? Nay, I am ashamed. Or as my daughter? But all the children of Israel know that she is not my daughter." Trusting in the will of the Lord, the man reached Bethlehem leading a she-ass on which rode the Virgin.

(Infancy Gospel of James 17:1)

Pieter Bruegel the Elder
Census at Bethlehem
1566
Musées Royaux des Beaux-Arts,
Brussels

Joseph Seeks Shelter

Once in Bethlehem, the time came for the child to be born. Joseph anxiously searched for a room where Mary, already in labor, could give birth. Because there was no room in the inn, nor at his relatives' homes, he found a stable. While the Gospel of Saint Luke mentions explicitly a manger, an animal stable, the Infancy Gospel of James tells another version. According to the latter, the delivery took place in mid-journey, in a cave. Except in rare cases, such as in this interesting Chinese painting, the figurative arts have neglected the cave version. (Infancy Gospel of James 18:1)

Lu-Hung-Nien
Saint Joseph Searches in Vain for Shelter in Bethlehem
early 20th century
Private collection

大倉 陸鴻年敬繪

The Nativity

Mary gave birth to Jesus in a humble place, in a situation of need and dire poverty, in either a manger, according to Luke, or a cave, according to the Infancy Gospel of James. The Son of God came into the world in a situation of extreme indigence, in shocking contrast with the enormous cosmic and celestial echo of his birth. The apocryphal Gospel describes the birth of Christ through Joseph's thoughts and perceptions. For example, as he walked about looking for a midwife, he saw everything around him freeze for an instant: The birds in the sky froze in the air; some laborers who were eating stopped, with their hands in the bowl or in mid-air; a flock of sheep walking to their pasture halted in the middle of the path; even the hand of the shepherd carrying the staff to strike them stopped in mid-air. After the moment of total immobility, everything returns to normal: The miracle has taken place. (Infancy Gospel of James 18:2)

Donato di Niccolò di Betto Bardi,
known as Donatello
Nativity
1460
Museo Bardini, Florence

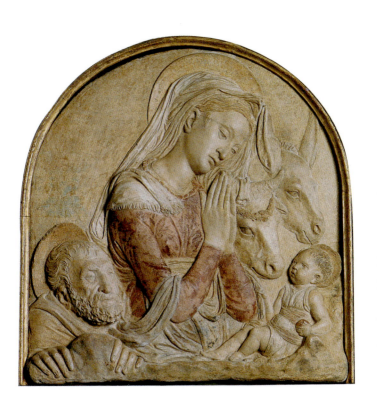

The Nativity

The sources speak of a true, natural birth, albeit an extra-ordinary one because the conception was virginal. Born without sin, Mary is exempted from the pains of childbirth. The apocryphal sources describe a painless birth, confirmed by the fact that Mary immediately began to care for the infant. There was no midwife either: She arrived after the event, confirming its exceptional nature. In the figurative arts, the birth of Jesus is rendered in surroundings that are always changing, in keeping with the incongruity of the sources. Thus in this painting, Jesus is already born and has been placed on the ground, surrounded initially only by Mary and Joseph, although in other works, an ass and an ox may appear in the background, warming the infant's body.

Master of the Nativity
Nativity
late 15th century
Pinacoteca Nazionale, Cagliari

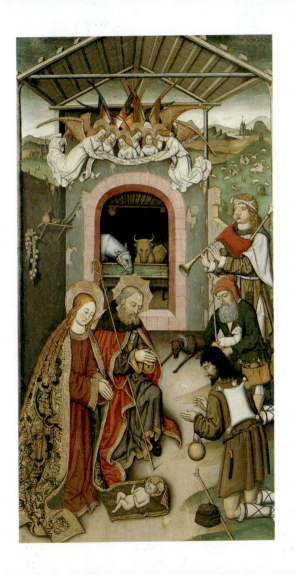

The Mystical Nativity

The Nativity theme has given rise to many different interpretations in art. Sometimes unusual, deeply symbolic elements are included. The iconography of the *Mystical Nativity* is one such painting. It celebrates the birth of the Savior, but with a greater, apocalyptic meaning. The episode of the birth is fused with the mystery of divine grace that transfigures the entire universe. In the upper register of the composition, dancing angels are surrounded by the golden disk of divine grace; they celebrate God's victory over the Devil. Below, angels embracing human beings allude to humankind's return to the straight path after a time of trouble; because of this, the demons flee and hide under the rocks. The three angelic figures on the roof of the hut-cave and those on the ground wear garments with colors emblematic of the three theological virtues: white for faith, green for hope, red for charity. Thus this complex work celebrates the triumph of God the Father and Mary the Queen of Angels, but is also a warning to viewers to forsake evil ways and follow the straight path.

Alessandro di Mariano Filipepi,
known as Sandro Botticelli
Mystic Nativity
1500
National Gallery, London

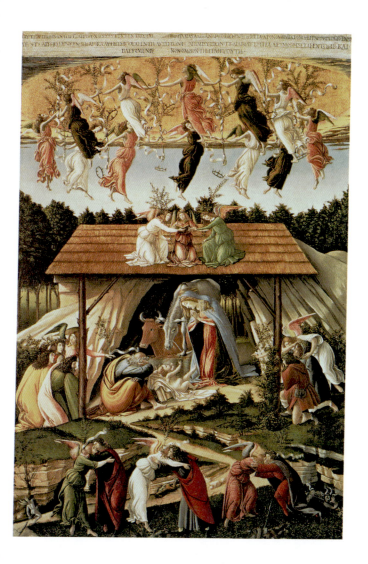

The Disbelieving Midwife

The episode of the midwife who cannot believe Mary's virgin birth is reported only in the Infancy Gospel of James, and later in Jacopo da Varagine's *Legenda Aurea*. Joseph had called the midwife to assist at the delivery, but when she arrived on the scene the birth had already taken place. Seeing Mary's intact womb, she immediately realized that she had witnessed a miraculous event and ran to call her friend, Salome, who was doubtful and, anticipating Saint Thomas, exclaimed: "As the Lord my God lives, unless I put my finger inside and prove her nature, I will not believe that a virgin has brought forth." She did so, and her hand became paralyzed. Shocked, Salome asked forgiveness for her disbelief. An angel appeared and invited Salome to hold the Child. The Child was laid in her arms, and she was healed. The episode ends with Salome promising, "I will do him worship, for a great king is born unto Israel." (Infancy Gospel of James 19:3; 20:4)

Jacques Daret
Adoration of the Child
c. 1433–35
Museo Thyssen-Bornemisza,
Madrid

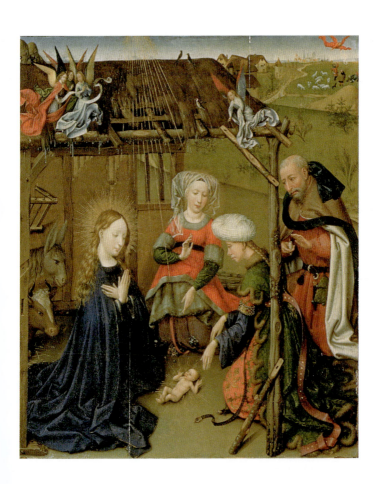

Mary's Adoration of the Child

A frequent scene in art, directly linked to the Nativity, is Mary kneeling with her hands in an orant pose, adoring the Child. The composition takes on a Eucharistic meaning with Jesus lying on the ground, almost in a sacrificial pose, a victim who will redeem humanity. This iconography has been inspired by the *Revelations* of the thirteenth-century mystic Bridget of Sweden who, in one of her visions, saw the Madonna kneeling before the Infant in an adoring, praying pose. (Bridget of Sweden, *Revelations*)

Antonio Allegri da Correggio
The Adoration of the Child
c. 1518–20
Galleria degli Uffizi, Florence

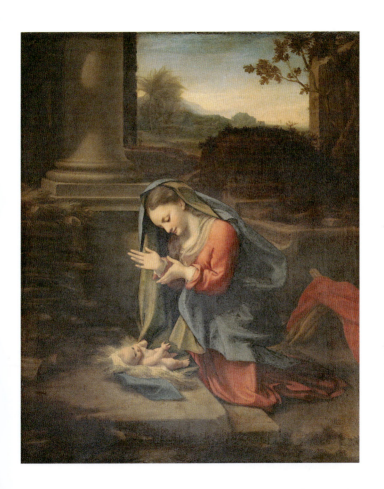

Mary Arranges the Newborn Jesus

All biblical sources have interpreted the fact that Mary began immediately to care for her son as proof of the painless birth. Saint Luke describes the tight sequence of Mary's actions: She gave birth to Jesus, wrapped him in swaddling clothes, and placed him in a manger. The presence of the ox and the ass that warm the Child with their breath is narrated in the apocryphal Gospels. In these unofficial sources, Mary, three days after her son's birth, left the cave, went into a stable, and placed the Child in the manger where the two animals were. (Luke 2:6–7; Pseudo-Matthew 20:4)

Nativity Scene
late 12th century
Notre-Dame, Chartres

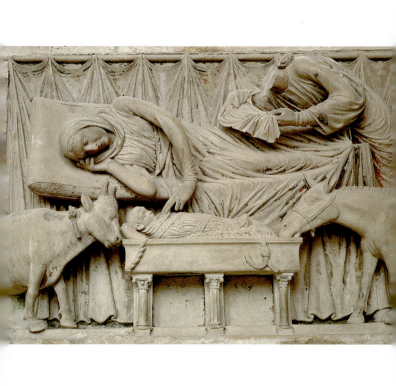

The Mother's Prescience

The Madonna with Child was a popular subject of works commissioned by private patrons, especially in the Quattrocento and Cinquecento. The object of these paintings is not so much to portray the loving relationship between mother and child, as it is to prefigure the Passion and death of Christ. Both figures are usually sad, and sometimes the Child is laid on a sarcophagus, already sleeping his metaphorical mortal sleep, his head resting on a pillow or his Mother's mourning-black mantle. By her expression and posture, we understand that the Madonna is aware of her son's destiny; although Jesus is still a babe in her arms, she knows that she will face immense grief in her role of co-redeemer of God's will.

Giovanni Bellini
*Madonna Enthroned
Adoring the Sleeping Child*
1475
Gallerie dell'Accademia, Venice

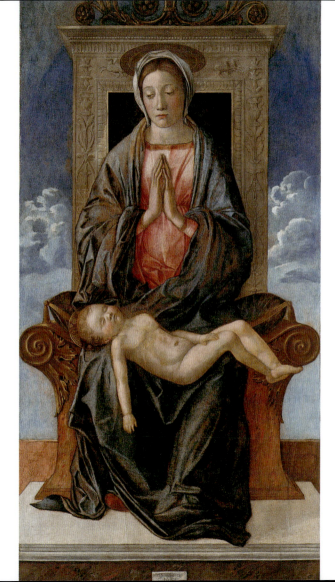

The Announcement to the Shepherds

"Do not be afraid; for behold, I proclaim to you good news of great joy that will be for all the people. For today in the city of David a Savior has been born for you who is Messiah and Lord." Thus the angel of the Lord spoke to the terrified shepherds who were keeping watch over their flocks in the fields near Bethlehem. (The greeting, translated into Latin, has become part of the ritual celebrating the installation of new popes.) A great number of the heavenly host then appeared with the angel, praising God with the well-known words "*Gloria in excelsis Deo*" ("Glory to God in the highest"). Although Luke does not mention an actual choir, the pictorial tradition has usually rendered the heavenly host as a band of musicians. This episode is often represented next to the Nativity, where Mary is depicted as she proudly tends to her newborn. (Luke 2:8–14; 8:6)

Master of the Strozzi Chapel
Nativity
early 14th century
Santa Maria Novella, Florence

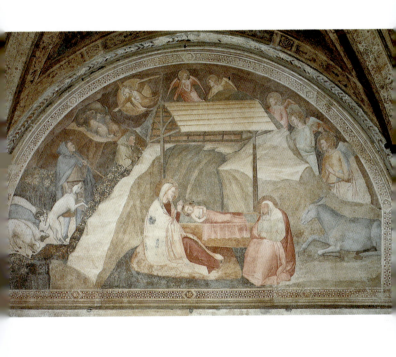

The Adoration of the Shepherds

"Let us then to Bethlehem to see this thing that has taken place, which the Lord has made known to us." After consulting with one another, the shepherds hurried off to the town that had been mentioned to them and easily found Mary and Joseph with the Child wrapped in swaddling clothes, lying in a manger. The Mother of God proudly showed them her first-born son. According to a medieval tradition, the straw on which Jesus was laid in the manger was brought to Rome as a relic by Saint Helen, the mother of Emperor Constantine. The shepherds left the cave and returned to their flocks "glorifying and praising God for all they had heard and seen, just as it had been told to them," in effect becoming the first true "evangelists"—meaning "those who bring good tidings," from the Greek *éu*, meaning "good or well," and *aggelia*, meaning "news"—of the redemption brought by Christ. (Luke 2:15–19)

Doménikos Theotokópoulos, known as El Greco
Adoration of the Shepherds
1603–5
Museo del Patriarca, Valencia

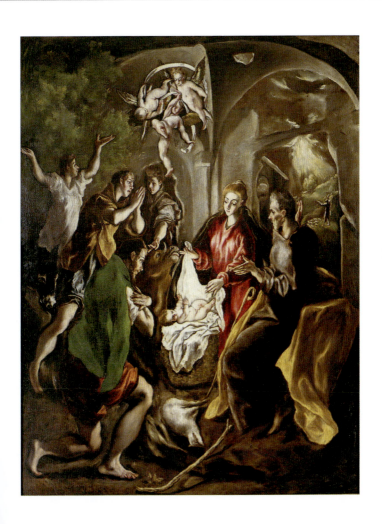

The Adoration of the Shepherds

Images and metaphors of shepherding and sheep appear frequently in the Gospels and are part of the symbolism that Christianity has "borrowed" from paganism. The Greeks believed that tending flock was an activity close to nature, the sky, and the gods, and they customarily sacrificed animals to the divinities. For this reason, the lamb became the sign of Jesus, who offered himself as a sacrificial victim for the salvation of humankind. This allusion was apparently perceived by Mary as well, for Luke writes that Mary, intuiting the terrible fate to which her son would be subjected, "kept all these things, reflecting on them in her heart." The episode of the Adoration of the shepherds is a very popular subject in art, sometimes represented as a crowded scene, sometimes as a more intimate, quiet portrait in which Mary is always the dominant figure, busy tending to her infant son.
(Matthew 18:12–14; Luke 2:15–19; 15:3–7)

Matthias Stormer
Adoration of the Shepherds
1630
Museo Nazionale di Capodimonte,
Naples

276

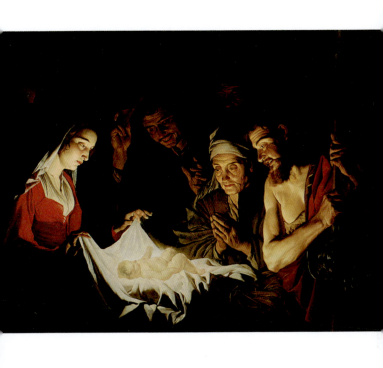

The Journey of the Magi

The Gospel according to Saint Matthew is the only biblical source that describes this episode. He narrates that upon reaching Jerusalem, the Magi paid homage to Herod, king of Judea, and asked, "Where is the newborn king of the Jews?" For they had seen "his star at its rising" and had come to worship him. But when King Herod heard this, unaware of the Old Testament prophecy, he was disturbed, and asked the scribes where the Messiah was to be born. Having heard that it was Bethlehem, he called the Magi and sent them there, asking them to go and find the Child, that he too might go and worship him. Guided by the star, the Magi arrived in Bethlehem, where they found Mary and Jesus surrounded by angels.

(Micah 5:1–4; Matthew 2:1–12)

Andrea Mantegna
Adoration of the Magi
(detail)
c. 1466
Galleria degli Uffizi, Florence

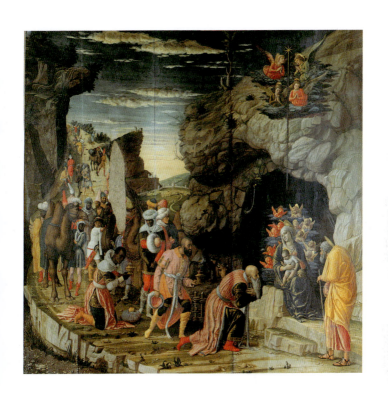

The Adoration of the Magi

According to the Gospel of Saint Matthew, the Magi were
the first religious authorities to worship Christ. Of the three
gifts they brought, the third one, myrrh, is the most important.
This plant was used to make medicinal and sacred ointments;
the word "Christ" means "the Anointed One," consecrated
with a symbolic unguent, a chrism, to be king, healer, a
Messiah sent by God. Myrrh was also used to prepare bodies
for burial, and thus is also a symbol of the expiation of sin
through death. The offer of myrrh evokes the theme of the
Madonna's foreknowledge and for this reason, although the
Adoration of the Magi is a joyous event, the Madonna is often
portrayed as sad and pensive. The second gift, incense, was
used in the temple and refers to Jesus' priesthood and the
prayers that rise up to God. Finally, gold symbolizes royalty
and is also an aid to Mary and Joseph's poverty.
(Matthew 2:1–12)

Leonardo da Vinci
Adoration of the Magi
1481–82
Galleria degli Uffizi, Florence

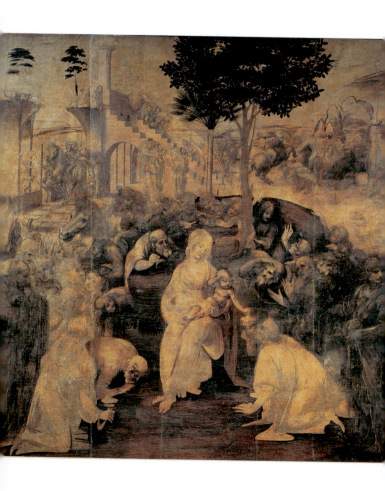

The Adoration of the Magi

The passage in Matthew does not mention the number of Magi, but the prevailing tradition, based on the fact that three gifts were offered, speaks of three men. In the Armenian Infancy Gospel the number "three" does appear together with the names of the Magi: Melquon, later called Melchior, king of Persia; Caspar, king of Arabia, and Balthazar, king of India. Still according to the tradition, the Magi came from faraway countries located in the three then-known continents of Europe, Asia, and Africa, to signify that Jesus' redeeming mission was intended for all nations. For this reason, the three kings are often portrayed as a European, an Arab, and a African. Similarly, the Madonna is often portrayed as blond-haired and blue-eyed, following the aesthetic canons of Western culture, but more likely she was dark-haired and dark-eyed, with the typical traits of a Middle Eastern woman.
(Matthew 2:1–12; Armenian Infancy Gospel 5)

Albrecht Dürer
Adoration of the Magi
1504
Galleria degli Uffizi, Florence

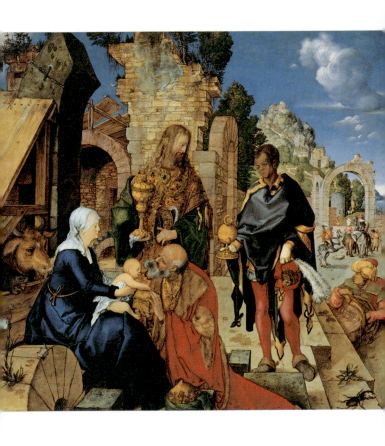

The Adoration of the Magi

"Moreover, a great star, larger than any that had been seen since the beginning of the world, shone over the cave from the evening till the morning. And the prophets who were in Jerusalem said that this star pointed out the birth of the Messiah." The star showing the way is a typical motif of late Mesopotamian religions. The comet traditionally used instead is an invention of Giotto, who had been enthralled by the 1301 appearance of Halley's comet and immortalized the event in his *Adoration of the Magi*, part of the frescoed cycle in Padua's Scrovegni Chapel. Since then, artists have drawn from his inspiration. Here the Madonna holds Jesus on her lap and proudly shows him to the worshiping Magi.

(Pseudo-Matthew 13:7)

Stefano da Zevio
Adoration of the Magi
1435
Pinacoteca di Brera, Milan

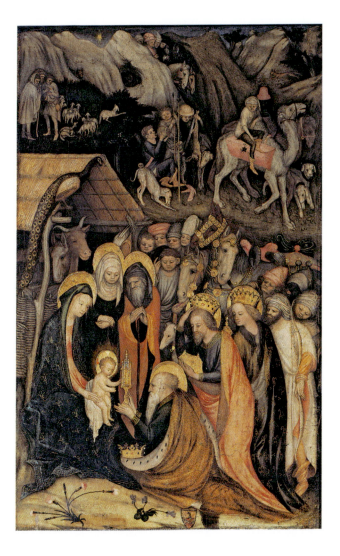

The Circumcision

"When eight days were completed for his circumcision, he was named Jesus, the name given him by the angel before he was conceived in the womb." Circumcision is a Jewish practice that consists in cutting part or all of the foreskin. The *Bris Milah*, or "circumcision covenant" between God and Abraham, is meant to be a sign of the eternal bond between God and the people of Israel. Jesus was circumcised not because of duty, but in order to be like his brethren. In the Middle Ages, this episode began to take on a symbolic meaning, as the first shedding of the blood of the Christ. Mary is depicted here as an anxious mother who carefully watches the hands of the priest about to perform the act.
(Genesis 17:7; Luke 2:21)

Michael Pacher
The Circumcision
1475–81
Parish Church, Saint Wolfgang

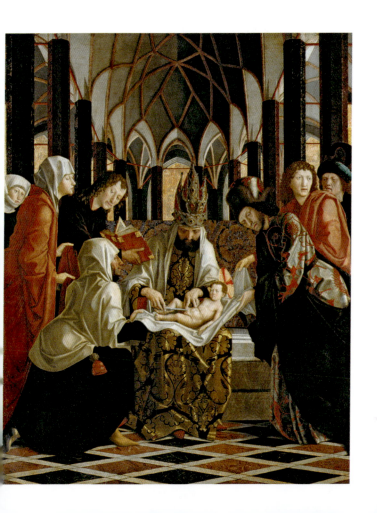

The Purification of Mary

"When a woman has conceived and gives birth to a boy, she shall be unclean for seven days, with the same uncleanness as at her menstrual period. On the eighth day, the flesh of the boy's foreskin shall be circumcised, and then she shall spend thirty-three days more in becoming purified of her blood; she shall not touch anything sacred nor enter the sanctuary till the days of her purification are fulfilled." The purification law, formulated by Moses, required that after giving birth all women undergo purification in the temple and make a sacrificial offering. Mary was not bound to follow this law, for she had become Mother through the Holy Spirit, keeping her virginity. Nevertheless, she chose to submit and thus became a model of humility and obedience to God. In Leviticus it is written that poor families could sacrifice "a pair of turtledoves" instead of the customary lamb, and this is what Mary did. She offered the true Lamb that would redeem humanity, foreshadowing with her act what is prefigured in the ritual offerings of the ancient law.
(Leviticus 7:2–4; Luke 2:22–24)

Stephan Lochner
Presentation of Christ in the Temple
1447
Hessisches Landesmuseum,
Darmstadt

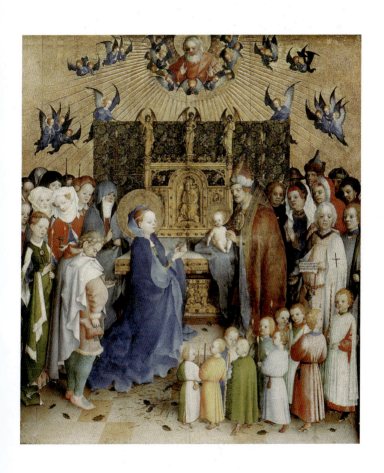

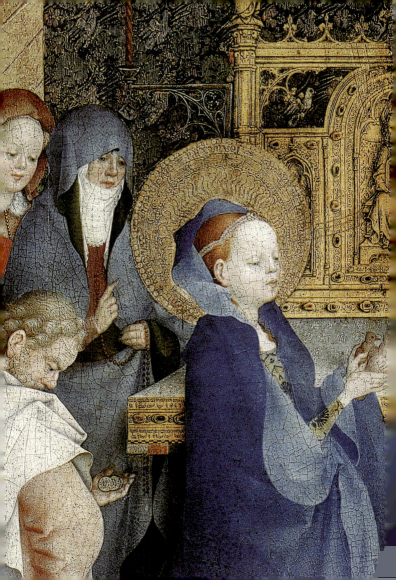

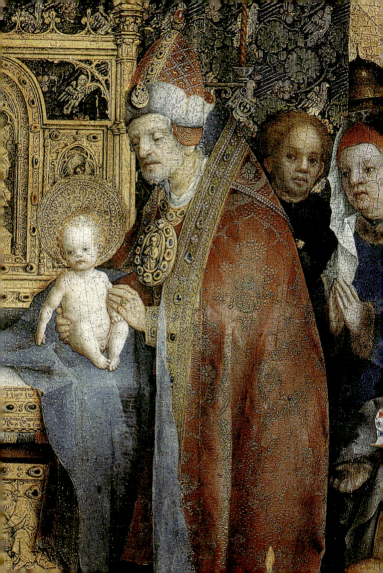

The Presentation to the Temple

On the day of her purification, the Most Holy Virgin pre-
sented Jesus Christ to the temple, following the ancient law
that required parents to present to God their firstborn son,
who would be returned to them after a money offering had
been made. The law had been written to remind the people
of Israel that they had been freed from the Pharaoh's slavery
thanks to the intervention of God, who had slain all the
Egyptian firstborn males, saving the Jewish ones. In fulfilling
the presentation ritual, Mary was not offering her son in
homage to God, but for the salvation of the people of Israel
and the entire human race.
(Luke 2:22–35)

Duccio di Buoninsegna
Presentation to the Temple
(detail)
1308–11
Museo dell'Opera del Duomo, Siena

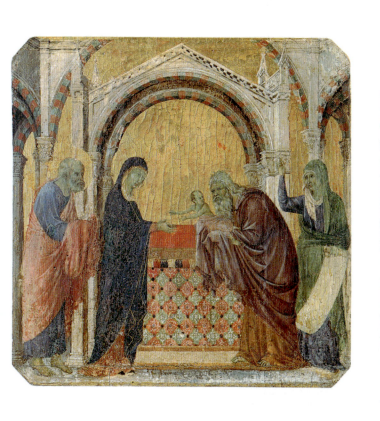

The Song of Simeon

When Jesus was presented to the temple, a righteous man by the name of Simeon, who was waiting for the consolation of Israel, immediately recognized him as the true Messiah. Taking the Child in his arms, he thanked the Lord and praised Him with the laud *Nunc Dimittis*—"Now dismiss"—in which he professed to be ready to die, for his eyes had seen the Savior. Simeon then turned to the Virgin, bitterly predicting the pain that her son would suffer and her own grief. The prophetess Anna, who was also at the temple, gave thanks to the Lord and praised him for having sent the world its Savior. (Luke 2:22–38)

Rembrandt van Rijn
Simeon and Anne Recognize the Lord in Jesus
c. 1627
Kunsthalle, Hamburg

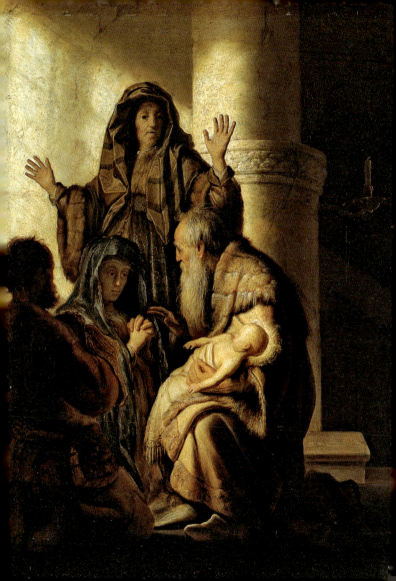

Joseph's Dream

"The angel of the Lord appeared to Joseph in a dream and said, 'Rise, take the child and his mother, flee to Egypt and stay there until I tell you. Herod is going to search for the child to destroy him.'" In Matthew's text, Joseph is a true servant of God, humble, obedient, responsible, and always available to obey God's unfathomable plan. The carpenter of Nazareth is truly a righteous man because of his great faith. Guided by the hand of God, Joseph becomes the guardian of the Redeemer and of Mary. He protects them and continues to work until his late years to support both his wife and the Son. (Matthew 2:13–15)

Philippe de Champaigne
The Dream of Joseph
1642–43
National Gallery, London

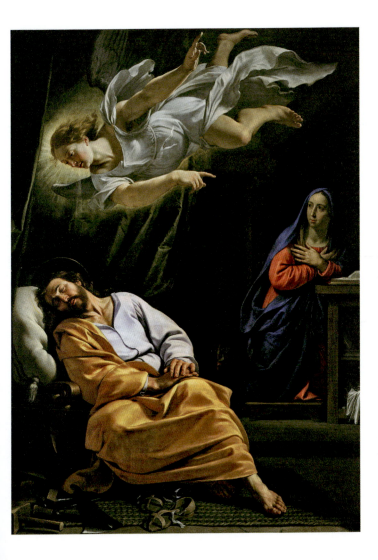

The Slaughter of the Innocents

Warned in a dream not to return to Herod, the Magi went
back to their homelands via a different route. Upon learning
that he had been deceived, the king flew into a rage and
decreed that all the children of Bethlehem under two years of
age be slain. In the New Testament, this episode appears only
in the Gospel of Saint Matthew, but the Infancy Gospel of
James has a more extensive version, which reads: "And when
Mary heard that the children were being slain, she was afraid,
and took the young child and wrapped him in swaddling
clothes and laid him in an ox-manger." In the meantime,
Elizabeth was seeking a hiding place for the young John until,
by God's will, a mountain opened and let them in. Herod fea-
red that John was the Messiah, and had his father Zachariah
killed for refusing to reveal where Elizabeth and the child
were hiding.
(Matthew 2:13–18; Infancy Gospel of James 22:1–3, 23:1–4)

Guido Reni
Slaughter of the Innocents
1611
Pinacoteca Nazionale, Bologna

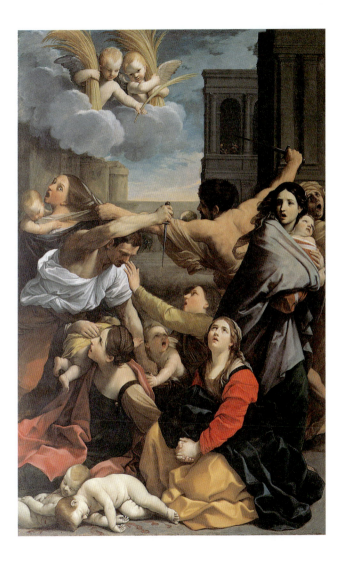

The Flight into Egypt

And so "Joseph rose and took the child and his mother by night and departed for Egypt. He stayed there until the death of Herod, that what the Lord had said through the prophet might be fulfilled, 'Out of Egypt I called my Son.'" Luke does not mention the flight into Egypt; as a matter of fact, he writes that on the eighth day after the birth, the parents took the Child to Jerusalem to have him circumcised, then returned undisturbed to Nazareth. With the journey of the Holy Family to Egypt, Matthew shows us a Christ who shares the destiny of his people already from a young age. Mary knows that Egypt will be a haven for her son, as it was for the patriarchs—Abraham, who escaped famine there, and Joseph, whose brothers had sold him to Egyptian merchants. (Genesis 12:1; 37:2–36; 46:1–7; Exodus 1:1–6; Matthew 2:13–15)

Adam Elsheimer
Flight into Egypt
1609
Alte Pinakothek, Munich

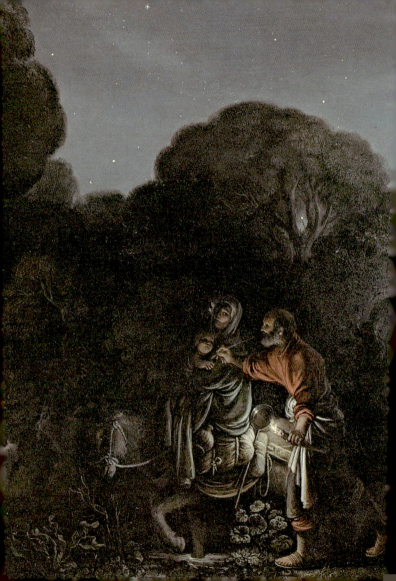

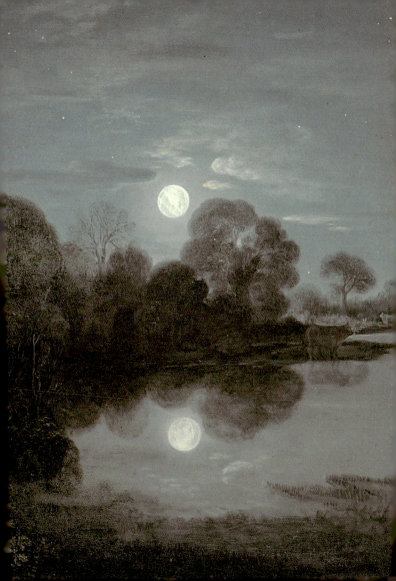

The Flight into Egypt by Sea

"They lived in Egypt, in a land called Matarea, as Brocardus (thirteenth century) and Cornelius Jansen (1585–1638) wrote, although Saint Anselm (1033/34–1109) claimed that they lived in Heliopolis, formerly known as Memphis, now Cairo." As Saint Alphonse Maria de Liguori makes clear in his *Glorie di Maria* (Glories of Mary), we ignore both the final destination of the Holy Family and the route they followed. Many cities claim the honor of having welcomed Mary, Joseph, and Jesus: The apocryphal sources mention Matarea; some have theorized Heliopolis, because a Jewish community lived there, some seven miles northeast of Cairo. According to the apocryphal sources, the journey to Egypt was made partially on foot with the help of a mare and partially by crossing the Red Sea—just as the Israelites had done under Moses—on a fisherman's boat and with the help of an angel.
(Arabic Infancy Gospel 24; Alfonso Maria de Liguori, *Glorie di Maria*)

Lodovico Carracci
Flight into Egypt
1600
Private collection

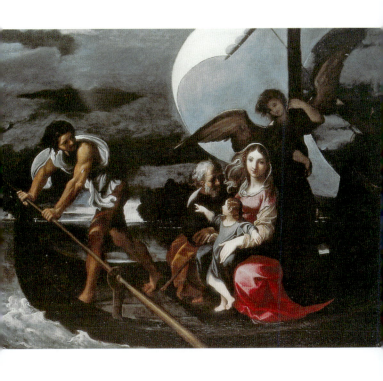

Rest During the Flight into Egypt

Although no specific reference exists in the biblical or apocryphal sources, the rest during the flight into Egypt is a well-known episode often depicted in Christian art. This moment of reflection arises from a desire to explore the human aspect of the Holy Family, especially the relationship between Mother and Child. Clearly, in such a difficult and troubled journey, one naturally thinks about the worries of a mother for her child: a warm embrace, a playful gesture, and also the need to feed the baby are all elements that highlight the sweet, human intimacy between Mary and Jesus, who is not only her son but also that of the Heavenly Father.

Anton van Dyck
Rest on the Flight to Egypt
1627–32
Alte Pinakothek, Munich

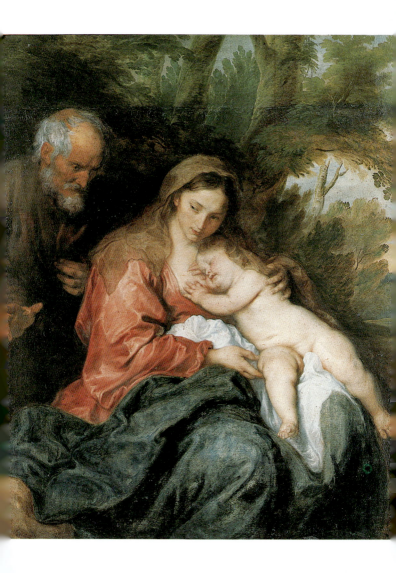

The Miraculous Palm Tree

The apocryphal literature describes the journey into Egypt in fantastic detail. On the third day of the trip, Mary was fatigued by the excessive heat of the desert sun and sought rest under a palm tree. Seeing that it was full of fruit, she longed to eat some of it. Jesus, always attentive to his Mother's wishes, asked the tree to bend its branches so that they could pick some date nuts. Satisfied by the obedient tree, the Child asked an angel to carry a branch to Heaven. Having thus blessed the tree, he decided that winners of competitions should henceforth be greeted thus: "You have attained the palm of victory." From that time on, the palm would be used as a symbol of the martyrdom and glory of the saints.
(Pseudo-Matthew 20:1–2, 21)

Bonanno Pisano
Flight into Egypt
1180
Duomo, Pisa

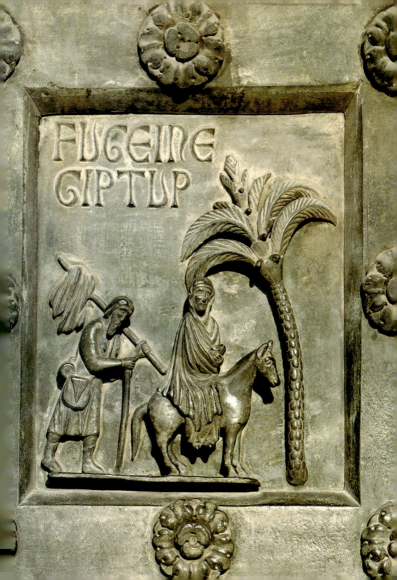

The Holy Family Near the Fountain

One of the first divine acts of Jesus, performed in his mother's presence, is the episode of the miraculous fountain, immediately after the palm tree incident. Because Joseph was worried about "the want of water, because the skins are now empty," and they had none to refresh themselves and the cattle, Jesus ordered the palm tree to open from its roots "a vein of water which has been hid in the earth, and let the waters flow, so that they may be satisfied . . . And a spring came forth exceedingly clear and cool and sparkling." In this painting, the spring is rendered as an architectural fountain which Mary leans upon with Jesus.

Albrecht Altdorfer
Rest on the Flight into Egypt
1510
Gemäldegalerie, Berlin

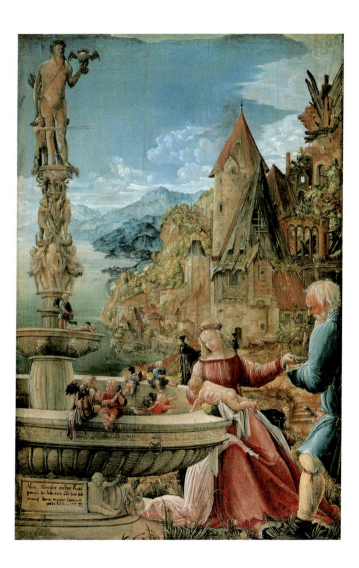

Returning Home from Egypt

While all the other canonical and apocryphal texts assume that the Lord sent an angel to Joseph to reassure him that it was now safe to go home to Palestine with his family, the Gospel of Pseudo-Thomas tells of the divine message given to Mary. "And now an angel of the Lord came to Mary, and said: 'Take the Child and return to the land of Judea because those who were plotting against his life have died.'" And while there are several miraculous and fanciful episodes about the flight into Egypt, not even the apocryphal texts mention the return journey. Once back in the Holy Land, Joseph decided to settle in Nazareth in Galilee, because Archelaus, the son of Herod, was now king of Judea. For this reason, Jesus would be called the Nazarene.

(Matthew 2:19–23; Pseudo-Thomas 25)

Giovanni Carnovali,
known as Piccio
Flight into Egypt
1849
Pinacoteca Civica, Pavia

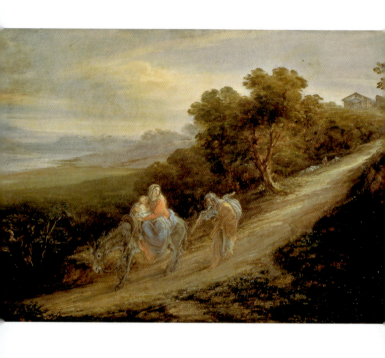

Saint Anne Metterza (with Mother and Child)

While the four official Gospels do not mention Mary's mother, the Christian tradition draws from the apocryphal texts that tell about the life of Mary's parents, and include Saint Anne in episodes about the life of Jesus. The picture of Anne as a grandmother who tends to her little grandson, lightening the mother's chores, is a reassuring one. The medieval tradition created an iconographic composition with Saint Anne as the third figure, behind or between Mary and Jesus. It is natural, therefore, to believe that there was a close bond between mother and daughter, a female complicity in a sort of triune union that comes close to the representation of the three figures of the Trinity.

Tommaso Cassai, known as Masaccio,
and Tommaso di Cristoforo Fini,
known as Masolino da Panicale
Madonna and Child with Saint Anne
1424–25
Galleria degli Uffizi, Florence

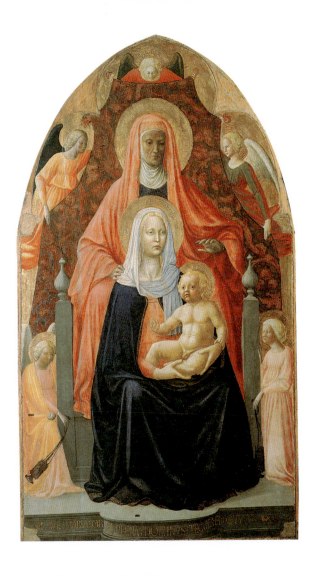

The Holy Kinship

The fact that some of the canonical Gospels refer to Jesus'
brothers led to the belief that Mary may have had other chil-
dren after him and thus could no longer be called a Virgin.
The issue was resolved by referring to certain relatives of
Saint Anne as "brothers." After her husband Joachim died, it is
believed that Saint Anne remarried, as was the custom, taking
as her husband Cleopas, Joachim's brother, and after Cleopas
died, another brother of Joachim's, Salomas. She had two other
girls, also called Mary; they are mentioned in the Gospels as
Mary of Cleopas and Mary of Salomas. The sons of these
women, who must have been raised close to Jesus in what
has been called the Holy Kinship, although technically Jesus'
half-cousins, could have been called "brothers" and so identi-
fied in the Gospels.
(Matthew 7:46–50; Mark 3:31–34; Luke 8:19–21)

Lucas Cranach the Elder
Altarpiece of the Holy Family
1509
Städelsches Kunstinstitut, Frankfurt

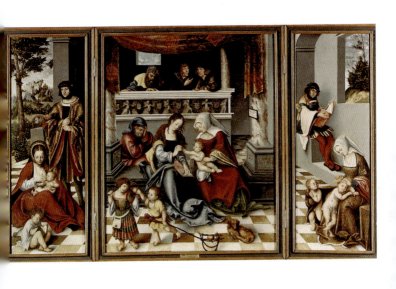

The Madonna with Child and Saint John

Although in the canonical Gospels the only meeting between Jesus and Saint John before the Baptism is when their pregnant mothers meet, it is believed that they spent part of their childhood together after Elizabeth's death. The apocryphal Life of John according to Serapion reports a meeting between the two children. Seeing John grieve over his mother's death, Jesus comforted him: "I have come with my beloved mother to prepare the burial of the blessed Elizabeth, your happy mother." Seeing that Mary is crying because John is now alone, Jesus tells her not to fear, because it is God's will. Traditionally, the two cousins have been depicted playing together under the Madonna's watchful gaze. This particular episode, while highlighting the humanity of a normal childhood and the games the children played, is often filled with metaphorical attributes. For example, Saint John leading the lamb is an allusion to his preaching, which announces the coming of the Messiah, who is the Lamb of God.

Leonardo da Vinci
Virgin of the Rocks
1483–86
Musée du Louvre, Paris

The Holy Family

Jesus, Joseph, and Mary often appear together in the popular Christian iconography as part of one family, without dwelling on the delicate issue of Joseph's paternity, and so the Holy Family has become the model of the ideal family. Mary is portrayed as a young, attentive, and solicitous mother, who is sometimes sad because she is conscious of her son's fate. Jesus is a tender, playful, affectionate child; Joseph, usually portrayed somewhat apart, is the older father who looks after his family. It is an earthly, human family that lives a parallel life with the divine family of the Trinity. Inside the earthly family, Mary's true maternal nature is revealed: She is the Mother of the Son of God, conceived in her womb and raised with her love, thus contributing to the human development of the divine person.

Michelangelo Buonarroti
Holy Family
1504–6
Galleria degli Uffizi, Florence

The Nursing Madonna

"And the Word was made flesh." In Jesus Christ, divine nature was joined to human nature, making his descent to Earth possible. The birth was natural, and like all children, the Savior-made-man suckled at his mother's breast. Like any other mother, the Madonna lovingly holds her son in her arms; the Child hungrily grasps the breast. The iconography of the *Nursing Madonna* recurs frequently in the history of art. The Madonna gazes intently at her Child in a deep, silent dialogue; because of this, over time, this iconography has also become known as the Virgin of the Dialogue.

Nino Pisano
Madonna del Latte
1343–47
Museo Nazionale di San Matteo, Pisa

The Madonna and Pap

Like any other mother, Mary teaches her child how to eat, but Jesus seems more attracted by a new toy—the spoon he holds in his right hand—than the food the Madonna is offering him. Here again, the simple act of feeding takes on a sacrificial connotation. The Virgin looks pensively at the bowl, while in the foreground the knife alludes to Jesus' future death, which will redeem humankind from the Original Sin (symbolized by the apple) through the sacrifice of his body, here symbolized by the bread, which in turn evokes the Eucharist. Realistic, human elements are interwoven with the exceptional qualities of the divine Child, whose innocent unawareness contrasts with Mary's painful knowledge.

Gerard David
*Madonna and Child
with the Milk Soup*
c. 1520
Musées Royaux des Beaux-Arts,
Brussels

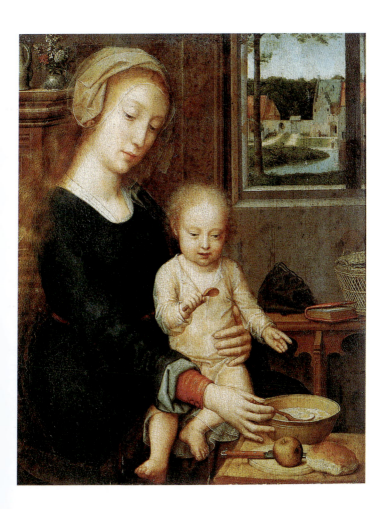

The Madonna and the Snake

Even while still learning how to walk, Jesus reveals his and his
mother's redeeming roles. Here, Mary the Immaculate is help-
ing the Child crush the snake, the symbol of sin. In this image
of Jesus' small foot atop the Virgin's foot crushing the head
of a coiled snake, there is no feeling of divine triumph over
the enemy; rather, we sense the tender strength of a love that
conquers evil. In fact, Jesus is aided by his Mother—the new
Eve, and the emblem of the Church—but it is his weight,
not the Mother's, that defeats evil. The iconography of the
Immaculate Conception evolved from this concept, perhaps
inspired by the words of Pius V in the Rosary Bull that affirmed
the double, simultaneous crushing of the snake: "The Virgin
has crushed the serpent's head with help from the Child."

Michelangelo Merisi da
Caravaggio
*Madonna del Palafrenieri
(Madonna of the Footmen)*
1605
Galleria Borghese, Rome

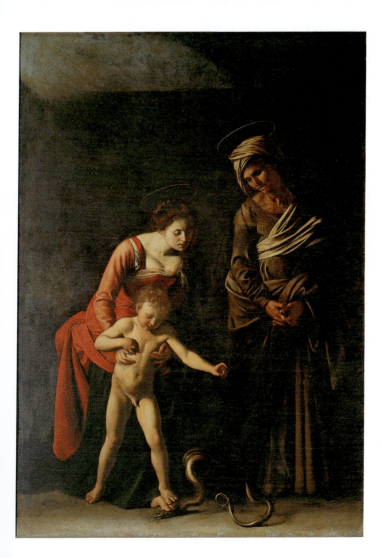

The Madonna Teaches Jesus to Read

Mary teaches Jesus how to read from infancy, just as her mother, Anne, had taught her. Mary's mission, however, is more complex because what she must teach, the book of Scripture, is Jesus himself. With her example and actions, Mary can teach us how to read the mystery of God, thus fulfilling her fundamental role of intermediary between the Book and the reader. In some renderings of this theme, the book is closed and positioned near the divine couple, signifying the apocalyptic end of the world. In other images, such as this one, it is open, allowing Jesus not so much to read it as to write it. (John 1:14)

Raffaello Sanzio, known as Raphael
Conestabile Madonna
1504
Hermitage Museum, Saint Petersburg

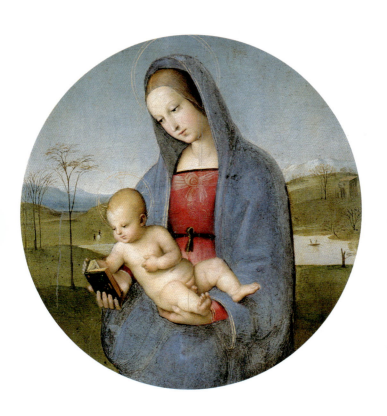

The Holy Family at Work

The Gospel of Saint Luke describes Jesus' life in Nazareth with Mary and Joseph: "He . . . was obedient to them: and his mother kept all these things in her heart. And Jesus advanced [in] wisdom and favor before God and man." Joseph is the quiet and collected head of household. He realizes that he is much inferior to his wife and the Son, yet his humility not only teaches him to accept the situation, but also makes him proud. Mary, as was customary for women, is obedient to Joseph and performs her housewifely duties, preparing meals, keeping the house clean, and doing chores. In turn, in her natural role of mother, she tells Jesus what to do depending on the needs and circumstances of family life, including asking him to do chores around the house.
(Luke 2:51–52)

Modesto Faustini
Saint Joseph at Work
1887–90
Spanish Chapel, Shrine of the
Holy House, Loreto

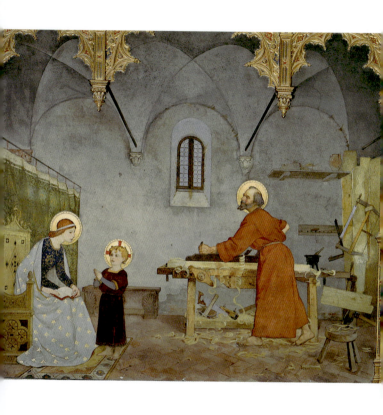

Jesus' Childhood

The apocryphal texts contain a collection of miracles that Jesus performed between the ages of five and twelve; the implied intention of the texts is to flesh out his childhood, which the canonical Gospels neglect. The texts portray a somewhat naughty child who sometimes uses his thauma-turgic powers for his own use. Mary, like any other mother, worries about her son, even mediating to fix his pranks. (Pseudo-Matthew 26:1–3)

Bartolomé Esteban Murillo
Holy Family with a Bird
1650
Museo del Prado, Madrid

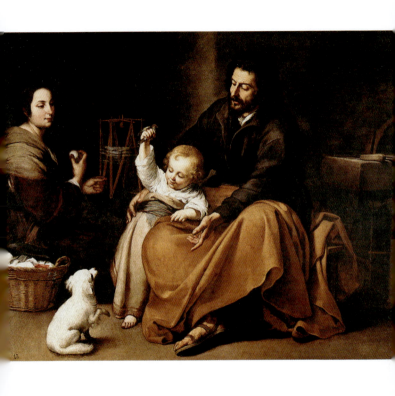

Benedicite
(Blessing of the Bread)

One episode of Jesus' childhood that is often depicted in art, but not found in any text, is the recitation of the Blessing of the Bread, in which the teenaged Christ, sitting at the table with Mary and Joseph, presciently performs the gestures of the Last Supper. Like a good mother, Mary teaches Jesus to be grateful for the meal she has prepared, and to share the bread with those who must do without. In reality, the "bread" is the body of Christ that is placed on the Church altar and has been given to Mary as a gift. This relationship between Mary and the Eucharist is expressed in her contemplation of the Son as he breaks the bread, an act that will become sacrament.

Charles Le Brun
The Holy Family, or The Grace
1655
Musée du Louvre, Paris

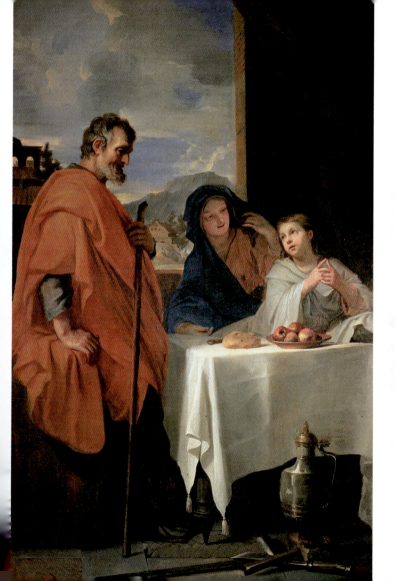

Jesus Among the Doctors

The only event in Christ's childhood mentioned in the cano-
nical Gospels took place when he was 12. He had gone with
his parents to Jerusalem to celebrate Passover. At the end of
the Feast, Mary and Joseph took the road back to Nazareth,
thinking that Jesus was with relatives in the group. But when
they could not find him, they retraced their steps back to
Jerusalem in search of him. It took three days for them to
find him: He was in the temple, listening to the law doctors
and conversing with them, astonishing everyone with his
understanding and his answers. For Mary the search must have
seemed an eternity, worried as she was and despairing about
her son, whose fate she knew was terrible, but which she
hoped was still a long way off. In the figurative arts, this episo-
de has been rendered in a variety of ways. Sometimes it has
been subdivided into different moments: Jesus converses with
the doctors in the temple; his parents find him; and
Mary reprimands him.
(Luke 2:41–51)

Bernardino di Betto, known as
Pinturicchio
*Christ Among the Doctors
of the Church*
1501
Santa Maria Maggiore, Spello

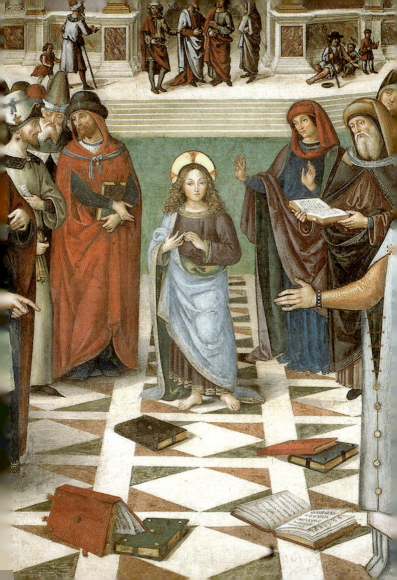

Mary and Joseph Reprimand Jesus

As soon as they saw him in the temple Mary, who was a strong woman, spoke instead of Joseph, scolding him thus: "Son, why have you done this to us? Your father and I have been looking for you with great anxiety." Jesus replied unexpectedly, "Why were you looking for me? Did you not know that I must be in my Father's house?" Like any worried mother, Mary reproves Jesus for wandering away from her and Joseph. From his words, however, she understands that he was not lost, although the texts do express the insouciance of a 12-year-old boy who worries his parents. Christ reveals his spiritual maturity in the temple. He also shows great respect and filial piety and returns with his family to Nazareth, where he would remain with them for almost 20 years.
(Luke 2:41–51)

Simone Martini
Christ Returning to His Parents
1342
Walker Art Gallery, Liverpool

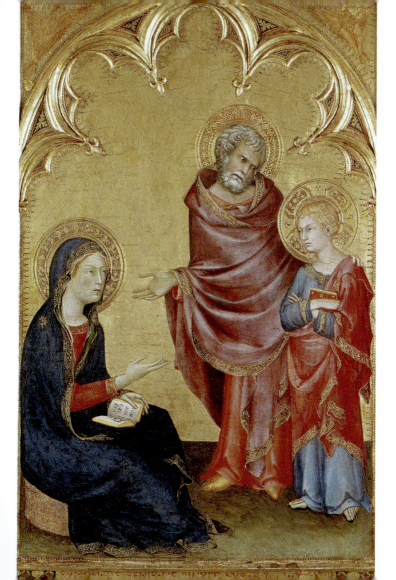

Christ as an Adolescent

The years from Jesus' visit to the Jerusalem temple at the age of 12, to the beginning of his public life at the age of 30, have often been called his "dark years." In the canonical Gospels the period is wrapped up in a short line: "And advanced [in] wisdom and age and favor before God and man." But the popular tradition has tried to imagine the Messiah's teenage years, such an important period in a man's life, and filling it with lessons, friendships, discoveries, and desires such as the urge to be free and autonomous from one's parents. Mary, the vigilant Mother, always finds a way to be close to her son, supporting him and walking with him down the path of maturity, although she knows that sooner or later she will have to let him walk down his own path.

(Luke 2:52)

Francisco de Zurbarán
Christ and the Virgin in the House at Nazareth
c. 1635–40
Cleveland Museum of Art, Cleveland

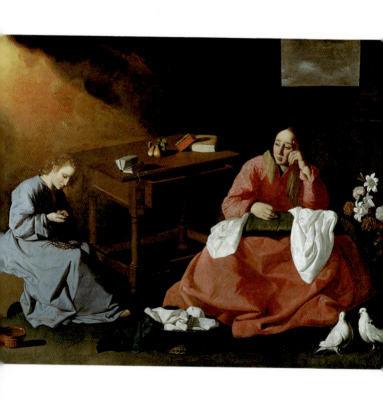

The Passing of Saint Joseph

Even if Joseph is only a modest character in the New Testament, Christians have always deeply venerated him. This devotion probably gave rise to the apocryphal story of Joseph the Carpenter, which recounts the death of the saint. In fact, by the time Jesus began his public life, Joseph was probably dead, for he is not mentioned at the Cana wedding. Biblical sources ignore the place or date of his death, or where he was buried. What we do learn from the apocryphal text is the tender, close relationship that binds Mary, Jesus, and Joseph, now old and dying. When Mary understands that her husband is about to die, Jesus reveals to her that he too "like the other mortals" will pass from this life, but his soul will rise to Heaven leaving his inert body on Earth. And although everything transpires according to the divine plan, when Joseph dies, Jesus and Mary humanly mourn him.

Luca Giordano
The Death of Saint Joseph
c. 1690
Pinacoteca Comunale, Ascoli Piceno

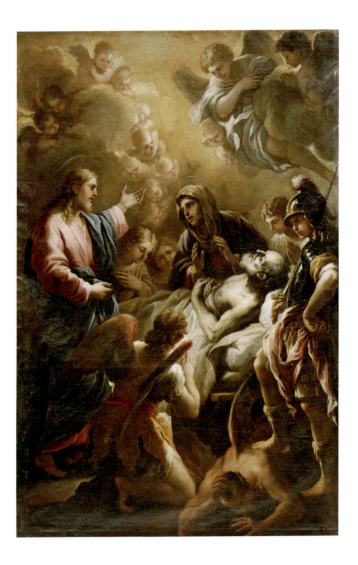

The Wedding at Cana

Saint John introduces the episode of the wedding at Cana as Mary's first intervention in Jesus' public life. The event dramatically highlights the Mother's cooperation with the Son's redeeming mission. At the beginning of the passage, Mary's presence seems simply due to the fact that Jesus had been invited as a guest to the wedding, but the meaning and role of her presence soon become abundantly clear. When there was no more wine, it was the Virgin, used to her role as "queen of the hearth," who realized it immediately. As in other episodes, Mary played her role of mediator but also showed her strength as a woman and a mother by asking her son to intervene to save the bride and groom from embarrassment and keep the feast merry.
(John 2:1–12)

Volvino
The Wedding at Cana
(detail)
837
Sant'Ambrogio, Milan

The Wedding at Cana

Mary's intervention at the wedding showed the immense depth of her faith. Until then—at least according to the canonical Gospels—Jesus had performed no miracle, but like any good, proud Mother, the Madonna believed in her son's abilities even before seeing any sign of it. In fact, John the Evangelist stresses the fact that only when he "revealed his glory" did "his disciples begin to believe in him." But Mary, just as she did at the time of the Annunciation, showed her full faith in divine intervention, so that when Jesus replied to her, "Woman, how does your concern affect me? My hour has not yet come," he was trying her faith, but also wanted her to understand that he no longer depended on her. Artists have often depicted this banquet with precise renderings of the laid-out table and details from daily life, some of them profane—or at least extraneous to the sacred nature of the event.
(John 2:1–12)

Duccio di Buoninsegna
Wedding at Cana
1308–11
Museo dell'Opera del Duomo, Siena

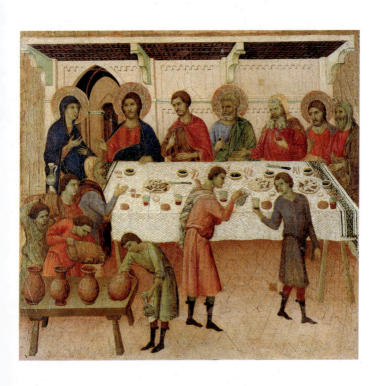

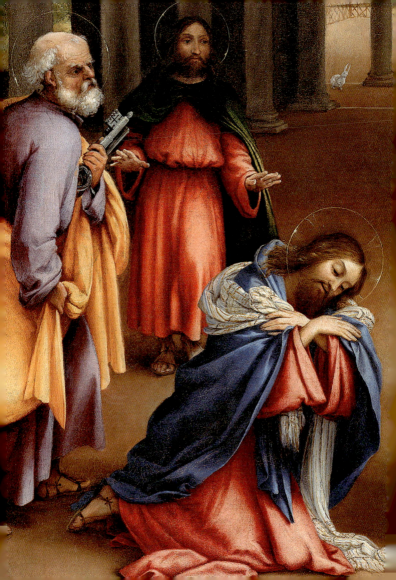

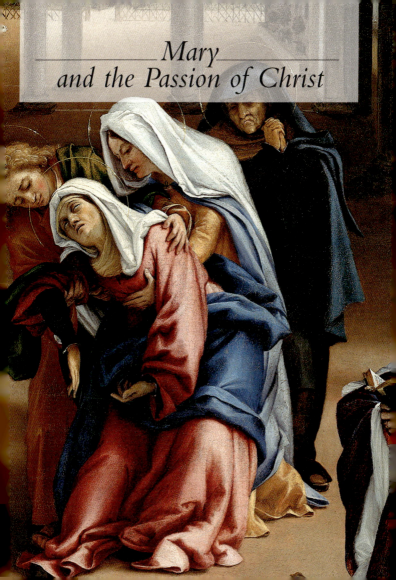

Mary
and the Passion of Christ

Christ Takes Leave of Mary

After Christ's childhood years, the Gospels rarely mention the Madonna, but wanting more, popular devotion has woven episodes to fill the missing parts. In one of these episodes, Christ, having turned 30, leaves home to take care of "his Father's business." Mary wanted to keep him at home as long as possible, but it could not be. She knew that she could not and must not obstruct God's call, even though she knew what the future had in store for her son. For this reason, artists usually represent her as overcome with grief: Mary faints before Jesus, who bows to her out of respect. This event, imagined by popular devotion, is a prefiguration of the real event narrated in the New Testament, when Mary faints before her crucified son.

Lorenzo Lotto
Christ Taking Leave of His Mother
1521
Staatliche Museen, Berlin

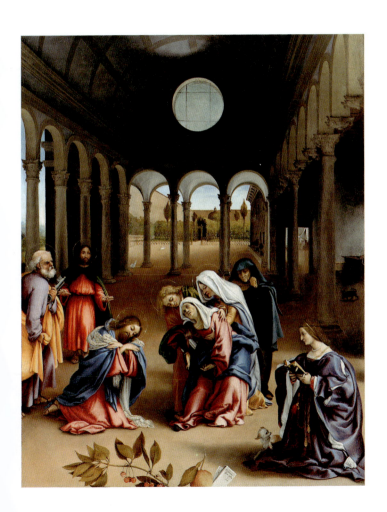

The Ascent to Calvary

Mary's presence as Jesus makes the Way of the Cross is
not mentioned in any sources, neither the biblical nor the
apocryphal ones. She appears at the feet of the Cross only in
the Gospel of Saint John, the beloved disciple to whose care
Jesus entrusted her as he lay dying on the Cross. Still, it is
natural to think that the Madonna must have followed step by
step the painful stages that led to the Crucifixion, just as she
painfully waited for the Resurrection. Confirming this belief,
artists have always included her in depictions of the Passion
and death of Christ, and have developed iconographic tropes
such as the *Pietà*. Jesus was betrayed, taken before Pontius
Pilate, the Governor of Judea, and sentenced by the people;
after being scourged, his journey of Passion began.
(John 19:25–27)

Giambattista Tiepolo
Road to Calvary
1740
Sant'Alvise, Venice

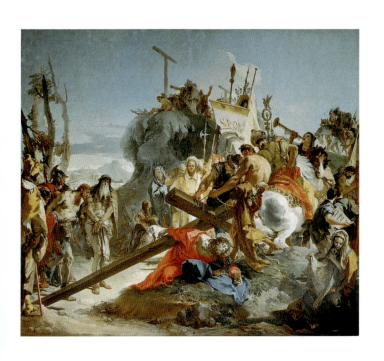

The Ascent to Calvary

Christ was forced to carry the Cross on his shoulders up to the top of Golgotha—which in Hebrew means "the place of the Skull"—also known as Mount Calvary. Because he was walking slowly under the strain and the immense effort, the governor's soldiers compelled one of the onlookers, a certain Simon, a Cyrenian, to help Jesus carry the Cross. In this painting by Simone Martini, Mary—usually depicted wearing a dark blue mantle, escorted by a disciple— walks along the *Via Crucis*, next to her son. She looks on as Jesus admonishes the women of Jerusalem, "Do not weep not for me; weep instead for yourselves and for your children, for indeed, the days are coming when people will say, 'Blessed are the barren, the wombs that never bore and the breasts that never nursed.'" (Luke 23:28–29)

Simone Martini
The Carrying of the Cross
c. 1333
Musée du Louvre, Paris

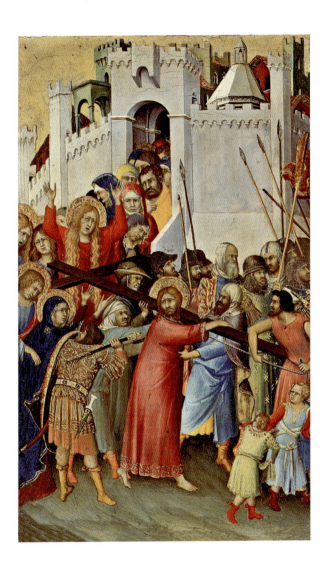

Christ Is Undressed on His Way to Calvary

"They divided my garments among them, and for my vesture they cast lots." All the biblical sources that narrate the Crucifixion mention the episode in which Christ was stripped by the Roman soldiers, who divided the garments among themselves. While the garments were torn into four parts, one for each soldier, the tunic was seamless, woven in one piece, so they cast lots for it. Thus the lots became one of the symbols of the Passion. Again, there is no mention in the Gospels that Mary witnessed the undressing, though an unofficial tradition has Mary covering her son's nakedness with her own veil. In this rendering, the Virgin is in the foreground and shares in the humiliations heaped upon her son before the Crucifixion. (John 19:24)

Workshop of Francesco di
Giorgio Martini
*The Disrobing of Christ on
Mount Calvary*
1497
Pinacoteca Nazionale, Siena

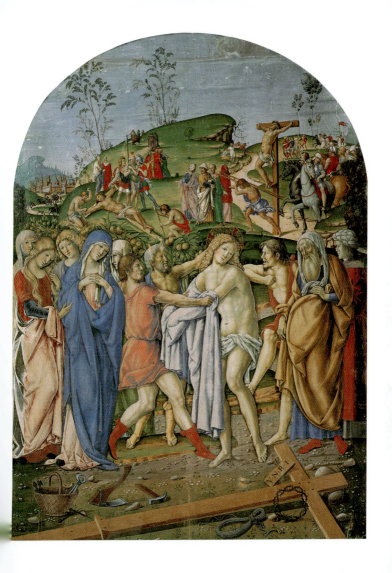

Christ Is Nailed to the Cross

Both the canonical and the apocryphal Gospels only briefly mention Jesus being nailed to the Cross, but describe in detail the events surrounding him as he hangs from the Cross after it has been raised. No source reports on the techniques used to nail him up. This episode is only rarely represented in art, and several solutions have been employed. In the earliest images, Christ is shown climbing a ladder to the Cross that is already planted vertically; the modern, more frequently used solution portrays Jesus lying on the Cross as it rests on the ground, being nailed in that position, then raised. At the side, Mary witnesses the heart-rending torture, but looks away, unable to bear the sight.

Fra Angelico
Christ Nailed to the Cross
1440
Museo di San Marco, Florence

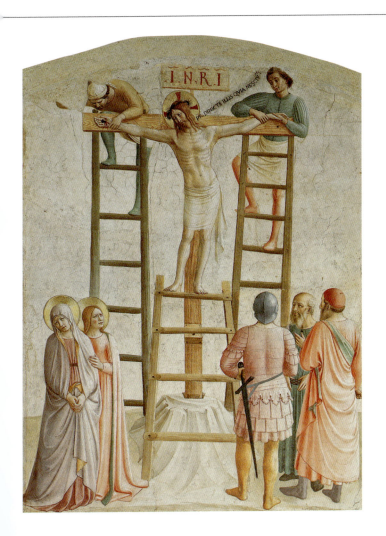

The Crucifixion

"Father, forgive them; for they know not what they do," Jesus implored as he was crucified, alongside two thieves. On top of the Cross, the soldiers nailed a plate with the ironic inscription "INRI" (*Iesus Nazarenus Rex Iudaeorum*, or "Jesus of Nazareth King of the Jews"). After a three-hour agony, Christ cried out to his Father, "My God, my God, why have you forsaken me?" and died. The Gospels report different versions of the last words of Jesus Christ: In Luke, they are "Father, into your hands I commend my spirit." In John, "It is finished." In Mark, he simply cries out in a loud voice. In artists' depictions, Mary, at the feet of the Cross, lives her son's agony; she has been shown covering her tear-stained face with her veil, fainting into the arms of a group of other women, or throwing herself on the ground, crying out her pain. Only an apocryphal source imagines the Virgin anxiously waiting at home for news of her son's death, which the apostle John is to bring to her. As soon as he appeared at the door, Mary, who had just fearfully witnessed an earthquake, exclaimed: "These miracles that are happening now announce my Son's death."

(Matthew 27:46; Luke 23:46; John 19:40; Gospel of Nicodemus 10:1; Gospel of Gamaliel 2:4)

Nicola Pisano and Arnolfo di Cambio
Crucifixion (detail)
1265–68
Duomo, Siena

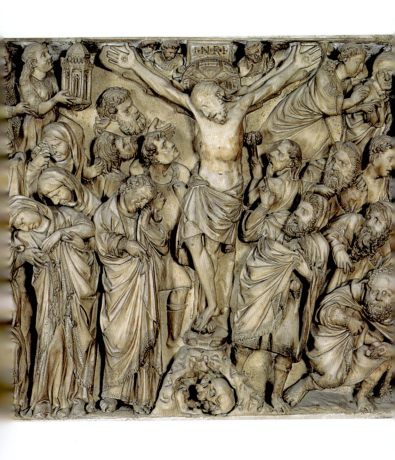

The Crucifixion

"Standing by the cross of Jesus were his mother and his mother's sister, Mary the wife of Cleopas, and Mary of Magdala." John's is the only Gospel that explicitly marks Mary's presence at the feet of the Cross. It was at this time that Jesus entrusted his beloved disciple to her. A popular tradition developed from this event (it cannot be verified, and is therefore considered unreliable) in which Mary followed John to Asia Minor and died in Ephesus. The Evangelist mentions three other women standing next to the Virgin under the Cross, only two of whom are identifiable: Mary of Cleopas and Mary Magdalene. The third woman is referred to as "Mary's sister." Since, according to tradition, Mary's mother Anne had two other daughters from subsequent marriages, the woman could be Mary of Salomas, who was Anne's third husband, coming after Cleopas. (John 19:25).

Paolo Veronese
Crucifixion
1582
Gallerie dell'Accademia, Venice

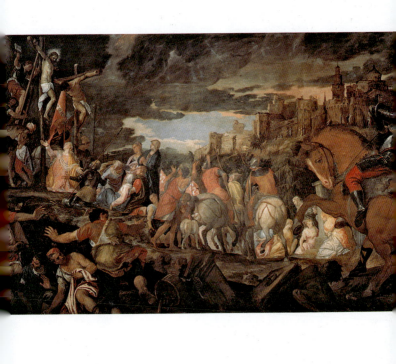

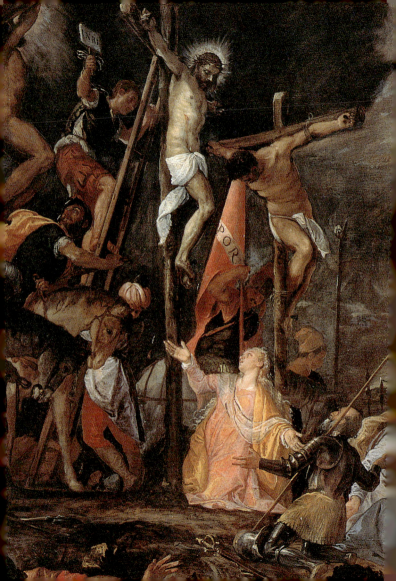

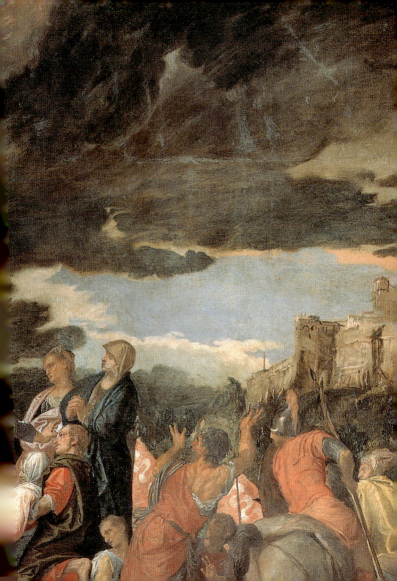

The Crucifixion

"And, behold, the veil of the sanctuary was torn in two from top to bottom. The earth quaked, rocks were split, tombs were opened, and the bodies of many saints who had fallen asleep were raised." When Jesus died, the sky and the earth darkened, the temple curtain that Mary had woven when she was a young girl was torn down the middle, and the earth trembled. Witnessing these momentous events, many of those present beat their breasts and wailed, while the centurion who stood at the feet of the Cross cried, "This man was innocent beyond doubt." At the Cross stands Mary, overcome with grief, with the other women and a group of Jesus' friends who had followed him from Galilee. Intensifying the agony of the drama in this painting by Guttuso, the women at the feet of the Cross express their grief with intentionally theatrical gestures. (Matthew 27:52; Luke 23:47)

Renato Guttuso
Crucifixion
1941
Galleria Nazionale d'Arte Moderna,
Rome

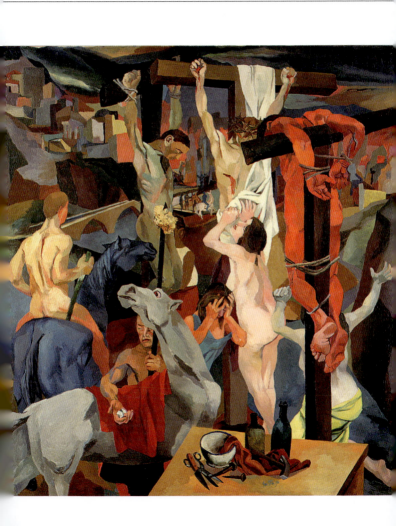

Mary Faints at the Foot of the Cross

Many works of art have portrayed Mary fainting at the Cross when Jesus died, even if none of the available sources mention the episode. In some cases, Mary is portrayed falling back, her back arched, her clasped hands stretched out toward Christ. In some images, she collapses to the ground and lies lifeless, her eyes closed; in others, she bends her head forward, as if weighed down by grief. Sometimes she is supported by John, her "new son," or by the women who surround her and hold up her senseless body. Whether it really happened or is the result of artistic elaboration, clearly the grief that Mary felt at her son's death is a universal grief that still affects us after two millennia.

Andrea Mantegna
Crucifixion
1457–59
Musée du Louvre, Paris

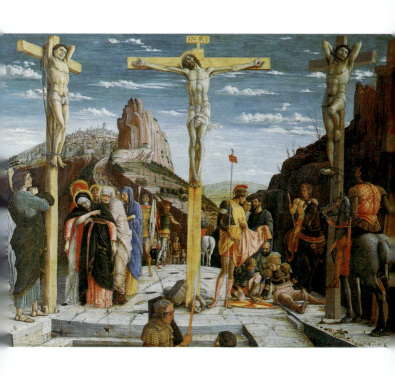

The Deposition from the Cross

Jesus was crucified with two thieves on Good Friday. Because the agony and suffering of the men executed on Calvary, next to the city, would have ruined the Sabbath, the priests sent some soldiers to accelerate the death. The soldiers broke the legs of the two thieves with a club, but when they came to Christ, they saw that he was dead already. One of them, Longinus (who later converted), pierced Christ's side with a spear, causing blood and water to ooze out. Meanwhile, the Madonna and the other bystanders followed the agony. "But a man named Joseph, a member of the high council and a just and righteous man of the Jewish city of Arimathea, who had been opposed the council's decision, and who was waiting for the kingdom of God, personally went to Pilate to ask that he might take away the body of Jesus." According to some medieval legends, it was this Joseph of Arimathea who collected the blood and water that had spilled from the wound into the goblet Christ had used at the Last Supper, the Holy Grail. (Gospel of Nicodemus 9:3)

Donato di Niccolò di Betto Bardi,
known as Donatello
Deposition
1465
San Lorenzo, Florence

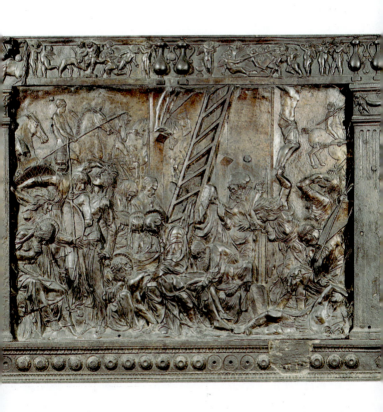

The Deposition from the Cross

Having received permission to bury the body, Joseph of Arimathea and Nicodemus, a noble Pharisee who had supported Jesus, remove the body from the Cross. While the former, identifiable from Nicodemus because he is younger, supports the lifeless body, the second pulls the nails, which along with the pincers and the hammer become the "Passion tools." Witnessing the Deposition are John, Jesus' favorite disciple, and Mary, who kisses her son's wounds. Then the body of Christ was laid on the stone used to prepare corpses for burial. It is the "anointing stone" now set at the entrance to the Basilica of the Holy Sepulcher in Jerusalem, which myriads of pilgrims kiss and oil with perfumed unguents. (Gospel of Nicodemus 11)

Bernardino Butinone
Deposition from the Cross
(detail)
1500
Civiche Raccolte d'Arte,
Castello Sforzesco, Milan

Mourning the Dead Christ

The *Compianto* scene—mourning the body of Christ—is barely mentioned in the Gospels, having been developed and codified in the devotional tradition. Its purpose is to celebrate the sacrifice that Jesus Christ made for the salvation of the human race. After he was deposed from the Cross, his lifeless body was laid on a shroud supplied by Joseph of Arimathea. According to the sources, three men took part in the mourning: John, representing the disciples; Joseph of Arimathea; Nicodemus; and four women: Mary, who lovingly takes her son's hand in her own for the last time; Mary Magdalene; and the two other Maries, who were probably the Virgin's sisters. The last three are the women who would visit the tomb on Sunday and find it empty. While in the various representations the number of men does not change, the number of women does, from four to three or, more rarely, two. In this painting by Perugino, the onlookers are more numerous and each one reacts to the painful moment in his or her own personal way. (Gospel of Nicodemus 11)

Pietro Perugino
*The Mourning of the Dead Christ
(Deposition)*
1495
Galleria Palatina, Palazzo Pitti,
Florence

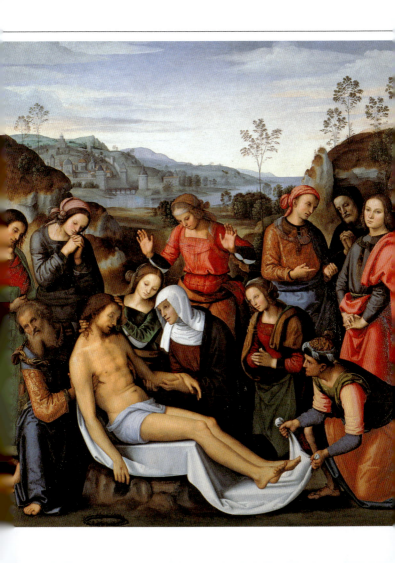

The Pietà

An implicit follow-up to the *Compianto* is the Pietà (Mercy)
episode, which also does not appear in written sources. In this
case as well, popular devotion created the iconography that
over time has acquired a compositional autonomy, becoming
the bearer of a universal meaning: the immense grief of a
mother at the death of her son. The solitary scene presents the
Virgin holding in her lap the lifeless body of Christ. It is
Mary's final, dramatic farewell to Jesus, who for the last time
lies on her knees, motionless like a sleeping child.

Michelangelo Buonarroti
Pietà
1499
Basilica di San Pietro, Vatican City

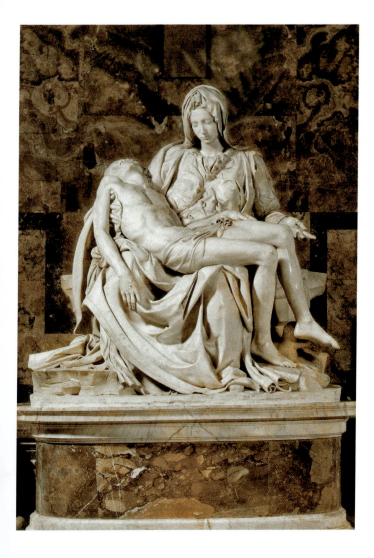

The Pietà

The *Pietà* is the final fulfillment of Mary's prescience. When he was still in her womb, she had dreamed that he was dead. She raised him and held him in her arms, consciously accepting his dramatic destiny; she followed him step by step on the way to the Cross; and now she finally takes his lifeless body in her arms, living the immense sorrow that she knew would come. Notwithstanding her foreknowledge, her despair has now become physical, tangible, and heart-rending.

Annibale Carracci
Pietà
1599–1600
Museo Nazionale di Capodimonte,
Naples

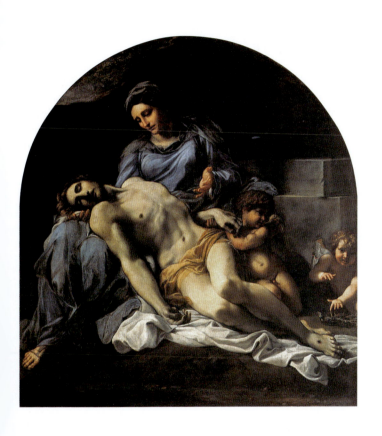

The Pietà

Mary fainted during the Crucifixion. Here, she mourns her son privately in one last, intimate goodbye. Her face, sometimes drawn, sometimes lined with tears, expresses all of a mother's love. Pity joins to love in these representations. The Madonna strokes, contemplates, and kisses her son's body, as if to steal a memory of his human existence. Sometimes, the body of the 33-year-old Christ is out of scale, smaller than the mother's. In fact, one touching incongruity of this composition is that Mary can physically hold up her son's lifeless body. The image of the *Pietà* began to appear in the fourteenth century; it probably originated in northern European wood sculptures of groups known as *Vesperbild*, in which the dead Christ was represented in the arms of his Mother.

Sofonisba Anguissola
Pietà
1560
Pinacoteca di Brera, Milan

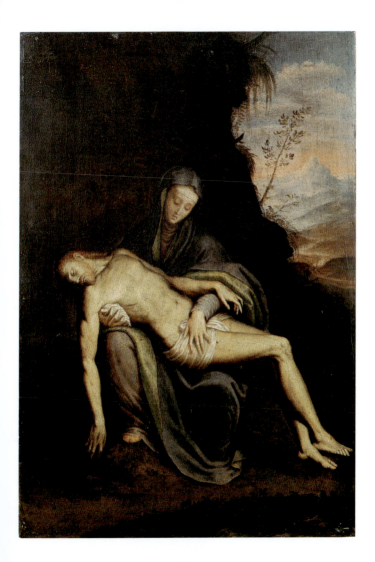

Christ Is Carried to the Tomb

As the Passover Sabbath drew near, the preparations for the burial of Christ's body were hasty. Nicodemus brought an embalming mixture of aloe and myrrh. For the most part, neither the sources nor the iconographic tradition describe the embalming of Christ's body, or if they do, it is summary. Wrapped in a sheet, the body is transferred to the tomb. Three men—Joseph, Nicodemus, and John—carry him, followed by Mary, who has collected what little strength she has left to escort the son in his last earthly voyage. Popular devotion has recognized the sheet, or "sacred linen," Joseph of Arimathea had supplied in the Holy Shroud, a relic conserved in a Turin church that has been subjected to several tests to determine its age and authenticity.

(Gospel of Nicodemus 11)

Antonio Ciseri
The Entombment
1883
Guildhall Art Gallery, London

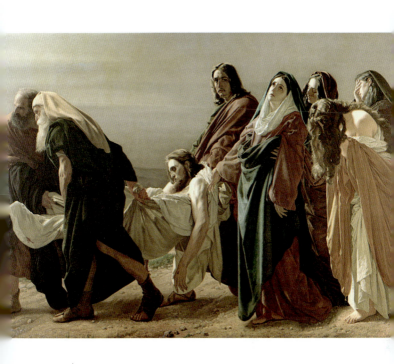

Christ Is Carried to the Tomb

The body of Jesus was laid in an empty sepulcher owned by Joseph of Arimathea, which was hewn into the rock near Golgotha. According to tradition, Joseph holds the body by the shoulders, Nicodemus by the feet. In some works of art, however, the body is carried by other figures, such as the apostles, witnesses to the Crucifixion, or simple bystanders.

In the far distance, the three empty crosses on Calvary Mount are a backdrop to the agony of the Virgin, who is represented fainting again, supported by the devout women.

(Gospel of Nicodemus 11)

Raffaello Sanzio, known as Raphael
The Entombment
1507
Galleria Borghese, Rome

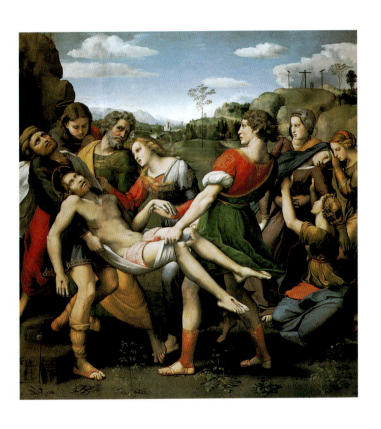

The Deposition in the Tomb

The corpse of Christ was laid in the tomb and the entrance
was sealed with a heavy stone. In this case also, while the
canonical sources provide scant details, devotional tradition
and the figurative arts show us a grief-stricken Mary lingering
next to her son, stroking him or holding his hand. She helps
Joseph and Nicodemus lower the body into the tomb—some-
times only the entrance is visible, or, as in this case, the tomb
is rendered as a stone sarcophagus. Mary was present at the
funeral until the final sealing of the tomb with the stone.

Tiziano Vecellio, known as Titian
Entombment
1559
Museo del Prado, Madrid

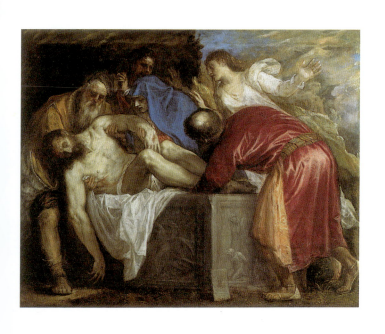

The Deposition in the Tomb

According to an apocryphal text, the Gospel of Gamaliel, the Virgin was not present at her son's burial but learned of his death and deposition from the apostle John. The apostle tried to comfort her, saying, "'Stop your crying now, because they prepared him for burial, as is fitting, with balm and incense and new linen cloths. Even the tomb where they have buried him is new, and near a garden." But the grief-stricken Mary replied, "Were my Son's tomb like Noah's Ark, I still would not be consoled unless I see it and let my tears fall over it." According to this source, the Madonna discovered the empty tomb when, tired of weeping, she ran to the place John had pointed out to her. This version, however, has not been represented in the visual arts, which are all faithful to the belief that Mary was present at every moment of the Passion and death of Christ.

(Gospel of Gamaliel 3:40–41)

Rogier van der Weyden
The Entombment
c. 1450
Galleria degli Uffizi, Florence

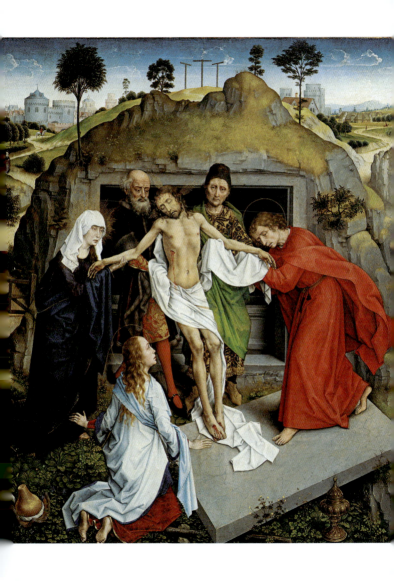

The Resurrection of Christ

After Jesus' burial, Mary was probably waiting to receive the glorious, expected news of his Resurrection. The wait on Holy Saturday is one of the highest moments of Mary's faith in her Lord. Still, although the canonical Gospels report several apparitions of the resurrected Christ, they do not mention a meeting with his Mother. And in fact, the New Testament does not give a full account of the 40 days that elapsed after the Easter Resurrection. For this reason, some artists represent the Resurrection without officially including Jesus' appearance to his Mother. However, in the background of some paintings we see small, secondary female figures that represent the devout women at the tomb and are also a subtle allusion to the presumed encounter between Mary and her resurrected son.

Paolo Veronese
Resurrection
c. 1572–76
Hermitage Museum, Saint Petersburg

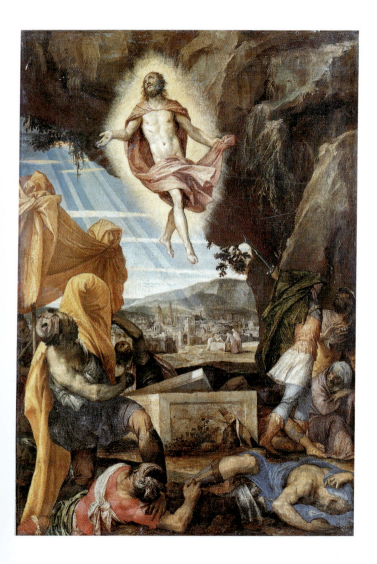

The Devout Women at the Tomb

On Easter Monday, some women went to the tomb. Their number and identity are uncertain. Matthew mentions Mary Magdalene and "another Mary," perhaps one of the Madonna's sisters; Mark mentions Mary Magdalene, Mary the mother of James, and Mary the daughter of Salomas, who was Anne's third husband. Luke speaks of "women" in general. John mentions Mary Magdalene and two of Jesus' disciples, one of whom is Peter. But although the Gospels fail to mention the Virgin, the apocryphal Gospel of Gamaliel narrates that after crying and mourning for two days, Mary decided to visit the tomb. She found the stone rolled to one side and the tomb empty, and cried out: "This miracle happened on behalf of my son." The figurative arts often represent the arrival of the women at the sepulcher, sometimes with the Resurrection of Jesus depicted simultaneously with the discovery of the empty tomb. (Gospel of Gamaliel 4:3)

The Devout Women Walk to the Tomb
4th–5th centuries
Bayerisches National Museum,
Munich

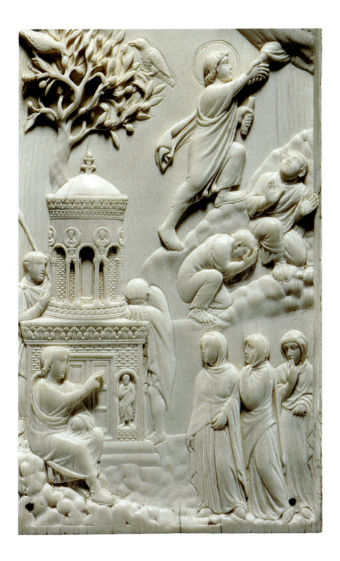

Mary of the Seven Sorrows

When Jesus was presented to the temple, the prophet Simeon had predicted that a sword would pierce Mary's heart. These words have suggested an iconography, Mary of the Seven Sorrows, which, in contrast with her joyful experiences, retraces the dark, difficult moments of her life. The first sorrow is Simeon's prophecy, the second the flight into Egypt to save Jesus at the time of Herod's persecution. When Christ is 12 years old, he goes missing for three days before his parents find him in the Temple of Jerusalem. In the fourth and fifth sorrows, Mary follows her son as he walks the Way of the Cross and witnesses his Crucifixion. She experiences her sixth sorrow when she holds the lifeless body of Jesus, who has been taken down from the Cross; in the seventh and final, she attends her son's burial. Initially, the seven sorrows were depicted as distinct moments coordinated into a single image, but later they were symbolically transformed into seven swords that pierce Our Lady of Sorrows, the *Addolorata*.

Bernard van Orley and Pedro Campana
Triptych of the Seven Sorrows of the Virgin
(detail)
c. 1520–35
Musée des Beaux-Arts et d'Archéologie,
Besançon

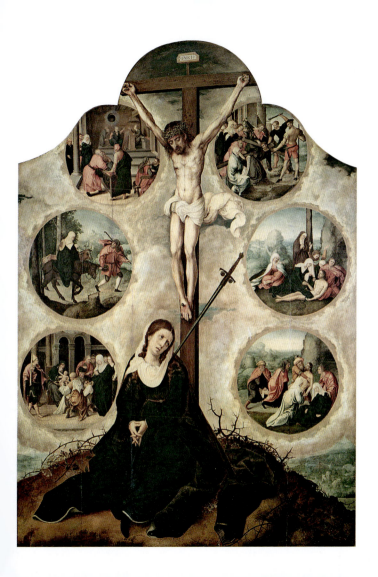

The Virgin Shows the Man of Sorrows

In this image, closely linked to the *Pietà*, the Virgin holds up the body of her son in the foreground; the wounds caused by the Crucifixion are clearly visible. This intense, moving scene has become a central element of devotional tradition, in memory of the suffering that Jesus bore to save the human race. Objects and figures linked to the Passion are portrayed: the nails and pincers used to nail him to the Cross; the water bowl in which Pontius Pilate washed his hands; Judas's kiss; the 30 pieces of silver paid for his betrayal; the scourge and the crown of thorns; the kicks; and, obviously, the Cross. In her role as co-redeemer, Mary partakes of her son's suffering and shows him to the faithful, that they may fully embrace his mission of salvation.

Hans Memling
The Virgin Showing the Man of Sorrows
1475–79
National Gallery of Victoria, Melbourne

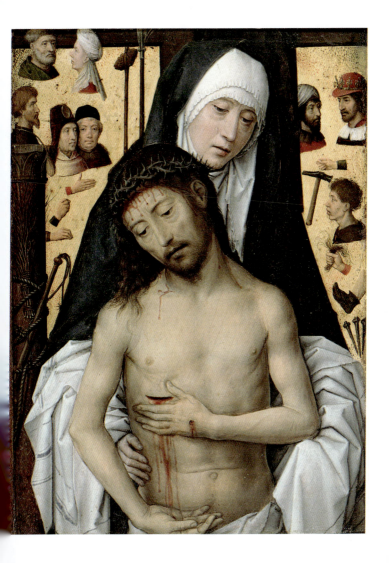

Christ Appears to His Mother

Christ's Apparition to his Mother to announce his Resurrection is only mentioned in the apocryphal Gospels. Mary had gone to the tomb and, finding it empty, cried and wailed. Then Jesus appeared and tried to comfort her. Surrounded by a golden, luminous cloud, Mary did not recognize him until he revealed himself: "Be not afraid, be not confused, look carefully at my face, oh Mother, and be convinced that I am your Son . . . I am the Jesus over whose death you cried; now he lives! I am the Jesus for whose love you shed tears. Now he comforts you before all others with his Resurrection." While the texts place this conversation near the tomb, artists have often placed it in an interior, probably the Virgin's house. Seated, she tries to find solace in a prayer book when Jesus appears to her in flesh and blood, his wounds clearly visible; in his hand he carries the banner of Resurrection. (Gospel of Gamaliel 6:9–11)

Giovanni Francesco Barbieri,
known as Guercino
*The Resurrected Christ Appears
to the Virgin*
1629
Pinacoteca Comunale, Cento

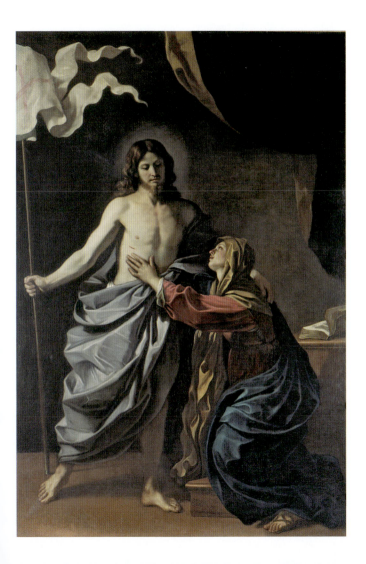

The Pentecost

In retracing the steps in the Virgin Mary's life, even Vatican Council II affirms her presence at the Pentecost. This event represents the founding act of the Church, and thus the figure of the Virgin praying—pleading for the gift of Spirit that had come to her at the time of her own Immaculate Conception and again at the divine conception of Jesus—could not be missing. Having been in a unique position to experience the preciousness of this gift, Mary can appreciate it more than any other. Unlike the apostles who are anxiously waiting in the Cenacle, the Virgin is fully aware of the importance of the promise her son made to the apostles: "And I will ask the Father, and he will give you another Advocate to be with you always." (John 14:16)

Sienese artist
Pentecost
from the *Antiphonary*
Miniature
15th century
Basilica dell'Osservanza, Siena

bñdic. n̄ X. Sps dñi re

pleut orbē tīar: alla

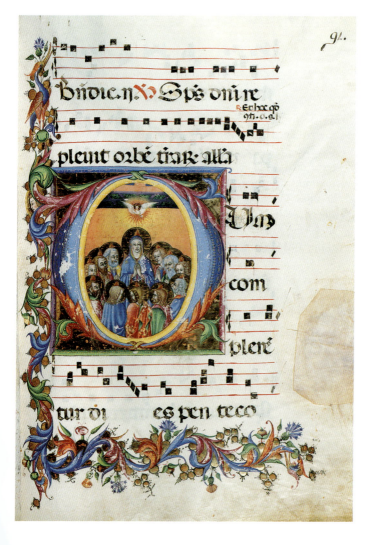

Uñs

com

plenē

tur ōi es pen teco

The Pentecost

Mary's first communion with the Holy Spirit is renewed and strengthened at the Pentecost, insofar as, while at the feet of the Cross, she was invested with a new role: that of mother to Jesus' disciples. The importance of her new role is confirmed in works of art, which often depict her at the center of the apostles. The dove of the Holy Spirit appears centered above the Madonna like a stream of light—or sometimes like small flickering flames—falling on the disciples.
(John 14:16)

Girolamo Francesco Maria
Mazzola, known as Parmigianino
Pentecost
1610–30
Civiche Raccolte d'Arte, Castello
Sforzesco, Milan

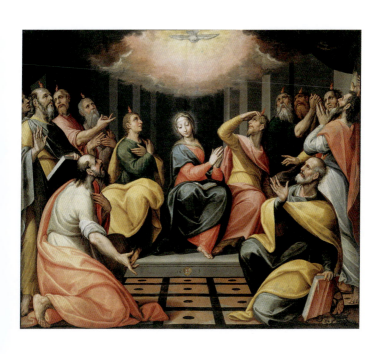

The Pentecost

On the day of the Pentecost, the Holy Spirit invoked by the Virgin gathered with the apostles in the Cenacle, filled those present with its gifts, and transformed them so that they could spread God's word by preaching the Gospel to all nations. Though we have no information about Mary's life in the primitive Church, even after Whitsunday she most likely continued to live a humble, secluded life. Illuminated and guided by the Spirit, her modesty deeply influenced the community of the Lord's disciples, who always looked to her as a guide, a spiritual mother. After the Pentecost, it was the apostles' duty to disseminate the story she told them about God's incarnation in her womb and Jesus' childhood years, sharing intimate details that no one but she could have known.
(John 14:16)

Paris Bordone
Pentecost
1520–30
Pinacoteca di Brera, Milan

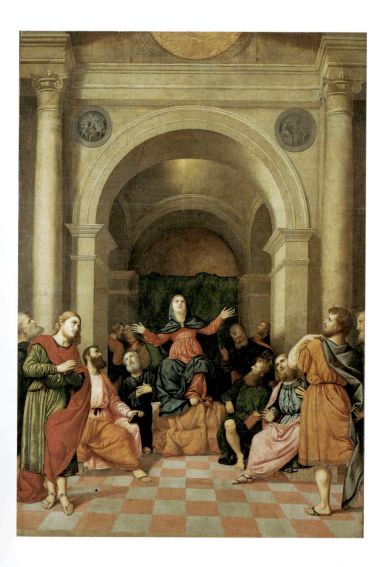

The Announcement to Mary of Her Death

According to Pseudo-Joseph of Arimathea, an apocryphal Gospel, when Jesus was still alive Mary had asked to be given three days' forewarning of her death. Many years after the Pentecost, when the apostles had scattered far and wide to spread the Word, an angel appeared to Mary bearing a palm frond. He greeted her with the same formula used by the Archangel Gabriel at the Annunciation, then continued: "Receive this palm which the Lord promised you . . . Your assumption will be in three days." The frond the angel offered her is the same one that the angels had taken to Heaven, as commanded by the infant Jesus, during the flight into Egypt, because the tree had cast a shadow and offered its fruits to the exhausted, hungry Virgin.
(Pseudo-Joseph of Arimathea 1–4)

English school
The Annunciation of the Virgin's Death
from the *Hunterian Psalter*
Miniature
c. 1170
University Library, Glasgow

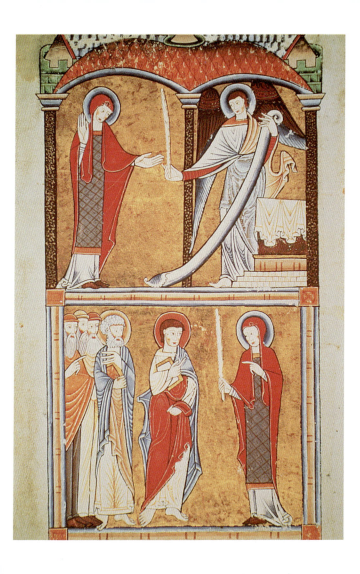

Dormitio Virginis
(The Virgin's Dormition)

According to Pseudo-Joseph of Arimathea, being close to
death, the Madonna wished to meet the apostles once more
for a final goodbye, but they were scattered all over the world.
In the meantime, the Madonna "washed and dressed like a
queen, and lay awaiting her son's coming, which had been
promised to her." And then the miracle happened: A cloud
collected the apostles and brought them before the Virgin,
who told them she was about to reach her son in Heaven.
Mary passed away painlessly, and for this reason some believers,
such as the Franciscans, prefer to think that she simply "fell
asleep." Thus some representations of her death are called
"dormitions," because Mary fell asleep on Earth only to
wake up directly in God's kingdom.
(Pseudo-Joseph of Arimathea 5–10)

Paolo Veneziano
Dormitio Virginis
1333
Museo Civico, Vicenza

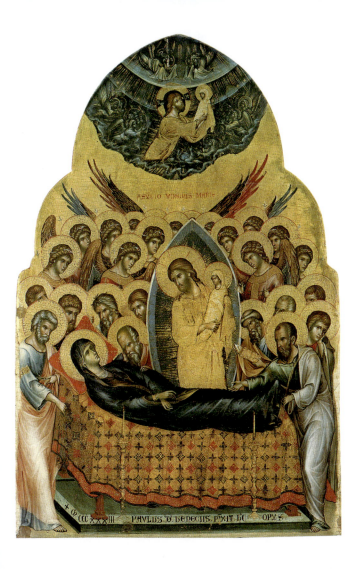

The Death of the Virgin

The Virgin's death has frequently been interpreted in art as a vigil—a pensive time when the apostles wait before the body of the quietly sleeping Virgin. The sadness on the face of the onlookers—only male relatives, Joseph of Arimathea, and the apostles (except Thomas) are present—contrasts with the happy, entirely female bustle that surrounded Anne when she gave birth to the Virgin. The melancholy, thoughtful quality of this episode made it a popular subject of Counter-Reformation art, precisely because the artists chose to emphasize the human aspect in representing the feelings of the participants.

Michelangelo Merisi da Caravaggio
The Death of the Virgin
1606
Musée du Louvre, Paris

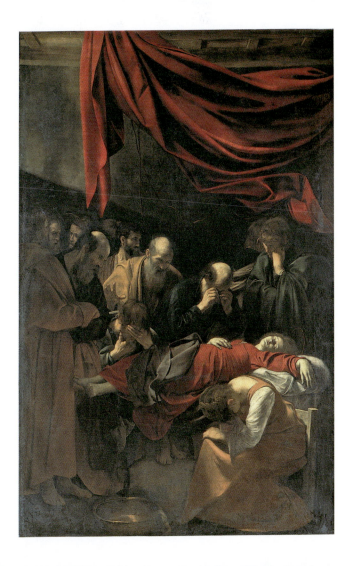

Christ Holds the Madonna's Animula

Upon Mary's passage from earthly life, she is welcomed into the hands of her son. Christ holds his mother's soul with the same tenderness with which she had held him when he was a baby. This iconographic motif is unusual because the central scene does not show the Mother of God rising to Heaven, but Christ coming down to Earth surrounded by cherubim. Pseudo-Joseph of Arimathea recounts the event thus: "Such was the brightness of the light and sweetness of the perfume, while the angels chanted the Song of Songs . . . that the bystanders all fell prone to the ground." This very ancient text speaks of a total paralysis of the bystanders, which erased the event from their memory, explaining why it is not mentioned in the official Gospels. The only witness who describes the passing of Mary is Joseph of Arimathea.
(Pseudo-Joseph of Arimathea 11)

Andrea Mantegna
Christ with the Soul of the Virgin
1460–70
Pinacoteca Nazionale, Ferrara

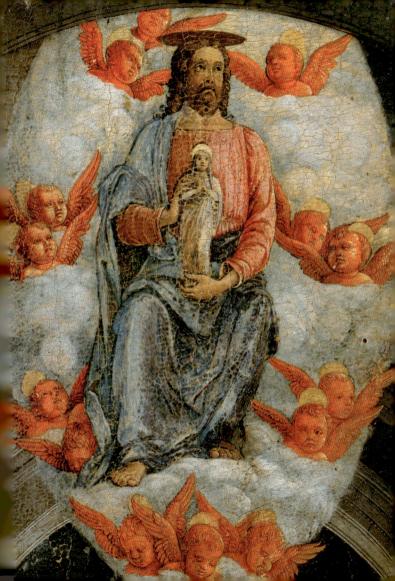

The Funeral of the Virgin

While in medieval art the compositions of the Virgin's death centered around the apparition of Christ, in the Quattrocento the liturgy being performed around the dying Virgin was emphasized. Although it is a death scene, the bystanders are not engaged in the customary mourning. Mary is imagined as an old woman lying on a bed that looks like a bier, usually dressed in red velvet. The apostles have their mouths open as if chanting. They wear colored garments; sometimes Saint Peter wears bishop's vestments, as if reciting a funeral ritual from a missal, aided by a cleric who holds a holy water aspersorium. (Pseudo-Joseph of Arimathea, 14–15)

Andrea Mantegna
Death of the Virgin
c. 1461
Museo del Prado, Madrid

418

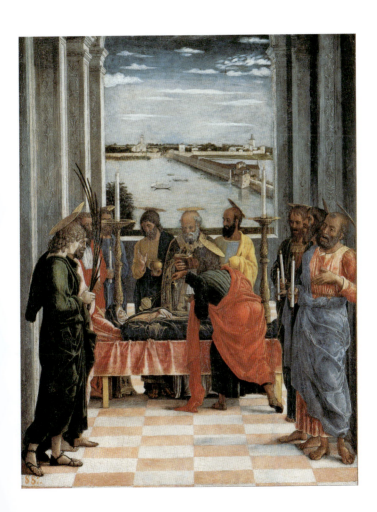

The Assumption

The apostles carried the Virgin's coffin from Mount Zion to a cemetery in the Valley of Jehoshaphat. During the procession, a Jew by the name of Ruben, urged by Satan, attempted to overturn the bier, but as soon as he touched it, his hand dried up and clung to it. Afraid, he asked the Lord for forgiveness, converted, and was healed. After they reached the necropolis and laid the body in a tomb, the disciples were blinded by an exceedingly bright light. It was Jesus with a multitude of angels; the Archangel Gabriel uncovered the coffin, and the Madonna's body, reunited with her soul, was carried to Heaven. This episode, reported in the apocryphal text Transitus Mariae (The Passing of Mary), is narrated differently in other unofficial sources. For example, the apostles are not always eyewitnesses to the Assumption, sometimes arriving on the scene when the tomb was already empty and finding it filled only with roses and lilies.
(*Transitus Mariae*)

Andrea Orcagna
*Dormition and Assumption
of the Virgin*
(detail)
1359
Orsanmichele, Florence

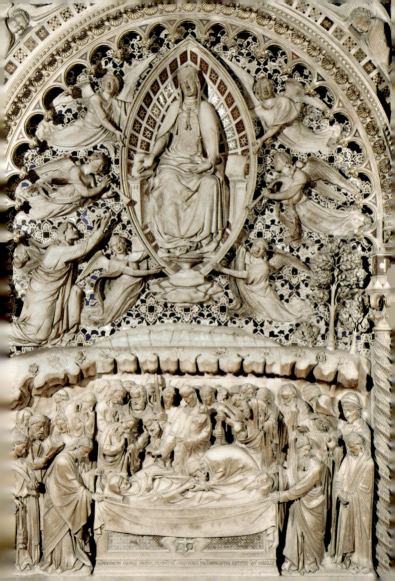

The Assumption

Mary, through whom the Son of Man came down to Earth,
was bodily raised from Earth to Heaven. The Correggio fresco
that depicts this episode in the cupola of the Parma Duomo is
truly spectacular: The Assumption takes place within the space
of perspective architecture and is animated by a circular,
ascending movement toward the center, culminating in the
light of Paradise in which Jesus appears to welcome his mother.
Around them are the blessed and a cortège of musical angels,
while the apostles witness the event from below. The subject of
Mary's Assumption to Heaven was especially popular during
the Counter-Reformation; at the time, several religious buil-
dings were dedicated to it.
(*Transitus Mariae*)

Antonio Allegri da Correggio
Assumption of the Virgin
1526–30
Duomo, Parma

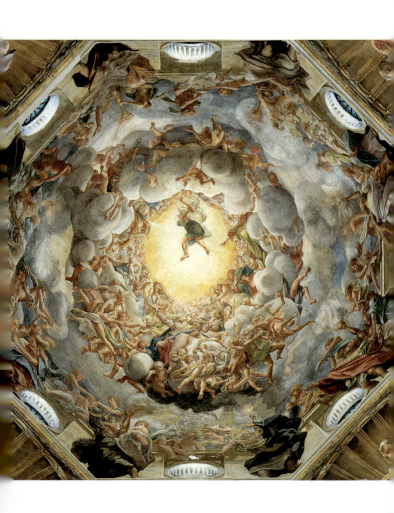

The Coronation of the Virgin

Having been raised to Paradise, Mary is crowned Queen of Heaven and Earth. The crowning episode is the final act, after her death and Assumption, in the stories about Mary. The ceremony is presided over by Christ, who places a crown on Mary's head. She sits on the same throne with him before the Eternal Father and the Holy Spirit. The scene takes place before the celestial court: angels, saints, and patriarchs, who all celebrate their Queen. In some artistic renderings, only God the Father crowns Mary, whose pose—the head bent and the hands joined in prayer—expresses her full obedience to and reverence for divine authority.

Gentile da Fabriano
Polyptych of Valle Romita
(detail)
c. 1400
Pinacoteca di Brera, Milan

The Coronation of the Virgin

After ascending to Heaven, Jesus "sits at the right hand of the Father," sharing with Him sovereign power and establishing the kingdom of the Lord. Raised to Heaven and crowned Queen, Mary participates in her son's government. While the term "Ascension" is active, suggesting a movement upward by one's own motion, the word "Assumption" has a passive connotation, in the sense that it is not a self-propelling movement. Likewise, the Virgin's sovereignty is conferred upon her by God the Father and Jesus Christ. The title of Queen sanctions the power she has received to perform her mission as advocate and intermediary between men and God. Her status ensures her communion and intimacy not only with her son Jesus, but also with the full community of believers.

Ambrogio Bergognone
Assumption of the Virgin Mary
with Saints Ambrosius, Augustinus,
Gervasius, and Prothasius
1522
Pinacoteca di Brera, Milan

Mary Enthroned Next to the Trinity

Mary's consent to Jesus' sacrifice, and the support she gave to his mission, were not just passive forms of acceptance, but authentic acts of love offered for the salvation of the human race. Thus she may be called a "coadjutant" of Christ's work of salvation. She is also the first redeemed human being, for she was lifted from sin through her Immaculate Conception and filled with the grace of the Holy Spirit. In some representations, she sits on a throne in Paradise next to the persons of the Holy Trinity. Surrounded by the heavenly court, in her role of mediator Mary oversees both earthly and otherworldly events, represented by two cities separated by a sea; seated on a throne, she listens to the souls of the dead who entrust themselves to her mercy.

Jean Fouquet
The Enthronement of the Virgin
from *The Book of Hours of Étienne Chevalier*
Miniature
c. 1452–60
Musée Condé, Chantilly

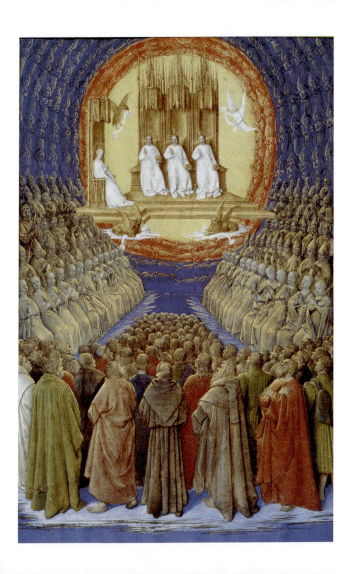

Mary, Guardian of the Church

In her roles of mediator, pleader, and comforter the Madonna is undoubtedly the person most invoked by those in need or who are in trouble. An emblem of the Church and the mother of all believers, Mary shields them from a God made wrathful by the progenitors' Original Sin. Sometimes, the *Mater Misericordiae* (Mother of Mercy) iconography is associated with her role of shielding sinners from the ire of God. Christ joins her in this protecting role, even stopping the arrows the Father is ready to throw.

Michael Parth
Mary Guards the Church While Christ Stops his Father's Ire
1520
Museo Diocesano, Bressanone

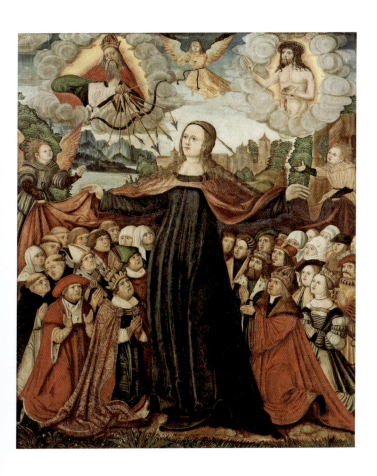

Paradise

The Virgin Mary sits in Paradise, first among the blessed. Images of the heavenly kingdom began to appear in the Middle Ages in connection with the Last Judgment, and are a frequent subject of frescoes decorating the intrados of cupolas, apsidal vaults, and the back walls of churches and chapels. While early images depict a marvelous garden surrounded by luxurious vegetation, later ones stress the peace and harmony of a world peopled by the souls of the elect. The rigid hierarchy of angels and saints and the perfect symmetry of the compositions are meant to convey the sense of quiet amity that is intrinsic to sacred places. At the center of this composition, Mary, seated on a throne of clouds and crowned by Jesus and God the Father, dominates.

Philipp Veit
Paradise
1819–20
Casino Massimo, Rome

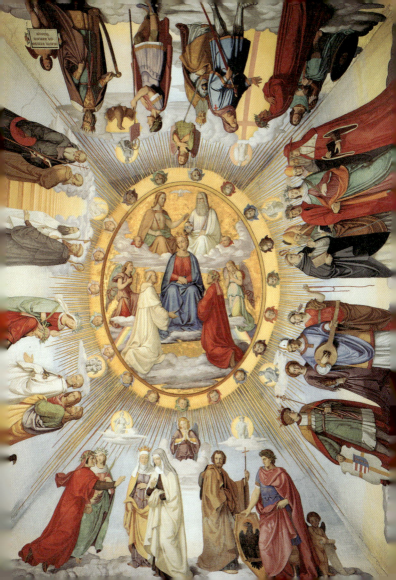

Paradise

In the fourteenth century, influenced by Dante's *Divine Comedy*, artists began to conceive of Paradise as a sequence of concentric circles, also called angelic choirs, surrounding the nucleus that contains Jesus. The latter is depicted inside a golden shield, attended by the seraphim, the angels closest to him. Under the Son, in the center of the celestial hosts is a large, crowned figure of Mary inside a bright mandorla. She is in a praying pose, confirming her acceptance of God's redeeming mission, in the instant when she was chosen to be part of God's divine plan.
(Dante Alighieri, *Divine Comedy*)

Giusto de' Menabuoi
Paradise
1375–76
Baptistery, Padua

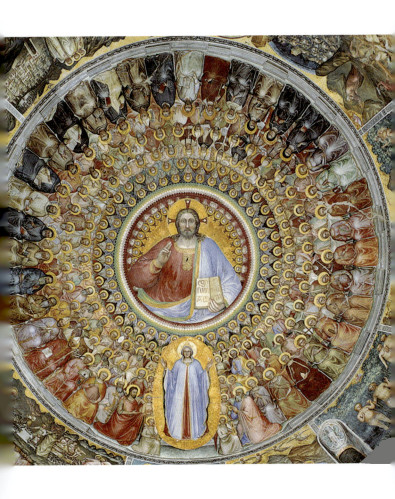

The Last Judgment

According to the many biblical premonitions of the Last Judgment, before the Apocalypse, the dead will be resurrected. Then the good will begin their everlasting life in God's kingdom, while the evil will be sentenced to eternal suffering in Hell. Obviously, the Virgin will be at the side of Christ, as the link connecting humans and God. In fact, it is important to note that she is generally represented as looking sweetly at the souls of the elect in the heavenly kingdom, while Christ looks sternly, almost harshly at those who are climbing down to the Infernals. Even the saints and the elect, arrayed around the two figures of Mother and Son, anxiously await to hear the verdict. The Last Judgment is the time of reconciliation between man and God when Original Sin, brought into the world by Eve, is redeemed before the entire divine family—the Trinity with the Virgin Mary.

(Genesis 3:15; Daniel 7:9–10; Matthew 25:31–46; Luke 16:20–26; Revelation 6:14; 20:13)

Michelangelo Buonarroti
Last Judgment
1537–41
Sistine Chapel, Vatican Palace,
Vatican City

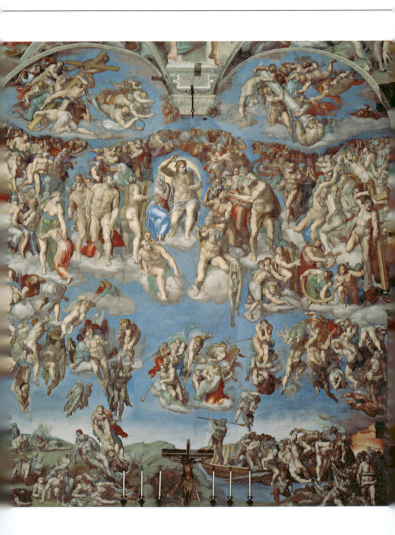

The Last Judgment

The Last Judgment, which is to come at the end of human history, is not directly concerned with the actions of each man or woman during their earthly lives, but with those of the entire human race. Matthew reports that Jesus said, "And then the sign of the Son of man will appear in heaven: and all the tribes of the earth will mourn, and they will see the Son of man coming in upon the clouds of heaven with power and great glory." Before such grandeur, Mary stands for Christian humility, grace, faith, and hope. She is the incarnation of the New Covenant between God and humanity.
(Matthew 24:30)

Stephan Lochner
The Last Judgment
c. 1435
Wallraf-Richartz Museum, Cologne

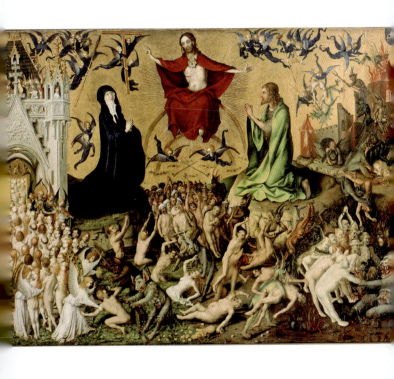

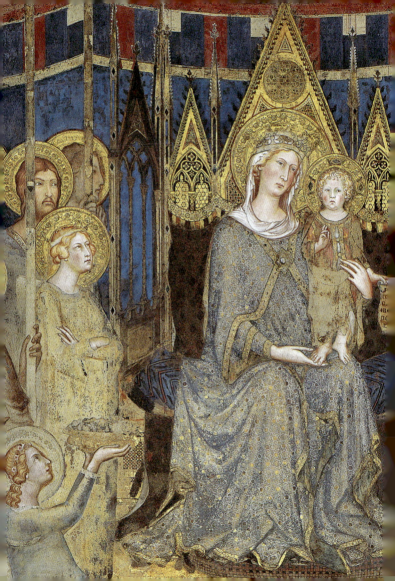

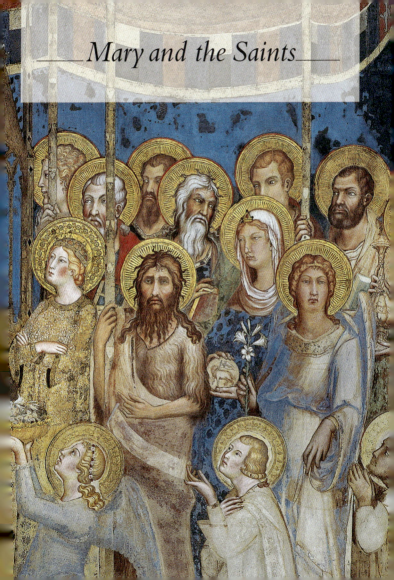

Mary and the Saints

Majestatis (Majesty)

The image of the Majesty began to appear around the twelfth century: At the center, the Madonna sits enthroned holding the infant Jesus in her lap, often surrounded by angels and saints. The artistic intention was the contemplation of the kingdom of God, where Mary reigns. Austere and detached, she sits on a sumptuous gilt throne, the aristocratic Queen of the heavenly hosts, which are symbolically welcomed under the same canopy. This type of composition was popular at least until the fifteenth century, especially in frescoes or wood altar pieces.

Simone Martini
*Maestà (Madonna with Angels
and Saints)*
1315
Palazzo Pubblico, Siena

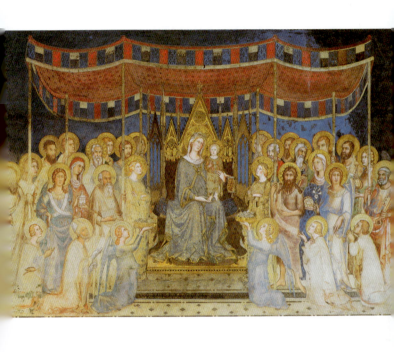

Regina Sanctorum (Queen of Saints)

Mary is the Queen of Heaven and of all those who inhabit it. Majesty representations show the celestial court and, in a perhaps profane rendition, the Queen on her throne surrounded by a hieratic, solemn, perfectly symmetrical lineup of angels and saints. In this composition, the figures appear flat, heightening the sacredness and spirituality of the scene. The Madonna, who represents the Church, reigns over the blessed men and women who are granted the privilege of being in her sight. These altar pieces used to be placed on top of the church's central altar, and must have surely aroused strong feelings of devotion in the faithful during the religious celebrations.

Duccio di Buoninsegna
Maestà
(detail)
1308–11
Museo dell'Opera del Duomo, Siena

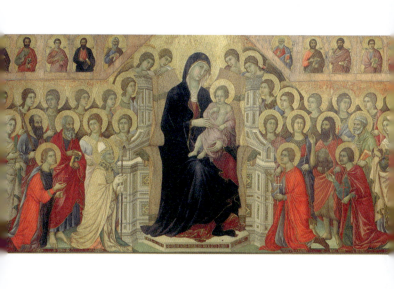

The Sacred Conversation

In the Quattrocento, the invention of the linear perspective brought about a new iconography in which the Virgin, seated on the throne with her Child and surrounded by saints, has lost the hieratic, static quality of the Majesties. This new iconographic model is called the Sacred Conversation: Several figures are grouped around the Madonna in a unified space that has become real, for the figures are in natural poses and spontaneously interact with her. In fact, the model is that of a dialogue on doctrinal or theological subjects before the Madonna and the Child, the latter taking on the connotation of the Word Incarnate. The presence of a saint, identified by his or her iconographic attributes, is variously justified; it might be the saint to whom the church is dedicated or that of the chapel where the painting is displayed, the guardian saint of the city, or even a saint invoked in times of need or disasters because of his or her particular qualities. Often these representations are *ex votos*; in these cases, the figure of the patron appears kneeling before the Virgin.

Piero della Francesca
*Madonna and Child with Saints
(Montefeltro Altarpiece)*
1472–74
Pinacoteca di Brera, Milan

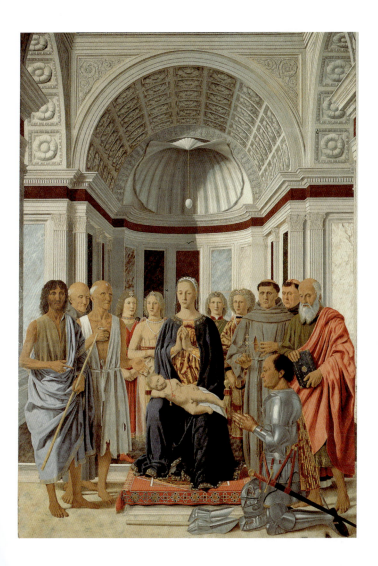

The Sacred Conversation

An image inspired by the Renaissance concept of egalitarianism, the Sacred Conversation presupposes a nonceremonial, direct relationship between the figures of the composition, who engage in an intimate, colloquial dialogue, though they are still ruled by a hierarchical order that separates Mary the Queen from the other figures. In this altarpiece, commissioned in 1496 by the monks of the Santa Maria in Organo Church in Verona, the Virgin appears inside a mandorla, surrounded by angels. The fruit-bearing trees on each side echo the shape of the frame surrounding Mary, an impression heightened by the posture of the saints in the foreground. Even though the figures cannot be identified for certain, they are most likely, on the left, Saint John the Baptist and Pope Gregory the Great; on the right, Saint Benedict, founder of the Olivetan congregation to which the monks who commissioned the painting belonged, and Saint Jerome, who bears a scale model of the Santa Maria in Organo Church.

Andrea Mantegna
Madonna between Angels and Saints
1497
Castello Sforzesco, Milan

Virgo inter Virgines (The Virgin Among the Virgins)

Mary is the model of absolute purity and, as such, a prototype and paragon of life. Over the millennia, many young women have tried to conform their lives around her favorite virtues: humility, charity, obedience, poverty, and virginity. Thus an iconography (not very diffuse) developed portraying the Madonna surrounded by women saints who were beatified precisely because they chose to devote their lives to chastity, penance, prayer, mercy, and contemplation. Among these saints is Catherine of Alexandria, who was tortured and beheaded; Cecilia, who had made a vow of chastity and was killed after she refused to sacrifice to the idols; Barbara, the daughter of the king of Nicomedia, who was sentenced to death for having chosen a hermit's life; and Margaret of Hungary, a leading Medieval mystic who became a nun in fulfillment of a vow she had made to her mother.

Gerard David
Virgo Inter Virgines
Miniature
c. 1500–10
The Morgan Library & Museum,
New York

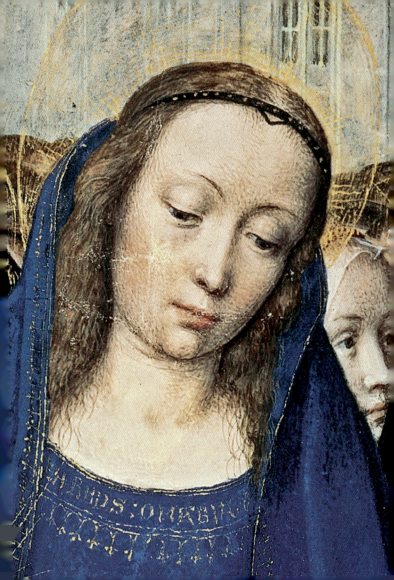

Deisis (Supplication)

Deisis is a Greek word that means "supplication, plea." It denotes an iconographic model that began in Byzantine culture. It portrays Christ the Judge between the Virgin and Saint John the Baptist, who are pleading on behalf of sinners. The Virgin is usually portrayed turned toward Christ, her arms raised in a slightly curved, pleading attitude, with Saint John the Baptist in the same posture. This symmetry is meant to signify that both Mary and the Baptist are precursors and coadjutors in the plan of salvation. In the Eastern Church, the *Deisis* often appears in the central register of the iconostasis, sometimes flanked by representations of archangels or local saints.

Onufer Qiprioti
Deisis
1596
Cultural Monuments Institute,
Tirana

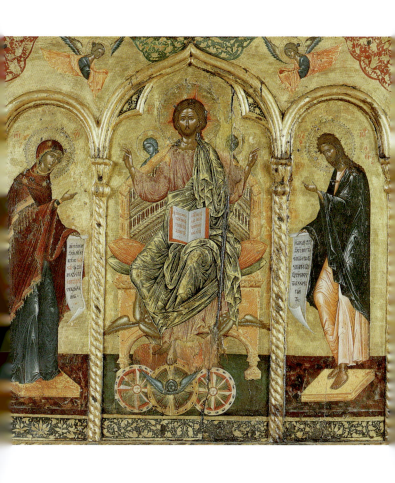

Saint Luke Painting the Virgin

Saint Luke is the Evangelist who wrote one of the four
canonical Gospels. Born in Antioch to a pagan family, he was a
physician until he met Paul of Tarsus and became a disciple of
the apostles. He heard about Jesus for the first time in 37 CE
and learned about his life from the accounts of his followers,
in particular Mary, who gave him information about Christ's
childhood. Because of the close relationship that developed
between Luke and the Virgin (he is, in fact, the only Evangelist
to include accurate information about her and the Child Jesus
in his narrative), a Christian tradition holds that Luke was
the first to paint the Madonna, and the only one to paint
her from life.

(Jacopo da Varagine, *Legenda Aurea*)

Master of the Altar of the Augustinians
Saint Luke Paints the Virgin
1487
Germanisches Nationalmuseum,
Nuremberg

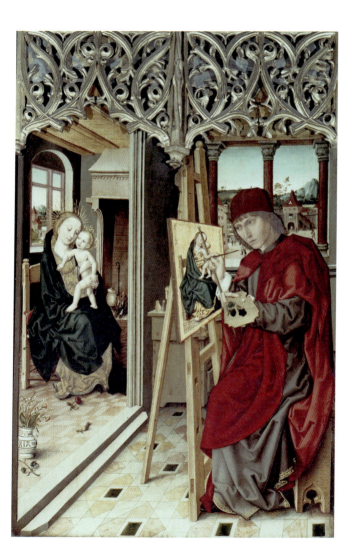

Saint Luke Painting the Virgin

The legend of Luke the painter arose during the iconoclastic dispute and is associated with the fact that, as a physician, he must have had some artistic rudiments, since physicians needed to have some drawing skills to reproduce medicinal plants in illustrated repertories. The earliest reference to this popular Christian belief is in the *Treatise on the Holy Images* by Andrew of Crete (eighth century), where the author confirms that the features of the Madonna painted by Luke are true to life. Apparently, Luke's paintings were kept for centuries in Rome and Jerusalem, and many copies were made of them. Many Byzantine images are attributed to him, including the Constantinople Madonna kept in the Santa Giustina Basilica in Padua, and an ancient image, the *Salus populi romani* (Salvation of the Roman People), kept in the Pauline Chapel of the Santa Maria Maggiore Basilica in Rome, to the left of the central altar.

(Jacopo da Varagine, *Legenda Aurea*; Andrew of Crete, *Treatise on the Holy Images*)

Jan Gossaert, known as Mabuse
Saint Luke Painting the Madonna
1520–25
Kunsthistorisches Museum, Vienna

460

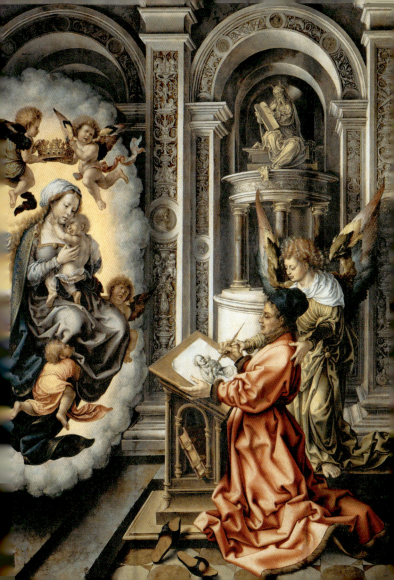

The Virgin of Pilar Appears to Saint James

According to a very ancient tradition venerated for centuries, in 40 CE the Virgin Mary traveled from Jerusalem to Saragossa to comfort and encourage the apostle James, who was preaching the Gospel on the banks of the Ebro River, but was not understood by the locals. Jesus had appeared to Mary to remind her that the work of the apostles was precious and that James, his faithful disciple, would be the first to follow his example. James would be martyred in Jerusalem, but before that Christ wanted Mary to appear to him in Saragossa and suggest that he raise a church to her where she would be prayed to and invoked. In this apparition, the Madonna is surrounded by angels; her feet rest on a *pilar*, or column, which became the distinctive sign of this apparition.
(Jacopo da Varagine, *Legenda Aurea*)

Nicolas Poussin
The Apparition of the Virgin to Saint James the Great
c. 1629–30
Musée du Louvre, Paris

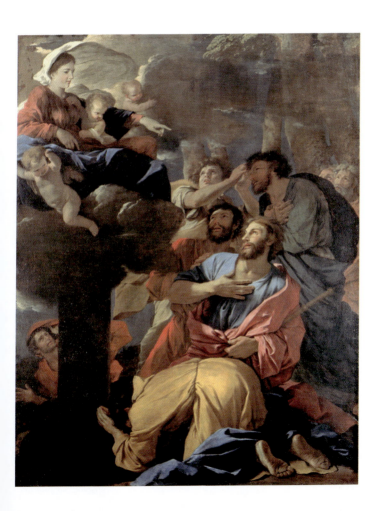

The Virgin Offers Saint Thomas Her Girdle

According to the apocryphal Gospels, Thomas "was saying Mass in India when, without knowing it was God's will, he was transported on the Mount of Olives where he saw the holy body of the blessed Virgin being raised to heaven. Then he prayed for her blessing and she granted his prayer and threw to him her girdle." Jacopo da Varagine's *Legenda Aurea* tells of another tradition: Because he was not present at the Assumption, Saint Thomas did not believe the apostles' accounts. To convince him, the Virgin dropped her girdle to him from Heaven. The image of the Virgin of the Girdle (*Madonna della Cintola*) is especially popular in Tuscany, where many shrines are devoted to the relic, venerated in Prato. (Jacopo da Varagine, *Legenda Aurea*)

Francesco Granacci
Madonna della Cintola
(Madonna of the Girdle)
16th century
Galleria dell'Accademia, Florence

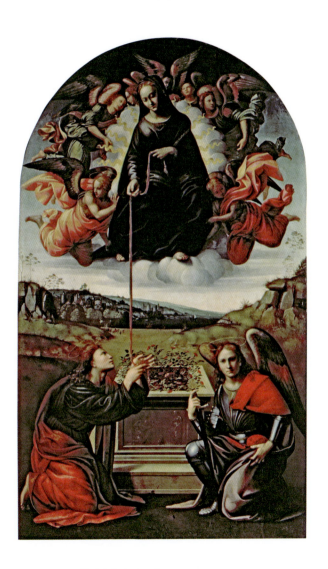

The Virgin Appears to Saint John on Patmos

Saint John, who wrote the fourth Gospel and Revelation, witnessed, with Mary, the Passion of Jesus and, according to tradition, lived with her in Ephesus. He died toward the end of the first century or the beginning of the second, after having been exiled to the island of Patmos. Born in Galilee, John was the youngest of the apostles; his mother was in the group of women who followed Jesus and helped him on his way to Calvary, perhaps a cousin of the Virgin. Since he had never attended rabbinical school, he was considered illiterate and common. Some have raised the hypothesis that he dictated his works to one of his disciples, who wrote them down. John was the first apostle that Jesus met (he was already a disciple of John the Baptist), and the last one to die. After fleeing with the others upon Jesus' arrest, John began to take care of Mary at the feet of the Cross, in obedience to Christ's command. (Jacopo da Varagine, *Legenda Aurea*)

Hieronymus Bosch
Saint John the Evangelist on Patmos
1504–5
Staatliche Museen, Berlin

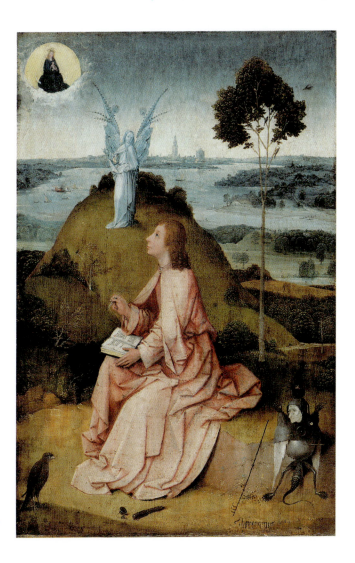

The Virgin Appears to Saint John on Patmos

According to an early tradition, John had already left Jerusalem by 57 CE and was preaching Christianity in Asia Minor, where he headed the Church of Ephesus and other nearby communities. He was persecuted by Emperor Domitian (51–96 CE), who knew of his fame and had him summoned to Rome. After ordering his head shaved to mock him, the emperor had him dipped into a cauldron full of boiling-hot oil before the Latin Gate. John came out unhurt. He was then exiled to Patmos, an island in the Sporades Archipelago, about 45 miles from Ephesus. There, in a cave, the saint received visions, which he collected in Revelation, the only prophetic book of the New Testament and the last of the Church-sanctioned sacred books. In art, John has been usually portrayed in the act of writing, inspired by the Virgin. After the death of Domitian, John made his way back to Ephesus, where he died around 104 CE.

Hans Burgkmair
Saint John the Evangelist in Patmos
1508
Alte Pinakothek, Munich

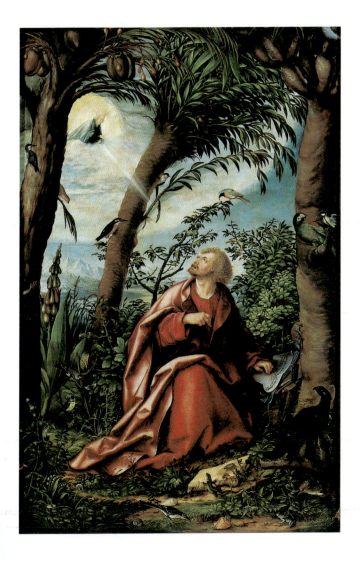

The Virgin Appears to Saint Nicholas of Myra

Elected bishop of Myra—an ancient city in Asia Minor—for the merciful and charitable qualities he had exhibited since childhood, Nicholas (270–346) was revered as a saint while still alive, on account of the many miracles he performed. According to traditional belief, the Virgin appeared twice to him: The first apparition took place before his ordination to the priesthood; the second was in 325, while he celebrated Mass at the end of the Council of Nicaea. In both apparitions, the Virgin exhorted him to continue his spiritual mission. At the Council of Nicaea, Nicholas had strongly supported the doctrine of the divinity of Christ. Saint Nicholas is the patron saint of Bari in Italy. The basilica dedicated to him is still a major destination of pilgrimages.

(Jacopo da Varagine, *Legenda Aurea*)

Antonello da Messina
San Cassiano Altar
1475–76
Kunsthistorisches Museum, Vienna

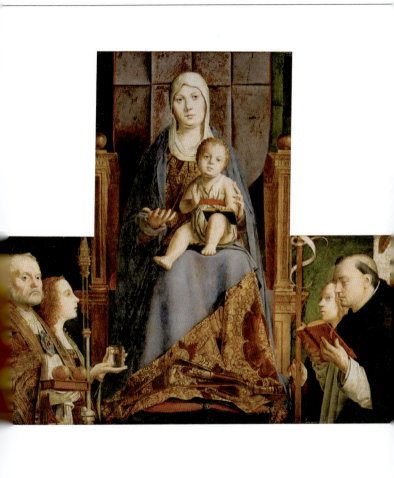

The Mystic Marriage of Saint Catherine

According to Jacopo da Varagine's *Legenda Aurea*, Catherine (*c.* 282–*c.* 305) was the young, attractive daughter of the king of Costas. Having betrothed herself to Christ, she refused to marry Maximinus Daia, governor of Egypt. To trick her, Maximinus subjected her to a debate with the scholars of the kingdom, who vainly tried to convince her to worship idols and renounce her Christian faith. But Catherine brilliantly contradicted the philosophers and orators; this so enraged the governor that he immediately had them burned at the stake. Catherine dauntlessly upbraided Maximinus's policy, especially his persecution of Christians, and for this was imprisoned and left to starve. According to one legend, for twelve days the saint was nourished by a dove sent by God. The governor decided to torture her on the wheel, but God miraculously broke it and saved Catherine. In the end, she was beheaded, but because of this miracle, the spiked wheel became her attribute. (Jacopo da Varagine, *Legenda Aurea*)

Michelino da Besozzo
The Mystic Marriage of Saint Catherine of Alexandria in the Presence of Saint John the Evangelist and Saint Anthony Abbott
c. 1420
Pinacoteca Nazionale, Siena

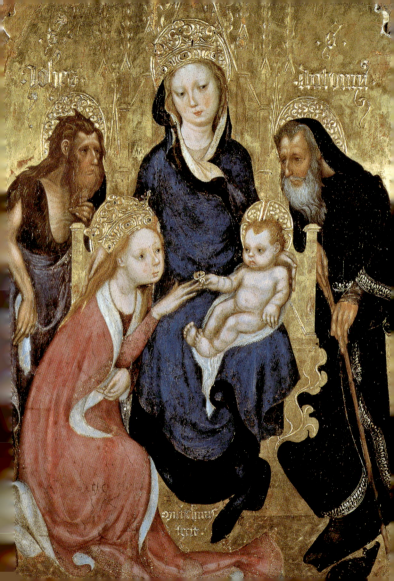

The Mystic Marriage of Saint Catherine

While little historical and biographical documentation exists about Saint Catherine of Alexandria, her life has been enriched by a trove of legends that have inspired several iconographic themes. Among these, the best known is the legend of her mystical marriage and the ring that Christ gave her directly. This iconography first appeared in the fifteenth century, perhaps because the attribute of the spiked wheel was sometimes painted so small that it resembled a ring. Here Jesus is on his Mother's lap; Mary symbolizes virginity, also an attribute of the saint, and the Church, which is the preeminent bride of Christ.

(Jacopo da Varagine, *Legenda Aurea*)

Giulio Cesare Procaccini
The Mystic Marriage of Saint Catherine
1620
Pinacoteca di Brera, Milan

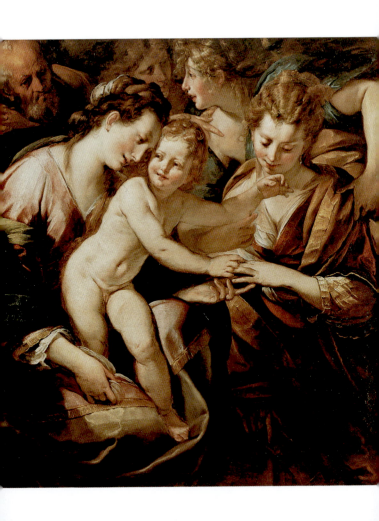

The Virgin Delivers the Chasuble to Saint Ildefonse

Ildefonse was born in Toledo, Spain in 606, while the city was held by the Visigoths. Although his family had ambitions for him, he decided to flee and become a Benedictine monk. When the bishop of Toledo died, Ildefonse was asked to take his place, and he reluctantly left his chosen life of contemplation, although he continued to study and write about the Virgin, to whom he was deeply devoted. A refined writer, he penned several treatises and composed well-known liturgical prayers to the Madonna. Ildefonse wrote about prodigious events, such as the miracle that took place during a solemn celebration on August 15, 660, when the Virgin appeared to him in the rectory of the cathedral: Praising him, she gave him a precious liturgical vestment—the chasuble—for him to wear to celebrate the mass. He died in Toledo in 667, and he became that city's patron saint.

Bartolomé Esteban Murillo
Descent of the Virgin for Saint Ildefonse
1660
Museo del Prado, Madrid

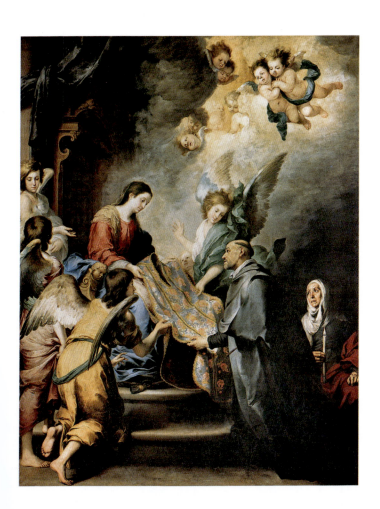

The Virgin Delivers the Chasuble to Saint Ildefonse

After his death, Ildefonse's followers clamored for him to be made immediately a saint. His name has always been linked to the Blessed Virgin Mary. The great masters of the Spanish Golden Age, such as El Greco, Velázquez, Murillo, Zurbarán, and many others, painted his likeness. As art is often a mirror of people's sentiments, such as their devotion to the Madonna and the saints devoted to her, throughout Europe, Ildefonse has always been portrayed next to the Virgin Mary. Ildefonse was one of the strongest upholders of Mary's virginity and wrote passionately about the subject.

Master of Saint Ildefonse
The Virgin Presenting the Chasuble to Saint Ildefonse
late 15th century
Musée du Louvre, Paris

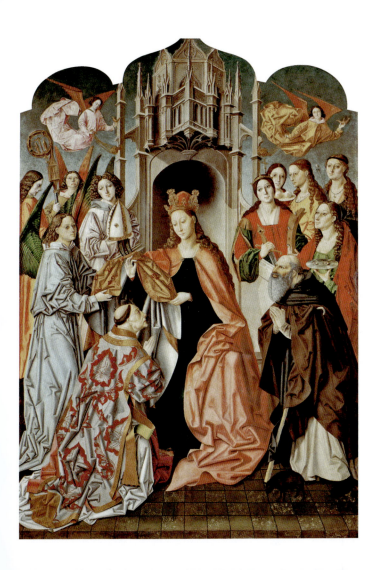

The Virgin Appears to Saint Bruno

Bruno (1030–1101) was a canon of Reims Cathedral who, beginning in 1056, held several important religious posts. In 1067, he was appointed archbishop of Reims. Manasses de Gournai, an apparently pious and devout prelate, also lived in the city; when he died, the whole town was shocked by a portentous event: The corpse of the prelate awoke, confessed his sin of simony, and revealed that he had been consigned to Hell. Deeply disturbed by the event, Bruno fled Reims for a hermit's life. With six companions, he moved in 1084 to the diocese of Grenoble, where Hugh of Châteauneuf, bishop of Grenoble, offered them a plot of land in Chartreuse in the Dauphiné Alps; there he founded the Carthusian order and built an oratory that soon became the mother house of the order. Medieval legends about this saint abound. One well-known tradition recounts that Bruno had been summoned to Rome by Pope Urban II, who needed his help. Bruno wanted to continue his hermit's life, but the Madonna and Child appeared to him and persuaded him to accept the difficult post.

Daniele Crespi
The Virgin and Saint Peter Approve the Rule
from *The Life of Saint Bruno*
1628–29
Certosa di Garegnano, Milan

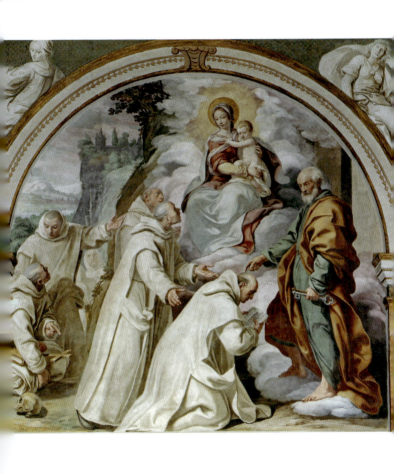

The Virgin Appears to Saint Bernard

Saint Bernard (1090–1153) was the son of a wealthy and noble family in Fontaines, France. At the age of 22, with 30 companions, he entered the Benedictine order in the new monastery of Cîteaux. Three years later he was asked to found a new convent in a secluded area of Clairvaux. Criticized for his harsh, rough manners, he nevertheless improved the monks' living conditions by reducing the time for prayer and improving their diet. The saint was a prolific writer of sermons, letters, and treatises on topics such as grace and free will, baptism, and bishops' duties. He is best remembered, however, for his affectionate writings about Mary the Mother of Jesus, whom he called "the mediator of graces," even though he refused to accept the doctrine of the Immaculate Conception. He died in 1153 and was sanctified by Pope Alexander II in 1174. (Saint Bernard of Clairvaux, *Sermons on the Madonna's Feast Days*)

Filippino Lippi
Apparition of the Virgin to Saint Bernard
1486
Badia Fiorentina, Florence

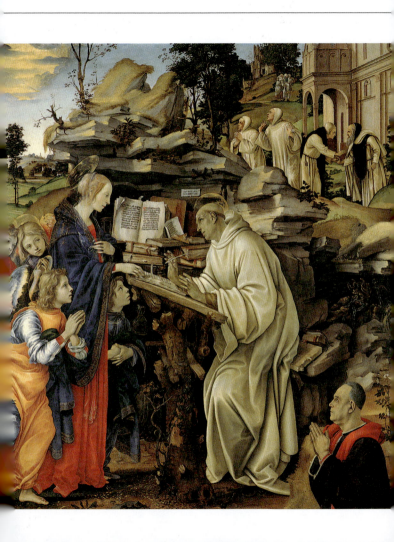

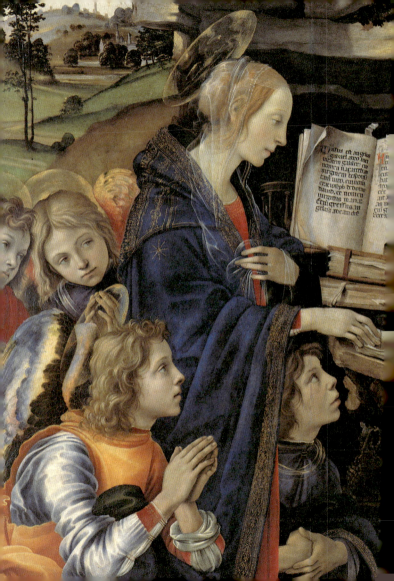

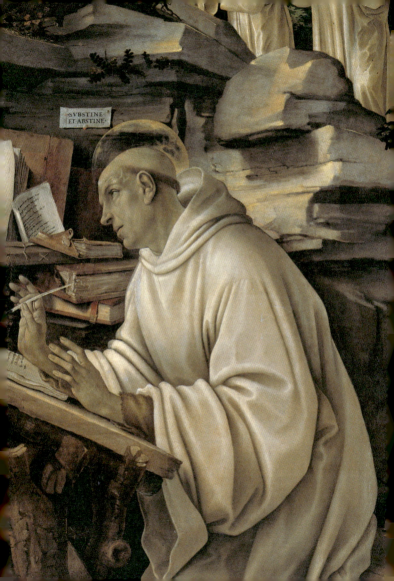

The Virgin Appears to Saint Bernard

Devotees of this Father of the Church believed that his written word, "as sweet as honey" (Saint Bernard was known as the *doctor mellifluus*), was directly inspired by the Virgin. For this reason, many works of art depict Bernard being visited by the Madonna, who gives him courage in times of weakness and inspires his sermons and homilies. Sometimes he is depicted with his attribute, the large white dog that his mother had seen in a dream. In the dream, Bernard's mother was carrying the dog in her womb; the meaning was that a dog would come to guard the house of God and bark at evildoers.
(Saint Bernard of Clairvaux, *Sermons on the Madonna's Feast Days*)

Giovanni Pietro Brago
The Virgin Mary Appears to Saint Bernard of Clairvaux
from the *Sforza Hours*
Miniature
c. 1490
British Library, London

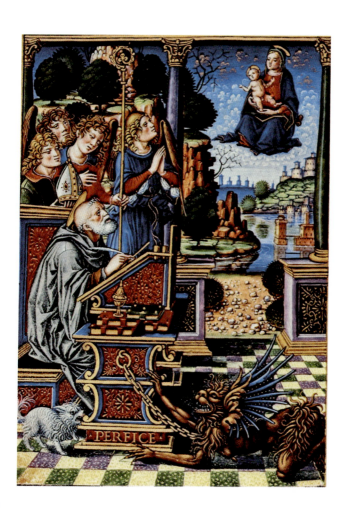

PERFICE

The Virgin Appears to Saint Dominic

Born in 1170 in Caleruega, a Spanish mountain village, Dominic intended to bring the clergy back to a more austere way of life. With this mission in mind, he founded a preaching order in Toulouse that followed the Augustinian Rule. The order engaged in itinerant preaching and lived on alms. Exhausted by apostolic activity and weakened by intense bouts of penance, he died in the Bologna convent on August 6, 1221, surrounded by his friars. Mary appeared frequently at Saint Dominic's side, inspiring and protecting him in his efforts to combat the Albigensian and Waldensian heresies. In one of her apparitions, Mary pointed to the Holy Rosary, suggesting that it be used against the enemies of Christianity, and always urged him to contemplate the mysteries of the faith. (Jacopo da Varagine, *Legenda Aurea*)

Guido Reni
Madonna of the Rosary
1596–98
San Luca, Bologna

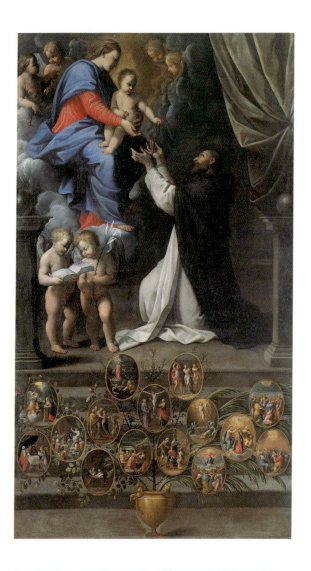

The Virgin Appears to Saint Francis of Assisi

Mary's apparition to Saint Francis (c. 1182–1226) is linked with the episode of the saint and his followers receiving the small church known as "Porziuncola" near Assisi—which was to be the seat of Francis' newly founded order— from the Abbott of the Subiaco Benedictine friars. There Francis spent the night in prayer and had a vision of Jesus and Mary, escorted by many angels. The Virgin explained that they had come simply to show their predilection and affection for this place from which many graces would issue forth. And in fact, the Porziuncola was approved by Pope Honorius III in 1223 as the seat of the Franciscan order. Francis died there in 1226; he later became the patron saint of Italy.

(Jacopo da Varagine, *Legenda Aurea*)

Orazio Borgianni
Vision of Saint Francis
(detail)
1608
Antiquario Comunale, Sezze

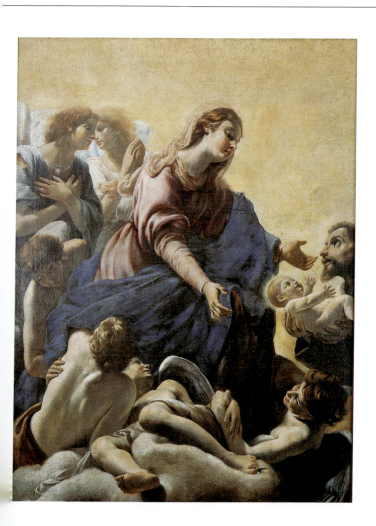

The Virgin Appears to Saint Anthony of Padua

Saint Anthony of Padua (1195–1231) entered the convent at the age of 12. He later traveled to Morocco to preach the Gospel there. After falling ill, believing it was a sign from God, he left to return to Europe, but the boat that was taking him back to his homeland was wrecked near Messina. Anthony survived the shipwreck; he sojourned in Sicily for some time in a Franciscan convent, where Mary and Jesus appeared to him in all their majesty and pointed out the spiritual journey on which he was to embark. Inspired by the apparition, Anthony began to walk toward Assisi, where he arrived on Easter Sunday, 1221, and where he attended the Franciscan assembly held on May 30, the day of the Pentecost. He entered the Franciscan retreat of Montepaolo near Forlì, in the Franciscan province of Romagna. There he became an ardent preacher, traveling throughout northern Italy. Anthony was canonized a saint by Pope Gregory IX in the Spoleto Duomo on May 30, 1232.

(Jacopo da Varagine, *Legenda Aurea*)

Anton van Dyck
Virgin and Child with Saint Anthony of Padua
c. 1630–32
Alte Nationalgalerie, Berlin

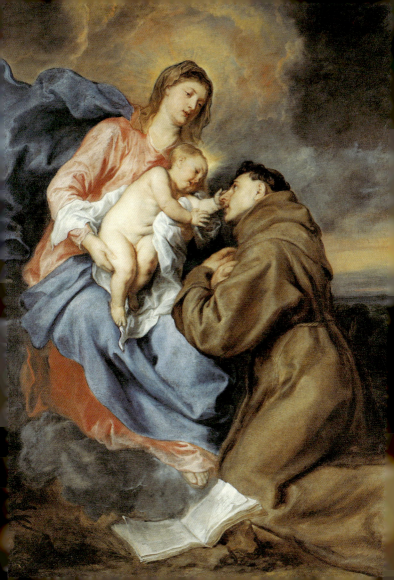

The Virgin Appears to Saint Simon Stock

Saint Simon Stock (1165–1265) was born in Kent, England. He initially lived as a hermit in England, then entered a Carmelite convent and became their celebrated leader. He was famous for his extreme devotion to the Virgin Mary. The cult of this saint is associated with a number of miracles that occurred after his death in 1265, and a legend that began to circulate in the Netherlands in the fifteenth century. According to this legend, the Virgin Mary appeared to one Saint Simon wearing the scapular, promising that anyone who wore it at the time of death would receive eternal salvation. Over time, the Christian tradition recognized this as the story of the Saint Simon Stock. Several artists have depicted the episode of the vision of the scapular, although the information is not historically reliable. Still, the scapular has remained for the Carmelite friars a sign that Mary, the Mother of Mercy, protects them.

(Jacopo da Varagine, *Legenda Aurea*)

Giambattista Tiepolo
Apparition of the Virgin to Saint Simon Stock
1749
Scuola Grande dei Carmini, Venice

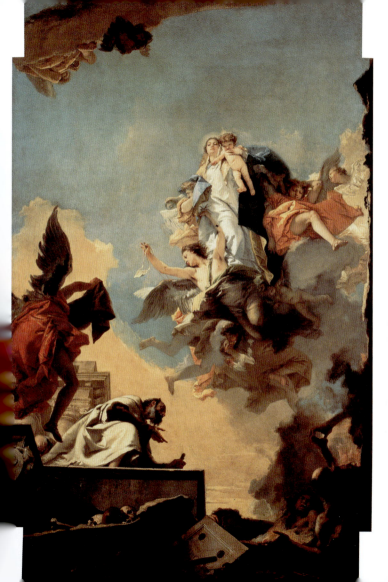

The Visions of Saint Bridget of Sweden

Born in Finstad, Sweden, in 1303, Bridget came from an aristocratic family. She had her first vision of the Virgin when she was seven years old. At the age of 14, she was given in marriage to the wealthy Ulf Gudmarrson, with whom she had eight children. After she was left a widow, Bridget turned to an ascetic, contemplative life and took an ash-gray habit as a symbol of poverty and penance. In these years she experienced many visions, which she called "celestial revelations," while in a state of ecstasy. Upon awakening, she would transcribe them with the help of her confessor. Bridget received numerous messages from Mary, which she transcribed in her writings. They affirm the truth of the Immaculate Conception, of Mary's divine maternity and of her role of co-redeemer of humankind. Bridget's language is rich with suggestive biblical symbols attributed to the Virgin such as the lily, the burning bush, the Ark of the Covenant, and the lamp. She died in 1373. (Bridget of Sweden, *Revelations*)

Vision of Saint Bridget of Sweden
from the *Revelations of Saint Bridget*
Miniature
late 14th century
The Morgan Library & Museum, New York

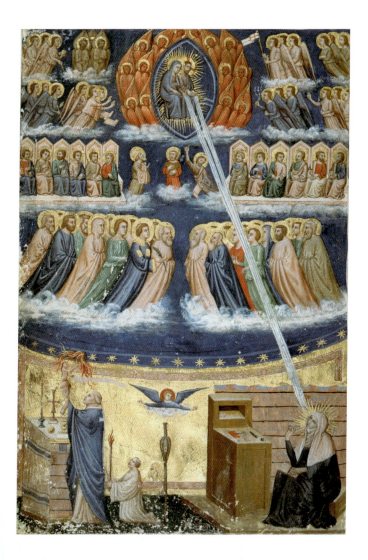

The Virgin Appears to Saint Sergius of Radonež

After spending eight years as a novice, Sergius of Radonež (1320–83) was tonsured and made a monk by the name of Seraphim. The Virgin appeared to him before he took his vows, to reassure him that even after his passing she would still protect the convent that he was to found in Rostov. When Sergius was made a deacon, his superiors gave him permission to live as a hermit in a forest, where he would spend his days praying, doing physical work, and meditating on the Scriptures. Legend has it that the Devil, furious at being defeated by the saint's prayers, sent three thieves his way; angered because they had found no money, they beat him with clubs and left him for dead. The saint had not tried to parry the blows but had offered his body up to martyrdom, thinking only of the Passion of Jesus. After the thieves left, he dragged himself to the monastery, where he was miraculously healed by an apparition of the Virgin, similar to the one he had received years before. Unfortunately, the beating left him misshapen and he henceforth had to walk with a cane.

Moscow or Pskov school
The Apparition of the Mother of God to Saint Sergius of Radonež
16th century
Intesa Sanpaolo Collection,
Gallerie di Palazzo Leoni Montanari, Vicenza

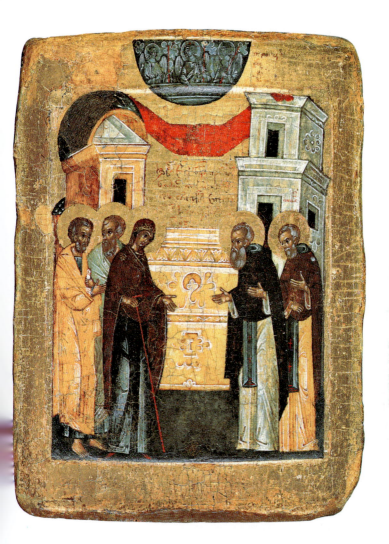

The Virgin Appears to Saint Bernardino of Siena

Saint Bernardino (1380–1444) was born in Massa Marittima, Tuscany. Orphaned at a young age, he was raised in Siena by two aunts. At the age of 22, he joined the Franciscan Order and became a reformist leader of the Observant Franciscans. The Virgin Mary appeared to Bernardino after he had been ordained priest and had been asked to preach to the common people. She promised him that he would convert sinners through his word and his miracles. Starting in 1417, Bernardino brought his extraordinary preaching to the people. His mission was marked by a special devotion to Mary and the veneration of the name of Jesus (with the use of the acronym IHS inspired by the Franciscan Spiritualists, who were the first to develop a mystical theology of the name of Jesus). Elected vicar-general of the Franciscan Order, he attended the Council of Florence, where he supported reuniting Rome with the Orthodox Christians. He was also active in the disputes between Guelphs and Ghibellines. He was canonized in 1450.

Benedetto Bonfigli
Gonfalon
1465
Galleria Nazionale dell'Umbria, Perugia

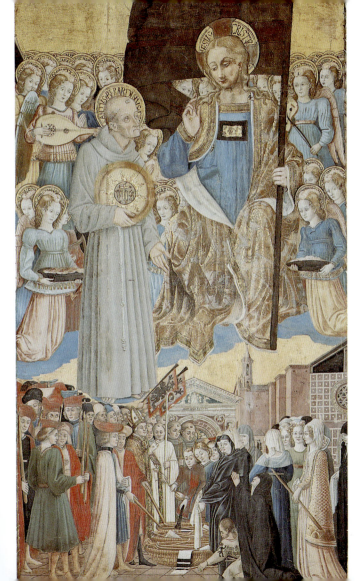

The Virgin Appears to Saint Frances of Rome

Frances (1384–1440) was born in Rome and grew up to be a Christian wife and mother. She experienced numerous mystical apparitions of her guardian angel, saints, and the Virgin Mary, to whom she was very devoted. Frances dictated 96 visions of the Virgin to her confessor. In 1425, during the papacy wars in Rome, she founded the Oblates of the Olivetan Monastery of Santa Maria la Nova, which was officially approved in 1433. The order later changed its name to Oblates of Saint Frances of Rome. Frances continued to live at home even after the approval, but when her husband died in 1436, she took the helm of the congregation. This mystic saint died on March 9, 1440, while reciting the Vespers to the Virgin, which she had been wont to do since childhood. She was canonized in 1608.

(Frances of Rome, *Visions*)

Orazio Gentileschi
The Vision of Saint Frances of Rome
1615–19
Galleria Nazionale delle Marche,
Urbino

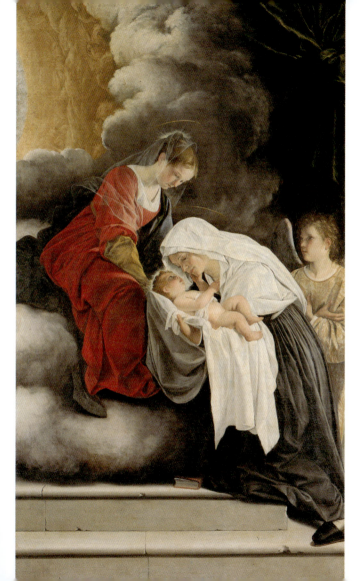

The Vision of the Blessed Amadeo Mendez da Silva

The blessed Amadeo Mendez da Silva (1420–82) hailed from a noble Spanish family with Jewish roots. He entered the Franciscan Order in 1455; upon being ordained, he celebrated his first Mass in the Oreno Convent near Milan on March 25, 1459. He is responsible for the Amadeite reform of the Franciscans. He later moved to Rome and became confessor to Pope Sixtus VI. While in Rome he wrote the *Apocalypse Nova*, a text that describes his mystical revelations. The image of the Virgin rising from the manuscript is an example of mediation between Jewish and Christian thought, with the Virgin exalted as the Seat of Wisdom. Leonardo da Vinci, who lived in Milan while Mendez da Silva was there, was deeply inspired by the *Apocalypse Nova*.

(Amadeo Mendez da Silva, *Apocalypse Nova*)

Pedro Fernández
*Vision of the Blessed Amadeo
Mendez da Silva*
c. 1513–14
Galleria Nazionale di Arte Antica,
Palazzo Barberini, Rome

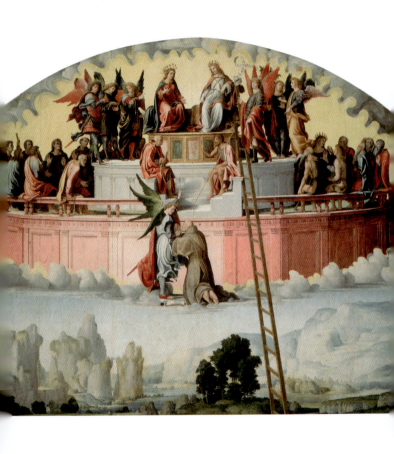

The Virgin Appears to Saint Philip Neri

Saint Philip Neri (1515–95) was the son of a Florentine notary from the upper crust of society. He received a good education and apprenticed in his father's study. Influenced by the Dominican friars of the San Marco Convent and the Benedictines of Montecassino, at the age of 18 he left his father's practice and moved to Rome, where he lived as a lay friar for 17 years. In those years he prayed intensely, especially at night, in the Catacomb of Saint Sebastian. There, in 1544, he experienced the ecstasy of divine love, which was believed to have left a permanent physical mark on his heart. In 1551, Philip was ordained to the priesthood and moved to the religious boarding house of San Gerolamo, where he soon acquired a reputation as a confessor, for he was believed to be able to read one's heart. He worked tirelessly to keep young people from falling into evil ways and, to that end, founded an oratory in Rome that offered spiritual readings, lauds, and the opportunity to do charitable work.

Guido Reni
Saint Philip Neri in Ecstasy
c. 1614
Santa Maria in Vallicella, Rome

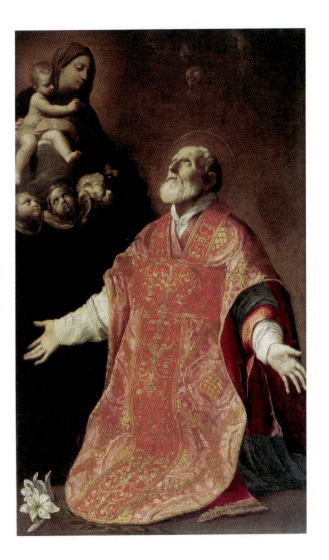

The Virgin Appears to Saint Philip Neri

Traditionally, Saint Philip Neri has been depicted experiencing the vision of the Virgin and Child. In 1575, when Pope Gregory XIII entrusted him with the ancient church of Santa Maria in Vallicella—a half-buried ruin of a building— Philip decided to demolish and rebuild instead of repairing it. With faith and determination, he overcame many obstacles and disputes. He claimed that he had made a pact with the Virgin that a new church would be built before his death; in fact, the building received a new roof and housed the priests in 1577, but would be consecrated only in 1599, four years after the saint's death.

Giambattista Piazzetta
The Virgin Appearing to Saint Philip Neri
1725
Santa Maria della Fava, Venice

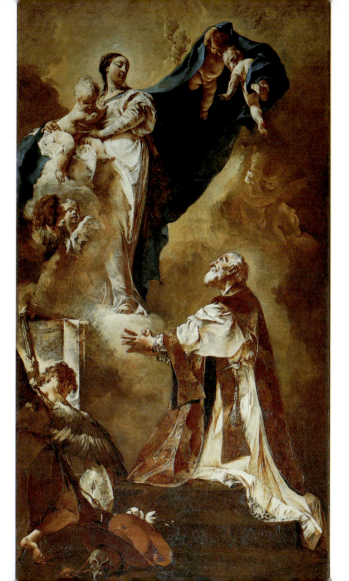

Saint Mary Magdalene de' Pazzi Receives the Veil of Purity

Caterina Lucrezia de' Pazzi was born in 1566 in Florence. At the age of sixteen, she entered the Carmelite Convent of Santa Maria degli Angeli and took the name of Mary Magdalene. She fell into ecstasy many times in her first five years at the convent, experiencing suspensions of consciousness and even miming scenes. Her out-of-body experiences are described in five manuscript volumes, in which her companion sisters recorded her gestures and words. In later years, she would also hear voices from above asking her to promote a renewal of the Church. The Madonna, appearing to her, gave her a veil, symbolizing her purity. She died in 1607 after a long illness, and her body rests in the monastery in Florence that was named after her.
(*The Complete Works of Saint Mary Magdalene de' Pazzi, Carmelite and Mystic*)

Guido Cagnacci
Madonna with Child, Saint Andrew Corsini, Saint Theresa of Avila, and Saint Mary Magdalene de' Pazzi
1630
San Giovanni Battista, Rimini

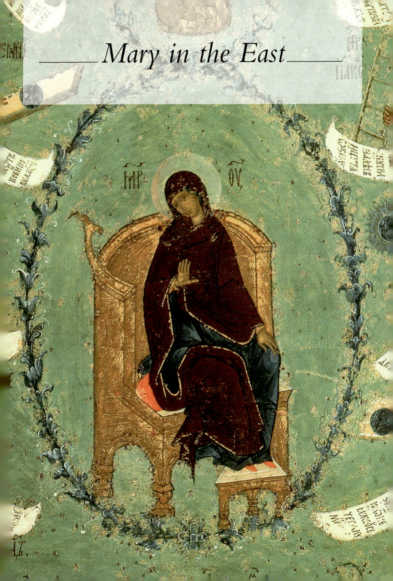

Mary in the East

The Lauds of the Mother of God

An icon (from the Greek *eikon*, or "image") is a sign of the presence of the divine on Earth. At the end of the iconoclastic wars, artists in Eastern Christendom were no longer permitted to freely follow their inspiration. Rather, they had to work within exact prototypes, especially concerning the images of Christ and the Virgin. A tradition of the Eastern Church holds that Saint Luke painted three portraits of the Virgin, which in turn became the models for the three main iconographic types of the Madonna: *Odigitria*, *Eleousa*, and *Hagiosoritissa*. Starting from these prototypes, the production of icons expanded to seven Marian types, each in turn with many variants. The icon of the Lauds of the Mother of God, however, falls outside these categories: Being of a more general nature, it was modeled on the *Akatisto*, one of the more popular hymns in Eastern Christendom.

The Lauds of the Virgin
16th century
Cathedral of the Dormition,
Kremlin, Moscow

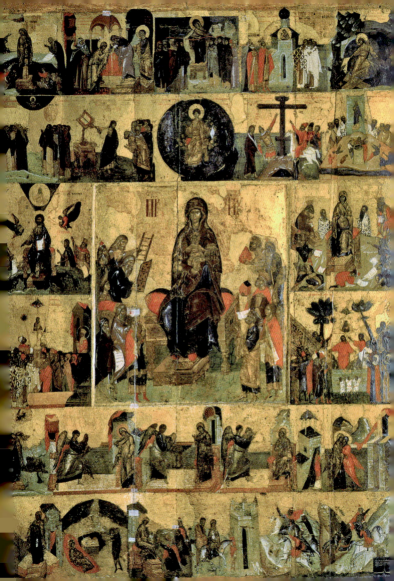

The Lauds of the Mother of God

Akatisto is an acrostic hymn (each line or section begins with a letter of the Greek alphabet), to be sung standing. Written by Roman the Melode in the fifth or sixth century, it is comprised of 25 sections that narrate episodes in the life of Mary. Over time, this hymn inspired the unusual icon of the Lauds of the Mother of God. In the center is the Virgin sitting on a throne, encircled by a garland. In a smaller oval on top is the blessing Christ. The Virgin is surrounded by the Old Testament patriarchs and prophets who had announced the coming of the Savior through Mary: Habakkuk, Jeremiah, Aaron, Moses, David, Ezekiel, Jacob, Gideon, Daniel, and Isaiah. They praise the Virgin with the words of their prophecies, which appear on the scrolls in their hands. Each one also holds his attribute: the burning bush for Moses, the Ark of the Covenant for David, the fleece for Gideon, and so on. In the bottom register, under Mary's throne, is Balaam, a pagan seer who had also prophesied the coming of the Messiah.

The Lauds of the Virgin
16th century
Russian State Museum,
Saint Petersburg

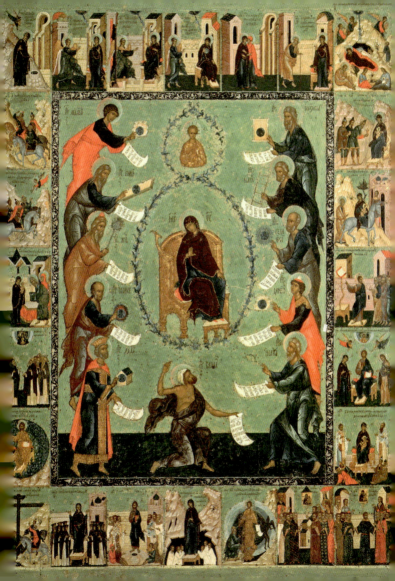

The Madonna Brephocratousa

Brephocratousa means "Mother with Child," or "she who carries the Child." This generic icon shows Mary holding Jesus in her arms, a simple representation of a mother and child, although the gold background marks the divinity of the two figures in the celestial glory of the Trinity. The unity of Mother and Child also connotes the cosmic meaning of the spiritual alliance between the Creator God and His creatures: a covenant reestablished by Jesus through Mary's co-redeeming action. There is also an ecclesial connotation to the icon, in the sense that the Virgin, who is the image of the Church, is also the prototype of motherhood and, as such, the mother of all the faithful. Although the Child in her arms is painted on a smaller scale, his features are those of a grown man.

Moscow school
Mother of God of Vladimir
late 15th–early 16th centuries
Intesa Sanpaolo Collection,
Gallerie di Palazzo Leoni
Montanari, Vicenza

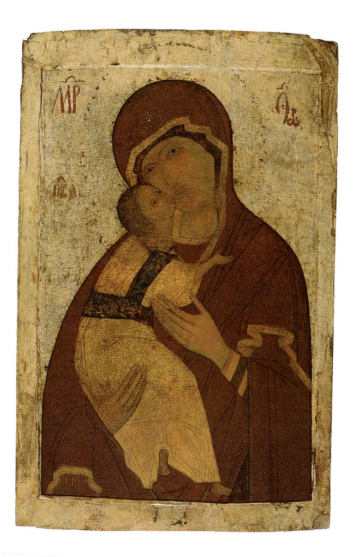

Mother *Théotokos*

Beginning with the *Brephocratousa* model, at least three variants developed that are closely linked to the figure of Mary or, rather, are derived from her three main attributes; the first of these variants is *Théotokos*, or "Mother of God." This became the foremost Marian title after the Council of Ephesus held in 431 CE, which affirmed the intrinsic mystery of the Incarnation. In response to the theory, pronounced by Nestorius for the first time in the fifth century, that it would be erroneous to proclaim Mary the "Mother of God," since it is inconceivable for a human being to generate a deity, the Council replied by concentrating on the physical procreation of Jesus, leaving the divine creation to God.

Attr. Onufer Qiprioti
Théotokos
16th century
Onufri Museum, Berat

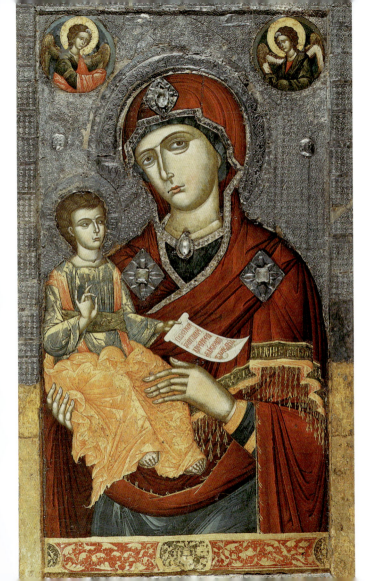

The Madonna Aeiparthenos

"Virgin" is Mary's second major title. *Aeiparthenos* means "always virgin" and alludes to her incorruptibility, symbolized by the veil or *maphorion* and the three stars that adorn her forehead and shoulders. The veil refers to chastity and modesty: It covers the head and shoulders, and in some icons the entire body of the Madonna. Over time, the veil became a required item of monastic clothing; because of this, Mary is considered the very first nun. The three stars are an ancient Syriac symbol of virginity that allude to the Madonna's integrity before, during, and after childbirth.

Icon of the Virgin and Child
c. 1204
Basilica di San Marco, Venice

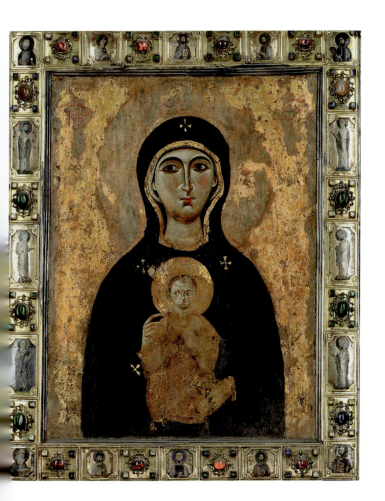

The Madonna Panagia

Mary's third title, *Panagia*, means "all holy," because she carries the *Panagion*—Jesus—in her arms. The Madonna rarely appears in icons without the Child: She either exhibits him gravely, holds him ever so lightly, or hugs him tenderly. In any case, the presence of Jesus embodies the mystery of the Incarnation. The Virgin's role of co-redeemer is also suggested by her over-sleeves, which evoke priestly garments and the Madonna's concelebrating role with Christ, the First Priest. The clearest symbol of her holiness is her halo; the three stars on her forehead and shoulders, symbolizing virginity, also designate the Holy Trinity.

Panagia Madonna
14th century
Byzantine Museum, Athens

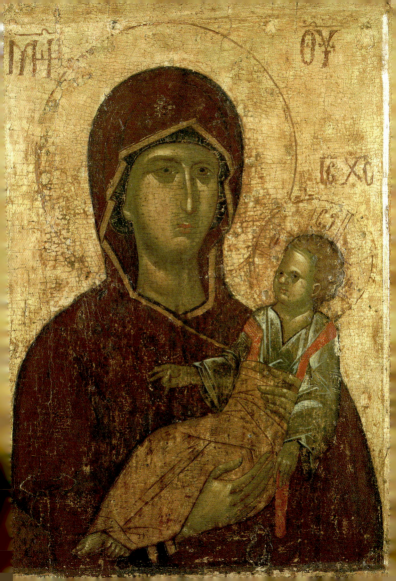

The Madonna Hodegetria

In the fifth century, one of the portraits of the Madonna painted by Saint Luke was given as a gift to Empress Pulcheria, who in turn donated it to a community of monks in Constantinople. These friars volunteered as guides to the blind, and because of this their convent was called "the Guides." Over time, the Virgin of this icon was called *Hodegetria*, which means "leader" or "she who shows the way," and a specific, codified iconography developed in which Mary is shown frontally, gazing at the onlooker; she holds the Child with her left arm and points to him with her right. She is shown either half- or full-length, sitting or upright; the model has many variations. Jesus is slightly turned toward his Mother; with one hand he holds a scroll, symbolizing wisdom, and with the other blesses the faithful. This Madonna is also called *Hodegetria* because she points to the way of salvation, which is Jesus.

Attr. Nikolaos Qiprioti
Madonna Hodegetria
16th century
National Museum of Medieval Art,
Korça

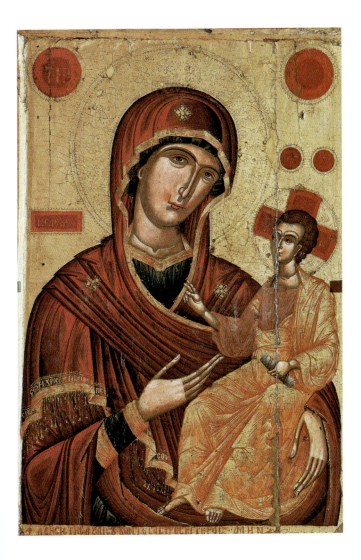

The Madonna Hodegetria Dexiocratousa

A variation of the *Hodegetria* Madonna is the *Dexiocratousa*, in which Mary holds the Son with her right hand instead of her left. The traits and posture of both iconographies are the same. Both project detachment and regality, conferring a fixed, hieratic quality to the composition. Jesus is depicted with a child's body and a man's face, suggesting both his divine wisdom and his future destiny of Passion and death. Mary shows the only way to God and to redemption, namely Christ. She points to her son as "the way, the truth, and the life."

Hodegetria
6th century
Saint Catherine's Monastery,
Mount Sinai

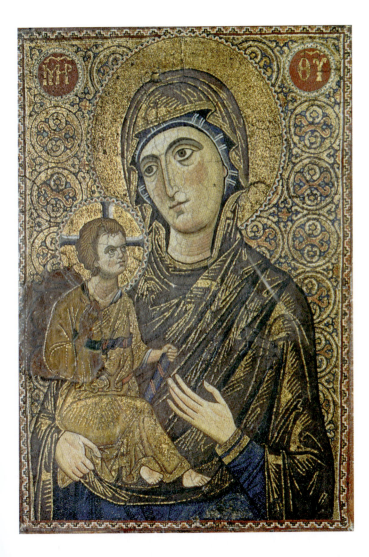

The Madonna Orans

Mary, a model of faith, represents the Church, the entire community of believers, whose mediator and advocate she is, interceding with God on their behalf. In some icons, she is shown pleading or praying, and this gave rise to the *Orans* model, from the Greek "she who prays." The icon shows her frontally, her open hands raised to shoulder height, her arms outstretched sideways but folded at the elbows. She invites the faithful to trust in Christ, to whom she turns. This pose is drawn from pagan antiquity; already used by Greeks and Romans, it was adopted by Christian worshipers from the outset, and is still used today.

Moscow school
*The Virgin of the Sign (Orans)
with Christ Emmanuel*
16th century
Mark Gallery, London

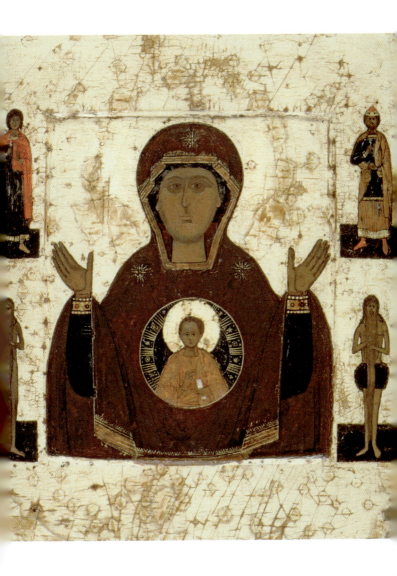

The Mother of God of the Sign

The prophecy of Isaiah about the coming of the Messiah gave rise to an unusual icon, developed from the *Orans* model: the Mother of God of the Sign. The Madonna is depicted half- or full-length, in an orant pose. She wears a shield that encloses Christ Immanuel, the Savior before his incarnation; in this way, she becomes the emblem of the Church that guards within itself the Word Incarnate, revealing it to humankind. At each side are seraphim, who are the ambassadors of the heavenly Host to humanity.

Mother of God of the Sign
17th century
Intesa Sanpaolo Collection

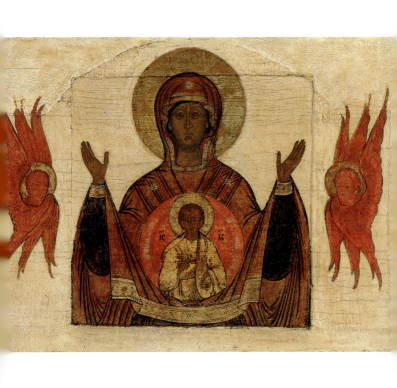

The Madonna Eleusa

The icon of the Madonna *Eleusa* (Greek for "tenderness") sheds the static, hieratic quality of the other iconographies, projecting instead feelings of intimacy and affection. The cheeks of the two figures are close, even touching: Jesus extends his arms to touch his Mother's neck, while Mary holds him lovingly. The Virgin has a sweet expression veiled by the melancholy prescience of her son's Passion and death. For this reason, this model has traditionally captured the moment when Jesus reveals to his Mother his future death and Resurrection. The union of Mother and Child could also symbolize the wedding of the Savior to the community of believers, here represented by the figure of the Mother-Church.

Novgorod school
The Mother of God of Tenderness
15th century
Intesa Sanpaolo Collection,
Gallerie di Palazzo Leoni
Montanari, Vicenza

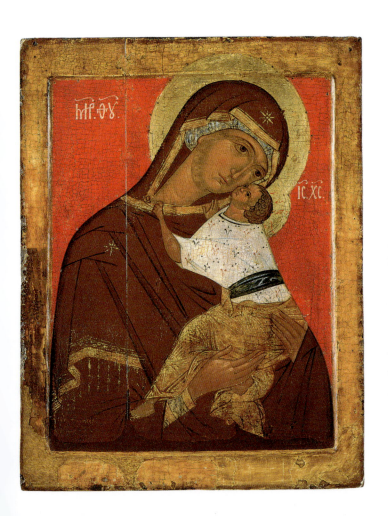

The Madonna Pelagonitissa

A variation on the *Eleusa* model, the Madonna *Pelagonitissa* exhibits more natural gestures and interplay between Mother and Child. The Child is restless in his Mother's arms, like any child, but the restlessness also expresses the deep fear and anguish provoked by the foreboding of his future Passion. The heightened expressivity of his face and posture project a visceral human quality, increasing the emotional involvement of the faithful who contemplate the divine mystery. This type of icon became popular in the Byzantine Empire starting in the eleventh and twelfth centuries.

Makarios Zographos
Madonna Pelagonitissa
1421–22
Zrze Monastery, Skopje

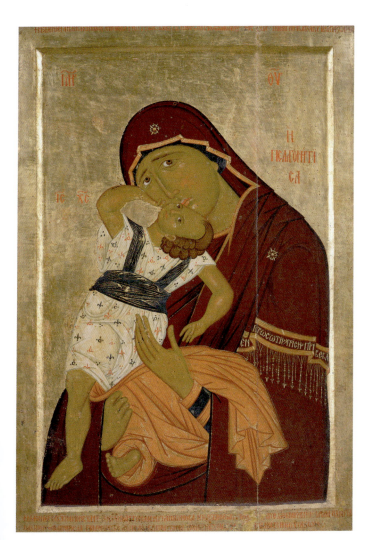

The Madonna Hagiosoritissa

In this iconographic model, the Madonna appears alone, without the Child. Her gaze is directed at the onlooker; even if her shoulders are turned slightly to the side, her arms open at breast height in a praying pose. This model is believed to have been drawn from one of the portraits that Saint Luke made of the Virgin, kept in the Chalcoprateia shrine in Constantinople, although it was lost during the iconoclastic wars. Apparently, the precious relic attributed to the Evangelist was kept in a sacred urn, or *Hagia Soros*, from which the name *Hagiosoritissa* was derived. The icon was also known as *Chalcopratissa*, from the name of the temple located near the *chalcos* ("copper market"), and as Madonna of the *Paraclisis*, which means "plea" or "prayer" in Greek.

Hagiosoritissa
1150
Cathedral, Freising

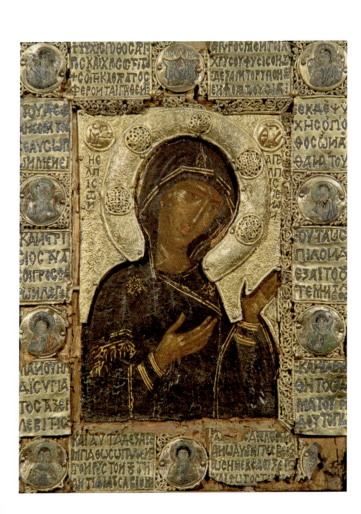

Blachernitissa

The icon of the *Blachernitissa* shows Mary in a variant orant pose that developed into an autonomous model because the prototype was kept and venerated in the Blachernae Shrine, the largest Marian temple in Constantinople. The original icon was probably lost in the fire that destroyed the shrine in 1433. A distinctive detail of this model are the garments: Mary's veil, or *maphorion*, is emphasized; the original was a famous relic that was kept at Blachernae. Before the shrine was destroyed, several miracles had been attributed to *Blachernitissa*, and as such the shrine was considered a holy bulwark that protected the city from enemies.

Virgin Oranta
c. 1224
Tretyakov Gallery, Moscow

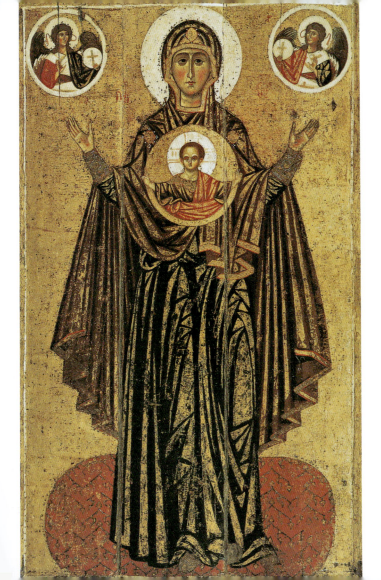

The Madonna Basilissa

Seated on a throne with the Child on her knee, Mary is surrounded by angels and saints in a pose characteristic of the Queen of the heavenly court. The throne represents the Madonna's regal glory; dressed as an empress (*Basilissa*), she hieratically gazes at the faithful. The Queen of Heaven is the most perfect of all human beings. But to the faithful she is also the Queen of Mercy, insofar as she is co-redeemer and advocate of humankind. This type of image was very popular in the early Christian churches, where it usually occupied the place of honor in the center of the apse.

Joan Athanasi
Madonna Basilissa
1777
Institute of Cultural Monuments,
Tirana

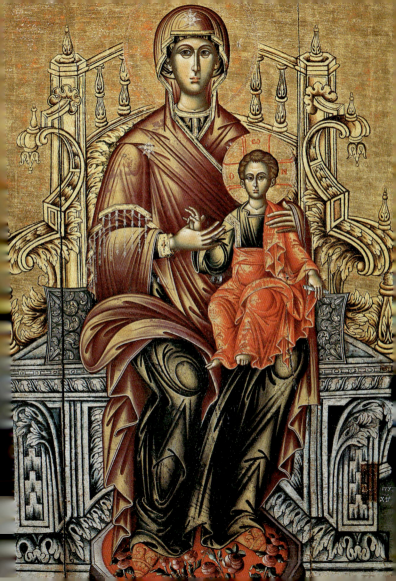

The Madonna Nikopeia

The Madonna *Nikopeia* is the best-known variant of the *Basilissa* image. Mary is shown at half-length. She holds tight to her chest with both hands a mandorla with the Christ Child inside. The two hieratic, stately figures gaze fixedly at the onlooker. The term *Nikopeia* means "she who brings victory" and is closely associated with the mystery of the Incarnation and of Jesus' redeeming work. The *Nikopeia* image was inspired by Nike, the Greek goddess of victory, who was portrayed in warrior dress with a shield in her hand. The aegis of the goddess has been replaced by the oval containing Jesus, the true bearer of redemption. The great popularity of this icon is due to the victorious meaning it suggests: First under the Byzantine Empire, then in the West, it became a bulwark of armies leaving for war.

"And the Word of God Was Made Flesh"
mid-19th century
Intesa Sanpaolo Collection,
Gallerie di Palazzo Leoni Montanari, Vicenza

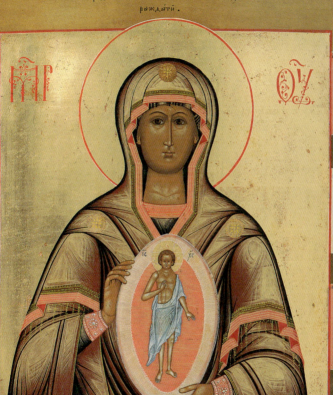

The Madonna Galaktotrophousa

The Madonna *Galaktotrophousa* (from the Greek *gala* or *galaktos*, which means "milk"), also known by the Latin name *Maria Lactans*, is the Madonna of Milk or the Breastfeeding Madonna. The icon emphasizes the Virgin's motherhood: She offers her breast to her son while lovingly holding him on her lap. The Child takes on the future Eucharistic meaning of his body and his blood as the bread and wine offered to the faithful. This composition was not widespread in Byzantium; it became popular in the West starting in the Middle Ages, in keeping with a gradual humanization of the divinity. Perhaps a reproduction of this subject is also linked to the story of the flight into Egypt and the alleged relic of the Virgin's milk: a crystallized drop of milk believed to have fallen from Baby Jesus' mouth.

Cretan school
The Virgin Lactans with Two Angels
15th century
Benaki Museum, Athens

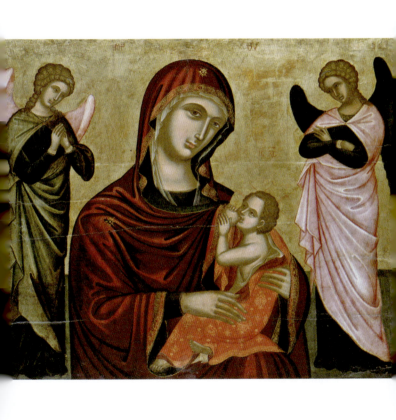

The Madonna of the Cut Mountain

"While you looked at the statue, a stone which was hewn from a mountain without a hand being put to it, struck its iron and tile feet, breaking them in pieces. The iron, tile, bronze, silver, and gold all crumbled at once . . . but the stone that struck the statue became a great mountain and filled the whole earth." Daniel's prophecy to Nebuchadnezzar, king of Assyria, inspired the image of Mary as the "inviolate mountain." The king had dreamed of a giant statue with a gold head, silver chest and arms, bronze stomach and hips, and iron and clay legs and feet. The stone that broke the giant sculpture was Christ; the mountain was Mary; and the different parts of the giant were the worldly kingdoms fated to succeed one another until the coming of the Savior, who would be born of a Virgin without human intervention. Thus this icon is rich in symbolism: On the Mother's chest, in addition to the mountain, is Jacob's Ladder; from the cut throne rise two green buds wound around two lit candelabra, symbolizing the burning bush, which burns without consuming itself. The seat rests on a garden that suggests the *hortus conclusus*, the enclosed garden that represents Mary's inviolate womb. (Daniel 2:34–35)

Russian school
Virgin and Child
16th century
Kolomenskoye Church, Moscow

548

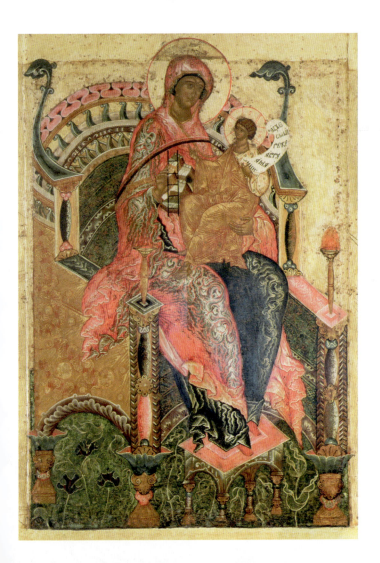

The Madonna Tricherousa

An icon endowed with thaumaturgic powers and the first *ex voto*, the Madonna *Tricherousa* ("three-handed") first appeared in the eighth century in Syria at the time of the iconoclastic wars. John Damascene, a valiant defender of the cult of images, was unjustly accused by the iconoclastic Emperor Leo III the Syrian, who had one of John's hands cut off. The saint spent the night praying before the icon of Mary, promising that if he were healed, he would continue his battle in defense of image worship. Mary appeared to him in a dream and reassured him. When he awoke in the morning, his hand was back in place. He gave thanks by hanging a silver hand on the icon. Starting from this episode, the iconography of the Madonna *Tricherousa* developed over time, until the third hand naturally extended from the mantle.

Workshop of Ivan Michajlovič Pachomov
Madonna Tricherousa
1807
Intesa Sanpaolo Collection, Gallerie di
Palazzo Leoni Montanari, Vicenza

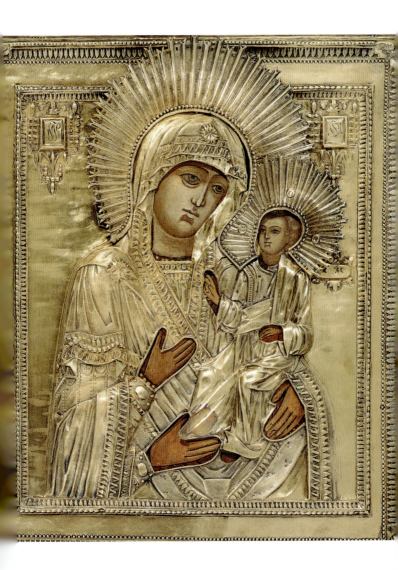

The Madonna of the Incorruptible Flower

A refined, aristocratic icon, the Madonna of the Incorruptible Flower began to appear in the modern age, starting in the seventeenth century. Crowned and dressed in rich, sumptuous garments, Mary appears as *Basilissa* holding Jesus, who is also dressed in regal clothing, wearing a crown and carrying a scepter and a sphere in his hands. Mary holds a flowering rod; buds and flowers surround the two figures, filling the scene with symbols of Mary's virginal, whole, and incorruptible status, such as the evergreen plants. Other elements, including the altar on which Jesus rests his feet, the heavenly palace, the open book, the garden, the gate to Paradise, the burning candle and the prayer censer all enrich the metaphorical contents of the scene.

Antonios Sigalas
Madonna of the Incorruptible Flower
1786
Byzantine Museum, Athens

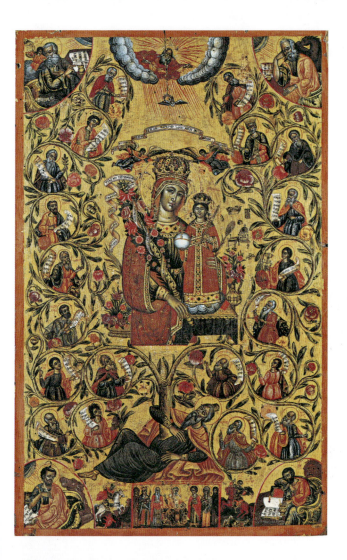

Mary
Through the Centuries

The Earliest Representations of Mary

Among the earliest surviving Marian representations is this interesting third-century wall painting of a female figure—usually identified as the Virgin—breastfeeding a child. At Mary's side is a male figure, probably a prophet, who points to a shining star above her head. The prophet figure could be Isaiah alluding to his prophecy about the birth of the Messiah. It could also be Balaam pointing to the rising star he had predicted: "There shall come a Star out of Jacob, and a Scepter shall rise out of Israel." In pagan and imperial images, the star represents the exalted position of the figures below. The symbol was appropriated in early Christian art to symbolize the grace pouring down on the Virgin from Heaven.

Madonna, a Prophet, and a Star
290
Catacombe di Santa Priscilla, Rome

The Earliest Representations of Mary

Compared to the early Marian figures in the Catacombe di Santa Priscilla, this *Orant Madonna* looks colder, more detached, less human. The image marks an important shift that would deeply affect early Christian figurative art; this anonymous artist was not interested in the prevailing style of realism, but in expressing sacredness. Seen frontally, Mother and Son are portrayed flatly, their arms open in a gesture that recalls the shape of the Cross. The two figures are repeating a popular gesture used by early Christians; as we know from the writings of Tertullian (*c.* 160–220 CE), in the second and third centuries people prayed with open, raised arms in memory of the crucified Christ. Everything in this image reinforces the hieratic quality of the figures and their detachment from the faithful: the frontal position, the fixed gaze, the flat, two-dimensional representation, the absence of movement. Deprived of volume, Mary's figure is not a realistic representation of a human being, but a symbol, an expression of the idea of divinity.

Madonna and Child
350
Cimitero Maggiore, Rome

Early Christian Art

The Basilica of Santa Maria Maggiore was erected in 432–440
by order of Pope Sixtus III. By then, Christianity had become
the state religion of the Roman Empire and the Church was
the principal art patron. In churches, mausoleums, and baptis-
teries, mosaic wall decorations were replacing frescoes. The
decoration of Santa Maria Maggiore's triumphal arch presents
the story of the childhood of Christ as narrated in the apo-
cryphal Gospels. On the left is the *Annunciation*, with
Mary sitting in front of her house, holding the temple's purple
curtain and surrounded by angels. The dove of the Holy Spirit
and the Archangel Gabriel hover above her. Richly clothed
like a Roman noblewoman, Mary gazes fixedly at the viewer.
Her face is totally devoid of feeling or expression: The large,
wide-open eyes are silent and her handsome face shows no
reaction to her divine destiny. The position of her body and
her hieratic posture directs the viewer's attention to the hea-
venly realm.

Annunciation
(detail)
5th century
Santa Maria Maggiore, Rome

Early Christian Art

In 402, the capital of the Western Roman Empire was moved from Rome to Ravenna, a seaport on the Adriatic that was closer to Constantinople, the capital of the Eastern Roman Empire. As a result, from the fourth to the sixth centuries Ravenna was adorned with new buildings decorated with images that reveal a shift from a Western, concrete conception of divinity, to an Eastern, transcendent one. The mosaics decorating the basilica of Sant'Apollinare Nuovo show an image of the Madonna sitting on a throne with the Son in her lap, flanked by four angels. These mosaic decorations in the early Christian era were also intended to increase the luminosity of the church: In addition to receiving direct sunlight from the windows, the faithful were also bathed in the reflected light of the mosaics' glass tiles. The hieratic composition, the gold background, and the detached gazes of Mary and Jesus—physically close yet spiritually distant from the angels—all contribute to heighten the sensation of being immersed in a transcendent, divine atmosphere.

Madonna Enthroned
between Four Angels
6th century
Sant'Apollinare Nuovo, Ravenna

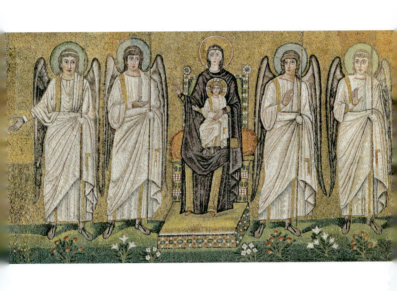

Early Middle Ages

After the Eastern Roman Emperor Justinian the Great conquered Rome in 552, the city continued its process of Christianization. Among other monuments, the Byzantines built the church of Santa Maria Antiqua, which was later buried in an landslide in 847 and unearthed only in the last century. The church's interior walls are decorated with a cycle of frescoes in which four successive stylistic phases have been identified. The frescoes in the chapel of a high dignitary are from the eighth century. This moving Crucifixion scene shows Christ with his eyes wide open, about to breathe his last breath (the *Christus triumphans* iconography—Christ triumphing over death—would later be derived from this detail). At the feet of the Cross is the apostle John and a grieving Mary. The latter, her hands to her face, meets her son's gaze in a wordless communion of suffering. The simplified use of line and color and the static quality of the figures are typical of Eastern art, supporting the theory that the artists had moved to Italy from Greece or Asia Minor in the wake of the iconoclastic wars. This representation of the Madonna's emotional outpouring is the first example of the *Mater Dolorosa* (Grieving Mother) iconography in Western art.

Crucifixion
8th century
Santa Maria Antiqua, Rome

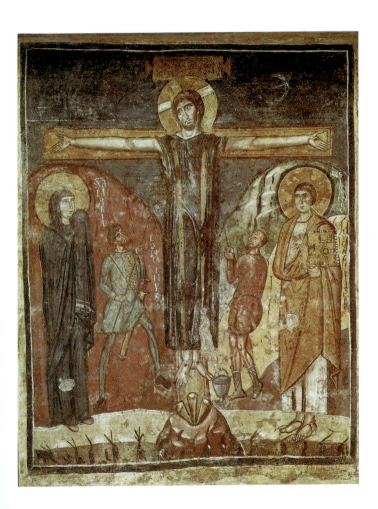

Early Middle Ages

Starting in the eighth century, the Carolingian expansion
wiped out the Barbarian kingdoms of the Italian Peninsula.
Charlemagne's domination of Italy was supported by the
Church. His reign fostered a gradual artistic rebirth after the
devastating Longobard occupation. To this period belongs one
of the most important surviving Early Medieval fresco cycles,
the work of an exceptional artist whose name has been lost.
This masterpiece is located in the small Church of Santa Maria
Foris Portas in Castelseprio near Varese. On the walls of the
main apse, in two registers, are episodes from Christ's child-
hood. This *Journey to Bethlehem* is set in an elaborate, carefully
conceived architectural and landscape field that is vastly differ-
ent from the customary golden Byzantine backgrounds. The
figures are brought to life by expressive, vibrant contour lines
that highlight the postures and the perspectival composition.
Old Joseph trudges along behind the ass carrying the pregnant
Mary; she looks at him sweetly, as if to reassure him that there
is no danger, because her childbirth is divine. The face of the
Madonna is very unlike the Eastern, iconlike depictions of
the time. These frescoes stand out for their animated, natural
qualities, unique in the art of the period, and must have been
created by a painter who was free to fully express his creativity.

Journey to Bethlehem
831–49
Santa Maria Foris Portas, Castelseprio

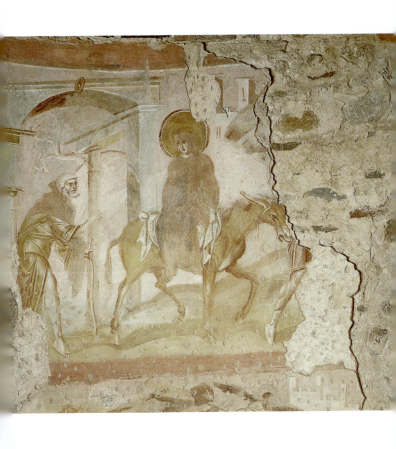

Early Middle Ages

In Early Medieval sculpture, reliefs are flattened and hard, without the volume and depth gained from chiaroscuro. They are crowded with ornamentation (following the trend of *horror vacui*—"fear of the void"), and there is often an asymmetrical use of space. A strong, expressive style developed, as exemplified in this *Visitation*, a relief from the altar of the Longobard Duke Ratchis. The figure of the Virgin and her cousin Elizabeth are aligned on the same plane; their forms and proportions are symbolic: Their heads are thinner toward the chin and wider in the forehead where reason, man's noblest aspect, resides. But the anti-naturalism of Byzantine art—expressed here through the figures' hard lines and lack of modeling—which served to go beyond the concrete, to attain the transcendental idea, here becomes a means to express immediacy.

Visitation
739–44
Museo Cristiano, Cividale

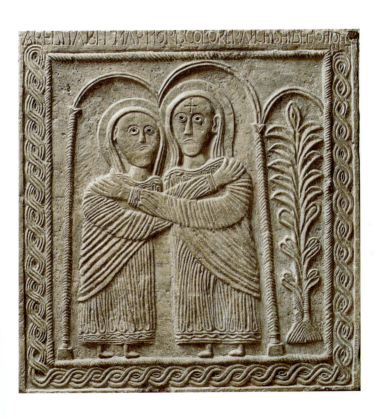

Romanesque Art

Having safely reached 1000, leaving behind the apocalyptic fears that had accompanied the approach of the millennium, there was a general sense of rebirth and a new, positive outlook on the future. New religious orders multiplied, most of them devoted to a specialized veneration of Mary, in answer to the growing importance of the role of the Mother of God in the hearts of the faithful. In art, new solutions were sought that might better express these changes. The mosaic in the apse of the Church of San Clemente in Rome is significant in this respect. Executed in the first half of the twelfth century, this *Triumph of the Cross* is filled with acanthus scrolls; in the center is the Crucifix with twelve doves symbolizing the apostles. The Cross stems from an acanthus plant from which spirals rise to fill the apse and curl around minor figures and motifs. On either side of the Cross are Mary and Saint John, who intercede with Jesus on behalf of the faithful entering the church. This is an adaptation of the Eastern *Deisis* model.

Triumph of the Cross
(detail)
12th century
San Clemente, Rome

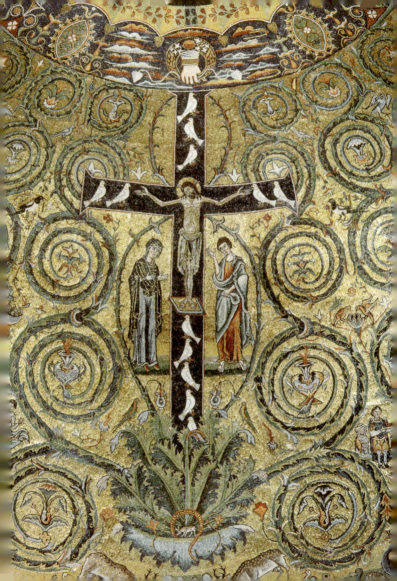

Romanesque Art

The *Deposition* painted in the crypt of the Duomo of Aquileia
is a true masterpiece of Romanesque art, completed at the end
of the twelfth century. The anonymous artist introduced for
the first time a type of Marian image that would become very
popular in the coming centuries: the *Pietà*. The Madonna, most
likely assisted by Joseph of Arimathea, takes in her arms the
body of the Son, who has just been deposed from the Cross:
His arms fall heavily to the ground and his chest is arched
in an unnatural pose. To one side of the central couple, the
devout women are weeping, and to the right are the suffering,
contrite faces of John and Nicodemus. A simple, clear, incisive
line delineates the outlines of the faces, giving them great
emotional expressiveness. The realistic color palette heightens
the pathos of the event—a definitive departure from the tran-
scendent, yet less emotional, depictions that had characterized
European art until then.

The Deposition of Christ
(detail)
late 12th century
Basilica, Aquileia

574

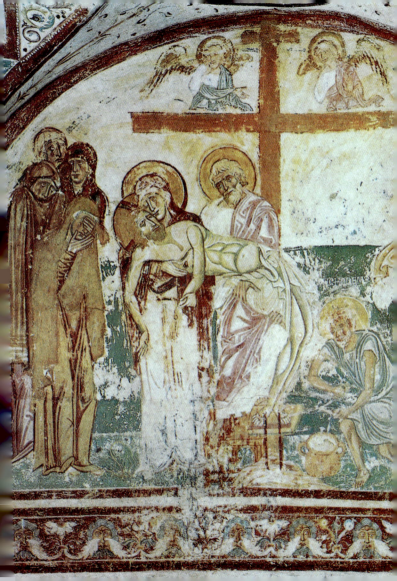

Romanesque Art

In the Romanesque period, sculpture became preeminent throughout Europe. Part of the medium's function was didactic, to show divine truths through images. As they listened to the priest, the faithful would look at the art and learn. For this reason, the Western Church disagreed with the Eastern Church's negative view of images. This controversy broke out in the iconoclastic wars of the eighth and ninth centuries, when most divine images were destroyed in the East. The West, on the other hand, always encouraged the depiction of the divine through the visual arts, such as this *Deposition* by Benedetto Antelami. In the upper corners are classical representations of the Sun and the Moon. The two female figures preceding the two groups—the Christians on the left and the pagans on the right—symbolize the Church and the Synagogue. The Madonna is to the left of the Church, her head bent to touch the hand of her son, who is about to be taken down from the Cross. Her garment and veil are rendered with pleats and dots—small holes made with the drill. This relief interprets the psychological reaction of each character; each gesture and pose expresses the emotions of the participants, but without theatricality, and the result is a composed, balanced, classical composition.

Benedetto Antelami
Deposition from the Cross
1178
Duomo, Parma

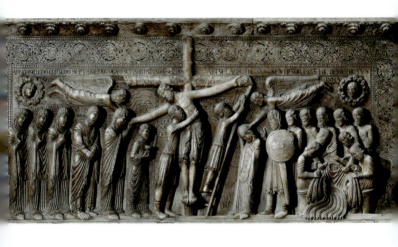

Romanesque Art

In Romanesque cathedrals, the sculptures decorating the portals, capitals, and pulpits were designed to be a true *Biblia Pauperum* (Poor Man's Bible), the Scriptures made understandable to the mostly illiterate masses. In this portal of the Saint Madeleine Basilica of Vézelay, the Madonna is at the center of the tympanum's upper register, in the act of showing the Son to the Magi. She is also in the lower register, in the Annunciation scene with the Archangel Gabriel. This relief is an example of the finest Burgundian sculpture of the time; expressive force and emotional tension are achieved through the movement of the figures and the rich drapery, with dynamic, intersecting lines that almost seem to oscillate.

The Childhood of Christ
12th century
Saint Madeleine Basilica, Vézelay

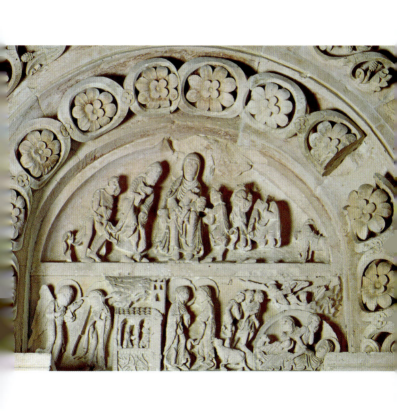

Gothic Art

In Europe, the end of the thirteenth century marked the birth
of an iconographic renewal in all the arts: architecture, sculp-
ture, painting, and the decorative arts, including illuminations
and stained glass. This change was characterized by the tran-
sition to a new visual language—called "Gothic" in reference
to the Barbarian kingdom of the Goths—that was fluid, dyna-
mic, and more human. These changes were accompanied by a
renewed cult of the Virgin, whose figure became more central
in sacred art. In this period, churches and cathedrals became
more vertical, with an emphasis on natural light; the airy
structures were filled with extraordinary stained-glass win-
dows. Typical of these are the windows of Chartres Cathedral,
depicting saints, biblical figures, and episodes from Jacopo da
Varagine's *Legenda Aurea*. One window at the south end of the
chancel portrays Mary the Queen sitting on a throne, with the
Child on her lap. Though posed statically in a composition still
based on Eastern models, the Mother and the Child engage
the viewer with their expressive faces and novel gestures, hei-
ghtened by the luminosity of the stained glass.

Notre Dame de la Belle Verrière
(detail)
1200–36
Cathedral, Chartres

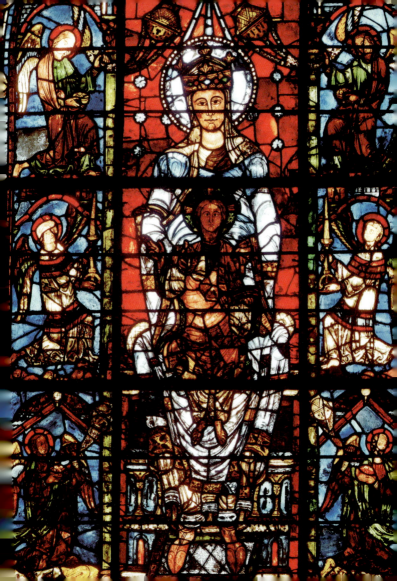

Gothic Art

Gothic art reached the Germanic lands a few decades later than the rest of Europe. At least until 1230, this new visual language was not seen in the Romanesque and Ottonian cathedrals. An emblematic example is the Strasbourg Cathedral: Destroyed by a fire in 1176, it was repaired (but not rebuilt) about 50 years later, when the new Gothic visual style was wed to the preexisting, still sound, Romanesque structure. The lovely, clearly Gothic-inspired sculptures within follow a precise decorative plan. At the entrance to the southern transept the faithful are welcomed by a lunette above one of the two symmetrical portals, depicting a *Death of the Virgin*; there, a simple frame can scarcely hold the figures of Jesus and the apostles crowded around the Madonna's bed. Lying on her back, she is no longer conscious, as shown by her static, vacant face. Her body can be glimpsed through the elegant drapery that, unlike in earlier examples, is now used to heighten the harmony and proportion of the figures.

The Dormition of the Virgin
c. 1225
Cathedral, Strasbourg

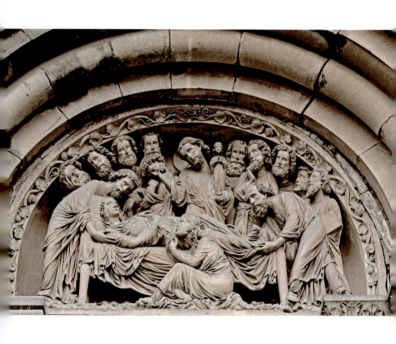

Gothic Art

Writing in the mid-sixteenth century, Giorgio Vasari noted that Cimabue was the first artist to move away from the "Greek manner," by which he meant the solemn, hieratic Byzantine style, towards a new, soft, naturalistic language. In this fresco, which Cimabue painted on the eastern wall of the north transept of the Lower Basilica in Assisi, we notice a change in spatial awareness: The positions of the Virgin's throne and the angels surrounding it create a sense of depth that was absent from Eastern icons. At the same time, the physiognomies, faces, and gestures of the characters have become humanized: Mary's face is rendered delicately with soft, sweet traits previously unknown in art. Also, the portrait of Saint Francis— an object of special veneration—is astounding for the extreme likeness it bears to the saint, based upon a description by his fellow friar Tommaso da Celano.

Cenni di Pepo Cimabue
*Madonna Enthroned with the Child,
Saint Francis, and Four Angels*
1278–80
Basilica Inferiore di San Francesco,
Assisi

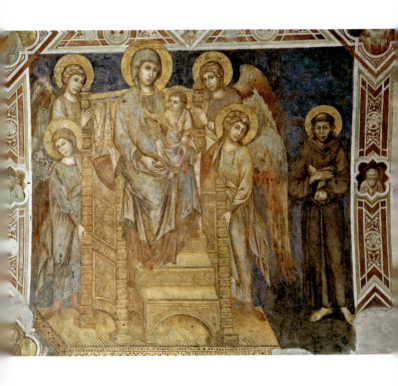

Gothic Art

While Cimabue was the first to take steps toward the creation of a new, modern artistic language, it would be up to Giotto, his best student, to achieve a true revolution in painting. The altar frontal depicting the *Dormition of the Virgin*, originally in the Florentine Church of Ognissanti, remains faithful to the traditional iconography that called for the Madonna to be arranged on a sarcophagus-bed, surrounded by the apostles, yet its sharp definition of space and the moving, tender participation of the figures in the scene is highly innovative. No longer detached, rapt bystanders, they are fully involved in the sad event: Some are engaged in conversation; others bring their hands together as if in prayer; and a dejected Saint John kneels by the sarcophagus, his shoulders turned toward the viewer. In a totally novel approach to the subject, the Madonna is caught in her final moment: Her soul has just left and, eyes half-open, she breathes her last.

Giotto di Bondone
The Dormitio of the Virgin
c. 1310
Staatliche Museen, Berlin

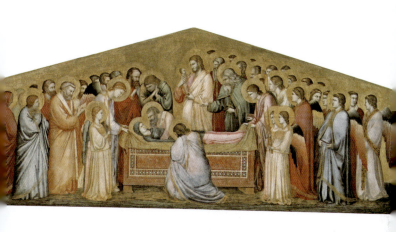

Gothic Art

Born into a family of artists, Giovanni Pisano became the most skillful practitioner of Italian Gothic realism. His *Madonna and Child* in the Scrovegni Chapel in Padua is larger than life, sculpted with a complex rhythm of lines that creates the illusion of movement. The dynamic lines and luminous modeling define the two figures, engaged in an intense dialogue portrayed through looks and gestures. The French-inspired contrapposto is clear in Mary's markedly arched back, which is balanced by the position of the Child, detached from his mother's chest. Mary's eyes meet her son's in a dramatic instant, with an expression alluding to Christ's future Passion, and her devastation at that knowledge. One strong, spirited line—characteristic of Pisano's sculptures—runs along the thick folds of the Madonna's dress, rising up to her profile, and following the direction of her gaze directly to the Child.

Giovanni Pisano
Madonna and Child
1305–6
Cappella Scrovegni, Padua

588

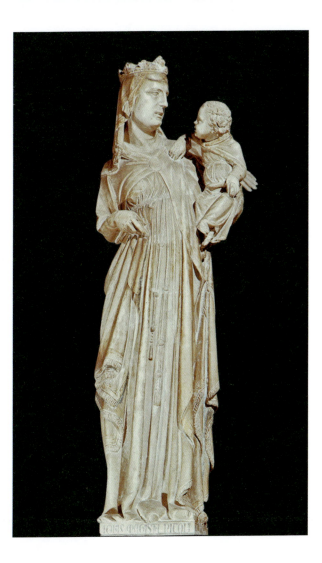

Late Gothic Art

Toward the end of the fourteenth century in Italy, the Gothic had run its course; at the beginning of the Quattrocento, in Florence, the Renaissance was born. Still, Gothic elements, especially outside the Tuscan city, would continue to be incorporated into art of the Quattrocento, enhancing the elegant, vivid forms. Because of this decorative excess, this Late Gothic period is also known as the Flowery Gothic. Among the best artists of this period is Pisanello, who executed this *Madonna of the Quail* with a quick, fluid stroke. The background of the painting is almost abstract, suggestive of Heaven, but the arrangement of flowers and birds demonstrates the naturalistic feeling that would mark all of Pisanello's work.

Antonio di Puccio Pisano,
known as Pisanello
Madonna with the Quail
1420
Museo di Castelvecchio, Verona

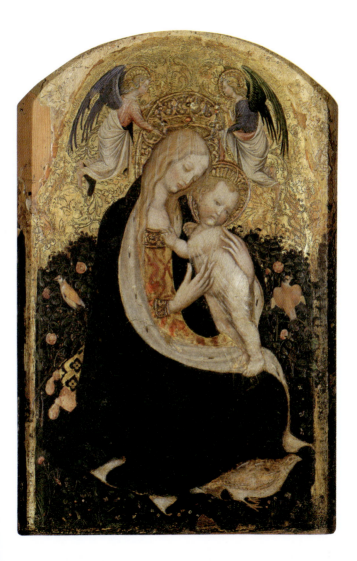

Late Gothic Art

Late Gothic is also known as International Gothic because the complex, fragmented political geography of the time led to far-flung lordly courts linked by a unified cultural language designed to express pomp, elegance, and wealth. This ornamental exuberance found its highest point in illuminated manuscripts. The Limbourg Brothers in particular, active in France in the early part of the fifteenth century, revolutionized the medium. Although still tied to the calligraphic aesthetic of the French style (as we can see in this *Pentecost*, drawn with clear lines and chromatic richness, especially in the mantle folds of the apostles and the Madonna, who is the focus of the composition), they also displayed a firm knowledge of the latest Italian and Flemish styles, the former clearly visible in the perspectival rendering of the floor, the latter in the richly descriptive architecture that frames the scene.

Limbourg Brothers
Pentecost
c. 1420
Musée Condé, Chantilly

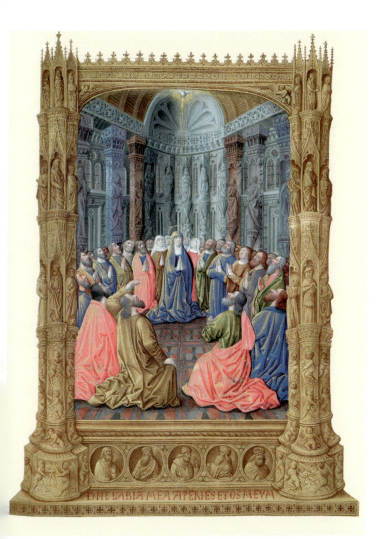

The Renaissance

During the transition from the Late Gothic to the Early Renaissance, artists representing Christian themes still followed the authority of the great painters and sculptors of the recent past, but mediated the traditional style with a new need for historical contemporaneity and realism. In particular, the Florentine Renaissance emphasized a more intellectual, archetypal vision of man's dignity. This was particularly true of Masaccio, who composed this Trinity as a pyramid, not just as an allusion to the divine triangle, but to highlight his perfect, controlled study of perspective. Still, Masaccio did not forget the Virgin: Under the Triad, she is no longer a young girl, but is portrayed more realistically as she stands under the Cross and points to her son. The Virgin's gaze is solemn and directed at the viewer, as if she is showing us the Trinity and explaining it not as an abstract dogma, but as the mystery of God revealing Himself to man through Christ's suffering. Christ redeemed humankind even from death, which is here rendered allegorically in the lower part of the fresco as a skeleton.

Tommaso Cassai,
known as Masaccio
Trinity
1425–28
Santa Maria Novella, Florence

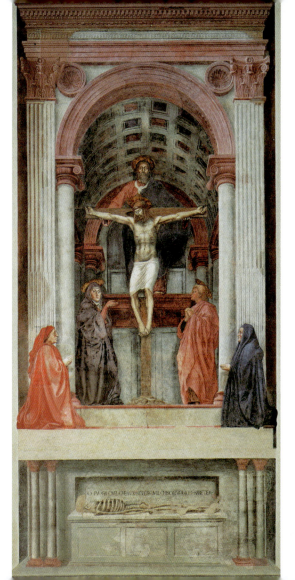

The Renaissance

One of the leading European schools during the Renaissance was the Flemish, which included Jan van Eyck. The painter's careful attention to light, his punctilious description of details, and his faithful modeling of objects, all contribute to the lucid realism in his treatment of any subject, including the sacred. The *Chancellor Rolin Madonna* was commissioned by the powerful counselor to the Duke of Burgundy for use in his private chapel. Nicolas Rolin, whose features van Eyck describes faithfully, is shown wearing a finely rendered, sumptuous brocade gown as he kneels before the Virgin. She is wrapped in an equally elegant crimson fabric, embroidered with precious stones along the borders. The Madonna holds the naked Child, who blesses the patron. In the background, beyond the arcade, is a finely drawn landscape. The artist's acute delineation, however, is softened in the rendering of Mary's face, which is intentionally idealized, though still endowed with an aristocratic, refined sensitivity.

Jan van Eyck
The Virgin of Chancellor Rolin
1435
Musée du Louvre, Paris

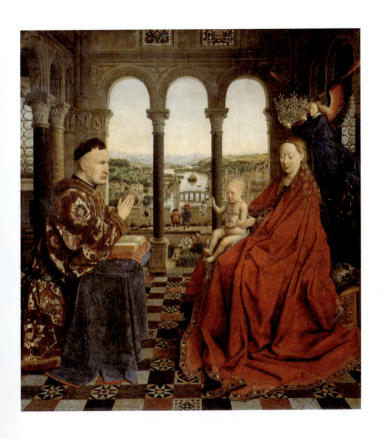

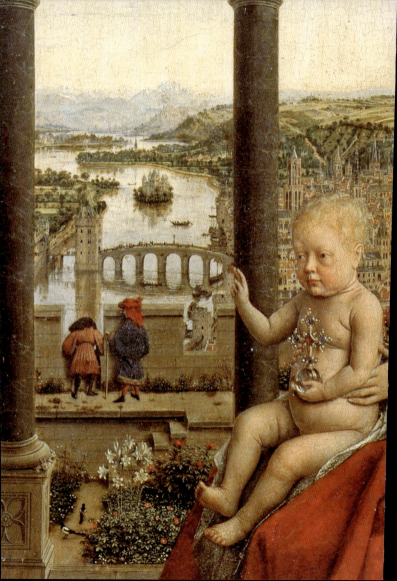

The Renaissance

The art of Donatello progressed through a number of stages, from his first Late-Gothic images to Classical-Renaissance creations such as this *Annunciation*. Many elements of this sculpture are drawn from classical Greek art, such as the firm composure of Mary's features, or Roman art, such as the rich ornamentation and gilding of the architectural frame. The artist exploited the depth created by the light-and-shadow play of such diverse materials as the stone and gold in the frame to further heighten the setting, creating a sort of stage. However, the richness of the decoration somewhat distracts the viewer's attention from the expressive beauty of the faces, expectantly awaiting the great announcement. Mary steps back demurely at the news, though her gaze is strong, showing her conscious acceptance of God's will.

Donato di Niccolò di Betto Bardi,
known as Donatello
Annunciation
(detail)
c. 1435
Basilica di Santa Croce, Florence

The Renaissance

Barthélemy d'Eyck was probably in contact with brothers Jan and Hubert van Eyck and was deeply influenced by their sharply defined, detailed compositions in which light is used to unify the scene and define each object. Between 1443 and 1445, commissioned by cloth merchant Pierre Corpici, d'Eyck executed this *Annunciation* triptych for the Church of the Holy Savior in Aix-en-Provence. Unfortunately, the work was later dismembered: The central panel, with the scene of the Annunciation with Mary and the Archangel Gabriel, is still in Aix, but was moved to the Madeleine Church. The scene is set inside a temple, where an unusual, perspectival flight of arches creates an exactingly defined space in which the two monumental figures are snugly arranged. The Madonna has idealized features and long, light-colored tresses; she receives the message while kneeling at a lectern in the center of the naves, and has been captured raising her hands, troubled, in a gesture of frightened reluctance. The Archangel is kneeling under a sort of porticoed entrance defined by two slender pillars and surmounted by the figure of God the Father, from whose right hand issues a ray of light that descends to lightly graze the Virgin.

Barthélemy d'Eyck
Annunciation
1443–44
Sainte Marie-Madeleine,
Aix-en-Provence

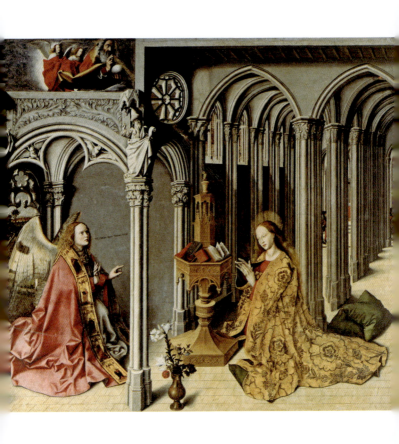

The Renaissance

Martin Schongauer was a German painter and engraver, an exceptional member of the late-Quattrocento Alsatian school. He only worked on religious themes, including at least 130 engravings of episodes from the Passion of Jesus, the Annunciation, the Coronation of the Virgin, and other New Testament stories. Few of his paintings have survived; one is the splendid altarpiece of the *Virgin of the Rosebush*, which adorns Saint Martin's Church in Colmar. Although it has been cut on all sides for insertion in its current woodcut frame, an echo of solemn, refined naturalness still survives in the composition. The Virgin is sad and engrossed in thought. She holds the Child close to her; he clings to his mother's neck and is about to burst into tears, in a seemingly precocious intuition of his destiny. Above the duo, two angels are about to place a richly wrought crown on Mary's head. Mother and Son are outlined with such power and precision that they seem detached from the background, where the climbing tendrils and the finely drawn roses intertwine and seem to continue beyond the picture field. The frame echoes the trompe l'oeil window, which allows the viewer to peer into the divine mystery.

Martin Schongauer
Madonna of the Rose Bower
1473
Saint Martin, Colmar

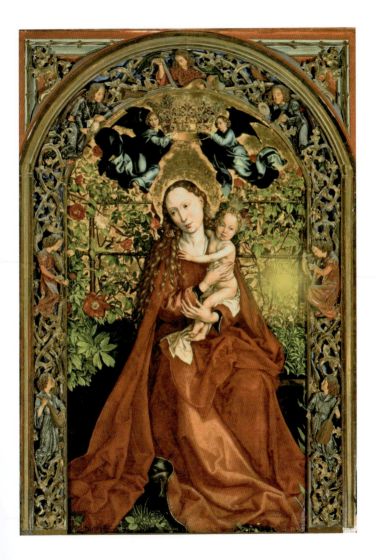

The Renaissance

Madonna of the Carnation has been ascribed to a young Leonardo da Vinci. It includes elements that the great master was to develop consistently in his later work, in particular details such as the shine on the Virgin's hair, and the psychological state of the figures, such as the Virgin tenderly turning her gaze toward the Child and playing with the small flower. The Virgin is portrayed in a three-quarter view; her figure is comfortably arranged in the surrounding space, creating a unity between the Mother and Son in the foreground and the landscape that rises behind the two mullioned windows, with dark to light tonality—a harbinger of the use of aerial perspective, which will become prevalent in the future.

Leonardo da Vinci
The Madonna of the Carnation
1478–80
Alte Pinakothek, Munich

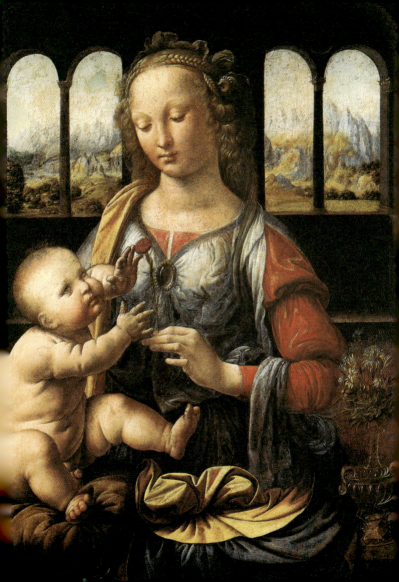

The Renaissance

Inspired by the popular *Vesperbild* iconography, in which the seated Madonna holds the dead Christ on her knees, this *Pietà* hangs at the Museu de la Catedral in Barcelona. Commissioned by the cultivated archdeacon Luis Desplá for his private chapel in the cathedral, the painting depicts Mary's last, anguished farewell to her son. This moment of intense, intimate grief is shared by the patron, who kneels to the left of the Virgin in a devout pose (his clearly identifiable features suggest that this is a realistic portrait), and by Saint Jerome on the right, engrossed in reading. The grieving expression of the Virgin is echoed in the purplish sky, where large, lead-colored clouds are amassed, harbingers of a coming storm; the scene is bathed in the cold, uncertain light from the horizon. Still, the tragic feeling of death is contrasted with the tiny flowers blooming at Christ's feet and the small animals scurrying in the foreground: The lizards symbolize the soul's redemption; the butterflies and the snail are emblems of the Resurrection; and the ladybug, which has traditionally foreshadowed good things, is a symbol of the Virgin.

Bartolomé Bermejo
Pietà of Canon Luis Desplá
1490
Museu de la Catedral, Barcelona

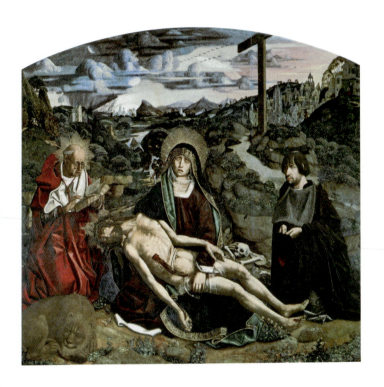

The Renaissance

This *Madonna of the Chair* is of the highest artistic quality, having been commissioned by Pope Leo X, a man of highly refined taste. The Virgin sits on a chair not unlike those used by popes. Her attire is completed by an elegant silk scarf and a turban wrapped around her head, in the fashion of Roman noblewomen. The infant Jesus, wearing a plain gold shirt, nestles against his mother's breast while Saint John gazes at him in ecstatic contemplation. Both the Madonna and the Child look at the observer, thus breaking the balance of the composition, an artistic device that the artist would employ often in his late work.

Raffaello Sanzio,
known as Raphael
Madonna della Seggiola
1514
Galleria Palatina, Florence

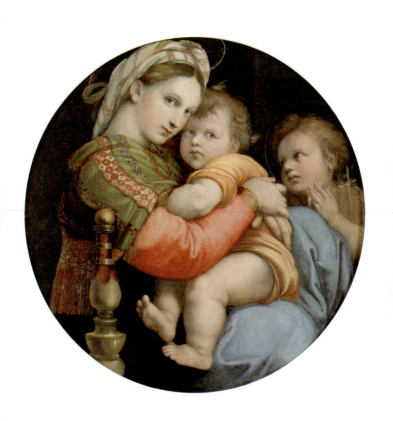

Mannerism

Mannerism was a Cinquecento trend that expressed artists'
determined attempts to carve a path independent of the
Renaissance—though the stylistic innovations of the great
artists of the Renaissance were not completely ignored. This
painting is an excellent example of Mannerism. It projects
the deep anxiety of a time that saw the great universal values
affirmed by the Roman Church collapse: In the sixteenth cen-
tury, Martin Luther pointed out that the path to a direct,
unmediated relationship with God could be achieved through
introspection rather than relying on the Church to interpret
God's teachings. The distressing leaden sky heightens the ten-
sion introduced by the elongated, anti-Classical deformation of
Christ's body. While the pyramid composition of the figures
and the expressive contrapposto of the two bodies are
Michelangeloesque, the scene's intensity is portrayed above all
in the undulating mass of Mary's dress, which is rendered with
color instead of chiaroscuros. The dramatic composition fully
expresses the era's sense of uncertainty, but the artist also articu-
lates the Virgin's final, desperate encounter with her dead son.

Sebastiano del Piombo
Pietà
1516–17
Museo Civico, Viterbo

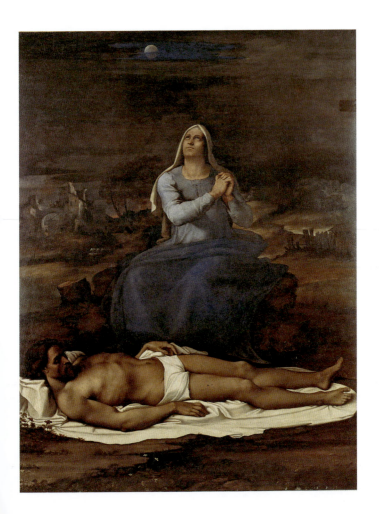

Mannerism

In this *Deposition*, the sense of drama comes from the pyramid-like arrangement of the bodies and the resulting unstable equilibrium, rather than any gesture of the characters. The picture plane is almost totally filled by the grieving party carrying the body of Christ, thereby abolishing any perspectival space that might distract the eye. This Madonna lives outside man-made certainties; overwhelmed by grief, she cannot stand on her feet. Her eyes gaze at the painful reality and her figure stretches upward. The light coloring of the painting gives lightness to the figures, but is unnatural: The composition seems hallucinatory, no longer concerned with the historical narrative portrayed in Renaissance art.

Jacopo Pontormo
Deposition
c. 1528
Cappella Capponi, Santa Felicita,
Florence

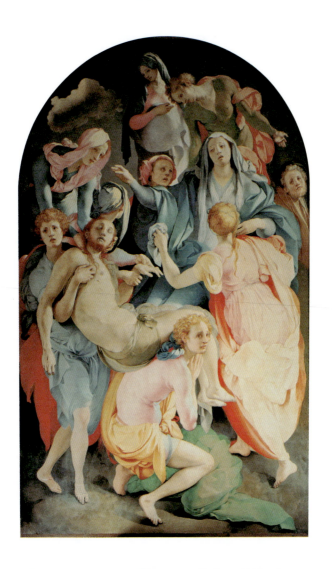

Mannerism

Parmigianino, one of the more original Italian Mannerists, painted this Madonna during his stay in Bologna, bringing to that Late-Raphaelite environment a new formal language of sensitivity, elegance, and grace. This work evidences an intellectual anti-naturalism based on oval, elongated forms and a cool color palette. In this painting, the Virgin is so formally elegant that her feelings seem suspended in a rarefied atmosphere, further amplified by the moonlit night scene in the background. Mary seems absent, indifferent to what is happening on her very lap: the languid look exchanged between Jesus and Saint Marguerite.

Girolamo Francesco Maria Mazzola,
known as Parmigianino
*Madonna with Saint Margaret
and Other Saints*
1528–29
Pinacoteca Nazionale, Bologna

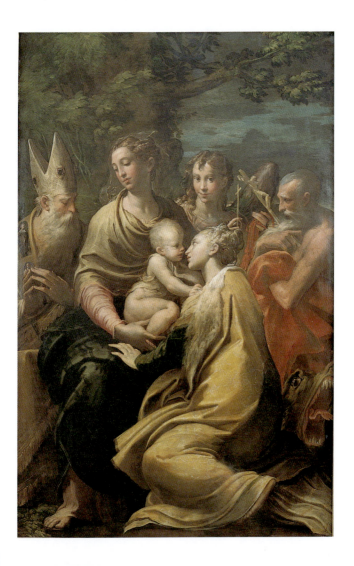

The Counter-Reformation

The Counter-Reformation ushered in a period in which religious iconography was critically redefined. The many artistic devices that had developed since the middle of the Quattrocento, permeated as they were by new religious ideas, or by elements the Church considered profane, had resulted in a proliferation of representations that the Catholic Church began to question. The Counter-Reformation, which culminated in the 1563 Council of Trent, promulgated rules for artists as well. Paintings had to have clear and accessible meanings and they had to faithfully interpret the canonical texts used for worship, which everyone knew. With his artistic instinct and his successful evocation of Raphael's art, Barocci achieved an authentic sense of spirituality in works, such as this *Virgin with Child and Saints Simon and Jude*. His intention is didactic and edifying, and the atmosphere wholesome. The image of the Virgin is given great honor and veneration as befits a holy, exemplary life like hers.

Federico Fiori Barocci
San Simone Madonna
1567
Galleria Nazionale delle Marche, Urbino

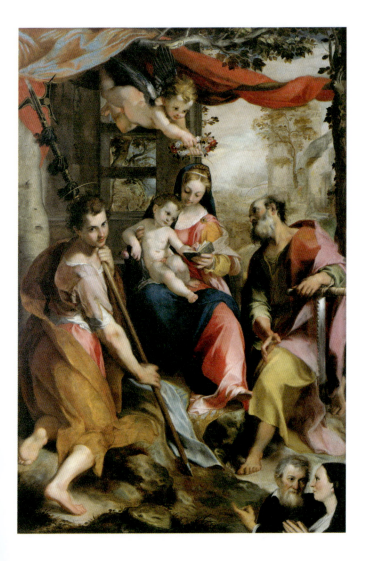

The Counter-Reformation

The rules issued from the Counter-Reformation about sacred art marked an important shift that began the transition from the Renaissance to the Baroque. In particular, artists introduced a number of stylistic novelties that perfectly embodied the requests of the decree. Among them, Ludovico Carracci proposed anew a sense of realism, including naturalistic light, and a realistic portrayal of events. The scene of this *Annunciation* is framed by a simple, subdued landscape. The background is rendered with only a few details so as not to detract the viewer's attention from the angel announcing to a young Mary her future destiny. The theatrical effects typical of Mannerism are gone, making way for an art with subtle coloration that eschews all anecdotal references.

Lodovico Carracci
The Annunciation to Mary
1603
Galleria di Palazzo Rosso, Genoa

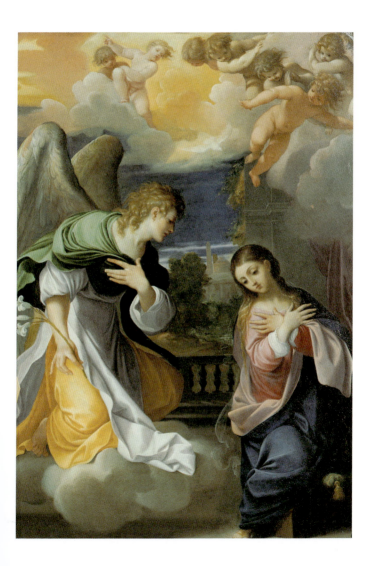

The Seventeenth Century

Caravaggio's was a revolutionary art. He painted directly on canvas, without preparatory drawings, and chose as his subjects lowly, real-life individuals picked up on the street or in taverns. He achieved extraordinary results in sacred art. This *Madonna di Loreto* is a plain Virgin dressed in an unobtrusive red gown, her hair loosely gathered on her head. Standing on the threshold of a modest home, she displays the Child to two humble, adoring pilgrims. Exhausted by the long journey, the pilgrims kneel with their hands joined in prayer and silently contemplate Jesus, quietly astonished at the realization that they are witnessing a miracle. The scene exudes a feeling of compassionate humanity, further heightened by the pilgrims' dirty, torn clothes and Caravaggio's novel approach of filling the foreground with the man's dirty feet.

Michaelangelo Merisi da Caravaggio
Madonna di Loreto
c. 1604–6
Sant'Agostino, Rome

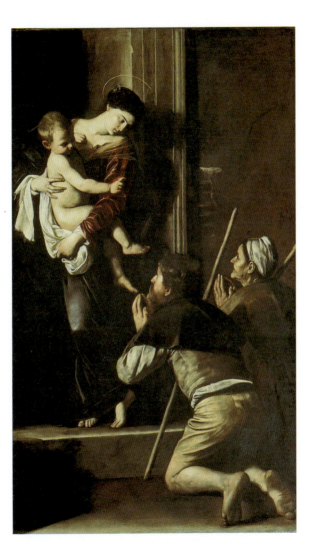

The Seventeenth Century

Baroque painting—which had an exemplary practitioner in the Flemish painter Pieter Paul Rubens—was directed, like a theatrical drama, with the intention of stirring up the emotions and the sentimental involvement of the faithful. This very large canvas depicts the final, culminating act of the Crucifixion: To make sure that Jesus has died, a solder thrusts a spear into his ribs, a final violation of his lifeless body. In the foreground to the right is Mary supported by the other women; unable to bear the sight of this gratuitous torture, she turns her head from the scene. The artist has the Virgin with a visage that expresses the universal suffering a mother feels as she watches her own son die. Heightening the drama and the anguish of the episode is the powerful palette: The leaden clouds lend a cold light to the scene, against which the subdued strokes of color stand out. The strong chiaroscuro adds contrast, and the description of the characters, who seem to come to life as if on a stage, render the full truth of the historical event.

Pieter Paul Rubens
*Christ on the Cross between
the Two Thieves*
1620
Koninklijk Museen, Antwerp

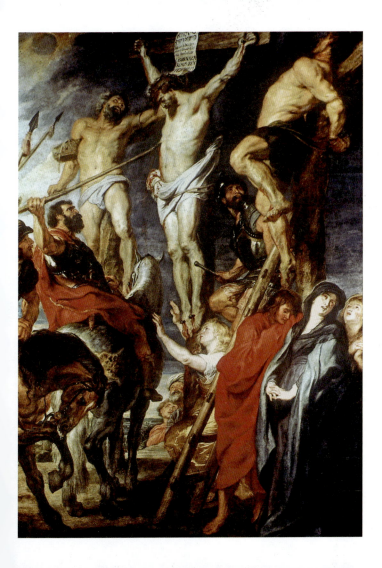

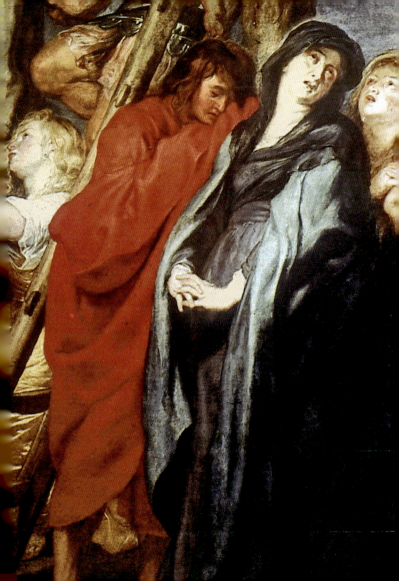

The Seventeenth Century

A leading interpreter of European naturalism, Diego Velázquez treated his themes—whether portraits, mythological, or sacred subjects such as this *Coronation of the Virgin*—with the same approach. The Madonna has been raised to Heaven and is about to receive the crown through which the light of the Holy Spirit filters; the crown is held by Jesus and God the Father, seated on each side of the Madonna. The artist has caught Mary in the very instant when, like a devout handmaid, she is about to receive the infinite privilege that has been accorded to her: With eyes closed, she has one hand to her chest and the other stretched to one side, as if bowing in a sign of submission to divine authority. Thick, solid strokes describe the figures and a transparency is achieved through the clouds, which are imbued with light that adds substance to the figures. The physical and psychological naturalness of the faces and poses of the little angels that peek out from the clouds or play with the Virgin's drapery is extraordinary. A stately painter, Velázquez succeeded in valorizing the splendor of the subject through wide strokes and deliberate chromatic arrangements.

Diego Velázquez
The Coronation of the Virgin
1645
Museo del Prado, Madrid

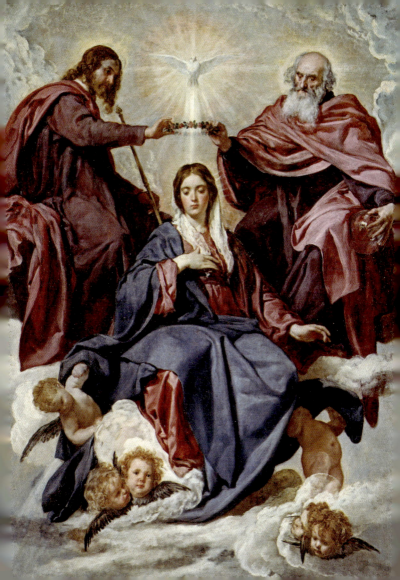

The Seventeenth Century

Rembrandt translated sacred themes into simple scenes from domestic life. In this painting, the artist has caught a moment of evening relaxation: Joseph is in the shadow, busy completing a carpenter's job, while Mary sweetly embraces little Jesus, who leans on his mother as if seeking balance. In the center of the spare, simple home is a small fire with flickering flames that light up part of the room, and a curled-up cat warming itself near the open fire. The attention to the light, a careful choice of colors, and a vibrant stroke create a profound sense of naturalness. For Rembrandt, this *Holy Family with Curtain* was also an exercise in trompe l'oeil technique, for the family scene is like a painting inside a painting, which is revealed through the image of a curtain pulled to one side, on the right, hanging from a finely drawn wood frame.

Rembrandt van Rijn
The Holy Family with a Curtain
1646
Staatliche Museen, Kassel

The Eighteenth Century

Behind the sumptuous, elegant art of the eighteenth century, intellectual forces were at work that would lay the foundations of the modern age. The Baroque style was rejected on several fronts—from its artificial excesses to its strong, contrasting use of chiaroscuro. the new trend was toward a luminosity and lightness of form. Jean-Antoine Watteau imagined a Holy Family immersed in a nature free of decay or degeneration. The atmosphere is dreamlike, rather than realistic. Mary's pose is natural and affectionate and the light colors heighten her sweetness. She is in the midst of a carefree moment with her child, but what the artist has emphasized is not the circumstance itself, but the feeling, the emotion, and the calmness surrounding it.

Jean-Antoine Watteau
The Holy Family
1717–19
Hermitage Museum, Saint Petersburg

The Eighteenth Century

The search for simple, natural forms did not entirely erase artists' penchant for the theatrical. In eighteenth-century art, architectural elements are often rendered as stage sets and the episodes resemble dramas with characters engaged in acting or opera-singing. Giambattista Tiepolo developed a renewed interest in chiaroscuro effects and in bright colors imbued with light and iridescent reflections. The exceptional chromaticism of his work is visible in the Madonna's garments, which almost seem to move due to the light-reflecting folds; the same effects of light and shadow are evident on the white sheet on which Jesus is lying. The Madonna is in the foreground in a highly expressive, almost theatrical pose.

Giambattista Tiepolo
Nativity
1732
Basilica di San Marco, Venice

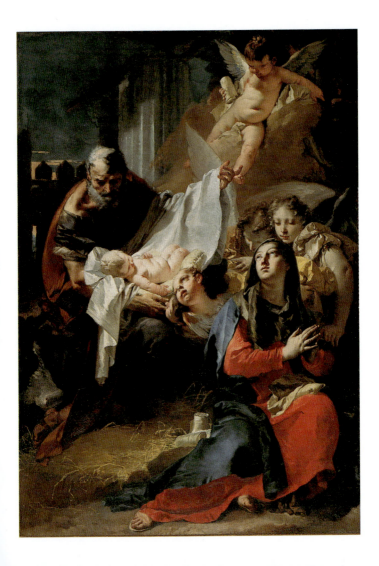

Neo-Classicism

The second half of the eighteenth century was shaken by two great revolutions: the American (1776) and the French (1789). These deeply unsettling years brought forth a new artistic current that was antithetical to the sumptuous, striking art of the Baroque and Rococo periods: Neo-Classicism. In France, Jacques-Louis David pointed the way to the new style, simultaneously with the new social-political responsibility that the revolution demanded of artists. Although most of his work is about characters from Classical and pagan antiquity or from recent history, in one devotional painting, *Saint Roch Asking the Virgin Mary to Heal Victims of the Plague*, David applies his interpretive skill to moral and religious virtues. Above a mass of tortured bodies, the Mother and Child are silhouetted in a bright aura against a dark, pernicious sky. On the right is Saint Rocco, his hands joined in prayer: he stretches toward the Virgin driven in a naturalistic gesture. The Virgin, understanding his plea in her role of mediator, engages in an intimate dialogue with Jesus.

Jacques-Louis David
Saint Roch Asking the Virgin Mary to Heal Victims of the Plague
1780
Musée des Beaux-Arts, Marseille

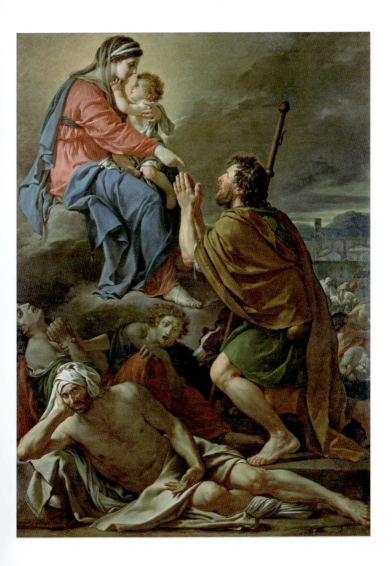

Neo-Classicism

In the nineteenth century sacred art declined, pushed aside by the return to a Classicism that favored mythological themes, and by the birth of the Romantic movement, which explored the emotional intensity provoked by a painting, rather than the theme represented in it. Jean-Auguste-Dominique Ingres is considered the champion of the Classicist style for his linear and elegant stroke, his studied, well-conceived coloring, and his stern judgment in regard to the emotional excesses of Romantic painting. His *Virgin with the Host* frames the figure of Mary inside a succession of impeccable, undulating outlines: Her hands joined and her eyes closed, she is deep in prayer before the Host that symbolizes the sacrifice of Christ. The composition revolves around a calculated symmetry, arranged in a monochrome background of rich browns, grays, and blacks. In the foreground, the Madonna is monumental, her face and hands lit by the light of salvation. The bystanders bathe in that light and share Mary's deep faith and firm acceptance, feelings that the artist successfully evokes through the Classical restraint of the scene.

Jean-Auguste-Dominique Ingres
The Virgin with the Host
1841
Pushkin Museum, Moscow

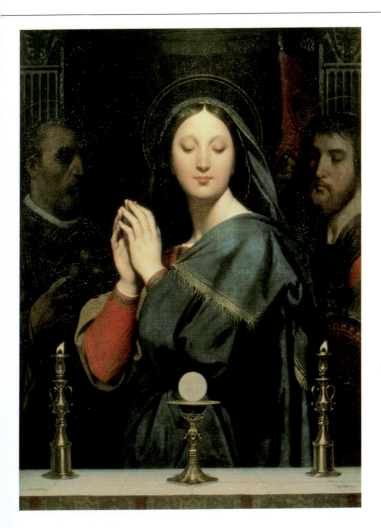

The Nineteenth Century

This fresco, by the German Johann Friedrich Overbeck, was initially painted for the façade of the Porziuncola, the small Assisi church that the saint had chosen as his seat; the church was later enclosed inside the larger Basilica di Santa Maria degli Angeli. The painting depicts Jesus and Mary appearing to Saint Francis, who kneels before them and, with open arms raised to Heaven, pleads for a plenary indulgence. The two figures stand inside a golden shield, surrounded by an array of musical angels. Mary is seated next to Christ in a posture of deep concentration and prayer, a pose that aims to represent the transcendental through rigid, precise lines. The result is a static composition characterized by a use of color that serves the subject represented. This technique made Overbeck the "prince of Christian painters," the best interpreter of Catholic revivalist ideals in Romantic Germany.

Johann Friedrich Overbeck
Saint Francis Receiving the Pardon of Assisi
1829
Basilica di Santa Maria degli Angeli, Assisi

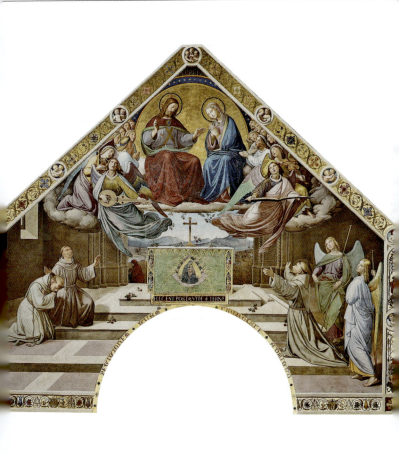

The Nineteenth Century

The Pre-Raphaelite movement arose in the first half of the nineteenth century, led by a group of students from the Royal Academy in London, including Dante Gabriel Rossetti. These young artists attacked the industrial civilization of the time, seeing in the machine the enemy of creativity. They advocated a return to nature, seeing in its beauty the only manifestation of the presence of God on Earth. This credo was translated into painting with a revived attention to the quotidian elements of the sacred event, eschewing all forms of academism. The Pre-Raphaelites denied the importance of Renaissance art, in particular of Raphael, whose art they considered a formal exercise devoid of content. In this painting by Rossetti, entitled *Ecce Ancilla Domini* ("Behold the Handmaid of the Lord"—the words spoken by Mary when the Archangel Gabriel announced her future pregnancy), a young, gaunt Mary, curled up in a corner of her bedroom, appears troubled by the appearance of the angel. She receives the momentous news from the Archangel Gabriel who advances with self-assured but delicate composure, carrying a branch of lilies, a symbol of the maiden's purity. A bright, cold light frames the scene, lending a sense of unreality, heightened by the refined color palette.

Dante Gabriel Rossetti
Ecce Ancilla Domini
1850
Tate Gallery, London

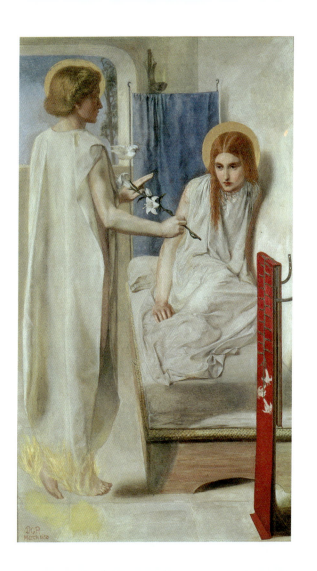

The Nineteenth Century

At the end of the nineteenth century, Gauguin, having perma-
nently left France, moved to the Island of Tahiti in the South
Seas in search of the exoticism and simplicity that marked pri-
mitive life. Here his canvases became populated by native men
and women caught in different moments of their everyday lives,
and his style gained a new expressive, symbolic content. In this
context, the artist's innovative approach to sacred themes is
interesting: *La Orana Maria* depicts the Virgin's apparition to
two Tahitian women in the heart of a wild, uncontaminated
forest (likely an allusion to Mary's purity). On the left, an
angel with multicolored wings points out the Madonna and
Child to the two women who are approaching, their hands
joined in prayer. The Madonna carries the Child on her
shoulder, in an unusual pose. She is dressed like—and has the
body and features of—a Tahitian woman. Even Jesus has native
features. In the foreground is a still life of exotic fruit and the
words "La Orana Maria," or "Hail Mary."

Paul Gauguin
La Orana Maria (Hail Mary)
1891
Metropolitan Museum of Art,
New York

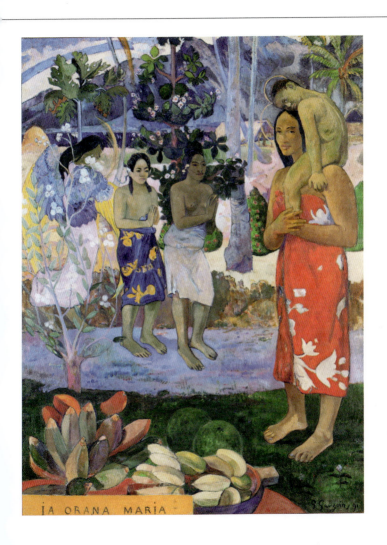

IA ORANA MARIA

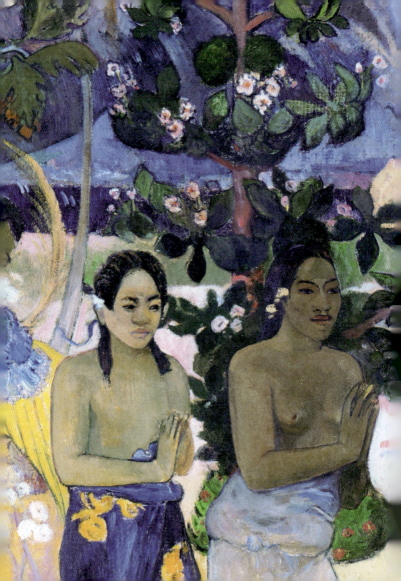

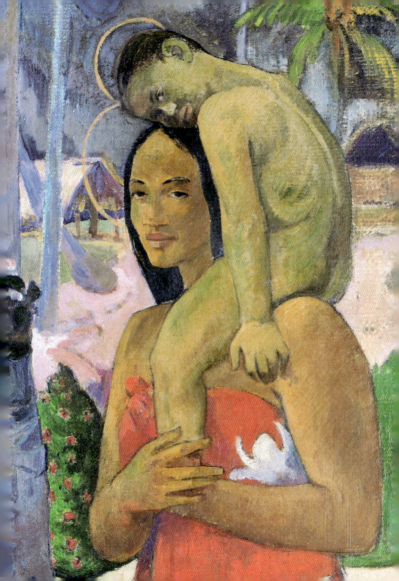

The Nineteenth Century

The painter and theoretician Maurice Denis was a leading exponent of the *Nabis* group (from a Hebrew word meaning "prophet") formed in Great Britain at the end of the nineteenth century. The Nabis experiment sought to blend elements from the latest artistic trends, such as Impressionism, Symbolism, Japanism, and Modernism, to achieve a style of pure color and simplified forms. This *Visitation* melds these elements in his depiction of the meeting between Mary and her cousin Elizabeth. Dressed like an elegant Parisian of the times, the Madonna meets her cousin in front of a flowering arbor through which one glimpses, in the background, a small, modern town. The feelings of affection uniting the two women are clear from their gestures: Mary's open, extended hands and Elizabeth's restrained, yet moving gesture. Denis was able to create a composition in which the sacred theme is barely discernible behind the worldly, secular semblance of a simple conversation between two upper-class women.

Maurice Denis
The Visitation
1894
Hermitage Museum,
Saint Petersburg

The Twentieth Century

Natalija Sergeevna Goncharova was a leading Russian artist of the early twentieth century. Attracted by French Fauvism, in about 1910 she joined the Neo-Primitivist group, then slowly moved toward Futurism and Cubism and introduced the so-called Cubo-Futurist movement. Her paintings are mostly of secular subjects, and she approached religious themes with the same simplified forms informed by her attraction to Cubist decomposition. In this *Nativity*, the artist has portrayed the Madonna opening her arms to welcome Jesus with the swaddling clothes that the women are bringing to her. The marked, expressive faces, including Jesus' sweet, dreaming expression, the powerful use of color, and an impetuous, incisive stroke that outlines the figures and the drapery give the scene a look of efficient restraint, and at the same time a strong visual and emotional impact.

Natalija Sergeevna Goncharova
Nativity
c. 1910
Krupivnitsky Collection, Moscow

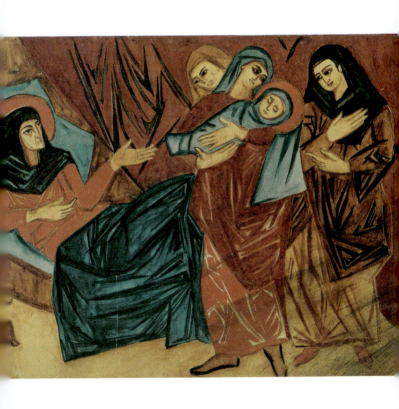

The Twentieth Century

In the mid-twentieth century there was a revival of religious art, promoted by artists who introduced a modern, innovative language. Among them was Henry Moore, who sculpted many *Virgins with Child*. The artist promulgated a "primitive" language that became biomorphic abstraction in his human figures. His compositions of the Madonna with the Child in her arms project a strong emotional synthesis and impact: with intentionally roughly outlined features, they exalt the affectionate union of the two figures. In this work, perhaps more than in others, in the very fusion of their bodies the two figures seem to share in the divine mission they are about to undertake.

Henry Moore
Maquette for a Madonna and Child
1943
Alberto della Ragione Collection,
Florence

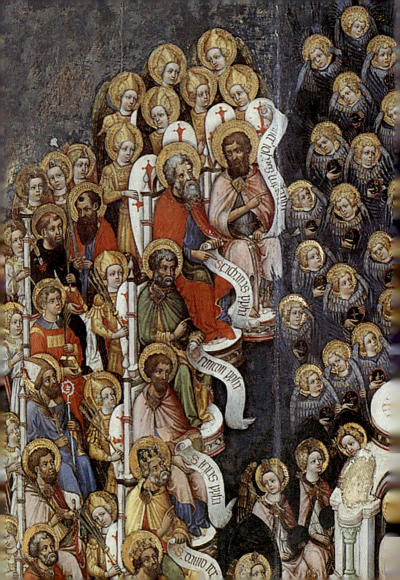

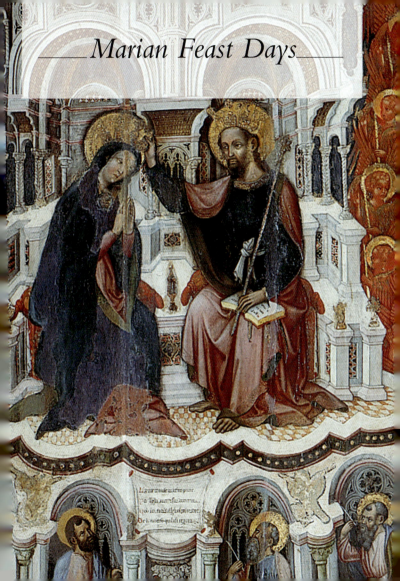

Most Holy Mary, Mother of God

January 1

An ancient Marian feast of the Church of Rome, Most Holy Mary, Mother of God was part of the liturgy of the city of Rome already in the sixth and seventh centuries. Held on January 1, the feast celebrates Mary's divine maternity (Mary *Théotokos*), proclaimed at the Council of Ephesus in 431. With time, the custom of celebrating it on the first of the year was lost, and different countries developed different customs, until in 1931, on the fifteenth centenary of the Council of Ephesus, Pope Pius XI extended the feast day to the entire Roman Church, to be celebrated on October 11. But Vatican Council II, while restructuring the Roman calendar in 1969, reinstated the ancient feast on January 1 and named it "Most Holy Mary, Mother of God." The date is important for several reasons. First, because it is the eighth day after Christmas, creating a bridge between the two celebrations, both of which revolve around the mystery of the Incarnation. Second, it is the first day of the year, thus coupling sacred commemoration with the lay holiday. Since 1967, January 1 has also been declared World Peace Day.

Bartolomeo Bulgarini
Madonna with Child
1350
Museo di Villa Guinigi, Lucca

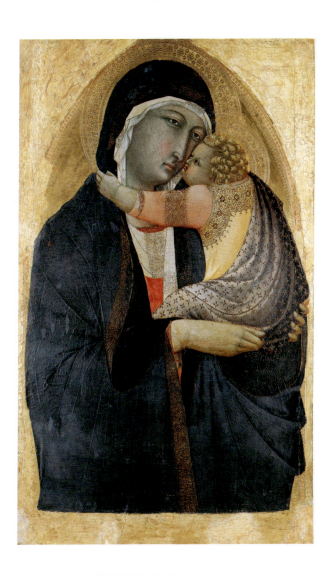

The Marriage of the Blessed Virgin Mary

January 23

The marriage of Mary and Joseph (considered by many merely a betrothal or a guardianship), has always been the subject of debate and contrasting positions in the Church. In 1961, the Holy See added the feast of the Marriage of the Blessed Virgin Mary to the list of "devotional" holy days, which are celebrated only in certain places and are denoted on specific calendars, for specific reasons.

Domenico Beccafumi
The Marriage of the Virgin
1518
Oratorio di San Bernardino, Siena

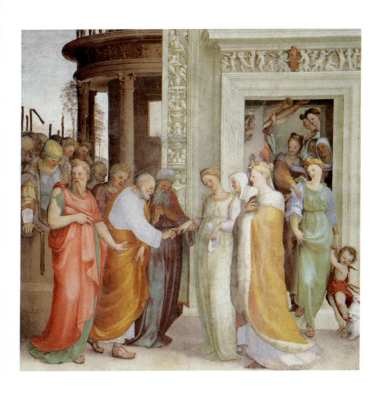

The Presentation of the Lord

February 2

The earliest information about this celebration comes from Egeria, a pilgrim, and is dated toward the end of the fourth century. In the Church of Jerusalem, the date was set at first for February 15, or 40 days after the birth of Jesus, which in the Eastern Church was celebrated on January 6. During the sixth or seventh century, when the feast began to be observed in the West as well, it was moved to February 2, because in the Western calendar Christmas falls on December 25. In the seventh century, Pope Sergius I introduced the feast in Rome under the name "*De purificatione Mariae*" (On Mary's Purification), and it was listed as such in the 1570 Missal of Pius V. In the tenth century, in Gaul, a solemn blessing of the candles used for this celebration was organized: the first Candlemas. This solemn day recalls Mary's action of presenting her son Jesus to God in the temple, offering him in sacrifice for all of humanity.

Vittore Carpaccio
Presentation in the Temple
1510
Gallerie dell'Accademia, Venice

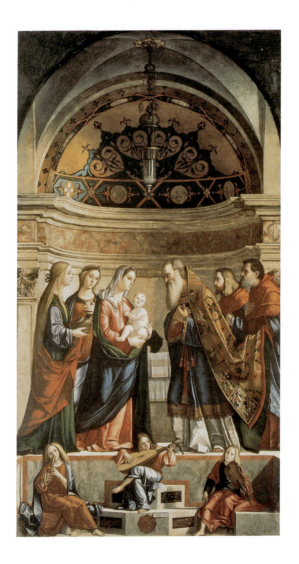

Blessed Virgin Mary of Lourdes

February 11

The feast of Our Lady of Lourdes is very dear to popular devotion. It was first observed at the end of the nineteenth century, to commemorate one of the most famous Marian apparitions. On February 11, 1858, in Lourdes, France, in the diocese of Tabes, Bernadette Soubirous witnessed the first of eighteen apparitions of the Virgin. In 1891, Pope Leo III authorized the diocese to celebrate a local holiday in remembrance. In 1907, Pope Pius X extended it to the entire Roman Church with a decree of the Holy Congregation of Rites. The 1969 reform of the Roman calendar provides for the holiday only optionally, and changes its name to Blessed Virgin Mary of Lourdes, to highlight the figure of the Madonna, not the historic fact of her apparition, as the purpose of the celebration. In her manifestations, Mary identified herself as the Immaculate Conception and carried messages of penance and conversion. Thus, on February 11 one could also celebrate the mystery of the Immaculate Conception of Mary.

Blessed Virgin Mary of Lourdes
Popular sacred image
19th century

The Annunciation of the Lord

March 25

The angel's announcement presents the figure of Christ in Glory. For this reason, the Catholic liturgy treats the Annunciation not only as a Marian feast, but also as the feast of the Lord. It originated in the East, probably after the fifth century, when the anniversary of the birth of the Lord and his manifestation grew in importance and a small liturgical cycle developed around it. Luke's narrative became the subject of a separate feast under Emperor Justinian I between 530 and 550. From the beginning, the Feast of the Annunciation was set for March 25, both because December 25 is the anniversary of the birth of Christ (calculating the time between conception and birth), and because it was then popularly believed that Christ became incarnate on the day of the Spring equinox. However, March 25 usually falls during Lent, and in ancient times no holidays could be celebrated in that period. This problem was resolved at the Trullano Council held in Constantinople in 691, which made an exception and ruled that this all-important feast, one of the most important in the Byzantine liturgical calendar, could be celebrated with the Eucharist on any day, even if it were to fall on Good Friday or Easter Sunday.

Tiziano Vecellio, known as Titian
The Annunciation
1562–64
San Salvatore, Venice

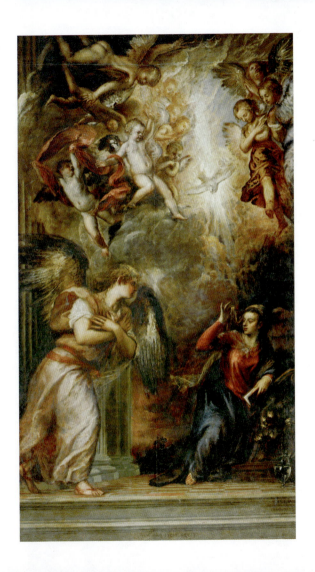

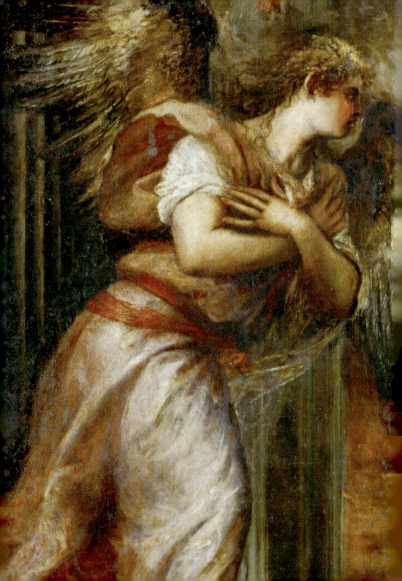

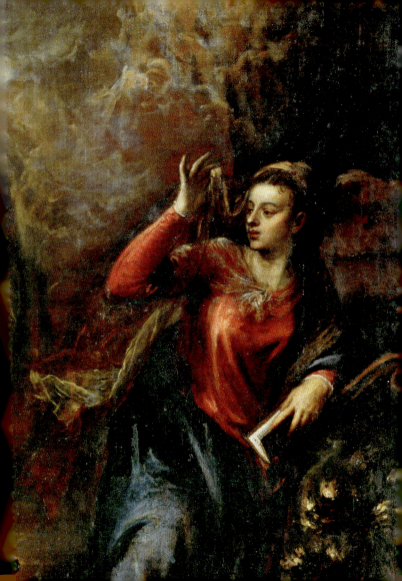

Blessed Virgin Mary of Fatima

May 13th

Not an actual holy day of the liturgical calendar, this optional festivity commemorates the six apparitions of the Blessed Virgin to the three young shepherds: Francisco and Jacinta Marto and Lucia de Jesus Santos. The apparitions took place between May 13 and October 13, 1917 in Fatima, a hamlet in central Portugal. The Blessed Virgin appeared as a beautiful lady dressed in white, hovering above an oak tree, bright and enveloped in a blazing light. More than the historical event, the liturgy highlights the message of penance and prayer for the salvation of the world, which Mary relayed to the three children. The commemoration became an official feast only in the third edition of the Roman Missal, in 2000.

Apparition of the Virgin Mary of Fatima
Popular sacred image
20th century

Blessed Virgin Mary the Helper

May 24

"Help of Christians" is the title by which Mary is invoked in the litanies dedicated to her, also known as Lauretane or Lorettans, because they were initially recited at Loreto. Her role of mediator and helper of those who turn to her has always been stressed. Christ on the Cross entrusted the faithful to her, as if they were her children. The official Latin appellation, *Auxilium Christianorum* (Help of Christians), was given to Mary by Pope Pius V in 1570, when he entrusted to her the armies of Western Christendom that were threatened by the Turks. The Christians went on to defeat the Muslim fleet at the Battle of Lepanto in 1571. The returning army stopped by Loreto to thank the Virgin, invoking her as Our Lady of Help. Pope Pius VII later established the festivity on May 24, 1815, to give thanks for having been freed after his five-year imprisonment by Napoleon.

Paolo Finoglio
Virgin in Glory with Saints
17th century
Chiesa del Gesù, Lecce

The Visitation of the Blessed Virgin Mary

May 31

The feast of the Visitation of the Blessed Virgin Mary arose in the midst of the conflicts engendered by the Western Schism, when Pope Urban VI and the antipope Clement VII both claimed the papal throne. At the time, the archbishop of Prague, John of Jenstein, suggested this feast not so much for theological reasons as to invoke Mary to put an end to the schism. On June 16, 1386, he decreed that the feast be celebrated on April 28 in the diocese of Prague. In 1390, a jubilee year, Pope Boniface IX, successor of Urban VI, in the bull *Superni Benignitas Conditoris* extended the feast to the entire Western Church. The feast was at first approved by the supporters of the Roman pope and opposed by those who favored the antipope. When the schism ended, Boniface IX reconfirmed the bull in 1441 and changed the date to July 2. The date was changed again, to May 31, with the reformation of the Roman calendar. The episode being commemorated, the Visitation when John the Baptist meets Jesus in the womb, marks the transition from the Old to the New Testament.

Juan Barcelo
Visitation Polyptych
(detail)
1488–1516
Pinacoteca Nazionale, Cagliari

The Sacred Heart of Mary

3rd Saturday after Whitsunday

The origin of the cult of the Sacred Heart of Mary is to be sought in the words of Saint Luke the Evangelist, for whom the heart of Mary is a casket containing the holiest of memories. The figure of the Madonna is an emblem for those who listen to the word of God and treasure it, a model for all the faithful who trust in the message of salvation. In 1648, John Eudes, founder of the Brotherhood of the Heart of Mary, received permission to celebrate the first feast, but only in the diocese of Autun, France, on February 8. In 1805, the Sacred Congregation of Rites granted the privilege of this holy day to the religious brotherhoods or institutes that requested it. In fact, this feast was listed in 1914 for only a few places. After World War II, Pope Pius XII extended it to the entire Roman Church and set it for August 22, eight days after the Assumption. In the current Roman calendar, the feast is listed as optional, to be celebrated on the third Saturday after the Pentecost, immediately after the feast of the Sacred Heart of Jesus.

Sacred Heart of Mary
(detail)
18th century
Museo di Arte Sacra, Tavarnelle
Val di Pesa, Florence

Most Holy Mary of Consolation

June 20

The feast of the *Consolatrix afflictorum* (Consoler of the Afflicted) commemorates two miraculous events. It is said that old King Arduin of Ivrea (Italy) had retreated to the Abbey of Fruttuaria. There, he received instructions from Mary, who appeared to him in a dream together with Saint Benedict and Saint Mary Magdalene. She asked him to build three churches to be dedicated to her: in Belmonte Canavese, Crea Monferrato, and Turin. In 1104, the Virgin also appeared to a blind man, whom she promised would regain his sight if he went to Turin to look for a painting of her. Having reached his destination, the blind man began digging, found an image of the Virgin, and his sight was restored. The icon had probably been hidden during the iconoclastic wars, to save it from being destroyed. This icon has since been lost, and the painting that is now worshiped, dating to the end of the fifteenth century, was inspired by the image of the Madonna of the People of Rome. This *Madonna of Consolation* holds the blessed Child in her arms. The feast is preceded by a solemn novena and is celebrated on June 20.

Cretan school
Virgin Mother of Consolation
15th century
Benaki Museum, Athens

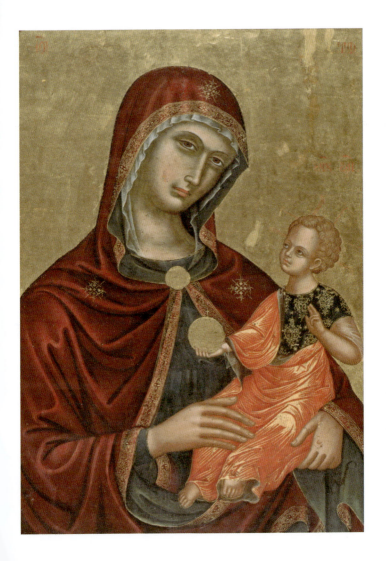

The Deposition of the Sacred Veil of Mary

July 2

In Constantinople, the cult of Mary grew exponentially when some of her relics made their way into the city: her *maphorion*, her belt, and her first "portrait" painted by Saint Luke. In the fifth century, all three relics were in the Byzantine capital, including the *maphorion*, the mantle used by the Virgin to cover her head and shoulders. According to the legend, it was discovered in Capernaum, Palestine, by the patricians Galbius and Candidus in the fifth century. It belonged to a Jewish woman who kept it in a wooden casket; the patricians stole the casket, replacing it with one of the same size. From Capernaum, they took the sacred veil to Constantinople, where it remained until the city was overrun by the Turks in 1453. A variation of the legend, however, reports that the veil was taken in 568 to the Church of Santa Maria in Regola in Imola, Italy, as a present from the Exarch Longinus, who allegedly rebuilt the basilica in the same year that the relic arrived. Still, the Byzantine Church continues to celebrate July 2 as the day when the veil was deposited in the Church of Blachernae.

Deposition of the Robe in the Blachernae Shrine
1627
Church of the Deposition of the Robe, Kremlin, Moscow

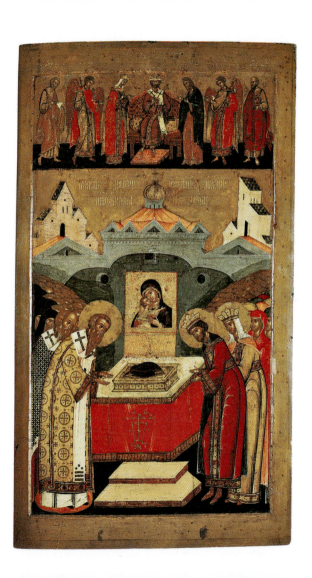

Holy Mary of Mount Carmel

July 16

Mount Carmel is the hill on which the prophet Elias defended the people of Israel and convinced them to have faith in God. There, in the early thirteenth century, the Carmelite Order was founded, calling itself the Order of Our Lady of Mount Carmel. This feast was already celebrated beginning in the fourteenth century. It was an important day in the early seventeenth century, when the Chapter General of the Carmelites declared it the Order's principal holiday. Pope Paul V recognized the appellation as a distinctive title of the Carmelites. On this holy day, one offers thanks to Mary, in whom the entire family of Mount Carmel places its trust. The Carmelites serve Mary, obeying her with faith and purity. The Madonna was considered the Lady of Palestine, and therefore of Mount Carmel. The feast, added by Pope Benedict XIII to the liturgical calendar in 1816, is not in the current calendar approved by Pope Paul VI on February 14, 1969. It remains an optional holiday, celebrated on July 16 or on a suitable day close to then.

Pietro Lorenzetti
Madonna with Angels between
Saint Nicholas and the Prophet Elisha
1328–29
Pinacoteca Nazionale, Siena

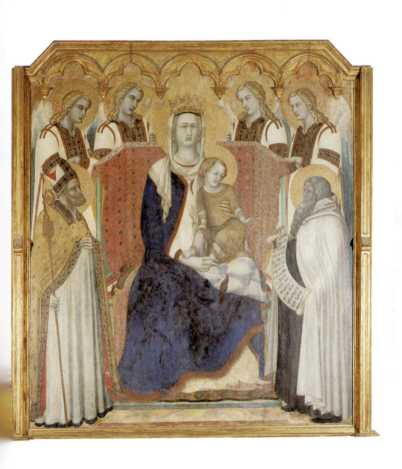

The Dedication of Santa Maria Maggiore Basilica

August 5

This holiday was established to commemorate the day when the Basilica of Santa Maria Maggiore was dedicated in the early fifth century. It rises on the Esquiline Hill in Rome, and was built by order of Pope Sixtus III. To commemorate this event means to celebrate Mary as well, not only because the church is dedicated to her, but because she is the very image of the Church. Starting in the seventh century, the church was also known as Santa Maria *al presepe*, because it houses wood slats from an ancient manger that was, according to popular tradition, the manger where Mary placed the Infant Jesus in the Bethlehem grotto. The liturgical celebration of this feast became part of the Roman calendar only in 1568, having been approved by Pope Pius V.

Tommaso di Cristoforo Fini,
known as Masolino da Panicale
Founding of Santa Maria Maggiore
1420s
Museo Nazionale di Capodimonte,
Naples

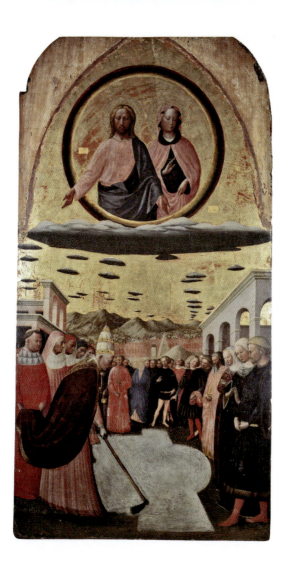

The Assumption of the Blessed Virgin Mary

August 15

The Assumption of the Blessed Virgin Mary is one of the four holy days that originated in the Eastern Church; the other three are the Nativity, the Annunciation, and the Purification. They began to be celebrated in the West around the sixth or seventh century. Still today, it is the most ostentatious of feasts, both for its great popularity and for the variety of local customs. In Jerusalem, it used to be celebrated on August 15 in the church built by Eudocia in Gethsemane, in a building that was believed to have risen from the site of Mary's tomb. Emperor Mauritius (582–602) extended the holiday, which he called *Koimisis* (the Dormition), to the rest of the Eastern Roman Empire. It is not clear how this feast reached the West, but it was first mentioned in the seventh century, under Pope Sergius I, and called the Feast of the Assumption. It was probably celebrated by the many Eastern monks who had migrated west after the Persians and Arabs had invaded Byzantium. The Assumption of Mary—her full participation in body and soul to the Glory of the Resurrected Christ—was proclaimed dogma by Pope Pius XII only in 1950.

Niccolò di ser Sozzo
The Virgin of the Assumption
Miniature
1336–38
Archivio di Stato, Siena

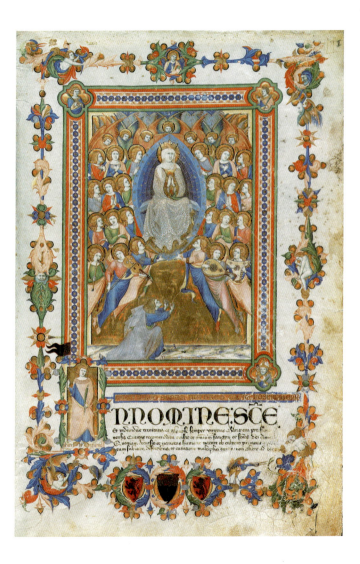

Blessed Virgin Mary the Queen

August 22

To round out the feast of the Assumption, August 22 commemorates the Blessed Virgin Mary the Queen, reminding the faithful of the link between Mary's ascent to Paradise and her glorification as the Queen of Heaven and Earth. The title of queen is one of her most frequent invocations, used both in the liturgy as well as popular devotion and art. Requests for instituting this feast of Mary's universal queenhood were first made at the Marian Congress held in Lyon in 1900 and reiterated at the Fribourg (1902) and Einsiedeln (1906) Congresses. However, it was only in 1954 that Pope Pius XII instituted the holiday, setting it for May 31. The reformed liturgical calendar moved the feast of the Visitation to that day and changed this holiday to its current day, August 22.

Jacobello del Fiore
Coronation of the Virgin
1438
Gallerie dell'Accademia, Venice

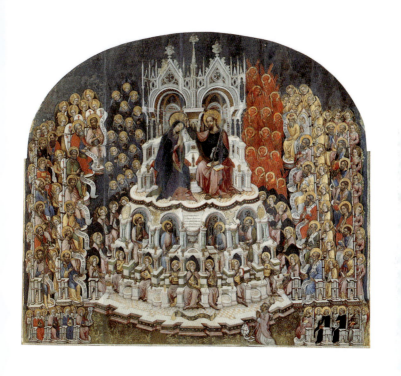

The Deposition of the Sacred Girdle of Mary

August 31

The relic of Mary's girdle is the subject of several traditions. The first claims that, in the fourth century, Emperor Arcadius came into possession of the girdle in Jerusalem. The second holds that it was Emperor Justinian who found it in the sixth century, in the city of Zela in Asia Minor. There is no agreement in the sources even concerning the construction of the shrine in Constantinople that housed the relic. We know that it was placed in a precious reliquary and brought to Constantinople, where it was kept in the Basilica of Chalchoprateia. The Greek Church commemorates the deposition of the girdle in the basilica on August 31. Still, a Western tradition (not recognized in the East) holds that the sacred girdle was later carried to Prato, Italy, by Michael, a merchant of the city, who just before dying gave it to the Provost of the Church of Santo Stefano. The girdle became an object of worship and pilgrims began to flock to Prato. It was recognized by the Vatican and is the second most important relic in the world, after the Holy Shroud. Today, it is still shown to the faithful five times a year: on September 8, Christmas, Easter, May 1, and August 15.

Agnolo Gaddi
The Virgin Giving the Holy Girdle to Saint Thomas
from *Legend of the Holy Girdle*
14th century, Duomo, Prato

The Nativity of the Blessed Virgin Mary

September 8

Like the other early Marian festivities, the commemoration of the birth of the Virgin originated in the East. The source of this episode is the Infancy Gospel of James. It began to be celebrated in Jerusalem in the fifth century, when a large church built on the alleged site of her birth was dedicated. It is not clear why the date selected was September 8, but presumably it was the day on which the new church was dedicated. This holiday became very important in the Eastern Church and inaugurated the Byzantine liturgical year. Around the seventh century, it began to be recognized in the West, together with the feasts of the Annunciation, the Purification, and the Assumption. Pope Sergius I gave solemnity to the imported Marian holidays by decreeing a procession from the Church of Sant'Adriano al Foro to the Basilica of Santa Maria Maggiore. Under Pope Pius X, the holiday was removed from the list of prescribed holidays.

Pietro Lorenzetti
The Birth of Mary
1342
Museo dell'Opera del Duomo, Siena

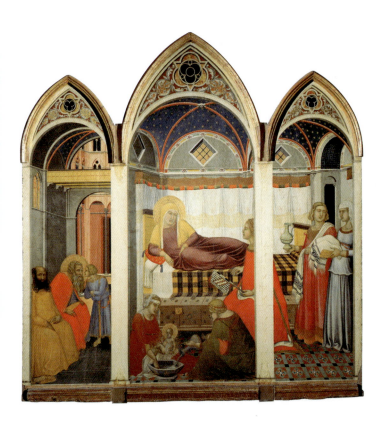

Most Holy Name of Mary

September 12

The celebration of the Most Holy Name of Mary, abolished in the 1969 reform of the Roman calendar because the glorification of the Virgin's name is already implied in the celebration of her Nativity (September 8), was restored as an optional feast in the third edition of the Roman Missal in 2002. The feast was first instituted by Pope Innocent XI (1611–79) when the Austrian King John Sobieski defeated the Turks; after this battle, the Ottoman Empire finally gave up its attempt to conquer Europe. The date set for the feast is September 12, in close correlation with the feast of the Nativity, which it complements.

Jean Hey (Master of Moulins)
The Coronation of the Virgin
from the *Bourbon Altarpiece*
(detail)
c. 1498
Moulins Cathedral, Allier

Blessed Virgin Mary of Sorrows

September 15

The cult of the Virgin of Sorrows began in the twelfth or thirteenth century, in memory of the suffering that Mary felt by sharing in her son's sacrifice. Over time, the feast was given other names and celebrated on different dates. It was instituted in the Church of Cologne on April 22, 1423, by a decree of the Provincial Council, to be celebrated in the province. The date selected was the third Friday after Easter. About 50 years later, in 1482, the Franciscan Pope Sixtus IV composed a Mass entitled "Our Lady of Mercy" and included it in the Roman Missal. In 1668, the Servites, or Servants of Mary, an order founded in 1240, received permission to celebrate the feast of the Madonna of the Seven Sorrows on the third Sunday of September. Pope Pius VIII extended the Mass of Our Lady of Mercy to the entire Roman Church in 1814, setting it on the third Sunday of September, creating a double feast. Finally, Pope Pius X moved the date to September 15, linking the feast to the Exaltation of the Cross, and changed the name to the more universally appealing Blessed Virgin Mary of Sorrows.

José de Mora
Virgin of Sorrows
late 17th century
Victory Church, Osuna

Blessed Virgin Mary of Merced

September 24

The Blessed Virgin Mary is considered to have inspired the founding of the ancient order of La Merced. Saint Peter Nolasco, the founder, was born in Mais Saintes Puellas near Toulouse, France, around 1180 and moved as a teenager with his family to Barcelona. There he was deeply affected by the wretched state of the Christians who had been enslaved by the Moors. He became a merchant to more easily penetrate the Muslim world. In Valencia, he paid ransom out of his own money to free 300 slaves. During the night of August 1 in 1218, the Virgin Mary appeared to him, suggesting that he found a religious order devoted to rescuing slaves, which he did on August 10. In 1272, the order was named Saint Mary of Merced, from the expression used by King Alphonse X the Wise (1221–84), "to rescue slaves is a work of great mercy" (merced in Spanish). In 1696, Pope Innocent XII showed his appreciation for this Marian appellation when he set aside September 24th as a day to commemorate it.

José de Mora
Blessed Virgin Mary of Merced
late 17th century
San Ildefonse, Granada

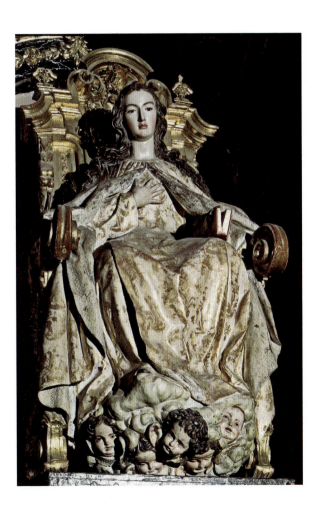

Blessed Virgin Mary of the Rosary

October 7

The feast of the Virgin of the Rosary was instituted after the Christian fleet defeated the Muslims at the naval Battle of Lepanto in 1571. The victory was attributed to the intercession of Mary, whom the entire Christian community was invoking by praying the Rosary, using the prayer beads disseminated by lay Rosary brotherhoods that became popular starting in the late fifteenth century. On March 17, 1572, the Dominican Pope Pius V, in his bull *Salvatoris Dominis*, instituted the feast of the Madonna of Victory, setting it for October 7, because the Battle of Lepanto had taken place on the first Sunday of October. In 1573, his successor Pope Gregory XIII allowed the Feast of the Rosary to be celebrated on the same day in all the churches, chapels, and brotherhoods dedicated to the Rosary. After the great victory over the Turks at Petrovaradin in 1716 by the Christian army under Prince Eugène of Savoy, Pope Clement XI extended the feast to the entire Western Church. In the reformed Roman calendar decreed by Pope Pius X in 1913, the Feast of the Rosary was definitely set for October 7.

Albrecht Dürer
Feast of the Rose Garlands
1506
Národní Galerie, Prague

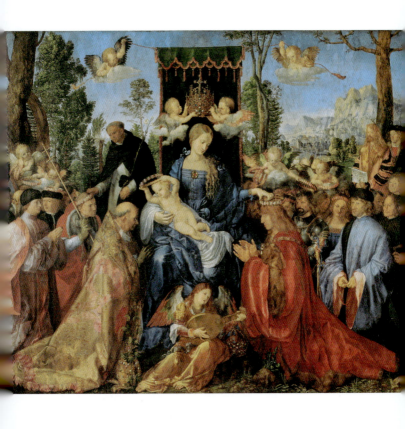

The Presentation of the Blessed Virgin Mary

November 21

The episode of the presentation is reported in the Infancy Gospel of James. The feast began with the dedication on November 21, 543, of the new Church of Saint Mary that Emperor Justinian I had built on the ruins of the Temple of Jerusalem, where the Madonna was believed to have lived before being betrothed to Joseph. The feast of the Presentation of the Virgin arrived relatively late in the West. In the ninth century, it was celebrated by the Eastern monasteries scattered in southern Italy, then expanded to the rest of Europe. At the time of the Post-Tridentine liturgical reformation, Pope Pius V removed the feast because it was based on apocryphal sources, but later Pope Gregory XIII granted King Philip II of Spain permission to celebrate it, and Pope Sixtus V fully restored it. The present Roman calendar does not fully recognize this episode because it has no biblical foundation, but does list it among the optional feasts.

Luigi Scaramuccia
Presentation of the Blessed Virgin Mary to the Temple
1675
Galleria Nazionale dell'Umbria, Perugia

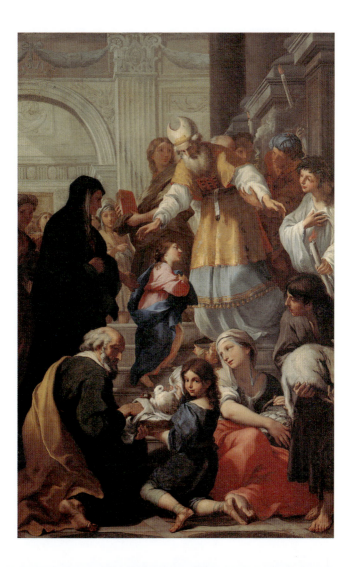

Our Lady of the Miraculous Medal

November 27

A shrine was built in Paris to house a chapel containing a miraculous medal. On July 19, 1830, the Virgin appeared to a young novice, Catherine Labouré of the Daughters of Charity; the Madonna asked her to create a medal. In February 1832, a terrible cholera epidemic broke out in Paris, and in June, the Daughters of Charity, including Catherine, began to distribute the first two thousand medals. By 1842, the cult of the miraculous medal of Our Lady of Graces, whose feast is celebrated on November 27, had spread to all the continents, and everywhere there was news of conversions and healings. In addition, a spectacular event further endeared the medal to the faithful: the sudden conversion of a Jew, Alphonse Ratisbonne, in Rome on January 20, 1842, following a vision. The Madonna had appeared to him in the Church of Sant'Andrea delle Fratte, exactly as she is depicted on the miraculous medal.

Le Cerf
*Apparition of the Virgin to
Saint Catherine Labouré*
1835
Private collection

The Immaculate Conception of the Blessed Virgin Mary

December 8

In the early eighth century, the feast of the Conception of Saint Anne, "mother of the *Théotokos*," was celebrated in the Eastern Church on December 9. This holiday did not directly commemorate the Immaculate Conception of Mary, but rather the event reported in the Infancy Gospel of James, according to which Joachim and Anne, "although sterile," had conceived Mary. Around the year 1000, in some parts of the West an analogous feast was being celebrated on the day before, December 8, which was dedicated to the Conception of the Holy Virgin Mary. Starting in the twelfth century, the word "Immaculate" was added. Notwithstanding the opposition of Saint Bernard and the Dominicans, the feast continued to grow in popularity. In 1476, Pope Sixtus IV added it to the Roman calendar. The dogma of the Immaculate Conception, however, was only officially proclaimed in 1854 by Pope Pius IX. Since then, the modified liturgy stresses the importance of Mary's exceptionality.

Pietro Gagliardi
The Immaculate Conception Saves Humanity from the Original Sin
1856–69
Sant'Agostino, Rome

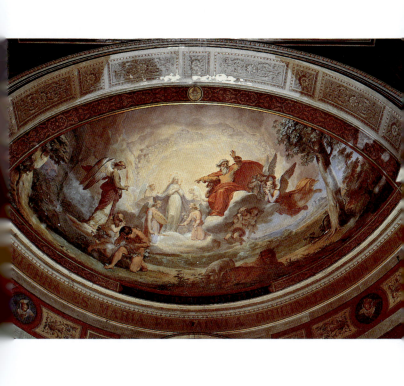

Blessed Virgin Mary of Loreto

December 10

This is an optional holiday that commemorates the arrival of
the Holy House of Nazareth—the house where the Madonna
had received the Annunciation—in Loreto, Italy. The legend
narrates that the house was transported by angels during
the night of December 9 in 1294. Actually, Crusader ships
transported the house when the Christians were driven from
the Holy Land. Several studies and tests have confirmed that
the Holy House, which, according to the legend, the angels
dismantled and rebuilt stone by stone, is indeed from Palestine.
The stones, cut according to a technique used by the ancient
Hebrews, bear graffiti resembling Judeo-Christian marks
found in the Holy Land and dated between the second and
fifth centuries CE. Furthermore, the shape of the walls coin-
cides perfectly with the boundary walls of the grotto, which is
preserved in Nazareth. The Holy House of Mary, an important
pilgrimage site, is located inside a shrine that was built around
it in the fifteenth century.

Giambattista Tiepolo
*The Transport of the Holy House
of Loreto*
1744
Gallerie dell'Accademia, Venice

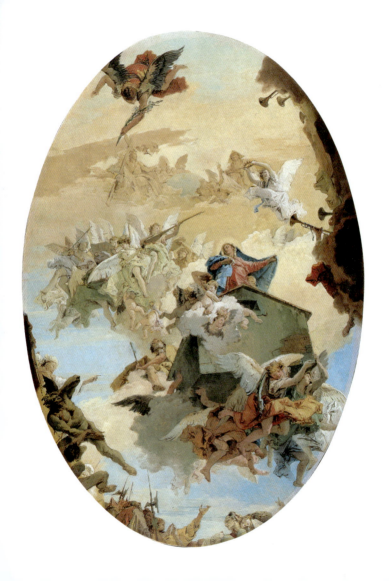

Our Lady of Guadalupe

December 12

Our Lady of Guadalupe is the name by which Catholics worshipped Mary after several apparitions that took place in Mexico in 1531. Several times between December 9 and 12 of that year, Mary appeared to Juan Diego Cuauhtlatoatzin, an Aztec who had converted to Christianity. A shrine now stands on the place where the visions were seen. It was built in 1976 to replace the previous seventeenth-century church, which in turn had replaced a chapel originally built in 1531, right after the apparitions. Apparently, the word "Guadalupe" was dictated by the Virgin, and could be the Spanish transliteration of the Aztec expression *coatlaxopeuh*, meaning "she who crushes the serpent," a clear reference to Genesis. The devotion to Our Lady of Guadalupe spread quickly to all corners of Latin America. In 1667, Pope Clement IX issued a bull setting December 12, the date of the last apparition, as the day of her commemoration. Juan Diego was proclaimed a saint by Pope John Paul II on July 31, 2002.

Miguel Cabrera
The Virgin of Guadalupe
1764
Museo de America, Guadalupe

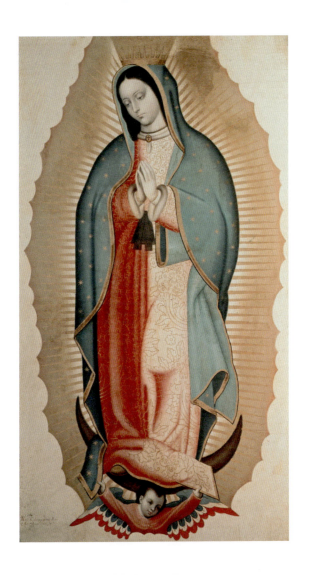

DATE	CITY	COUNTRY	WITNESS	TYPE OF APPARITION
40	Saragossa	Spain	The Apostle James the Elder	Blessed Virgin of Pilar
45	Ephesus	Turkey	The Apostles	Our Lady of the Assumption
45	Ephesus	Turkey	Saint Thomas	Our Lady of the Assumption
July 47	Le Puy-en-Velay	France	Villa	Our Lady of Puy
c. 95	Patmos	Turkey	Saint John	Woman of the Apocalypse
231	New Caesarea	Turkey	Saint Gregory	Mary
mid-3rd century	Lenola	Italy	Saint Paterno, and Egyptian monk	Madonna
325	Myra	Turkey	Saint Nicholas of Bari	Mary Virgin
August 5, 352	Rome	Italy	Pope Liberius	Our Lady of the Snow
363	Caesarea	Turkey	Bishop Basilius	Sovereign Mediator of Her Son Jesus
371	Tours	France	Saint Martin	Madonna
380	Tagaste	Algeria	Saint Monica	Mary
431	Béhuard	France	Saint Maurilius	Holy Virgin
455	Constantinople	Turkey	Leo I	Holy Virgin
552	Gualdo Tadino	Italy	Narsete	Holy Virgin
560	Genoa	Italy	Arghenta	Our Lady of the Vineyards
late 6th century	Bonito	Italy	Peasants	Our Lady of the Snow
626	Constantinople	Turkey	Patriarch Sergius	Queen of Heaven
636	Boulogne	France	Unknown	Mary
August 15, 660	Toledo	Spain	Saint Idelfonse	Virgin Mary
663	Benevento	Italy	Saint Barbatus	Madonna della Libera
684	Clermont	France	Saint Bonito	Mother of God
715	Propezzano	Italy	Three archbishops	Madonna della Crognale

DATE	CITY	COUNTRY	WITNESS	TYPE OF APPARITION
754	Mainz	Germany	Saint Boniface	Mother of God
766	Montreuil	France	Saint Opportuna	Holy Virgin
800	Rosenthal	Germany	Lucianus, a nobleman	Holy Virgin
815	Corbie	France	Saint Anscarius	Most Holy Virgin Mary
963	Mount Athos	Greece	Athanasius	Virgin
May 1000	Montefortino	Italy	Santina	Mary Most Holy
April 1001	Borgo Incoronata	Italy	Count Irpino	Mother of God Crowned
1016	Ivrea	Italy	Arduinus, a monk	Mary the Consoled
1025	Monserrat	Spain	A mother	Mary
1038	Valverde	Italy	Dionysius, a thief	Holy Mary of Valverde
1041	Nocera	Italy	Caramari, a peasant woman	Mother of God
1050	Sopetrau	Spain	Ali, son of the Muslim king of Toledo	Holy Mother
1060	Cluny	France	Hugh of Cluny	Holy Virgin
1061	Walsingham	Great Britain	Richeldis, a widow	Holy House of Mary
1064	Palermo	Italy	Ruggero	Madonna della Rimei
February 12, 1080	Conche	Italy	Saint Constantius	Madonna di Conche
1081	Liège	Belgium	Rupert de Deutz	Mother of God
1087	Oudenburg	Belgium	Saint Arnulfus	Mary
May 25, 1124	Montevergine	Italy	Saint William Abbot	Madonna di Montevergine
1144	Polsi di San Luca	Italy	A shepherd	Madonna of the Mountain
c. 1150	Crespano del Grappa	Italy	A young deaf-mute shepherdess	Madonna del Covolo
1091	Rome	Italy	Saint Bruno	Madonna with Child
1200	Castiglion Fiorentino	Italy	Two young shepherdesses	Madonna of the Bath
c. 1210	Toulouse	France	Saint Dominic	Madonna of the Rosary
1216	Assisi	Italy	Saint Francis of Assisi	Holy Mary of the Angels
August 1, 1218	Barcelona	Spain	Saint Pedro Nolasco	Our Lady of Merced
1221	Padua	Italy	Saint Anthony of Padua	Mother of God
1222	Bologna	Italy	Blessed Jordan of Saxony	Blessed Virgin Mary

DATE	CITY	COUNTRY	WITNESS	TYPE OF APPARITION
1225	Cologne	Germany	Saint Hermann Joseph	Holy Virgin Mary
1226	Wartburg	Germany	Saint Elisabeth of Thuringia	Virgin
1226	Trafoi	South Tyrol	Moritz, a shepherd	Three Holy Fountains
August 15, 1233	Florence	Italy	The Seven Saints of the Servite Order	Most Holy Annunciate
1246	Viterbo	Italy	Saint Rose of Viterbo	Heavenly Mother
c. 1250	Somma Lombardo	Italy	A deaf-mute young shepherdess	Madonna della Ghianda (Madonna of the Acorn)
1250	Lucca	Italy	Saint Zita	Holy Virgin Mary
July 16, 1251	Cambridge	Great Britain	Saint Simon Stock	Our Lady of Mount Carmel
1283	Forlì	Italy	Saint Pellegrino Laziosi	Most Holy Mary
1285	Tolentino	Italy	Saint Nicholas of Tolentino	Madonna
1290	Foligno	Italy	Blessed Angela	Mary
c. 1291	Pentone	Italy	Maria Madia	Madonna di Termine
November 1301	Messina	Italy	Several soldiers	Madonna di Montalto
1301	Laurignano	Italy	Simone Adami, a blind beggar	Madonna of the Chain
1308	Spoleto	Italy	Saint Clare of Montefalco	Madonna
1308	Finstad	Sweden	Saint Bridget	Holy Virgin Mary
April 28, 1310	Bergamo	Italy	A peasant	Madonna del Castagno (Madonna of the Chestnuts)
1313	Maria-Thal	Italy	A blind beggar	Madonna
1326	Guadalupe	Spain	A shepherd	Blessed Virgin Mary
1328	Florence	Italy	Saint Andrew Corsini	Mother of God
December 1336	Bra	Italy	Egidia Mathis	Madonna of the Flowers
1340	Tournai	Belgium	The hungry townspeople	Madonna
June 23, 1347	Bibbiena	Italy	Caterina	Madonna of Stone and Darkness
c. 1354	Rostov	Russia	Saint Sergius	Madonna
April 1356	Basella	Italy	Marina Cassone	Queen of Heaven

DATE	CITY	COUNTRY	WITNESS	TYPE OF APPARITION
1359	Naples	Italy	Charles, Count of Verona	Mary
late 14th century	Ostiglia	Italy	A young deaf-mute shepherdess	Madonna
1373	Mariahilf	Slovakia	Louis of Anjou	Mary
July 2, 1399	Assisi	Italy	A boy in a field	Madonna of the Olive
July 1399	Valverde	Italy	A peasant	Madonna
c. 1400	Bettola	Italy	A young shepherdess	Madonna of the Oak Tree
January 3, 1417	Albano Sant'Alessandro	Italy	Two lost merchants	Blessed Virgin of the Roses
1417	Siena	Italy	Saint Bernardino	Most Holy Mary
July 2, 1420	Castel di Godego	Italy	Pietro Tagliamento	Madonna of the Little Cross
1420	Faenza	Italy	A widow	Holy Virgin Mary
1424	Domrémy	France	Joan of Arc	Madonna
1425	Warta	Slovakia	A young man	Mother of God
March 7, 1426	Monte Berico	Italy	Vincenza Pasini	Virgin Mary
1429	Peñafrancia	Spain	Brother Simon Vela	Our Lady of Peñafrancia
May 26, 1432	Caravaggio	Italy	Giannetta	Holy Mary of the Fountain
1436	Rome	Italy	Saint Frances of Rome	Madonna
1440	Maria Fallsbach	Austria	A hunter	Holy Virgin
October 9, 1440	Desenzano al Serio	Italy	Ventura Bonelli	Madonna of the Leg
March 3, 1449	Cubas de la Sagra	Spain	Inés, a young shepherdess	Holy Mary of the Cross
1450	Neukirchen	Germany	Susanna Halada	Holy Virgin Mary
late 15th century	Graffignano	Italy	Several shepherds	Madonna
1450	Bologna	Italy	Saint Catherine Vigri	Mary
Augst 14, 1453	Ghisalba	Italy	Antoniola	Madonna of Consolation
1460	Loreto	Italy	The people	Holy House of Mary
1460	Saronno	Italy	Pietro Morandi, a paralytic	Our Lady of the Miracles
September 1468	Ospedaletto Euganeo	Italy	Giovanni Zelo	Blessed Virgin of the Tresto
November 1470	Badia di Cava	Italy	Gabriele Cinnamo	Most Holy Mary the Advocate

DATE	CITY	COUNTRY	WITNESS	TYPE OF APPARITION
August 1479	Mogliano Veneto	Italy	A deaf-mute woman	Madonna of the Graces
May 18, 1480	Canzano	Italy	Floro di Giovanni	Most Holy Mary of Alno
c. 1480	Rome	Italy	Blessed Amadeo Mendez da Silva	Queen of Paradise
1484–90	Sasso	Italy	The Ricovera sisters	Heavenly Mother
April 3, 1490	Crema	Italy	Caterina de' Uberti	Holy Mary of the Cross
August 29, 1490	Monte Figogna	Italy	Benedetto Pareto	Mother of Jesus
July 16, 1493	Racconigi	Italy	Antonio Chiavassa	Madonna of the Graces
July 17, 1494	Balze di Verghereto	Italy	Two young sheperdesses	Madonna
c. 1500	Pannesi di Lumarzo	Italy	Felice Olcese, a deaf-mute	Our Lady of the Woodland
September 1504	Tirano	Italy	Blessed Mario Omodei	Madonna
1506	Leon	Spain	A shepherd	Most Holy Mary
June 24, 1508	Chioggia	Italy	Carlo Baldissera Zanon	Blessed Virgin of the Little Ship
March 9, 1510	Motta di Livenza	Italy	Giovanni Cigana	Madonna
September 8, 1510	Aviano	Italy	Antonio Zampara	Madonna of the Mountain
May 1511	Castelleone	Italy	Domenica Zanenga	Holy Mary of Mercy
1511	Treviso	Italy	Saint Jerome Emiliani	Virgin
April 1514	Liveri di Nola	Italy	Autilia Scala	Holy Mary
1515	Garaison	France	Anglèse de Sagazan	Our Lady of Garaison
1518	Werthenstein	Switzerland	A devout hermit	Queen of the Sky
July 2, 1518	Camogli	Italy	Angela Schiaffino	Madonna of the Grove
August 10, 1519	Catignac	France	Jean de la Baume	Mary
1520	Tarbes	France	A young shepherdess	Mary
May 4, 1521	Cori	Italy	Oliva Iannese	Madonna of Help
1529	Sens	France	The people	Holy Virgin Mary
June 1529	Naples	Italy	A little old lady	Holy Mary of Constantinople
December 9, 1531	Guadalupe	Mexico	Juan Diego	Madonna crushing the Serpent
April 1536	San Bernardo	Italy	Antonio Botta	Mary
May 31, 1536	Monte Stella	Italy	Antonio de'Antoni	Madonna of the Star

DATE	CITY	COUNTRY	WITNESS	TYPE OF APPARITION
July 11, 1536	Combarbio	Italy	A young shepherdess	Madonna of Mount Carmel
Spring 1539	Sveta Gora	Slovenia	Ursula Ferligoj	Madonna
1543	Lowen	Belgium	Cornelius Wischaven	Mary
March 28, 1543	Ameno	Italy	Giulia Manfrei	Mary
c. 1547	Pietralba	Italy	Leonardo Weissensteiner	Holy Mary of Pietralba
February 22, 1550	Castel San Pietro	Italy	Antonia Beini	Blessed Virgin of Poggio
April 17, 1555	Corbetta	Italy	Some people	Blessed Virgin of the Miracles
May 21, 1556	Arcola	Italy	The Fiamberti sisters	Queen of Angels
1557	Brescia	Italy	Giacomo Leesma	Mary
April 22, 1557	Giulianova	Italy	Bertolino	Madonna of the Splendor
1566	Forlì	Italy	Jerome, a Capuchin friar	Mary
August 15, 1572	Caltagirone	Italy	A deaf-mute girl	Holy Mary of the Bridge
June 9, 1573	Monsummano Terme	Italy	Jacopina Mariotti	Most Holy Mary of Fontenuova
1576	Gubbio	Italy	Pacifico, a Capuchin friar	Blessed Virgin Mary
June 11, 1576	Casalbordino	Italy	Alessandro Muzio	Madonna of the Miracles
December 1578	Poggio di Roio	Italy	Felice Calcagno	Holy Mary of the Cross
July 8, 1579	Kazan	Tatar Republic	A woman	Our Lady of Kazan
1580	Trivento	Italy	Two Capuchin friars	Mary
July 12, 1586	Stezzano	Italy	Bartolomea Ducanelli and Dorotea Battistoni	Blessed Virgin of the Fields
1587	Rome	Italy	Saint Felix of Cantalice	Blessed Virgin Mary
1587	Rome	Italy	Saint Philip Neri	Mary
c. 1588	Florence	Italy	Mary Magdalene de' Pazzi	Madonna
1590	Lima	Peru	Ruys de Portyllo	Most Holy Virgin Mary
1594	Acquasparia	Italy	Bernardino di Colpetrazzo	Mother of God

DATE	CITY	COUNTRY	WITNESS	TYPE OF APPARITION
July 29, 1594	Morbio Inferiore	Switzerland	Two little girls, Caterina and Angela	Madonna of the Miracles
1596	Arona	Italy	Emmanuel Sa	Most Holy Mary
May 5, 1596	Fivizzano	Italy	Margherita "La Caugliana"	Blessed Virgin of the Adoration
September 1602	Lenola	Italy	Gabriele Mattei	Madonna
1602	Reggio Calabria	Italy	Brother Benedict	Mary
1602	Lampedusa	Italy	Andrea Anfossi	Our Lady of Lampedusa
1604	Ingolstadt	Germany	Father Jakob Rem	Mother of God
1606	Heiligwasser	Germany	Johann and Paulus Mayr	Mother of God
June 1607	Ardesio	Italy	Maria and Caterina Salera	Blessed Virgin of the Graces
1608 and 1671	San Bartolomeo al Mare	Italy	Giacinto Perato	Our Lady of the Oak Tree
1609 and 1610	Chiavari	Italy	Sebastiano Descalzo and Geronima Turrio	Our Lady of the Orchard
July 5, 1615	Chioggia	Italy	Brother Adam	Madonna of the Little Donkey
1616	Stans	Switzerland	Georg Nocker	Most Holy Virgin
February 2, 1617	Naples	Italy	Orsola Benincasa	Madonna
1620	Bosentino	Italy	Janesel	Madonna of Feles
February 1623	Castel San Pietro	Italy	Zenobia, a young shepherdess	Blessed Virgin of Lato di Monte Calderaro
June 21, 1623	Ozegna	Italy	Giovanni Petro	Blessed Virgin of the Convent and the Woodland
1623	Paris	France	Sister Catherine of Jesus	Virgin Mary
1627	Agrea	Spain	Mother Mary of Agrea	Madonna
1630	Lure	France	A shepherd	Holy Virgin Mary
November 1639	Savigliano	Italy	Tesio Petrina	Madonna
July 10, 1647	Ponzano Magra	Italy	Giovanni Battistoni	Our Lady of the Graces
1647–1718	Laus	France	Benedicta Rencurel	Mary
August 23, 1648	Corigliano Calabro	Italy	Antonio Ruffo	Madonna of Schiavonea
1649	Naples	Italy	Vincenzo Carafa	Mary

DATE	CITY	COUNTRY	WITNESS	TYPE OF APPARITION
1651 and 1652	Coromoto	Venezuela	A native tribal chief	Our Lady of Coromoto
February 2, 1655	Pieve di Rosa	Italy	Maria Giacomuzzi	Holy Mary of Pieve di Rosa
1657	Les Plantées	France	Pierre Port-Combet	Our Lady of the Reed
c. 1661	Janots	France	Saint Marguerite Marie Alacoque	Mary
1664–1727	Mercatello sul Metauro	Italy	Veronica Giuliani	Madonna
April 17, 1677	Torre di Ruggiero	Italy	Isabella Cristello and Antonia De Luca	Most Holy Mary of Graces
January 27, 1699	Castenaso	Italy	Maria Maddalena	Madonna
1710 and on	Ovada	Italy	Saint Paul of the Cross	Madonna
October 1, 1711	Valverde	Italy	Paola Ogna and Francesco Pellizzari	Madonna
1713 and 1714	Rubiana	Italy	Nicol Lorenzo	Madonna of Sorrows
August 4, 1716	Pellestrina	Italy	Natalino Scarpa	Madonna of the Apparition
1729	Piné	Italy	A devout woman	Mary
1729 and 1730	Montagnaga	Italy	Domenica Targa	Virgin Mary
1740	Rome	Italy	A wayfarer attacked by stray dogs	Madonna of Divine Love
April 2, 1779	Bocca Pignone di Ripalta	Italy	Domenico Malatesta	Madonna della Ghianda (Madonna of the Chestnuts)
1783–1824	Dulmen	Germany	Sister Ann Catherine Emmerich	Virgin Mary
August 1798	La Vang	Vietnam	Persecuted Christians	Our Lady of La Vang
1803	Villanova d'Asti	Italy	Maria Baj	Madonna of the Bulwarks
February 1821	Tinos	Greece	Michael Polyzois	Panagia (All Holy)
1830 and 1831	Paris	France	Saint Catherine Labouré	Madonna
August 13, 1831	Guadalajara	Spain	Sister Patrocinio	Holy Virgin
January 28, 1840	Paris	France	Sister Justine Bisqueyburu	Holy Virgin

DATE	CITY	COUNTRY	WITNESS	TYPE OF APPARITION
January 1842	Rome	Italy	Alfonso Maria Ratisbonne	Madonna of the Miracles
1842	Celles	Belgium	Sophie Deprez	Virgin Mary
September 1846	La Salette	France	Melanie Calvat and Maximine Giraud	Conciliator of Sinners
1846	Turin	Italy	Saint John Bosco	Mary
1856	Spoleto	Italy	Francesco Possenti	Holy Virgin Mary
February 11–July 16, 1858	Lourdes	France	Bernadette Soubirous	Immaculate Conception
1861 and 1862	San Luca di Montefalco	Italy	Santa Bonifazi and Federico Cionchi	Madonna of the Star
January 17, 1871	Pontmain	France	Eugène and Joseph	Our Lady of Pontmain
1872	New Pompeii	Italy	Bartolo Longo	Holy Virgin Mary
July 1875	Villareggio	Italy	Rosina Ferro	Mother of Sorrows
August 21, 1879	Knock	Ireland	Fifteen people	Worldless vision
1881–1947	Corato	Italy	Luisa Piccarreta	Mary
1883	Rovigo	Italy	Maria Inglese	Most Holy Virgin
December 8, 1896	Imbersago	Italy	Teresa Secomandi	Blessed Virgin of the Woodland
May 13–October 13, 1917	Fatima	Portugal	Lúcia, Francisco, and Jacinta	Our Lady of the Holy Rosary
1918 and on	Turin	Italy	Flora Manfrinati	Our Universal Lady
1924	Cernusco sul Naviglio	Italy	Elisabetta Reaelli	Madonna of the Divine Tears
May 31, 1927	Messina	Italy	Saint Annibale Maria di Francia	Mary as a Child
1930	Campinas	Brazil	Sister Amalia Aguirre	Our Lady of Tears
1932 and 1933	Beauraing	Belgium	Five children	Queen of Heaven and Virgin with the Golden Heart
1933	Banneux	Belgium	Mariette Beco	Virgin of the Poor
1934	La Vang	Vietnam	Two pagan women	Our Lady of La Vang
August 15, 1935	Itri	Italy	Luigina Sinapi	Madonna
1937	Voltago	Italy	Four people	Holy Virgin Mary
May 31, 1938	Milan	Italy	Sister Mary Pierina De Micheli	Madonna

DATE	CITY	COUNTRY	WITNESS	TYPE OF APPARITION
1938 and on	Paravati	Italy	Natuzza Evolo	Virgin
1940 and 1946	Pfaffenhofen	Germany	Barbara Ruess	Mediator of All Graces
1944–55	Balasar	Portugal	Alexandrina Maria da Costa	Madonna
1945–59	Amsterdam	Holland	Ida Peerdeman	Lady of All Peoples
1946–83	Montichiari	Italy	Pierina Gilli	Mystic Rose
April 12, 1947	Tre Fontane	Italy	Bruno Cornacchiola and his three sons	Virgin of Revelation
December 1947	Île Bouchard	France	Several people	Our Lady of Prayer
January 8, 1948	Caiazzo	Italy	Teresa Musco	Mary Immaculate
1948, 1985, and on	Gimigliano di Venarotta	Italy	Anita Feerici, and others	Madonna of Sorrows
April 1949	Ceggia	Italy	Mariolina Baldissin	Mary
1949–86	Balestrino	Italy	Caterina Richero	Madonna of Reconciliation
May 16, 1950	Venice	Italy	Sister Clare Scarabelli	Immaculate Heart
1951	Collalavenza	Italy	Mother Speranza	Holy Virgin Mary
1953	Bivigliano	Italy	Galileo Sacrestani	Most Holy Mary
1953	Rome	Italy	Elena Leonardi	Virgin Mary
1954	Pombia	Italy	Mrs. Frizzarin	Holy Virgin Mary
1955	Reggio emilia	Italy	Rosa Soncini	Blessed Virgin Mary
1956	Urbania	Italy	Augusta Tangini	Most Holy Mary
June 1, 1958	Turzovka	Slovakia	Mathias Laschut	Madonna of Lourdes
April 16, 1960	Neuweier	Germany	Erwin Wiehl	Madonna of Graces
1961–81	San Damiano	Italy	Rosa Buzzini	Madonna of Roses and Mother of Consolation
February 3, 1962	Monte Fasce	Italy	Father Bonaventura and Giliana Faglia	Our Lady of Fatima
May 26, 1967	Cefala Diana	Italy	Four boys	Mother of Sorrows
1968	Milan	Italy	Mother Carmela	Holy Virgin Mary
May 1968 and on	Placanica	Italy	Cosimo Fragomeni	Mary
1968–70	Zeitun	Egypt	Thousands of people	Mary
1970	Lecce	Italy	Angelo Chiaratti	Immaculate Conception
1970	Sesto San Giovanni	Italy	Lucia Frascaria	Holy Virgin

DATE	CITY	COUNTRY	WITNESS	TYPE OF APPARITION
December 31, 1973	Tampa	United States	Sister Briege McKenna	Queen of Peace
1973–81	Akita	Japan	Sister Agnes Katsuko Sasagawa	Holy Mother
1974 and on	Gallinaro	Italy	Giuseppina Norcia	Cradle of Baby Jesus
1976 and on	Betania	Venezuela	Maria Esperanza Merano Bianchini	Virgin and Mother of Reconciliation
1976 and on	Berlicum	Holland	Elisabeth Sleutjes	Tower of David
1977	Rome	Italy	Armanda, a housewife	Madonna
1981	Ohlau	Poland	Kasimir Domanski	Queen of Peace and of the World
June 1981 and on	Medjugorje	Herzegovina	Jakov, Vicka, Marja, Ivan, Ivanka, and Mirjana	Queen of Peace
1982–83	Damascus	Syria	Maria Kourbet Al-Akhras	Virgin Mary
1983–90	San Nicolas	Argentina	Gladys Herminia Quiroga de Motta	Our Lady of the Rosary
1984–93	Carpi	Italy	Gian Carlo Varini	Mother of Peace
1985 and on	Schio	Italy	Renato Baron	Queen of Love
1986	Scarpapé	Switzerland	Pino Casagrande	Holy Virgin Mary
1987	Padua	Italy	Amelia Favarin	Holy Virgin Mary
April 26, 1987, and on	Grushew	Ukraine	Maria Kyzyn	Virgin of Tenderness
1988–98	Conyers	United States	Nancy Flower	Madonna
1992 and on	Aokpe	Nigeria	Christiana Agbo	Mediator of All Graces
1993 and on	Ostina	Italy	Silvana Orlandi	Madonna of Reconciliation
1993 and on	Ischia	Italy	Several people	Madonna
April 11, 1994	Stupinigi	Italy	Eugenio Palio	Immaculate of Mercy
1994 and on	Forio d'Ischia	Italy	Several people	Madonna
1999	Marpingen	Germany	Several people	Immaculate Conception
February 2001	Capua	Italy	Antonio	Virgin of the Revelation of the Last Days
December 2004	San Bonico	Italy	Celeste	Madonna and three angels

Index of Episodes

Index of Artists

Photographic Credits